Series Editor

Erwin Chemerinsky, Dean, UC Berkeley School of Law

Paving the Way

Paving the Way

THE FIRST AMERICAN WOMEN LAW PROFESSORS

Herma Hill Kay

Edited by Patricia A. Cain
Foreword by Ruth Bader Ginsburg
Afterword by Melissa Murray

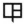

UNIVERSITY OF CALIFORNIA PRESS

University of California Press
Oakland, California

© 2021 by Herma Hill Kay Living Trust

Library of Congress Cataloging-in-Publication Data

Names: Kay, Herma Hill, author. | Cain, Patricia A., editor. | Ginsburg,
 Ruth Bader, writer of foreword. | Murray, Melissa, writer of afterword.
Title: Paving the way : the first American women law professors / Herma
 Hill Kay, edited by Patricia A. Cain ; foreword by Ruth Bader
 Ginsburg; afterword by Melissa Murray.
Description: Oakland, California : University of California Press, [2021] |
 Includes bibliographical references.
Identifiers: LCCN 2020047071 (print) | LCCN 2020047072 (ebook) |
 ISBN 9780520378957 (cloth) | ISBN 9780520976467 (ebook)
Subjects: LCSH: Women law teachers—United States—Biography.
Classification: LCC KF372 .K39 2021 (print) | LCC KF372 (ebook) |
 DDC 340.092/520973—dc23
LC record available at https://lccn.loc.gov/2020047071
LC ebook record available at https://lccn.loc.gov/2020047072

Manufactured in the United States of America

25 24 23 22 21
10 9 8 7 6 5 4 3 2

Contents

Foreword

Herma Hill Kay, author of this volume, was the fifteenth woman to hold a tenure-track position at a law school accredited by the Association of American Law Schools (AALS). For more than twenty-five years, she has devoted her time and talent to bringing vividly to life the work and days of the fourteen women who preceded her in appointments to AALS-accredited law faculties. And in a final chapter, she tells of the women who came next, achieving tenure-track appointments in the half-century and more since 1960. Retrieving this history was a huge undertaking, one of inestimable value. To tell the stories of the first fourteen, Kay read their publications, personally interviewed the nine still alive when she embarked on the project, and elicited the remembrances of both colleagues and scores of students. Without Kay's prodigious effort, we could not adequately comprehend how women altered legal education and law itself.

Most of the pioneers—the seven appointed from 1919 to 1949, and the equal number appointed in the next decade—did not think of themselves as exceptional or courageous. Eleven were married, nine had children. Several were family law scholars and reformers, but most taught in diverse areas, including commercial law, corporate law, and oil and gas law. As one of them commented: "We didn't talk about what we were doing. We

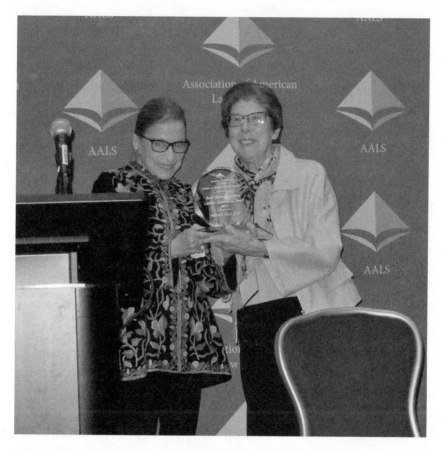

Figure 1. Justice Ruth Bader Ginsburg and Professor Herma Hill Kay together following Kay's recognition with the American Association of Law School's Ruth Bader Ginsburg Lifetime Achievement Award, 2015. Courtesy of Amanda Tyler.

just did it." Different as they were, they shared a quality essential to their success: perseverance. And all of them overcame the odds against them for the same reason: they found law study and teaching fulfilling.

Reading the manuscript, I found one thing missing; Kay tells us almost nothing about herself. It is fitting, I decided, to address that omission in this introduction by writing of Herma Hill Kay, law teacher, scholar, and reformer nonpareil. She is my treasured friend, so I will refer to her by her first name.

When Herma was a sixth grader in a rural South Carolina public school, her teacher recognized her skill in debate and suggested what she should do with her life: she should become a lawyer. Undaunted by the profession's entrenched resistance to women at the bar, that is just what Herma set out to do after earning her undergraduate degree from Southern Methodist University in 1956. Although initially told by famed professor Karl Llewellyn that she didn't belong in law school, Herma rejected that bad advice and became a stellar student at the University of Chicago. There, she worked as research assistant to pathmarking Conflict of Laws scholar Brainerd Currie, and co-authored two leading articles with him.[1] On Professor Currie's recommendation, Herma gained a 1959 clerkship with California Supreme Court Justice, and later, Chief Justice, Roger J. Traynor, a jurist known for his brilliance and his humanity. Despite Traynor's strong endorsement of Herma, Chief Justice of the United States Earl Warren wasn't up to engaging a woman as his law clerk in 1960, nor were his fellow Justices.

Traynor's recommendation carried heavier weight with the Berkeley law faculty, where Herma commenced her career in the academy, and in just three years, became a full professor with tenure in 1963. Inspired and encouraged by Berkeley's distinguished Professor Barbara Armstrong, first woman to achieve tenure on any United States law faculty, Herma made family law her field of concentration, along with Conflict of Laws.

At a young age uncommon for such assignments, in 1968 Herma was appointed Co-Reporter of the Uniform Marriage and Divorce Act. That endeavor of the National Conference on Uniform State Laws launched no-fault divorce as an innovation that would sweep the country in a decade's span. In the ensuing years, in California and elsewhere, Herma strove to make marriage and divorce safer for women.

Herma and I first met at a Women and the Law Conference in 1971. For the rest of that decade, she was my best and dearest working colleague. Together with Kenneth Davidson, we produced, in 1974, the first published set of course materials on sex discrimination and the law.[2]

Before our first conversation, I knew Herma through her writings. She co-authored, with Roger Cramton and David Currie, the casebook I used in teaching Conflict of Laws.[3] Her extraordinary talent as a teacher, I knew as well, had garnered many awards, lectureship invitations, and

visiting offers. I was also aware of Herma's reputation as a woman of style, who had a private pilot's license, flew a Piper Cub weekly, and navigated San Francisco hills in a sleek yellow Jaguar. In person, I quickly comprehended that Herma had a quality that cannot be conveyed in words. There was a certain chemistry involved when one met her, something that magically made you want to be on her side.

Herma's skill in the art of gentle persuasion accounts, in significant part, for the prominent posts she held in legal and academic circles. In 1973 and 1974, she chaired Berkeley's Academic Senate. She was, from 1992–2000, Berkeley Law School's valiant Dean, meeting budgetary restrictions by honing her skills as a fundraiser, planning for the Law School's new home, promoting depth and diversity in faculty appointments, and making the place more user-conscious and user-friendly. An unflinching partisan of equal opportunity and affirmative action, Herma managed to reset Berkeley Law School's course to advance the admission of African American and Hispanic students after the initial shock of Proposition 209, California's strident anti-affirmative action measure. Before and after her Deanship, she served the University and the University's Senate in various capacities, sitting on or chairing, by her own reckoning, "fifty zillion" committees.

Outside the University, she played lead roles in major legal institutions. She served on the Executive Committee of the AALS for four years, and became its President in 1989. She chaired the Association's Nominating Committee in 1992, and was a member of the *Journal of Legal Education* editorial board from 2001 to 2004.

Herma was Secretary of the American Bar Association's Section of Legal Education and Admissions to the Bar from 1999 to 2001, Executive Committee member of the American Bar Foundation from 2000 to 2003, and both Council and Executive Committee member of the American Law Institute from 2000 to 2007. In the private philanthropic domain, she chaired the Russell Sage Foundation Board between 1980 and 1984, and the Rosenberg Foundation Board from 1987 to 89. For many years, she served on the Editorial Board of the Foundation Press, and she counseled Senator Dianne Feinstein (D-CA) on judicial appointments between 1992 and 1996. In that capacity, she strongly supported my nomination to the US Supreme Court in 1993.

Herma was a proponent of interdisciplinary education, team teaching law and anthropology with Laura Nader in the early 1960s, and later, law and psychiatry with Irving Phillips. As Dean of Berkeley Law School, she launched the Center for Clinical Education, and made clinical experience a mainstay of the curriculum. In the summer of 1989, she delivered a series of influential lectures at the Hague Academy of Private International Law.[4] Showing how stunningly she could perform outside an academic milieu, in 1978, she flawlessly argued the *Hisquierdo* gender discrimination case before the US Supreme Court.[5]

A new chapter opened in Herma's life in 1975 when she married psychiatrist Carroll Brodsky, father of three boys, the youngest, age twelve, the older boys, teenagers. Carroll was as loving and supportive as a partner in life can be. Each week during Herma's deanship, Carroll sent a gorgeous floral display to brighten the Dean's workspace. And although Herma stopped piloting planes as she sought to balance career and family life, she became an avid swimmer and an accomplished gardener, growing roses and orchids on the balcony of her Telegraph Hill apartment.

Herma's persistent endeavor over a span of fifty-five years was to shape the legal academy and the legal profession to serve all the people law exists (or should exist) to serve, and to make law genuinely protective of women's capacity to chart their own life's course.

No person could be better equipped than Herma Hill Kay to write about the women in law teaching who paved the way for later faculty and student generations, populations that reflect the full capacity, diversity, and talent of all our nation's people. Her presentation of the history comprehensively and engagingly recounted in the pages of this book is cause for celebration.

Ruth Bader Ginsburg
Associate Justice
Supreme Court of the United States
August 1, 2015

Preface

Herma Hill Kay, the author of this book, unfortunately passed away before bringing her completed manuscript to publication. Many of us who were friends, admirers, colleagues, and students of hers thought that this project was so important that we committed ourselves to carrying on and finishing what she had started. I have had the privilege (and the pleasure) of being the person primarily responsible for this task.

Why me, you might ask? Good question, and it deserves an answer. I think it is because at some unspoken level Herma trusted me. She did ask me to write her biography one night. It was over drinks and we didn't sign a contract, even on the napkin in front of us, but she stuck with that choice, telling various students of hers who asked about biographical options that I was the one. She did not, however, ask me to finish this book. That decision was made by a number of her prior students and colleagues who contacted me and said: You are the one, and will you do it?

Well, I agreed that the book had to be finished. And, as my final thank you to Herma for everything she did for women in law, especially in the legal academy, I took on this task totally pro bono in order to honor one of the best who came before me.

Again, why me? I was not a student of Herma's. When I entered law teaching in 1974 at the University of Texas, I had never seen a female law professor in my life. I had a sense that some existed somewhere, but I certainly had no image. I had the great privilege to meet Herma in person in Berkeley in the mid-1970s. Isabel Marcus, whom I had just supported hiring at Texas in the government department, with an adjunct position in law, more or less demanded that I visit her in Berkeley before she moved to Texas. I had never been to California before.

Isabel was also adamant that I meet Herma. She introduced me to her in Herma's office at the University of California, Berkeley. I was actually stunned that this icon of women law professors would take the time to meet me in person. But that was pure Herma. She was always a connector for women who needed connections. And after that, I readily helped her in that process whenever I could.

But, again, why me? I honestly think it goes back to this simple and somewhat silly story. In 1976, Wayne McCormack, a mentor of mine at Georgia Law School (my alma mater), who was then deputy director of the AALS, called me. He asked me to produce what was then known as the Extravaganza or Faculty Follies at the annual AALS meeting. He remembered that I had been a drama major at Vassar, and he was apparently impressed with my production of Georgia's Libel Show in my third year of law school. C'mon, I thought. Is this guy nuts? This is a whole different level, and I am this unknown and untenured law professor at the University of Texas. But I abide by the principle that "one never says no" to someone who has given you a major boost in life. Wayne was a Texas graduate who had been the research assistant for Dean Page Keeton. I probably owe my entire academic legal career to him, so of course I said: "Yes."

I was able to convince several senior faculty members from around the country to participate in this "talent show and spoof of legal education." I also participated, and I thought that my own participation warranted something original. So, as I drove in my little red convertible with my Martin guitar in the back seat from Texas to Atlanta, I composed a song. I never gave it a title, but it was a critique of the patriarchal dominance of our legal society. I hypothesized a legal matriarchy, at least in law schools. First, I had Herma Kay replace Dean Sacks at Harvard Law. Then she fired the men and hired women law professors. She was challenged in the courts, but they

couldn't get anywhere "because President Bella Abzug had put Ruth Bader Ginsburg in Burger's chair." There is more, but I will spare you the details.

My friend Isabel sent a tape of this crazy song to Herma and she apparently loved it. I think she then connected with me on a more special level. My guess is that she appreciated me primarily because of my "spunk." Herma, after all, had a spunky streak too. She was once an active private plane pilot, she drove a yellow Jaguar, and she wore a hat when she interviewed for a faculty position (as did I).

We had other connections as well. She grew up in South Carolina. I grew up in Georgia. I struggled with my southern accent. She overcame hers. I once asked her how. She answered in two words: "voice lessons."

She completed her undergraduate degree at SMU, in Texas. And, of course, I was in Texas in the 1970s when female spunk was omnipresent. I had the opportunity and the privilege to hobnob with some very strong Texas women like Sarah Weddington, Sissy Farenthold, Ann Richards, Molly Ivins, Barbara Jordan, and Jane Hickie. Looking back on this time, my spunk was probably helpful in getting me a job at Texas. I'm *not* so sure that it helped me in getting tenure at Texas. Yet, it surely did help me to survive that experience.

So I completely understand these stories of the "first fourteen," whom I think of as my foremothers. Barbara Armstrong, drawn to theater, was like me. Which is better: law or theater? And I was particularly drawn to those early strong women in the South, who taught at Baylor and LSU. They were amazing. Herma thought so, too. She even met Margaret Amsler (Baylor) in person, since Amsler was the mother of one of Herma's close friends at SMU.

Although Herma asked me to write her biography, she also made me promise that I would never write a word about her until her own book on the first fourteen had been published. That is typical Herma—"don't talk about me, but talk about the others." That is another reason why I committed myself to this project. I knew how important it was to Herma. And, although I promised her that I would not write a word about her until this book was published, I hope you now have some idea of the high regard and respect I have for this amazing woman. Justice Ginsburg's Foreword tells you more. And let me just say that Herma's students routinely describe her as everything from a "mentor" to a "rock star."

Some minor details about this book: I have done my best to preserve Herma's "voice" throughout this edit. I have been greatly assisted by an independent editor whom Herma had employed to assist her in cutting the length of the original manuscript: Danielle McClellan, the current managing editor of the *Law and Society Review*. Sometimes she and I have agreed to update the information provided in Herma's original text, which was completed around 2010. Our updates are intended to give you the most current information available. I would also like to thank Kathleen Vanden Heuvel and Lisa Ferrari of the Berkeley Law Library, who have graciously and tirelessly responded to my cries for help with accessing Herma's many files and records relating to this book. And finally, I owe a debt of gratitude to my spouse, Jean Love, who, because of her own love and respect for Herma, dedicated countless hours to helping me review many versions of this manuscript.

Herma's methodology in identifying the first fourteen women was to restrict her criteria to those full-time law professors assigned to teach in the classroom, at schools that were both accredited by the American Bar Association (ABA) and approved for membership in the Association of American Law Schools (AALS). You will read more about this choice of criteria in Herma's own introduction. I understand why she chose these criteria and I support her choice.

But the selected ABA/AALS measure also created some challenges. One of her research methods was to methodically check the AALS's annually published directory of all law teachers to determine specific details about these early women. But the AALS Directories were not always absolutely correct. Herma, herself, discovered this late in her work on this project because woman number fourteen, Margo Melli at Wisconsin, was not initially listed correctly as being hired in 1959. Also, before 1960, law schools did not as clearly delineate between tenure-track faculty and lecturers or adjuncts as law schools do today.

And of course both the ABA and the AALS have had their own restrictive rules which served to exclude law schools that included more diverse populations, both as students and as faculty members. The first fourteen female law professors in Herma's list include no women of color. Legal institutions have historically been hostile to women but even more hostile to certain women. Even Howard Law School, a historically black law

school that met the ABA/AALS criterion, did not hire its first black female until 1963, when it hired Patricia Roberts Harris. Even earlier, in 1951, an ABA-accredited law school (but not yet an AALS member) had hired Sybil Jones Dedmond, who should be acknowledged as the first black female law professor at an ABA school. Herma remedies their omission from the list of the first fourteen by telling detailed stories of their remarkable lives in chapter 7 of this book.

In addition, Herma's decision to restrict entry into the list of the "first fourteen" to full-time classroom teachers ended up omitting a number of early women on law school faculties who were hired as librarians. Some of them (as you will see in chapter Four) switched from being full-time librarians to being full-time classroom teachers, and so their stories are included in this book. But some of them, such as Shirley Raissi Bysiewicz, who was hired as the first full-time tenure track female professor in 1956 at the University of Connecticut, are barely mentioned because they never became full-time classroom teachers.

The story of the early days of women in legal education is very complex. Making a list of "firsts" is a contested activity. But what you will read here is an engaging story of the women who were undoubtedly the "first fourteen" at ABA/AALS law schools. Herma was, of course, number fifteen. I hope to tell more of her story later.

Patricia A. Cain

Introduction

This book is about firsts. It tells the story of the first women law professors in the United States. Just as importantly, it is about the women who followed them into law teaching during the twentieth century. There were only fourteen such women who joined the faculty at an ABA-accredited / AALS member law school before 1960. And they paved the way for those of us who followed them. By the end of the twentieth century, we women law professors numbered 1,788.[1]

Not every first woman is able to open the way for others. Although the North American bullfighter, Patricia McCormick, overcame opposition from her parents and shunning by male bullfighters to gain acceptance from the public while she fought in the bullrings of Mexico and South America for eleven years, after she retired in 1962 few other women sought to become matadors.[2] By contrast, Barbara Nachtrieb Armstrong, the first woman law professor, opened the way for many others, even though she and the other early women law professors—the first few hired before 1960—had little contact with each other.

Armstrong was appointed to the law faculty at the University of California, Berkeley, in 1919. For the next forty years, only thirteen other women succeeded in obtaining similar appointments at law schools that

1

were approved by the American Bar Association and members of the Association of American Law Schools (ABA-AALS schools). This book is about those first few early women law professors, and those who followed, for whom the first fourteen paved the way.

THE CONTEXT: WOMEN'S GAINFUL WORK IN THE LATE NINETEENTH AND EARLY TWENTIETH CENTURIES

Women worked outside the home during this period predominantly as teachers, nurses, or librarians. The US Bureau of the Census reported that in 1900 there were 327,614 women teachers; 11,119 trained nurses; and 3122 librarians and librarians' assistants. It also disclosed that "the only three generally recognized professions of any considerable importance outside of teaching were law, medicine, and the ministry," going on to add that, in 1900, 1010 women worked as lawyers, judges, justices, or in related occupations such as abstractors, notaries, and justices of the peace; 7387 were physicians, surgeons, osteopaths and other healers; and 3373 were clergy or religious, charity, and welfare workers. It noted as well that in 1920, "the only important profession in which women are not represented to any appreciable extent is that of engineering," counting only 41 women engineers, but adding that there were a "not insignificant but still very small" number—only 137—of women architects.[3] Not surprisingly, the 2000 census reported that the number of women employed in the four professions of law, medicine, architecture, and engineering had multiplied. The greatest increase was in engineering, both in terms of absolute numbers and percentages, followed by law, medicine, and architecture.[4]

WOMEN IN THE LEGAL PROFESSION: 1896–1945

At the close of the Civil War, in 1865, there were no women lawyers in the entire country.[5] Between the late 1800s and the years immediately preceding World War II, few women were practicing law. Prior to World War II, women students comprised 3 percent of the national law student

population. Among the legal profession, only a little more than 2 percent were women. Those proportions increased during World War II because the exodus of young men to fight in the war virtually decimated the law school population. Some schools, such as Baylor, closed during the war years. Others temporarily increased their enrollment of women students. The number of women students enrolled in ABA-approved law schools reached an unprecedented 12 percent in the fall of 1942. Not all of the elite schools, however, resorted to this method of replenishing their student enrollment. In 1943, Harvard President James B. Conant responded to a query from Harvard graduate Herman Greenberg about how the law school was faring during the war years with this appraisal: "Not as bad as we thought. We have 75 students, and we haven't had to admit any women." Little did Conant suspect that only four years later he would approve hiring a woman to teach law at Harvard, three years before the school opened its doors to women students.

THE EARLY WOMEN LAW PROFESSORS: 1923–1960

I formulated the idea for this book shortly after I became President of the AALS in 1989. Reporters who interviewed me about the position asked whether I was the first woman president. The question was a sensible one, for even in 1989 there were not a great many women who had been or were officers of the Association, but my answer was "No." The first woman to hold the position was Soia Mentschikoff, then Dean of the Law School at the University of Miami, in 1974. She was followed by Susan Westerburg Prager, Dean of the Law School at UCLA, in 1986. I was actually the third woman to hold the office (albeit the first not to be a sitting Dean).

I knew which women had been AALS Presidents before me, and I began to wonder about the women who had begun their careers as law professors before I did. I was fairly sure that I could identify the first of them, for she was my senior colleague and mentor at Berkeley, Barbara Nachtrieb Armstrong. I set out to discover the others. By 1990, I had what I thought was a complete list of thirteen women who had been hired before 1960, and I presented a paper about them at a 1990 conference on the Voices of Women co-sponsored by the AALS, the ABA Commission on

Women in the Profession, and the ABA Section of Legal Education and Admissions to the Bar. I learned later that there was a fourteenth early woman law professor: Marygold ("Margo") Melli at Wisconsin, who had started teaching there in 1959. She resigned her position in 1960 so that she and her husband, Joe Melli, could be approved as adoptive parents by a social worker who refused to place an infant with a prospective adoptive mother who was a full-time law teacher. After they had successfully adopted the baby, Margo was reappointed to the Wisconsin faculty in 1962. That appointment was listed in the AALS *Directory of Law Teachers* as if it had been her first, rather than her second, appointment at Wisconsin, hence the confusion about her start date.

When I began conducting interviews for this book in 1989, nine of the fourteen early women law professors were still alive. I was able to interview all of them as well as a sample of their male colleagues, the women who came after them, and their students. Four of the fourteen I knew or had known personally: Barbara Nachtrieb Armstrong of Berkeley, who mentored me when I was hired as a beginning professor to replace her after her retirement; Margaret Harris Amsler of Baylor, whose daughter, Rikki, is a friend and was a classmate of mine at SMU, and who encouraged me to go to law school against the more cautious advice of my mother; Soia Mentschikoff, who was the only woman on the Chicago Law faculty when I was a student there, and functioned as a role model for me even though I never took a class with her; and Ellen Peters, the Chief Justice of Connecticut, who had earlier been the first woman professor at the Yale Law School, and who became my colleague and friend on the Council of the American Law Institute. I knew two others professionally through our shared interests in Family Law: Joan Miday Krauskopf, who began at Ohio State and returned there after twenty-four years at Missouri-Columbia, and Marygold "Margo" Melli, who was also an expert on criminal justice administration at Wisconsin. I knew another by reputation, Judge Dorothy Wright Nelson of the US Court of Appeals for the Ninth Circuit and the first woman professor (as well as Dean) at USC Law Center. Others—Janet Mary Riley of Loyola, New Orleans, Helen Steinbinder of Georgetown Law Center, Maria Minnette Massey of the University of Miami, and Clemence Myers Smith of Loyola, Los Angeles—I met during my work on the project. The remaining three I learned about second-hand from their

colleagues and students: Harriet Spiller Daggett of LSU, who specialized in oil and gas law as well as Civil Code subjects; Miriam Theresa Rooney, the founding Dean of Seton Hall Law School; and Jeanette Ozanne Smith, the highest-ranking graduate of the University of Miami Law School, who returned there to teach Contracts and Constitutional Law.

As those background circumstances make clear, I myself am the fifteenth woman law professor. I write this book therefore as a participant-observer, not as an impartial social scientist. I was motivated to write it because the stories of these fourteen early women law professors is rapidly being forgotten, and I hope that the information I provide here will encourage future historians and social scientists to undertake more sophisticated analyses of their careers.

The first three early women law professors began their teaching careers prior to World War II. Barbara Nachtrieb Armstrong, the first, held a Ph.D. in economics and a law degree, both earned at the University of California, Berkeley. She was appointed as an Assistant Professor in both departments in 1923 (having earlier been appointed a lecturer in law), teaching Labor Law and "Persons and Domestic Relations," a course that included what we now classify as Family Law, Marital Property, and elements of Estates and Trusts. Harriet Spiller Daggett, the second, taught at Louisiana State University, specializing in Mineral Rights (Oil and Gas), Family Law, and Community Property. The third, Margaret Harris Amsler, taught at Baylor University School of Law, following in the footsteps of her father, Judge Nat Harris, who had taught law there from 1920 to 1944. Judge Harris did not encourage his daughter's interest in becoming a law professor. Instead, he demanded that she earn an MA in English and French from Wellesley, considering a teaching career more suitable for her sex. Amsler dutifully went to Wellesley, but when she returned to Texas she entered politics rather than teaching. She was elected to the State Legislature in 1939. At that point, her father withdrew his objections to her plan to teach law, and she began her academic career at Baylor in 1941. There she developed a lifelong specialization in business law, teaching contracts, agency and partnerships, corporations, commercial transactions and bills and notes among other subjects.

The first three early women law professors operated in separate spheres. They never met in person, although each had heard of one of the other two.

Armstrong's name had been listed in the AALS annual directory of teachers in 1925, where Daggett and her colleagues at LSU saw it and began proudly acknowledging Daggett as the country's second woman law professor. Armstrong, for her part, knew Daggett's work in community property, since both women specialized in that field. Daggett's oldest son, DeVan Daggett, was himself a law professor who briefly taught at Baylor, and he told Amsler and his mother about each other. Armstrong and Amsler seem not to have heard of each other, separated as they were by distance and scholarly interests. Their stories are explored in chapters 1 and 2.

The woman hired in 1947 by President Conant to teach at Harvard was Soia Mentschikoff, and her appointment brought the total number of early women law professors teaching at ABA-AALS schools to four. Soia, as everyone called her, was easily the most prominent woman in legal education. In the words of her junior colleague, Professor Frank Zimring, she was "the first woman everything." She had attended Columbia's law school, where she became a research assistant for Professor Karl Llewellyn, the famous legal realist who was the chief drafter of the Uniform Commercial Code. After graduation, Soia became the first female partner in a major Wall Street law firm. But she accepted Llewellyn's invitation to work with him on the Code, and they married the year after she began teaching at Harvard. That created a problem for the school: Harvard wanted to make Soia a permanent member of the faculty, but they wanted nothing to do with Karl. Columbia avoided the problem by invoking its nepotism rule, which prohibited having a husband and wife on the same faculty. The dilemma created an opportunity for Edward Levi, the new Dean at the University of Chicago Law School. His faculty wanted to hire Karl, but he couldn't get Karl without Soia, and Chicago also had a nepotism rule. Levi proposed to Chicago's President, Robert M. Hutchins, that they could get around the nepotism barrier by appointing Karl a Professor of Law and Soia a Professorial Lecturer. The scheme worked, and Karl and Soia came to Chicago. She remained there for ten years after Karl's death in 1962, moving to Florida in 1974 to become Dean of the University of Miami School of Law. Her career is explored in chapter 3.

The remaining ten early women law professors all began their teaching careers between Soia Mentschikoff's 1947 appointment at Harvard and Marygold ("Margo") Melli's 1959 appointment at Wisconsin. These four-

teen women are a fascinating group, including as they do the granddaugh-ter of a Russian noble (Mentschikoff) and the wife of a rice farmer (Daggett). Five of them began their careers as law librarians (Miriam Theresa Rooney at Seton Hall, Helen Steinbinder at Georgetown, Janet Mary Riley at Loyola, New Orleans, and Jeanette Ozanne Smith and Maria Minnette Massey at Miami); all left the library for the classroom and became regular members of their faculties. One of these five (Rooney) became the founding dean of Seton Hall University School of Law. Two others, like her, were Catholics who taught at Catholic law schools (Steinbinder and Riley). Eleven of the fourteen early women law professors were married; nine had children. Amazingly, three of the first six went through law school support-ing young children: Daggett, Amsler, and "Clem" Smith of Loyola, whose story is in the appendix. Amsler and Smith even did so without the help of a spouse and yet still managed to graduate at the top of the class. Three (Rooney, Dorothy Wright Nelson of USC, and Mentschikoff) served as law school deans; two others (Amsler and Massey) were for a time acting or interim deans. Two (Nelson and Ellen Peters of Yale) left law teaching to become judges. The final two—Joan Krauskopf of Ohio State and Margo Melli—began teaching in 1958 and 1959 respectively. Both specialized in Family Law and they were the first of the fourteen to work together on a national project: the American Law Institute's Principles of Family Dissolution. The last to retire—Maria Minnette Massey—did so in 2008.

1960 AND BEYOND

Starting with my appointment to the Boalt Hall (Berkeley Law) faculty in 1960, thirty-six women joined the law faculties of twenty-six law schools during the 1960s. One of these women, Ruth Bader Ginsburg, began teaching at Rutgers, Newark, in 1963, and in 1972 became the first ten-ured woman appointed at Columbia. She left teaching to become a Judge of the US Court of Appeals for the District of Columbia Circuit in 1980 and was ultimately chosen by President Clinton to become the 107th Justice of the United States Supreme Court. The most recent female Supreme Court appointment also came from legal academia. Elena Kagan began her law teaching career at the University of Chicago in 1991 and

later served as dean of the Harvard Law School, followed by a stint as the first female Solicitor General. In 2010, President Obama nominated Kagan to the Supreme Court.

The number of women in law professorships increased dramatically throughout the rest of the twentieth century. Not only did the numbers increase but the diversity increased as well. The first African-American woman law professor hired by an ABA-AALS law school was Patricia Roberts Harris, appointed at Howard Law School in 1963. Before that, in 1951, Sybil Jones Dedmond became the first woman of color appointed as a tenured professor of law at an ABA-approved law school, North Carolina Central. But North Carolina Central did not become a member of the AALS until many years later. And in 1971, Joyce A. Hughes became the first black female faculty member appointed to a majority white law school, the University of Minnesota.

In 1974, the University of Texas School of Law hired its first woman on the tenure track, and she was the first female law professor in the country who self-identified as a lesbian: Patricia A. Cain, who specialized in income tax and later developed a specialty in feminist jurisprudence. By the end of the century, the number of women law professors in tenure-track appointments had increased from 14 to 1788, or just over 25 percent of all faculty members at ABA-approved law schools.

A number of these law professors appointed in the 1970s credit their appointments to the enactment of the Higher Education Amendments of 1972, which extended the sex discrimination provisions of Title VII of the 1964 Civil Rights Act to colleges and universities. As Barbara Babcock, appointed to the Stanford faculty in 1972, puts it in her memoir: "A little window of affirmative action for women (well, at least one woman per school) had opened. . . ."[6] It is also likely that the women law professors who came before them helped to pave the way by being outstanding legal academicians.

1 Leading the Way

BARBARA NACHTRIEB ARMSTRONG

Graduate school or Hollywood? This was the choice Barbara Nachtrieb faced as she entered her senior year at the University of California, Berkeley. In 1912, there were few women law students and virtually no women lawyers, but that year Lillian Gish appeared in D. W. Griffith's *The Musketeers of Pig Alley*, while Mary Pickford was already poised to become "America's sweetheart." As a student, Nachtrieb had starred in theatrical productions and participated in the Partheneia, an annual outdoor spring pageant presented by women students at the university.[1] She would have been a natural for the burgeoning silent film industry. Her portrayal of Cleopatra in the English Club's 1910 production of George Bernard Shaw's *Caesar and Cleopatra* drew at least one rave review. This was just the kind of epic that independent exhibitors like Adolph Zukor were importing to America from abroad. And, by one account, it was Zukor, who in 1912 presented Sarah Bernhardt in *Queen Elizabeth*, who sought to sign Nachtrieb.[2]

But Nachtrieb chose an academic career instead and ultimately became the nation's first woman law professor. She earned her JD from Boalt Hall in 1915 and began work on her PhD in Economics at UC Berkeley in 1919. Still, she never lost her flair for the dramatic, delighting her family and friends and infusing her classroom teaching with wit and energy.

Figure 2. Barbara Nachtrieb Armstrong. Courtesy of Berkeley Law School.

FAMILY BACKGROUND

Barbara Nachtrieb was the second of four children born to John Jacob "J. J." Nachtrieb and Anne "Annie" Day in San Francisco on August 4, 1890. Her mother was a native Californian, born in Sacramento of French and British ancestry. J. J. Nachtrieb came from a family of Methodist ministers in Ohio, although he was not himself a religious man. Nachtrieb, in later life, jokingly described herself as a "heathen."[3] Physical activity seems to have run in the family: Nachtrieb swam regularly in the cold mountainous waters of Lake Tahoe throughout her life. She relished retelling the stories about her pioneer grandmother, "who had walked the entire distance from Louisiana to Salt Lake City so that weaker women might have [her] turn to ride."[4]

EDUCATION AT BERKELEY AND BOALT HALL

Nachtrieb graduated from Lowell High School in San Francisco in 1909 and entered Cal, as the UC Berkeley campus was known, that fall. There she met Professor Jessica Blanche Peixotto. Although the university was founded in 1868 and began admitting women students in 1870, controversy surrounded its initial reluctance to hire women faculty. As early as September 1870, reports circulated that the Board of Regents had adopted a rule "whereby ladies are excluded from becoming teachers in that institution."[5] If such a rule existed, UC President Martin Kellogg recommended its reversal in 1889.[6] President Benjamin Ide Wheeler appointed Peixotto a lecturer in the Department of Economics in 1904, and "in the end, she was so valued by the department, and successful with her teaching and research, that the university . . . [promoted her to] professor of social economy in 1918, the first woman full professor at the university."[7] Peixotto and her male colleagues in the department together "shaped the department's programs and research emphases through the 1910s and 1920s."[8]

Nachtrieb developed what would become a lifelong interest in social insurance in an economics course she took called "Control of Poverty," which, she later recalled, taught that creating better standards of assistance and providing better public relief would hold poverty to a minimum.[9] Nachtrieb challenged her professor with her view that "you didn't control poverty unless you

got at the cause of it and stopped it where it started, and I did not hold with public relief, I thought it was a social vice."[10] She remembered being "squelched hard" for this response, but was not persuaded that she was wrong. She remained convinced that "[t]here must be a better way to do this."[11]

Nachtrieb would have her first opportunity to develop "a better way" in 1916, but first she chose to attend law school at UC Berkeley's Boalt Hall while maintaining her contact with the department of economics as an assistant.[12] At the time, UC undergraduate seniors in good standing in the Colleges of Letters or Social Sciences could be admitted to the law school without examination, complete their undergraduate degrees, and, if they chose to go on, enter the professional program as second-year students. As recommended by the school's *Announcement*, Nachtrieb took four prelaw courses in her junior and senior years and earned her undergraduate AB degree with honors in Jurisprudence on December 20, 1912.[13]

Nachtrieb participated in Berkeley's fiftieth commencement exercises for the class of 1913, held in the Greek Theater on May 14, 1913.[14] One of her classmates, John Lowrey Simson, received the prestigious University Medal awarded annually to the "Most Distinguished Graduate of the Year."[15] Years later, Simson would say that if he had not received the Medal, he thought Nachtrieb would have gotten it.[16] Nachtrieb herself confided to her close friend, Agnes Robb, that several professors told her that she should have received the medal but didn't because she was a woman.[17]

After finishing her courses in December of 1912, Nachtrieb experimented with teaching in a one-room country school, and proved to be an inspiring teacher and a strict disciplinarian.[18] However, she left teaching after less than a year and enrolled as a second-year student in Berkeley's School of Jurisprudence in August 1913. Nachtrieb joined thirty male classmates (one of whom, Lyman Grimes, would become her husband) and one other woman, Louise Cleveland. The two women may have felt less than entirely welcome: less than two months after classes began, the director of the school, William Carey Jones, was quoted in the *San Francisco Call* as stating that women were emotionally unfit for trial practice and should confine themselves to property law and probate cases which they could handle in their offices.[19]

At the time Nachtrieb began her professional studies, the law school was housed in a small, three-story building, newly completed in 1911.

Like all other members of the prestigious Association of American Law Schools (AALS),[20] Boalt Hall's complement of regular faculty—five professors, one assistant professor, and seven lecturers—was entirely white and male. Still, Nachtrieb and Cleveland were not the school's first women students. Emmy Marcuse had graduated in 1906.[21] Marguerite Ogden graduated in 1913 and went on to form a partnership with Annette Abbott Adams, a 1912 graduate who became the first woman appointed Assistant Attorney General of the United States.[22]

Nachtrieb's interest in social insurance continued to grow at Boalt. Her ultimate goal was not a modest one: she wanted to achieve security for industrial workers and their families. Struck by the connection between the rise of the machine age and the dramatic growth in industrial injury and industrial death as causes of destitution, she emphatically rejected both the public "dole" and private charity as inadequate solutions. She saw the former approach as too costly, particularly in the United States where "communities . . . are far less reconciled to a heavy social service tax burden than are comparable European countries."[23] She saw private charity as demeaning, labeling it a "bitter social disgrace" that ground down the self-esteem of its recipients. "This," she said, "is a social tragedy. The crucial interests of the community are bound up with the individual's need of economic security."[24]

Her solution lay in the enactment of a "rounded out legislative scheme for insuring to the worker the essentials of life" in order to prevent economic dependence.[25] She saw this approach as one of "destitution prevention," arguing that "[i]t is the function of social insurance to insure the worker" against the "catastrophes" of loss of earning capacity or the ill-health of his dependents, "and thus secure him against the commonest causes of want."[26] These early views would form the core of Nachtrieb's philosophy of social insurance and would become an ongoing cause in her professional career.

BEGINNING A PROFESSIONAL CAREER: PUBLIC SERVICE IN CALIFORNIA

Upon graduation from law school in 1915, Barbara Nachtrieb and Louise Cleveland briefly opened an office together for the private practice of law. At the time, there was no written bar examination; graduates of schools

like Berkeley, Stanford, USC, and Hastings were admitted on motion of a faculty member when they received their diplomas.[27] Perhaps apprehensive that their practice might not pay the bills, both women took other positions as well. Cleveland taught for the University of California Extension, offering a series of lectures in law for businesswomen.[28] In January 1916, Nachtrieb was offered her first opportunity to implement her "better way" of controlling poverty. On the recommendation of Katharine C. Felton, Director of the Associated Charities of San Francisco and a guest lecturer in the social economics program at Berkeley,[29] Governor Hiram Johnson named her Executive Secretary and Director of Surveys of the California Social Insurance Commission. Felton and Nachtrieb shared similar views about public relief; Nachtrieb believed that Felton, too, "hated relief" and "wanted to prevent having to have public relief of destitution by preventing destitution itself."[30]

The California Commission was a central player in the controversial movement for compulsory health insurance that commanded public attention between 1915 and 1920.[31] It was charged with examining the question "whether California needed to extend the social insurance legislation it had instituted with the passage of the Workmen's Compensation Act of 1913."[32] With Felton as a member, the commission decided to focus its efforts upon "the question of sickness in its relation to poverty in California and to consider the desirability in this state of that branch of social insurance which protects the worker against the losses of illness— social health insurance."[33] Nachtrieb's study, which was published on January 25, 1917, as part of the Commission's First Biennial Report,[34] found, among other things, that California had a comparatively low industrial sickness rate: "an average of six days in contrast to nine days found by the Federal Public Health Service in other communities." It drew on experience in other countries, primarily from continental Europe and Great Britain, to conclude that "[g]roup responsibility for illness through health insurance is the practical way to meet the problems created by illness in California."[35]

The commission's recommendation was proposed as an amendment to the California constitution, a process that required the passage of an enabling amendment by two-thirds of the legislature, followed by voter approval of a statewide referendum. The legislation was enacted in 1917,

and the referendum was placed on the state ballot in 1919, but it was defeated by a margin of nearly two to one.[36]

Nachtrieb had no doubts about why the proposal was defeated. Describing the unsuccessful legislative experiences of the eight state investigating commissions created along with the California Commission during "the brief period of the American health insurance movement of 1915–1920," she identified the obstacles to social health insurance as "commercial insurance companies, employers' associations, physicians' groups that joined hands in violent and quite unscrupulous antagonism to social insurance against general sickness," and singled out insurance companies and employers' associations in particular as experienced, competent, and well-financed opponents.[37]

Historian Roy Lubove later noted that "the health insurance movement had the misfortune to coincide with America's involvement in World War I, and its opponents did not fail to emphasize the Germanic origins of the idea."[38] He pointed to shamelessly jingoistic propaganda, including a "special California bulletin [that] had been published by the Insurance Economics Society. It carried the Kaiser's picture on the front cover, with the words: "'Made in Germany.' Do you want it in California?"[39]

Lubove concluded unambiguously that the "complete disaster" of the 1915–1920 health insurance campaign had only one lasting result: "The medical profession emerged from the struggle with an awareness of its political power and a determination to use it to protect its corporate self-interest."[40] That newfound power, Lubove noted, would be used to continue to resist any attempts to change the way medical services were organized and financed.[41]

BACK TO SCHOOL: LIFE AS A MARRIED PHD STUDENT

Following the completion of her duties with the commission in 1919, and after her marriage to her classmate, Lyman Grimes, on July 1, 1917, Barbara Nachtrieb Grimes returned to the University of California in 1919 to begin work on her PhD in Economics.[42] She did so in order to be able to write a book about compulsory health insurance, a subject that she believed had been introduced "before its time" in 1917: "The public was

not ready to accept it. I made up my mind right then that I was going to write a book, an American book written by somebody that cared."[43]

Upon Grimes's return to the University, Professor Peixotto took the initiative in helping her obtain a joint appointment as a Lecturer in Law and Social Economics in the Department of Economics and the School of Jurisprudence at Berkeley.[44] Her appointment in the law school may also have been facilitated by contemporary curricular developments. When she signed on as Lecturer in 1919, the school had just launched an experiment unique in legal education, a four-year program.[45] This program was designed to begin after a student's sophomore year of college, and would run concurrently with the three-year professional program, thus keeping the total years required to obtain degrees in both programs to six and enabling significant cross-pollination with other departments in the university—particularly political science, history, philosophy, and economics.[46]

Grimes's fit with this program was obvious. Not only had she anticipated such a program by enrolling in pre-law courses as an undergraduate, but also her concurrent appointment as a Lecturer in the Department of Economics positioned her to offer courses in that subject. Her JD degree also fulfilled the program's interdepartmental mission. Taken together, these factors enabled her to become one of the new breed of social scientists that the law faculty had in mind as future colleagues.[47] The University's appointment of the nation's first woman to teach at an AALS-member law school was not formally acknowledged. Since Grimes did not yet hold a professorial title, this omission does not seem remarkable. Her fame—some would call it notoriety—would come later.

Grimes's lack of female colleagues in the law school was amply compensated by their unusually strong presence in the Economics Department. At Berkeley, "social economics was a separate subfield for over twenty years."[48] Furthermore, "the professors who taught social economics at California were predominantly women, and under its rubric the department had three tenured women on its faculty roster in the 1930s."[49] Thus, while Grimes's appointment in the law school was unique, her presence in the department of economics was part of an environment created by Peixotto with the encouragement of university president Benjamin Ide Wheeler.[50]

Then as now, PhD students often aspired to an academic career, an aspiration seen by many faculty members as more appropriate for male than female candidates. Lucy Ward Stebbins, the second woman faculty member to be hired by the Department of Economics, and who served on Grimes's PhD committee with Peixotto, "remembered that 'most of the faculty thought of women frankly as inferior beings,' and were 'solidly opposed' to women's presence on the faculty."[51]

Grimes's paper on *Sickness as a Cause of Poverty in California and a Consideration of Social Health Insurance as a Remedy*, based on her 1917 report for the Commission on Social Insurance, was accepted by her committee on March 26, 1921, in satisfaction of the thesis requirement for her PhD. Still, matters may not always have run smoothly for Grimes. One week prior to her final examination she was assigned five new books to master. She successfully met this arduous test, only to be confronted afterward by a male faculty member who was present at the examination. As she later recalled to her nephew, Howard Mel, the threat was unambiguous: "You think you're pretty smart, young lady, but I'll make sure you never get on this faculty!"[52]

That threat was not fulfilled. The university conferred the PhD in Economics upon Barbara Nachtrieb Grimes on May 11, 1921. She was appointed to the faculty as an Instructor in Social Economics and Law in 1922 at a salary of $2,400, an amount $900 below that considered appropriate for an associate professor in the School of Jurisprudence.[53]

MANAGING WORK AND FAMILY

Barbara Nachtrieb Grimes became pregnant with her only child in late summer, 1921. Her daughter, Patricia "Patsy" Grimes, was born at Alta Bates Hospital in Berkeley on May 30, 1922. Perhaps in anticipation of that event, Grimes had taken an unpaid leave of absence from her teaching duties as a lecturer from January to June 30, 1922.

Grimes lived in Berkeley with her daughter and her husband, Lyman Grimes, until the couple separated in 1924.[54] Nachtrieb spent a year in Paris with her daughter, where she obtained a divorce from Grimes.[55] Patsy recalled that she had enjoyed Paris, particularly her trips to the zoo where

she rode on a donkey. She and her mother lived together in an apartment with her new Scottish nanny, a widow named Mrs. Stewart, who accompanied the family back to Berkeley and remained with them until Patsy was seven years old. Mrs. Stewart was the first of three live-in housekeepers who assisted the family, and Patsy was greatly attached to her.

Returning to the University in 1925, Nachtrieb was reappointed as Assistant Professor of Social Economics and Law at a salary of $2,700.[56] The School of Jurisprudence listed her name—along with that of its female law librarian, Rosamond Parma—for the first time in its official entry in the 1925 AALS Directory.[57]

The school's formal acknowledgement of the presence of two women on its staff attracted national media attention. On February 9, 1926, the New York *Herald Tribune* proclaimed that "California 'U' Has Corner on Women Law Teachers," going on to report Dean Orrin Kip McMurray's claim that "the West has set the pace for the rest of the Country" in "naming [women] on the same basis with men."[58] The story had legs. One afternoon, while Nachtrieb was at work in her Boalt Hall second-floor office, she looked up to meet the eyes of a strange man who turned out to be a reporter clinging to her window. Apparently, he had either scaled the wall or (more likely) crept along the ledge just to get a momentary glimpse of this female who held the lofty position of the nation's first woman law professor.[59]

In 1925, Nachtrieb resumed her regular courses in economics.[60] In addition, she offered her first course in the law school's professional program, "Law of Persons." The course description listed as its topics "the relations of parent and child; husband and wife; divorce; community property, with special reference to California law,"[61] thus anticipating the subject matter of the two courses that would claim her primary research and teaching efforts in later years, Family Law and California Community Property.

REMARRIAGE

Nachtrieb's marriage to Ian Alastair Armstrong took place during the summer of 1926, and, by all accounts, theirs was an extraordinarily happy

relationship. Ian confided in Nachtrieb's nephew, Howard Mel, the reason why he wanted to marry her. One evening, while he was visiting Nachtrieb at her home on Scenic Avenue in Berkeley, she became angry and kicked him. He didn't mind the kick, but what attracted him to her was how purposefully she pulled up her skirt before she kicked him so she wouldn't trip. Ian said that "this combination of passion and reason" caught his attention and identified Barbara as "the person for me."

In many ways, Ian was Nachtrieb's opposite. According to Mel, Ian was an extraordinarily personable self-made Scotsman, very fit and well groomed, who probably had not gone to school after the age of fourteen. Nachtrieb's daughter Patsy described him as very handsome, nice, charming, and amusing. He had worked several years for the Anglo-Persian Oil Company in Abadan. In San Francisco, he settled into a more conventional life working for Balfour Guthrie, a British importing firm. Like Nachtrieb, he had been divorced once. He was like a father to Patsy, and formally adopted her in 1950, when she was twenty-eight years old.

The family lived together in a little house with a small garden on Euclid Avenue in Berkeley. Each morning as they left for work, Barbara and Ian picked a rosebud from the garden for each other's buttonhole.[62] When Barbara came home in the evening, they had dinner together, and Patsy studied before going to bed. When Barbara was an assistant professor, she bought two adjoining lots at Lake Tahoe, paying something like $300 over ten or fifteen years for the land. It was in a private development called Tahoe Meadows where several Berkeley faculty members owned summer homes, and Ian built a tiny three-room cabin by hand there. Barbara and Patsy began to spend their summer months at the cabin and Ian would drive up on weekends. Patsy remembers the summers as happy occasions when she was able to spend uninterrupted time with her mother. Barbara did not bring work with her to the cabin; while there, she rested, swam, hiked, and enjoyed her family.

A POPULAR TEACHER

Barbara Nachtrieb Armstrong threw herself into her work at the University. Several Boalt Hall graduates who took courses from her in the

late 1920s and early 1930s recall that she was a dynamic teacher who set high standards for her students. Roger Traynor, later California's Chief Justice, observed that "Barbara Armstrong's radiance was at its brightest in the classroom."[63] Kathryn Gehrels took Armstrong's course on Law and Poverty Problems in the Social Economics program in 1928 as well as the Law of Persons in the professional law curriculum. She recalled that Armstrong focused on "those students with a serious interest in the law," and had a "special concern" for women students who intended to pursue a career in law.[64] However, she was a discerning mentor: women without career ambitions did not interest her, and "[t]he lazy, unprepared student similarly felt her wrath."[65]

So did the student who was rash enough to flout the university's attendance rules. Reportedly, Bernard Witkin, a member of the Boalt Hall class of 1927, once made the mistake of telling Armstrong that he had skipped his classes since he could pass the examinations without attending the lectures. Armstrong was outraged at this behavior and refused to give him credit in her course, which he needed to graduate. Witkin was forced to return to Boalt to complete his coursework, and, during the extra year he spent in residence, he began writing detailed outlines that eventually evolved into his *Summaries of California Law,* which soon became an essential part of every California lawyer's library.[66]

Two of the few black students who received degrees from Boalt Hall in the first half of the twentieth century were George Marion Johnson, later Dean of Howard Law School, and Pauli Murray, a noted civil rights activist who later became an ordained Episcopal priest. Johnson was the only black student in his class. He identified Armstrong and Roger Traynor as professors who went out of their way to encourage and help him. He took Domestic Relations from Armstrong and called her "one of the most dedicated and competent teachers I ever had."[67]

Professor Armstrong supervised Murray's master's thesis, "The Right to Equal Opportunity in Employment." Murray wrote that "Armstrong was hard-driving, had strong opinions and was merciless in her criticisms" and described her conferences with Armstrong as "an ordeal." Despite Armstrong's outrage when she learned that Murray planned to take the California Bar Examination in the summer while she was finishing work

on her thesis (Armstrong "told me bluntly that she did not think I had the mental or physical capacity to both complete my paper and pass the bar examination"), Murray accepted her "stinging remark" as "the challenge I needed." She reported,

> When the exam results were published, Mrs. Armstrong was so impressed with my performance that she voluntarily wrote a strong letter of recommendation on my behalf. 'I regard Miss Murray as a young woman of exceptional competence,' she said. 'She has, in addition to a very keen and quick mind, the capacity for hard work and an exceptionally pleasing personality.'[68]

SCHOLARSHIP: FIRST BOOK ON SOCIAL INSURANCE, 1932

In 1928, Armstrong gave up her joint appointment in the Department of Economics and moved full time to the School of Jurisprudence, earning tenure there as an Associate Professor in 1929. As enthusiastic as she was about teaching her students, both in and out of class, Armstrong was equally devoted to her research. She began work on her book on social insurance in the late 1920s. In researching the topic, she looked beyond California—indeed, beyond the United States—to models in other industrialized countries, primarily Great Britain and Germany.

The "well rounded" scheme she ultimately advocated contained two basic elements: (1) "a minimum wage which legislates a standard below which no wage is permitted to fall," and (2) a compulsory program of "social insurance which keeps this standard intact in periods when no wage can be earned."[69] Her proposed social insurance program included five components: (a) worker's compensation—insurance against industrial accidents; (b) social health insurance—insurance against sickness; (c) old age and invalidity insurance, and old age pensions—insurance against superannuation and disability; (d) survivors' insurance—insurance against dependency caused by the death of the breadwinner; and (e) unemployment insurance—insurance against involuntary idleness due to lack of suitable work. Armstrong argued that, taken together, these

components would produce a "living wage," a term she defined to mean a wage sufficient to obviate the necessity of public charity.[70]

Her book, *Insuring the Essentials: Minimum Wage Plus Social Insurance—A Living Wage Program* (1932), contains a wealth of historical information, going back to the middle ages in some instances, about the precursors to such programs, their modern development, and the experience of other nations—particularly Germany and Great Britain, but also Scandinavia, Europe, South America and Australia—with them. In concluding her book, Armstrong accurately pointed out that, in contrast to the rest of the industrialized world, "[t]he picture of the immediate future in the United States is, of course, a very different one. With nothing to start with but the least significant of the social insurance institutions, workmen's compensation, and not even complete coverage of our workers by that, most of the groundwork remains to be done."[71]

Under Armstrong's leadership, the 1916 California Commission had declared: "there would be no practical possibility of establishing at one time social health insurance, old-age and invalidity insurance, unemployment insurance and survivors' insurance."[72] But by the time her book was published in 1932, Armstrong allowed herself to be more optimistic. Her concluding paragraph read:

> [T]he position in which the United States finds herself relative to the rest of the world to-day is one of great advantage. She has a standard of living inherited from our 'frontier era' which is a higher standard of living than that of any other country. She has natural resources to which only those of the Soviet Union can even be compared. She has a chance to organize for the preservation of her superior position before the destructive forces of industrialization have progressed sufficiently to push a stratum of her workers down to European levels of insufficiency.
>
> It can reasonably be hoped that this opportunity may be seized at least in part.[73]

Armstrong would indeed have an opportunity to participate in the shaping and enactment of social insurance programs at the federal level. This opportunity came from the Roosevelt administration in 1934 after the country had experienced the shock of the stock market crash of October 29, 1929, and was in the throes of the Great Depression.

ARMSTRONG'S WORK ON THE SOCIAL
SECURITY ACT OF 1935

Franklin Delano Roosevelt was inaugurated on March 4, 1933. By that time, the economic crisis had worsened beyond expectations. Francis Perkins, Roosevelt's Secretary of Labor and the first woman to hold a Cabinet position, recalled the "terror" created by "unrelieved poverty and prolonged unemployment."[74] She noted that state and local governments had by that point reached the limits of both their funding and their borrowing capacity, and that in the country's darkest hour, "[t]he Federal Government and its taxing power were all one could think of."[75]

Roosevelt and his advisors recognized that immediate relief efforts, while essential, were not sufficient to produce lasting economic recovery, and that greater reforms were needed. Arthur J. Altmeyer, Assistant Secretary of Labor under Perkins, noted that while "[i]t is certainly true that the depression convinced the American people of the necessity for government action to relieve the human distress caused by unemployment, insecurity in old age, and widespread poverty," the most fundamental reforms made during the Great Depression had their roots not in the simple desire to "relieve the existing human distress," but rather in President Roosevelt's deep conviction that "[i]t is childish to speak of recovery first and reconstruction afterward. In the very nature of the processes of recovery we must avoid the destructive influences of the past."[76]

In his June 8, 1934, message to Congress, Roosevelt outlined, among other programs, "the great task of furthering the security of the citizen and his family through social insurance."[77] Advocating against a "piecemeal" solution, Roosevelt instead proposed a plan, "national in scope," that would "provide at once security against several of the great disturbing factors of life—especially those which relate to employment and old age," and would be funded through "contribution, rather than by an increase in general taxation."[78]

Three weeks later, on June 29, 1934, the President created the Committee on Economic Security and named Secretary Perkins as its Chair. His charge to the Committee was appropriately broad:

The Committee shall study problems relating to the economic security of individuals and shall report to the President not later than December 1, 1934, its recommendations concerning proposals which in its judgment will promote greater economic security.[79]

In the summer of 1934, Armstrong received a telegram from Tom Eliot, the Assistant Solicitor General, telling her that President Roosevelt wanted her to come to Washington to work as a consultant to the newly formed Cabinet Committee on Economic Security. He asked her to come to San Francisco so that he could interview her for the position.[80] Armstrong met with Eliot and signed a contract to serve as a consultant to the Committee both on unemployment insurance and old-age insurance.[81]

Armstrong recognized the unparalleled opportunity she had been offered. With the encouragement of her college classmate and close friend, University of California President Robert Gordon Sproul, she received from the law school a leave of absence for the fall semester, 1934, to go to Washington "to assist [the] President's Committee on Economic Security."[82] Leaving her husband and daughter in California, Armstrong spent nearly six months in Washington, from July 1, 1934, until mid-December, returning home by train shortly before Christmas.

Upon her arrival in the capital, Armstrong found a flurry of activity as the Committee, its Technical Board, and its various sub-committees, staff, advisory groups, and consultants were being organized, housed, and set to work.[83] From the beginning, President Roosevelt's hope for a "cradle to the grave" social insurance system was denounced by the conservative opposition as a form of "socialism" and was fraught with political pitfalls. Secretary Perkins recalled several nearly intractable points on which the Committee and the Congress had widely differing views.[84] One fundamental issue was whether the unemployment compensation program should be positioned as a stand-alone federal system or a federal-state cooperative system modeled on one recently enacted in Wisconsin. Another was whether the cost of unemployment insurance should be assessed only against employers or imposed upon workers as well. The most pressing issue was whether old-age insurance should be funded as a self-sustaining pay-as-you-go system that applied mandatory contributions from younger workers and employers to fund payments to older

retired workers, or a voluntary "old age assistance" program funded by immediate federal contributions. Perkins noted that the constitutional law problems attendant upon such a comprehensive program of social insurance "seemed almost insuperable."[85] The debates over these substantive issues also raised the serious political question of whether *any* program of health insurance could be enacted over the determined opposition of the medical profession.

Armstrong had developed her own positions on all of the disputed points in her 1932 book, long before her arrival in Washington. Thus when Dr. Witte took up his duties as Executive Director of the Commission on July 26, 1934,[86] and asked her to prepare a memorandum setting forth her views on what should be done about unemployment and old-age insurance, Armstrong had her answers ready. In her memorandum, she made clear that the country would need compulsory old-age insurance on a national scale, supplemented with a federal subsidy for the assistance programs that already existed in many states. She also advocated a national system of unemployment insurance rather than the Wisconsin federal-state plan, which permitted voluntary employer contributions segregated into individual company funds and which she deemed fiscally unsound.[87]

After Witte had read the memorandum, he called Armstrong into his office and made clear his displeasure with what she had proposed, telling her that "from a very high place certain results are wanted."[88] Armstrong was astonished. The memorandum reflected the positions she had advocated in her book and she could not understand why Witte could think she would propose anything else. Armstrong refused to alter her memorandum and left Witte's office.

Armstrong ultimately accepted a staff position focused on the development of old-age insurance. Armstrong believed that the contentious first meeting with Witte and her refusal to deviate from her published advocacy for a federal unemployment insurance plan led directly to her removal from consideration from the unemployment insurance committee and the offer instead of a staff position in connection with old-age insurance.[89] But she also recognized that, as a staff member, she was gaining access to the inside track on old-age security planning—a topic dear to her heart—and would be in a better position to influence the outcome.[90]

Events at a September 29 meeting proved explosive. Armstrong was "astounded" to see Witte present a report to the Technical Board with her name on it, but with her recommendations completely altered to endorse a federal-state approach to unemployment insurance and a plan of voluntary rather than compulsory old-age insurance. Armstrong confronted him openly at the meeting, disavowing the report's contents: "I see my name is on this report. This is *not* my report. This is just the opposite of everything that I recommended and said." Witte's retelling of the incident describes a purely logistical, rather than political, process: the tight schedule and the need to mimeograph the entire report before the Technical Board meeting necessitated that Witte create a document composed of his preliminary report upfront, followed by long appendices composed of the preliminary reports of the staff members bearing their own names.[91] In an accompanying footnote, Witte provides his own account of Armstrong's indignation at the meeting, noting that "[o]ne major staff member, however, took great offense because my recommendations differed from those which she made and were given in the main part of the report, while her recommendation (like those of all other staff members) appeared in an appendix."[92]

After her confrontation with Witte, Armstrong tried to see Secretary Perkins, who had not met with Armstrong since she had arrived in Washington.[93] Perkins refused to receive Armstrong.[94] At that point Armstrong concluded that Perkins was directing Witte, that Perkins was determined to have old-age assistance, rather than old-age insurance, and that accordingly she and Witte were "at war." Disdainfully dismissing him as "half-Witte,"[95] she and her major advisors Murray Latimer and Douglas Brown, together with the actuary Otto C. Richter, who had been borrowed from the American Telephone and Telegraph Company, went on with their work without regard to Witte's views.

Once her mind was set to it, Armstrong waged her "war" against Witte without giving or expecting any quarter. At the staff meeting following the meeting of the Technical Board, Armstrong formally introduced the proposal of the old-age security group for old-age insurance on a national scale. The Committee's legal advisor, Assistant Solicitor General Tom Eliot (who had interviewed her in San Francisco), immediately objected to the plan on the ground that it was unconstitutional. Although Armstrong disputed his opinion, Eliot believed he had a trump card: he reported that

Professor Thomas Reed Powell of Harvard had himself said it couldn't be done because it was unconstitutional.[96]

Armstrong made no further objection during the staff meeting, but she had devised a strategy. She had previously met Professor Powell, and she left the meeting that Friday and took the evening train to Boston to call upon him unannounced at his home. Upon learning of Eliot's assertion, Powell denied that he had ever said any such thing. In triumph, Armstrong returned to Washington the following Monday with a hand-written note from Powell to Eliot, saying that in his view a national compulsory old-age insurance system would be constitutional.[97] No further objections were raised. Put to the test, Armstrong had proved herself a formidable adversary.

From that point on, Armstrong, together with Latimer, Brown, and Richter, who had become her three closest and trusted advisors, went on with their work without interruption. They met with Witte only when he sent for them. As she put it, the question of old-age insurance had become not "if," but "how":

> [N]ow it was a question of what kind of a system would we have and how it would be worked out and what would be its general actuarial form and what would be the objective that we would work toward for benefits. And what would be the coverage. All those things now we could work on.[98]

Armstrong and her group may have often felt ignored, but they were not forgotten. Repeated efforts were made to discover what they were doing. During one closed-door meeting of the Subcommittee on Old Age Security, Chairman Latimer heard a little noise at the door. Putting his finger to his lips, he walked over, carefully grasped the door handle, then yanked it open, and one of Witte's young assistants, who had been listening at the door, tumbled into the room.[99]

When stealth failed to produce results, Witte turned to enticement, letting Armstrong know that "life could be much pleasanter for you if you weren't so rigid about those views about what you think and what you don't think," and offering Armstrong "persona grata" status at the White House.[100] Armstrong replied: "I think Mrs. Roosevelt is one of the great women of the world and I would love to know her, but right now I'm busy, very, very busy, and I'm afraid that nothing else can get in the way of what I want to do."[101]

In the end, Armstrong's position was vindicated. The Social Security Act of 1935 contained a compulsory national old-age retirement annuity plan financed by taxes on both employers and workers.[102] Unemployment insurance, however, emerged as a federal-state unemployment compensation plan, not a federal plan.[103] In her 1936 article describing the Act, Armstrong characterized the old-age security part of the statute as "directed at the *prevention* of destitution rather than its relief."[104] She was overjoyed at the result:

> I became almost a Pollyanna when I came home. To see something that you've been called an idiot for even trying to do something about for years, to see it happening is enough, and to have a part in it—oh, indeed, yes. Anybody could be pleased at that.[105]

As Armstrong was about to leave Washington for Berkeley in December, her work done, Witte called her into his office a final time to say goodbye. To her surprise, Witte told her that he had "great admiration" for her, and that she was the "tough fighten'est woman I ever met in my life."[106]

Secretary Perkins, for her part, took full credit for the bill as enacted, commenting that President Roosevelt "always regarded the Social Security Act as the cornerstone of his administration, and, I think, took greater satisfaction from it than from anything else he achieved on the domestic front."[107] Armstrong considered this stance to be disingenuous at best, adding, "It wasn't so much what she didn't do for the achievement of Social Security, as the way she took credit for what she had tried her utmost to prevent. I thought that was going too far."[108]

PROFESSOR OF LAW, 1935

Back at home in California, Armstrong was promoted to full professor of law in 1935 at a salary of $4,000, a sum that was $1,000 below what the law faculty had authorized as the lowest salary for a full professor in 1921.[109] The promotion came twelve years after her appointment as Assistant Professor and five years after her promotion to Associate Professor. In comparison, Armstrong's colleague, William W. Ferrier, Jr.,

moved much more quickly through the ranks: Ferrier joined the Boalt faculty in 1921 after practicing law for six years and was promoted to full professor by 1928.[110]

Armstrong took her place alongside Roger Traynor as one of Boalt's most successful teachers. One of her students, Richard C. Dinkelspiel, said that for the students the pair "stood out like beacon lights."[111] Dinkelspiel recalled that

> Barbara believed in progress and dealt in enthusiastic hope. Her causes were positive and affirmative. She did not dwell on righting ancient wrongs, but rather attacked immediate, existing problems. Workmen's compensation, labor law, social security, welfare, family law, women's rights—all felt the impact of her energy and imagination.[112]

Armstrong maintained her interest in social insurance both in teaching and writing. She was particularly concerned, however, that her first priority—to create and enact a compulsory program of social health insurance—remained unaccomplished. In his assessment of the Social Security Act, Professor Douglas had offered several reasons for the Committee's failure to propose a health insurance plan, including the danger of "overloading" the program, the lack of detail around the plan, limited public support, and the "intense, bitter, and persistent" opposition of the American Medical Association and similar state organizations.[113]

Armstrong's legislative experience had convinced her that Douglas's final reason was the most significant: the most controversial aspect of health insurance centered on the position of the doctor in the scheme. As she had done in analyzing other social insurance programs, Armstrong undertook a comparative study of comparable programs in effect abroad. She took a one-semester sabbatical leave with full salary from July 1 to December 31, 1936, and traveled by sea with her family to Europe to spend the period May through November studying health insurance programs in Great Britain, Denmark, and France. Armstrong published *The Health Insurance Doctor* in 1939.[114] Evidently she had learned her lesson about the political dangers of using Germany and Russia as examples for American audiences, noting in her foreword that "Britain, Denmark and France were selected advisedly. They are democratic countries and their experience is of special interest in America."[115]

After discussing the history, coverage, administration, and operation of each plan in detail, Armstrong pointed out the lessons she hoped the medical profession in the United States would draw from her study. She first focused on the similarities between the United States and the three countries she had studied, pointing out that all respected and preserved elements of traditional "private practice." She then linked this traditional doctor-patient relationship to the argument for universal health coverage:

> Indeed, the organization of medical service in each instance stands upon the foundation principle that the traditional free doctor-patient relationship is a desirable one and that, as economic conditions frequently deny it to workers and their families, health insurance should restore it to them and to the doctors who would like to serve them.[116]

Armstrong then went farther, advocating universal health insurance as desirable for the American doctor, as it allows physicians "a degree of professional freedom in the practice of medicine among the mass of the people such as is enjoyed in private practice only in treating the well-to-do," and provides a "steadier income" than most doctors enjoyed prior to the advent of universal coverage.[117]

Armstrong's busy life in this period was not entirely devoted to her work at the law school. The Boalt Hall faculty often entertained each other in their homes, and Armstrong and her husband were the center of a small group of friends who exchanged dinners, often followed by dancing. Professor Richard Jennings described a lively scene, often facilitated by Ian and the "marvelous concoction he called Pisco Punch." Jennings was not alone among Armstrong's colleagues at Boalt; other faculty members were extremely fond of Ian. Frank Newman, Armstrong's student and later her colleague and close friend, used to play the piano while Ian tap danced. Frank recalled that he played Fats Waller tunes, which Ian thought were just right for tap dancing.

THE SECOND CAMPAIGN FOR COMPULSORY HEALTH INSURANCE IN CALIFORNIA

Even before *The Health Insurance Doctor* was published in 1939, Armstrong had already begun to help renew the struggle in California for

compulsory health insurance. Her colleague in the Economics Department, Emily Huntington, commenting on the old-age insurance provisions of the Social Security Act, reported that Armstrong viewed the exclusion of health insurance as a "disappointment," and had expressed the view that "[t]he act was far from perfect, but I did the best I could."[118] In Huntington's mind, the act "was a very good 'best.'"[119]

In 1935, Huntington joined forces with Armstrong to promote compulsory health insurance in California. Between early 1935, when the first of several bills proposed by the California Medical Association was introduced into the legislature, and 1949, when the last of three bills supported by Governor Earl Warren was being considered, Armstrong and Huntington spent long hours lecturing to community groups, analyzing and consulting on various bills, and testifying before state legislative committees. As had been the case with Armstrong's work on social insurance, they formulated a clear picture of the essential components that should be included in a compulsory health insurance plan. As Huntington succinctly put it, she was only interested in "helping those with a real desire that California should adopt a good health insurance act, not some meager or faulty piece of legislation which would carry the title of 'health insurance.'"[120]

In 1939, Culbert L. Olson was elected Governor of California. A Democrat and strong supporter of Roosevelt's New Deal, Olson made compulsory health insurance a prominent plank in his campaign. Once in office, he appointed both Huntington and Armstrong to a subcommittee of the California Research Committee on Labor Problems. He charged the subcommittee with preparing a report and recommendations on health insurance legislation. The subcommittee's proposal included the following essential items: "a health insurance system must be compulsory, all wage earners covered; benefits in hospital, home and doctor's office; contributions from worker, employer and government; free choice of physician; health insurance funds administered by a state agency, not by a private insurance company."[121]

Governor Olsen included these recommendations in a bill, AB 2172, which was introduced into the legislature shortly after Olsen's election. Huntington recalled that she and Armstrong, "sometimes taking turns, spent many hours at legislative hearings—a long drive up and back [to

Sacramento] in between our teaching schedules."[122] The effort was fruit-less: the bill "never got out of committee."[123]

Armstrong's friend, Earl Warren, who had graduated from Boalt a year ahead of Armstrong, followed Olsen as Governor of California in 1943, and gave Armstrong her second opportunity to play a significant role in the development of a comprehensive social insurance program. At Warren's invitation, both Huntington and Armstrong closely moni-tored and actively participated in hearings on each of his three legislative proposals on health insurance, in 1945, 1947, and 1949. While each of the three bills attempted to expand health care coverage to the unin-sured, each had, in Armstrong and Huntington's minds, some serious faults.

According to Armstrong's friend and colleague, Frank Newman, Warren had invited Armstrong to help in the drafting of his bills. In 1945, Armstrong gave him her "ideal bill," but it did not get out of the committee that was considering it. In 1947, Warren asked her if "she'd tone it down a little." Reluctantly, she did, but that bill failed as well. Finally, when pre-paring for the 1949 effort, Warren called her in and said, "Now, Barbara, this time we don't want to make it strong at all." She replied, "Well, then, Earl, just get another drafter."

In both 1945 and 1949, rival health insurance bills were submitted by organized labor.[124] While these bills were similar to Warren's measures in terms of persons covered and benefits conferred, labor's bills provided for benefits outside, as well as inside, the hospital, and required that all funds be deposited in a state health insurance fund. In the end, neither Warren nor the labor unions succeeded in enacting health insurance in California. In the process of fighting for universal coverage, Huntington and Armstrong became frustrated with the power that the "doctor's lobby" had to prevent "even the emasculated bills of 1947 and 1949" from being passed.[125] Warren did ultimately have success in related areas, managing to increase the state's old-age and unemployment benefits. For her part, Armstrong continued without success to advocate for a national compul-sory health insurance plan as late as 1961, when she served as a resource person for the White House Conference on Aging, convened by President John F. Kennedy.[126]

WORLD WAR II: ARMSTRONG AND THE OPA

The period Armstrong devoted to the second struggle for compulsory health insurance in California overlapped with the years leading up to and encompassed by World War II. A fierce proponent of helping the allies by participating in "Bundles for Britain" and supporting US involvement in the war, she would not tolerate isolationism among her friends.

After the attack on Pearl Harbor led the United States to declare war in December 1941, Armstrong and many of her colleagues volunteered for the war effort. She arranged two back-to-back leaves of absence without salary from August 1942 to June 1944 to work with the Office of Price Administration (OPA), which was established in the spring of 1942 to prevent wartime inflation. She was appointed Chief Rent Attorney in San Francisco in 1942.

In that position, Armstrong once again threw herself energetically into her duties and found herself "at war" with those who resisted her efforts, this time to enforce strict rent controls. Armstrong's former student and close friend, Kathryn Gehrels, observed the escalating battle between Armstrong and the forces opposed to strict rent controls. She noted that Armstrong was running "one of the few effective rent enforcement operations in the entire country," and had the full support of local rent control chief Marjorie Fox.[127] "Undaunted" by the constant attacks, Armstrong "went through one of the grimiest of the OPA battles," and was dismissed from her post and "kicked upstairs" to become a National Hearing Officer.[128]

Armstrong's situation was made known to Julia Porter, Chair of the Northern California Women's Division of the Democratic Party, who telegrammed Washington and made telephone calls on Armstrong's behalf. The women decided to make an issue of Armstrong's treatment, and they succeeded in getting her reinstated in San Francisco.

Armstrong returned to the OPA in 1943 to serve as Hearing Commissioner for the 7th Region in San Francisco. In that capacity, she dealt with enforcing the set prices charged and points given applicable to consumer purchases of meat and gasoline.

ARMSTRONG'S ROLE IN THE BERKELEY OATH BATTLE

Armstrong's leave was shortened to end on February 29, 1944, and she returned to Boalt to find the law school decimated by the war. "By 1943–44, the student body numbered 41 in the fall semester and 37 in the spring," down from 221 in the fall of 1940.[129] The faculty size was reduced by half as many volunteered for the war effort.[130] Those who remained were pressed into teaching courses well outside their expertise. The task of rebuilding the school in the postwar years fell to a new dean, William L. Prosser.[131] By this time, Armstrong had been a member of the Boalt Hall faculty for nearly thirty years. Many of her colleagues had already retired, or did so in the late 1940s and early 1950s.[132] She was well known on the Berkeley campus, a close friend both of UC President Robert Gordon Sproul and his secretary Agnes Robb, and a prominent member of the law faculty. While she was not highly visible among the appointed leaders in the governance of the law school, she exercised her considerable influence through indirect means. An apt illustration is the central role she played behind the scenes in the Berkeley Oath Battle of 1949–50.

At the height of the cold war, President Sproul learned that the California Senate was considering a proposed constitutional amendment that would have authorized the state legislature to require employees of the University to sign a more stringent loyalty oath than that imposed upon all other state employees.[133] In an effort to preserve the University's autonomy, Sproul recommended to the Regents that the University preempt the legislature by requiring all University employees to sign an additional loyalty oath beyond the one already required of all state employees. On June 24, 1949, the full Board of Regents adopted the new oath requirement, and included an express proviso declaring "I am not a member of the Communist Party."[134]

Despite the fact that the Regents had already put in place a policy of nonemployment of Communists as early as 1940, faculty opposition to the new oath began at once on the Berkeley campus.[135] Efforts at joint consultation between the Regents and the faculty failed in early 1950, and in February, the Board of Regents demanded that faculty members sign the oath by April 30, 1950, or be fired.[136] In response, the Berkeley faculty established a Committee of Seven, which recommended that the faculty

voluntarily adopt a statement specifying that members of the Communist Party "are not acceptable as members of the faculty."[137] In a mail ballot that posed this compromise, the faculty voted overwhelmingly for the "no Communists" policy proposed by the Board of Regents.[138] This action led to the creation of a new (and more liberal) faculty Committee of Five to seek to resolve the crisis.

At this point, Armstrong was called upon unofficially to help create a new avenue of communication between President Sproul and the faculty. Sproul evidently wanted legal advice from a source other than the Office of the General Counsel for the Regents. Armstrong called her colleague Richard Jennings. At Sproul's request, Jennings prepared a confidential legal memorandum concerning the status of the faculty under the state constitution and other technical problems relating to constitutionality of the oath requirement.

Clark Kerr, a member of the Committee of Five, feared that "a divisive confrontation between the faculty committees was possible." Once again, Armstrong used her good offices to pull the factions together, arranging for Kerr to speak in a meeting that was described by Professor Stephen Pepper, the most liberal member of the Committee of Seven, as a "beautiful piece of reconciliation" and "one of the most extraordinary evenings that I have ever spent."

Ultimately, the Regents voted on August 25, 1950, to impose the oath as it had originally been drafted. The majority of the Berkeley faculty, including Armstrong and all other members of the law faculty, signed the oath.[139] Thirty-one members of the faculty, including twenty-four at Berkeley, refused to sign and were dismissed.[140] Nearly two years later, the California Supreme Court invalidated the Regents' action in a lawsuit brought by the non-signers.[141]

ARMSTRONG'S *CALIFORNIA FAMILY LAW* TREATISE

In the early 1940s, Armstrong began working on her third book—a monumental two-volume treatise on California family law. As she had done while researching and writing her two earlier books, she took time out from her teaching duties to complete it. The book, *California Family*

Law, in two volumes (*Persons and Domestic Relations* and *The Community Property System*) was published in 1953. It was designed especially for the family law practitioner who had a solo practice or who worked in a small firm. In the days before computer-assisted research, such attorneys typically lacked access to an extensive law library and were handicapped in their ability to remain current in the ever-changing field of family law. The format of the book took up the subject, topic by topic, discussing the statutes and the leading California cases, often quoting key passages from the opinions, and giving Armstrong's view on the law. Commenting on her professional reputation among lawyers, Richard Jennings identified the book as the cornerstone of her eminence:

> She made the field of Family Law in the state. All of the practitioners used her book to solve any problems they had. Well, Barbara was a high-powered, hard-headed lawyer. She could read a case and analyze it through to where this might be leading you in other cases—not a slot-machine approach to the law. She was very imaginative, very inventive.[142]

Kathryn Gehrels, a leading family law specialist, traced the format of the book to its source in Armstrong's teaching style, noting that Armstrong "was not content to teach only what was contained in statute books or court decisions, but always analyzed the law in light of what she thought it should be." Gehrels pointed to the numerous instances in Armstrong's book where the reforms first advocated by Armstrong were later enacted by the legislature as evidence of Armstrong's ability to "mobilize her students and colleagues to work for [the law's] change."[143]

In recognition of her achievements, Armstrong was appointed to a named professorship: in 1954, she became the A. F. and May T. Morrison Professor of Municipal Law at a salary of $12,600.[144] At the time, she was the only woman law professor in the country to hold a named chair. Dean William Lloyd Prosser used the publication of her treatise as fresh evidence in his case for a substantial increase in Armstrong's salary. He wrote a strongly worded letter to Clark Kerr, who had become the first chancellor of the university in 1952, advocating for Armstrong's raise and describing her treatise as "one of the most important legal texts to appear in California, or any other state in many years."[145] Prosser summed up the case for increasing Armstrong's salary:

It seems to me obvious that this work should have recognition in the form of financial reward. Professor Armstrong has been a valued member of our faculty. This is her third book, in addition to a great many articles in legal periodicals. She has five more years to serve before her retirement. Since I came here as dean I have had the feeling that her salary has lagged behind other members of the law school faculty whose contributions will still take quite a few years to equal hers, and that the university was open to the accusation that she has been held back because she is a woman.[146]

Prosser's blunt advocacy was successful. On September 1, 1955, Armstrong received a salary adjustment to $13,800.

LAST YEARS AT BOALT HALL

In the same year that her treatise was published, Barbara Armstrong endured the tragic self-inflicted death of her husband, Ian, who suffered from cancer, on November 16, 1953.[147] She chose to deal with the situation by giving Dean Prosser strict instructions that "she wants no one to mention the thing to her, or say anything about Ian, and that she wants no flowers or anything of the sort." Armstrong immediately moved out of the beloved home where she and Ian had lived during their marriage, into a new house that harbored fewer memories of their life together. Once again, she took refuge in her work, producing a supplement to her family law treatise in 1956.

Under the University's mandatory retirement system, Armstrong was scheduled to retire in July 1957. Dean Prosser, however, was not yet ready to let her go. As he wrote to Chancellor Kerr, the law faculty planned to reorganize the property law curriculum, which would affect Armstrong's courses. Unless Armstrong's services could be retained, any "new man" hired by the faculty to replace Armstrong in 1957 would waste considerable time and effort "working on courses which he may never teach again" after the 1958 reorganization.[148] Prosser asserted that "a good man of real standing cannot be expected to come under those circumstances."[149] Accordingly, Armstrong's retirement was postponed until 1958, although she was also recalled to teach half time in academic year 1959–60.

The University of California conferred an honorary degree upon Barbara Armstrong on June 10, 1961. In addition to listing her many

distinctions, the inscription sought to capture the essence of her excellence in these words:

> Acute, discerning, articulate when common sense needs expression, you have won the respect and affection of your colleagues and your students. For your knowledgeable concern with social legislation, for the high quality of your scholarship, and for selfless service to the institution and particularly to its students, your university salutes you today.[150]

Although Armstrong was not recalled to active service again after 1963–64, she continued to occupy her corner office on the third floor of Boalt Hall overlooking the grassy courtyard, preparing successive supplements to her family law treatise. The last of these appeared in 1966. On April 23, 1966, the Boalt Hall Alumni Association conferred its prestigious Citation Award upon her and her colleague, William Ferrier, Jr., in recognition of their distinguished careers as graduates of the law school.

Barbara Nachtrieb Armstrong died on January 18, 1976.

CODA: HERMA HILL KAY AND HER HAT

As it turned out, I was the "new man" who was hired in 1960 to take over Armstrong's courses in Family Law and Community Property, as well as to offer a course in the Conflict of Laws. Without her help, I would probably not have been hired.

I was clerking for Justice Roger Traynor at the California Supreme Court building in San Francisco when the appointments committee called, and I wore my best tailored suit to my spring 1960 job interview at Boalt Hall. The hat I had chosen to wear was a pale beige crushed velvet with a high crown and a brim that came down over my eyebrows. Wearing the hat, I went from office to office interviewing with members of the faculty. I also wore it to lunch. At about three o'clock in the afternoon, I was having tea with Barbara in her office. A reception with the faculty at four was the last scheduled event of the day. As Barbara and I sat in her office, her telephone began to ring. She picked up the phone and said, "Yes, yes, I know," and slammed the receiver down. The phone immediately rang again, and Barbara answered, "Yes, yes, of course!" When it rang a third time, she

exclaimed "Yes, I'll tell her. Stop calling!" Putting the receiver down, more gently this time, she looked at me across the table and said, "You're going to have to take off your hat. The men want to see what you look like." I was surprised and distressed. I had shoulder-length hair at the time, and it was a warm day. Hesitantly, I replied, "Well, Professor Armstrong, I can't take my hat off." Barbara demanded to know, "Why not?" "Well," I said, "my hair is all plastered down under the hat from the heat, and I just can't take it off." I added, more bravely than I felt, "If they want to hire me, they're just going to have to hire me with my hat on." Barbara gave me an appraising look. "All right, "she said. "Perhaps when you come back for your second day of interviews, you could wear a smaller hat." "Oh, yes, Mrs. Armstrong, of course I could," I replied with great relief, and added, "But I didn't know there was going to be a second day of interviews." Barbara looked at me again and said, with great determination, "There will be now." The invitation was extended, and the next week I returned for my second interview day wearing a small pillbox. Everybody could see what I looked like, and I was hired.[151]

2 Armstrong's Pre-World War II Contemporaries

HARRIET SPILLER DAGGETT AND
MARGARET HARRIS AMSLER

In 1909, while Barbara Nachtrieb was preparing to start college at Berkeley, Harriet Spiller was graduating from Louisiana State Normal School in Natchitoches in preparation for work as a teacher of mathematics and Latin at Jennings High School, and Margaret Harris was a small baby in Waco, Texas. These three women would become the nation's only female law professors in ABA accredited, AALS member schools prior to World War II.

All three began work as schoolteachers, a traditional female occupation, before becoming law professors, a decidedly untraditional one. They came to the study of law, however, by different routes, and although there was some overlap in teaching and scholarly interests, their primary fields of specialization were not the same. All were active in law reform, including the conceptualization, drafting, enactment, and implementation of new laws. They never met in person, although each had heard about at least one of the others.

HARRIET SPILLER DAGGETT

Harriet Spiller, an only child, was born to Blasingaim and Maria Louisa Dolan Spiller in Springfield, Livingston Parish, Louisiana, on August 5,

1891.[1] Maria, a teacher who had once been the principal of a boys' high school in Arkansas, home-schooled her daughter.[2] Following in her mother's footsteps, Harriet served as second assistant principal at Jennings High School between 1909 and 1914. She met her future husband, DeVan Damon Daggett, a rice planter, in Jennings, and they were married on December 28, 1914. After marriage, she resigned her position and undertook volunteer work with the Federation of Women's Clubs, helping to set up Louisiana's first "mobile library." She and her husband had two sons, DeVan Damon Daggett, Jr. (1917) and John Dolan Daggett (1920). When a rice crop failure soon after John's birth created a financial crisis, Harriet became the primary source of support for the family. With her husband's encouragement to go into the study of law, the family together moved to Baton Rouge in 1922 so she could continue her education at Louisiana State University.

Education

Between 1922 and 1929, while supporting her family, raising two young sons, and caring for her invalid mother, Daggett earned four degrees and embarked on her academic career—an astonishing achievement for any fledgling academic, but particularly so for a woman in the 1920s. In 1923, she acquired an AB in Government from LSU and went on to study law there.[3] The LSU law school, which had been established in 1907 and became an AALS member in 1924, received ABA approval in 1926, the year Daggett earned her LLB. While a law student, she taught Government to LSU undergraduates.

After her admission to the Louisiana Bar in 1926, Harriet Daggett next enrolled in LSU's graduate school to earn an MA in Political Science. Like Barbara Armstrong, initially she held a joint appointment in two departments. Concurrent with her graduate work, she was appointed a part-time instructor in the Political Science department. Unlike Armstrong, she spent only one year in a joint appointment. She became a full-time Assistant Professor at the law school in 1927, at a salary of $2,400, the year before she acquired her master's degree in 1928.[4] Taking a leave of absence and accompanied by her sons and mother, she attended Yale Law School, where she earned the JSD in 1929.

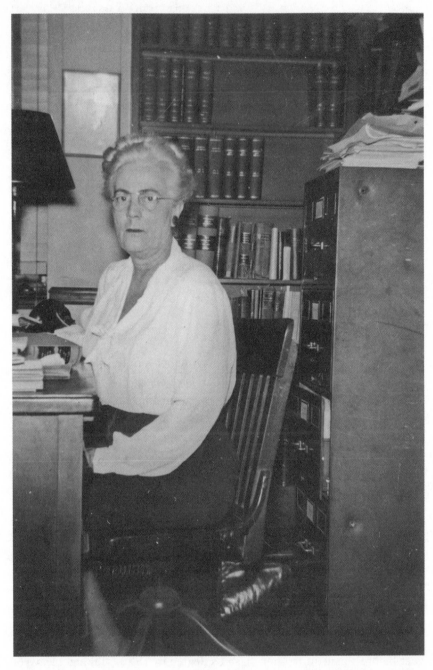

Figure 3. Harriett Spiller Daggett. Courtesy of the Louisiana State University Paul M. Hebert Law Center Archives.

Family Life

After returning from Yale, Harriet Daggett lived with her family in a home built under her husband's supervision in a wooded area outside Baton Rouge known as Parton Ryders. Mr. Daggett apparently never went into business again after his devastating financial losses as a rice planter, although he served for a time as a Federal Land Bank Inspector.[5] Instead, he devoted himself to his wife, the boys and the care of his many dogs. As her friend, Frances Landry, put it, "He was always there for her." Both of their sons attended LSU law school, both took classes from their mother, and both became lawyers.

Teaching Law: The Early Years

Daggett progressed rapidly through the law faculty ranks at LSU. Upon her return from Yale with her JSD, she was promoted to Associate Professor in 1930, at a salary of $3,600, and to Professor of Law in 1931, at a salary of $3,900.[6] With the latter promotion, she became the first woman to hold a full professorship in law—a rank she attained four years before Barbara Armstrong was granted such a position at Berkeley.[7]

Daggett began her academic career during the turbulent period in Louisiana history when Governor (and later Senator) Huey P. Long held virtually absolute political power in the state. Long was inaugurated as Governor of Louisiana on May 21, 1928, and immediately began efforts to improve the University's academic standing. Long saw to it that his personal choice became president of the University. That was James Monroe Smith, Dean of Education at Southwestern Louisiana Institute. Charles Wooten Pipkin, a member of the LSU government department, was chosen as dean of the graduate school in the summer of 1931, and by 1935 enrollment in that school had grown from 94 to 505.[8] Pipkin and President Smith sought to improve the LSU faculty both by lateral recruitment and by encouraging faculty at the school who held masters' degrees to enhance their academic credentials by acquiring PhD's at other leading institutions.[9] Daggett had anticipated this policy by earning her JSD at Yale in 1929, and Dean Pipkin publicly recognized her scholarship.

Daggett taught most of the Civil Law subjects, including Family Law and Louisiana Community Property, as well as Constitutional Law, Administrative Law, International Law, and Municipal Corporations. She also helped to create the new legal subject of Mineral Rights (Oil and Gas) with her treatise on the subject published in 1939.[10]

Students and Mentoring

The fact that Harriet Daggett was the only woman on the LSU faculty, combined with the fact that she taught both her sons, may have inspired her widely used nickname: "Ma" Daggett.

There were few women students in the law school. Frances Landry, who entered the law school in 1932, was the only woman in her class. Daggett became a mentor to Frances, who rewarded this attention by finishing first in her class. Although Daggett never expressly encouraged Frances to think about a career as a law professor, she tried to get her a fellowship at Yale. Frances, however, had other plans: she had fallen in love with Jules Landry, who was a senior at the law school the year she entered. They decided to marry as soon as Frances graduated. She was reluctant to tell Mrs. Daggett about her plans:

> I kept the secret from her because she had her hopes set on my going to Yale and I was worried about disappointing her. . . . But finally . . . I went to her office and I told her that I decided to marry Jules Landry and I wasn't sure I could go to Yale. And I thoroughly expected her to show her disappointment. And instead of that, she came from around her desk and threw her arms around me and said, 'I was wondering when you were going to tell me.' She knew it all the time.

Daggett, however, had not entirely given up on her hopes for an academic career for her protégé. After the marriage, she offered Frances a one-year clerkship with her as a legal research assistant. Frances acceded to her husband's wish that she practice law with him instead. She noted, "It was unfortunate that I couldn't please both of them."[11] Frances and Harriet Daggett remained close friends.

Social Life

Baton Rouge had a population of 30,729 in 1930 and 34,719 in 1940, and the academic community was relatively close-knit.[12] The LSU faculty relished their evenings at Harriet and DeVan's relatively remote home in Parton Ryders because their boisterous after-dinner singing around the Daggett piano did not disturb the neighbors.

In addition to entertaining her faculty colleagues, Harriet Daggett ran something of a salon attended by the editors and some of the writers of *The Southern Review*, the legendary literary magazine that was founded at LSU in 1935.[13] The gatherings at Mrs. Daggett's home were described by Frances Landry in awestruck terms:

> [A]fter the dinner, she would have what she called a 'dessert course.' And that's when the other friends came in. These were people like Robert Penn Warren, Kathryn Ann Porter and other leading writers. . . . In those days, a party was conversation and the exchange of ideas.

Daggett's Major Books

Harriet Daggett published three major books, in addition to a compilation of Louisiana statutes concerning child welfare, a Louisiana annotation of the American Law Institute's *Restatement of the Law of Conflict of Laws*, and many law review articles. She was a regular contributor to the *Louisiana Law Review*'s annual volume on *The Work of the Louisiana Supreme Court*, beginning with its first issue in 1938 and continuing through her retirement in 1961. Her area was a broad one, covering matters related to the Civil Code, including family law, successions, trusts, partition, community property, and mineral rights.[14] She also prepared a mimeographed casebook on family law.

Daggett's first book, *The Community Property System of Louisiana, with Comparative Studies*, appeared in 1931.[15] Daggett's achievement was remarkable because, as LSU's historian Professor Lee Hargrave explained, the small faculty was burdened by heavy teaching assignments and "did not publish substantially" during the 1920s.[16] Charles Wooten Pipkin wrote the editor's note to her book, and the law school's dean, Robert Lee Tullis, who had hired Daggett as a faculty member, took the

opportunity to single her out as a role model for her colleagues, suggesting pointedly that they follow her example by publication of their own work:

> It is a study that constitutes the most ambitious of the efforts emanating from the faculty of the Louisiana State University Law School. It comes from the pen of one whose capacity and industry, long manifest to those who have sympathetically watched her career, have united in a product that may well lead others to emulate her example, and not to allow the talents with which they are endowed and the learning which they have achieved to perish when their voices are no longer heard in class or court.[17]

The confidence of Pipkin and Tullis in the quality and originality of Daggett's research was amply fulfilled. Over thirty years later, the LSU Board of Supervisors, in its Resolution in her memory, observed:

> Her first book on community property is still considered the basic authoritative statement of the community property law of Louisiana. She was animated with a zeal to improve the community property law, and her forward-looking ideas had marked effect in shaping the course of development.[18]

Daggett's "zeal" to improve the community property law, and the goal of that improvement is plainly evident in the opening paragraphs of her Introduction to the book. She wrote:

> The Civil Law ideal of the marital relation, far kinder than the Common Law notion of a merged personality represented by the husband, has throughout the regulation of the community kept a more perfect balance between the rights of the spouses in their accumulations through the years. Furthermore, the strong framework which supports the community property edifice will permit of the minor adjustments necessary for perfect alignment with changing conditions.[19]

The most far-reaching of the "minor adjustments" Harriett Daggett recommended was the enactment of legislation authorizing spouses to make post-marital contracts adjusting their respective rights in their community and separate property estates.[20] Existing statutes and decisions treated husbands and wives differently depending on whether the wife was gainfully employed or a homemaker who did not work outside the home. The difference was so great, she wrote, that the Louisiana Community Property Regime "is *not* a community" but rather, "[s]o far

... as gainfully employed couples are concerned, Louisiana has a community property system for the husband and a separate regime for the wife."[21] It is a measure of the resistance, even if only passive, to this proposal that it was not accepted for nearly fifty years. When it was finally enacted in 1979, as part of the Revision of Civil Code book III, title VI (on Matrimonial Regimes), it proved to be the most controversial section of the new law.[22]

Unlike her first book, which modernized a centuries-old civil law topic, Daggett's second book, *Mineral Rights in Louisiana*, created a new legal field.[23] She had gathered material on the topic to use in her course, and was persuaded by her students to publish her research in 1939 "in the hope that it would render a service."[24] Work on the book seems to have been something of a family project, for she acknowledged both the help of her husband "for expert information and field notes" and her oldest son "for his research in the French authorities."[25] She focused on a discussion of "the mineral problems peculiar to Louisiana because of the Civil Code" and went on to explain why such a study would be useful:

> The law of oil and gas is new and without precedent. It deals with a new substance, a voluble 'mineral.' The uses of that substance are revolutionary. The right to search for it is a new right. The technological processes of that search are new. . . . The decisions of other states were of small value because Louisiana is a civil law state with an old civil code.[26]

This book was characterized as "the leading Louisiana treatise on this important and rapidly developing area of the law."[27] Daggett, however, was not content merely to write the authoritative book on the subject of oil and gas. She also founded the Louisiana Mineral Law Institute, and edited its Annual Proceedings for publication by LSU Press from 1956 through 1958.[28] In 1954, she was invited to become the Louisiana editor for the *Oil and Gas Reporter*, published annually by the Southwestern Legal Foundation. She held the post for three years.

Daggett began work on her third book, *Louisiana Privileges and Chattel Mortgages*, in 1933 while she was, as she put it in the Preface, "otherwise actively engaged."[29] She undertook the project at the suggestion of a Louisiana practitioner who told her "that a comprehensive study of the Louisiana law of privileges was needed and would be of real service to the

bar of the state."[30] The project was so "formidable" that she gratefully accepted the help of a series of four graduate research assistants. The book appeared in 1942. It is both comprehensive and scholarly, tracing as it does the origin of the concept of "privilege" to the Roman Law and explaining its manifestation in the Code Napoleon, and is oriented toward the practitioner, with its careful attention to detail and accompanying legal forms. It is plainly the work of a strong conceptual intelligence combined with a remarkable capacity for analytical ordering of a mass of disjointed and often contradictory material.

Daggett's scholarship was much appreciated by the Louisiana judiciary as well as by her students and colleagues. Chief Justice John B. Fournet of the Louisiana Supreme Court spoke eloquently of her contributions to the work of the Court:

> It seems particularly fitting that the Bench join hands with the alumni of our school and the Bar as a whole in paying you this tribute, for your writings constitute a distinct addition to the source material of our judicial research. I might even say that if there is a single conclusion in which *all* members of the Supreme Court are unanimously agreed, it is that the contributions of Dr. Harriet Spiller Daggett to the legal profession, as evidenced by her many articles and books, have been of immeasurable and invaluable aid to the court in the solution of some of its most complicated legal problems.[31]

Leadership on the Law Faculty

Harriet Spiller Daggett was not only a prolific pacesetter in faculty scholarship, but also a leader in setting faculty policy. Her scholarly eminence was demonstrated both in her own innovative publications, and in her tireless work on behalf of the civil law tradition in Louisiana. She taught all the civil law subjects to generations of LSU students; she analyzed and explained the Louisiana Supreme Court's civil law decisions to the practicing bar for a period of nearly thirty years; and when the vitality of the tradition was attacked by a newly-arrived colleague, she mustered three of her other colleagues in its defense. This ultimately led to the creation of the Louisiana State Law Institute in 1938, which formed a civil law section in 1960 charged with the "mission of promoting civil law studies and revising the Civil Code."[32] Daggett herself was appointed as a Reporter on

the Revision of the Civil Code and "took an active part in the revision of the Louisiana Statutes for the Louisiana State Law Institute."[33]

LSU and the AALS Desegregation Debate

Daggett's colleagues, honoring her at her retirement, stressed her influence within the faculty, stating that "[s]he had strong views on legal education forcefully expressed in faculty deliberations. In this respect she had a prominent part in the shaping of Law School policy."[34] One of her most significant contributions was the pivotal role she played concerning the faculty's vote on the question of racial segregation in law schools. This issue was presented by the so-called "Yale Resolution," debated at the December 1950 annual meeting of the Association of American Law Schools and voted on a year later.

The impetus for the Yale Resolution came directly from the United States Supreme Court's June 5, 1950, decision in *Sweatt v. Painter*, which had ordered the University of Texas Law School to admit black students.[35] A committee of law teachers from member schools of the AALS had filed an influential brief in the case opposing segregation in legal education.[36]

The LSU faculty was deeply divided over this issue. Jerome Shestack, who had just joined the LSU faculty, immediately became involved in the matter. Shestack and Daggett found that they were of one mind on the AALS resolution:

> [S]he was a heroine at LSU Law School. . . . [T]here was a resolution before the Association of American Law Schools, to avoid discrimination. . . . Harriet was part of the group that helped lead a narrow majority of the faculty that said we should desegregate.

At the AALS Annual Meeting in 1951,[37] Professor Charles Driscoll of Loyola University, New Orleans, spoke in favor of the Yale Resolution to explain to the body the dilemma faced by his faculty and that of other Southern schools:

> The simple truth . . . is that men and universities and communities act in response to pressure, that we are gathered here as men of good will to forge a new pressure and that when it is forged, it is going to be exerted, not upon ourselves, but upon others. . . . We seek to persuade them that an

overwhelming majority of American law schools will no longer associate with a law school which continues to discriminate.[38]

The Yale Resolution was put to a roll-call vote and was defeated. Of the Louisiana schools, Loyola and LSU voted in favor of the resolution while Tulane voted against it.[39] The proposal was then amended to broaden the wording of the proposed objective from "A student body selected without discrimination on the ground of race or color," to "Equality of opportunity in legal education without discrimination or segregation on the ground of race or color."[40] This amendment was accepted.[41]

As Dean Paul Hebert observed,

> Thanks to Dean McMahon and his courageous faculty, there was no turmoil when the first Negro students were accepted and were graduated from the LSU Law School. The problems that erupted elsewhere did not disturb legal education at this University—a real achievement for any law school in the deep South.[42]

Retirement

Harriet Daggett retired at graduation on August 11, 1961, having taught at LSU for thirty-six years. A testimonial dinner in her honor was held on September 29, 1961. After her retirement, Harriet Daggett continued to keep in touch with her many friends and admirers. Her two sons, her daughter-in-law, and her grandsons lived next door to her outside Baton Rouge.[43] She died on July 22, 1966. Frances Landry helped facilitate a gift of $10,000 from a Baton Rouge philanthropist, Mr. Paul Perkins, who wanted to do something at the law school in Mrs. Daggett's memory. The funds were used to establish the Harriet Daggett Memorial Fountain and Courtyard, which remains a peaceful oasis in the midst of the bustling life of the LSU law school.

MARGARET HARRIS AMSLER

Margaret Thomas Arnold Foster Greer Harris was born in Waco, Texas, on June 15, 1908, to Margaret Foster Greer and Nat Harris.[44] She was the third of five children. Her parents came to Texas from the southeast:

Figure 4. Margaret Amsler Harris. Courtesy of Baylor Law School.

her mother from Kentucky, and her father from Mississippi. Both gradu-
ated from Baylor in 1900. Margaret remembered hearing that her mother
was a very beautiful woman and that three of her Baylor classmates
wanted to marry her. Her mother took her time with the decision. In
1903, the three suitors, perhaps growing weary of the delay, presented
themselves to their classmate and asked her to decide which one of them
she was going to take. She chose Nat, who at the time was living in
Washington, DC, while attending night law school at Columbian
University (later George Washington University). He graduated on May
31, 1904, and they were married in June 1904. The family returned to
Waco in 1905, where Nat went to work as Assistant District Attorney.[45]

Education

It was unthinkable that Margaret would attend college at any school other
than Baylor. She had grown up on the Baylor campus, surrounded by mem-

bers of the faculty and their families.[46] By the time she was three years old, her father was teaching a pre-law course to Baylor undergraduates. Most of her classmates were children of the university faculty. At Waco High School, she took "the usual classical course for college preparation" which consisted of "four years of English, four years of math, history, political science, and economics, and Latin."[47] Margaret graduated second in a class of 300 students in 1925, thereby earning a scholarship to Baylor. She finished with high honors in 1929 and made her debut in 1930, at the last Cotton Palace Debutante Ball held before the Depression.[48] She was familiar with the law and lawyers, having accompanied her father to his law office and to court, and her aspiration was to follow in his footsteps. But he was uncertain about the feasibility of her plan to study law. She recalled:

> My father and I were very close. . . . I went to the courthouse with him and I was in his office frequently; it just seemed the natural thing to become a lawyer. . . . [H]e persuaded me to wait until I was mature before I made the final decision. So, when I graduated from Baylor, he gave me my Master's Degree at Wellesley. . . . Then I came back and taught a year in the public schools at Rockwell, which is right out of Dallas. Then I decided that I did love to study law so that's what I did.[49]

Once she had her father's approval to study law, it was natural that Margaret would choose Baylor. Her father was one of the founders of the modern Baylor Law School. Formally organized in 1857, it had closed during the Civil War.[50] Known as "Judge" Harris because of his election as a Justice of the Peace in 1908,[51] he was one of three practicing lawyers who served as adjunct faculty members when the law school reopened in 1920. His primary subjects were constitutional law and corporations.[52] Margaret enrolled there in 1932. At the time, Baylor was a small private school, which had been approved by the ABA in 1931 and achieved AALS membership in 1938. There were no other women in her entering class of thirty-five students, and only three other women in the law school. Normally a top student, she experienced academic difficulty only in the first class she took from her father. As she recalled,

> He was afraid that people would think we had a touch of nepotism there, so he gave me a B. My classmates waited on him and told him what they thought of him. Thereafter, he gave me what I made.

Margaret withdrew from law school at the end of her first year to marry her first husband, John Kenneth Gordon, whom she later described as "a very charming, delightful man, great fun to be with, but not husband material."[53] Their daughter, Frederica Elizabeth (known as Rikki), was born in Waco on May 11, 1934.[54] The marriage ended shortly thereafter. As she explained, "My husband left the state about five minutes ahead of the sheriff's posse, and I haven't seen him since." She reentered the law school in 1935. Like Harriet Daggett, Margaret worked her way through law school by teaching in another university department. Harriet taught Government, while Margaret taught French. Both were also raising young children while studying law. As Margaret put it, "I taught French full-time and went to law school full-time and took care of Rikki full-time, and I got about two hours sleep there every night for about two years." Despite this demanding schedule, she managed to find time for extracurricular activities. Baylor had no law review while she was a student, but there were two all-male law societies called the Forum and the Senate. The Forum invited her to become a member, and when she accepted, they had to change their bylaws to permit the admission of women.[55]

Beginning a Career: The Texas Legislature

Margaret ranked first in the Baylor Law School class of 1937 and was one of only three students who graduated with honors.[56] She began her professional career by practicing law with her father in Waco, and she was one of her own first clients. She represented herself in obtaining a divorce from Gordon in 1937 on the ground of desertion, explaining to an interviewer that "I didn't want him to get half my earnings."[57] In 1938, she ran for election to the Texas legislature, becoming the first woman elected to that body from McLennan County.[58] She carried on a house-to-house campaign, supplemented with ice cream suppers for the candidates and visits on her own to factories at 6:00 A.M. to meet the incoming shift. Her daughter, Rikki, age four, accompanied her on some of these trips, asking people to vote for her mommy and collecting nickels for the campaign.

Margaret served in the January 1939–40 regular session. She took an apartment in Austin with Elizabeth Barnes, a secretary in her father's law office who worked as a secretary in the legislature during the sessions. The

stipend for members of the House of Representatives was $10 per day. Margaret was appointed to the Judiciary Committee, the Penitentiary Committee, and the Education Committee.

During her tenure in the House of Representatives, Margaret opposed a sales tax measure proposed by Texas Governor W. Lee O'Daniel that would have raised money for teachers' salaries but also would have benefited the oil, gas, electric, and sulfur companies by imposing a small tax on them while granting them immunity from the larger general sales tax. O'Daniel proposed a constitutional amendment as the vehicle for the sales tax. Fifty-six representatives, including Margaret, opposed the measure, despite the governor's denunciations of them as "corrupt." Upon hearing his charges, her friends in the Senate passed a resolution declaring that she, at least, was not corrupt. O'Daniel, undeterred, kept up his attacks during his enormously popular radio broadcasts on Sundays. The newspapers and the labor unions, however, sided with the "56." Margaret acknowledged that she played a pivotal role in holding the opposition together:

> [T]here were fifty-six of us who voted against it in the beginning and fifty-six of us still voting against it in the end. It was interesting, I think, there were here and there members of the '56' [who] couldn't stand the pressure which their constituents were putting on them when they heard what Governor O'Daniel had to say on Sunday. . . . And I think if I had changed my vote, some of the men would have changed their votes, and it might have been adopted. But no man of the '56' could change his vote when the 'little woman' wouldn't change her vote.[59]

The Governor lost the battle, but he took his revenge: he opposed Margaret's re-election bid in 1940, and she was defeated.[60]

Family Life

Margaret became reacquainted with a high school classmate—Sam Houston Amsler, Jr.—in 1941, when he enrolled at Baylor Law School. Margaret and Sam began dating while he was in law school, but, since she was then a full-time teacher at Baylor, she refused to allow him to take her

courses. Sam and Rikki, then aged seven, got along famously. Margaret insisted that her marriage to Sam was all Rikki's doing:

> Rikki proposed to Sam. . . . On our second date, Rikki asked him why he didn't marry me so that he could be her daddy. And he promised her that he would. And so we were married, and he . . . has been a wonderful father for her.[61]

Sam and Margaret were married on September 14, 1942, and Sam adopted Rikki shortly thereafter.

Teaching Law: The Early Years

In 1932, Pat Morris Neff, the former District Attorney with whom Margaret Amsler's father had worked, became the ninth president of Baylor University. In 1940, he invited Margaret to join the faculty. She was paid $200 per month in 1940, a sum that was increased to $250 per month in 1941 when she began teaching full-time. Her course assignments were very flexible:

> I taught Contracts, Personal Property, and Real Property. In fact, I taught anything the men didn't want to teach. I've taught around the curriculum. . . . Then I finally sort of settled down in the statutory courses: Negotiable Instruments, Corporations, and Partnerships.

During the summer of 1942, she was appointed Marshal (briefing attorney) and Librarian for the Texas Supreme Court by its Chief Justice, James P. Alexander, who had been her professor for Practice Court. Margaret recalled that his action was not entirely welcomed by his colleagues:

> When I joined the Supreme Court, [it] had been in existence a hundred and three years, and there had never been a woman employee. There were not even women secretaries. . . . I remember, one day, Judge Critz, who was on the court, came by my desk, and he said, 'Miss Margaret, I don't think a woman has any place with the Supreme Court.' And, of course, I said, 'I'm sorry, Judge Critz, that you feel that way. I feel otherwise, and that's why I'm here.' After I'd been there about two months, he came bouncing down again

and he said, 'Miss Margaret, I wanted to come down and tell you that what this court has been needing for a hundred and three years was a little sex appeal.' I thought that was the *amende honorable*.[62]

The law school closed in 1943, during World War II. Amsler reported that "[i]n the beginning of 1943, we had five students show up and six professors. We couldn't quite work that, so the law school closed from then until 1946." She did not, however, stop teaching. The University remained open, and she was called upon to help out in the college:

> Mr. Neff would call me. He'd say, 'We need someone in business law.' So I'd go teach business law. 'Need someone in English.' And my Master's degree was in English, so I'd go teach English. 'Need someone in French,' so I'd go teach French. We had the Army Officers Training School program there, beginning around the time the law school closed. So Mr. Neff had me serve as head of the Geography Department.

Sam Amsler also taught Geography in the OTS program. He painted a vivid picture of the contrast between himself and Margaret as teachers:

> Now, I'll give you an idea of what the difference is between just a hack teacher and one who has some imagination. She and I were teaching the same course, Geography. . . . She taught the same thing, except you know what she added? They were planning the invasion of Europe! She had a plan of the thing, and, dang it, you know what? It worked out just the way they'd planned it. They didn't miss but very few points of the invasion.

When the law school reopened in January 1946, Sam returned to private practice in Waco. He was also beginning to build a practice in McGregor, where a Shell loading plant had opened. He rode on an "old, ramshackle bus" from Waco to get there each afternoon. Then, as business progressed, Margaret suggested that they sell their home and place on Lake Waco and move to McGregor. She told Sam, "It would be better for me to drive back and forth than for you to have a law practice and not live in the town." They built a house in McGregor in 1950.

Margaret, meanwhile, had taken over in 1946 as the nation's first female Acting Dean when the Baylor law school reopened after World War II. As she said of this time:

Mr. Neff called me and said, 'I've got 50 GIs wanting to start law school. I want you to start law school in March.' I said, 'No problem'. . . . We were simply amazed at the difference between the pre-war law students and the post-war law students. The post-war students knew what they wanted to do. They were eager to learn and it was just a joy to teach them. You didn't have any problems. You didn't have to spell it out, or inspire them. Just get there and teach and they lapped it up.

Interaction with Students

Margaret Amsler, like Harriet Daggett, was given an affectionate nickname by her students: "Lady A." Dean Charles Barrow attended Baylor in 1940–43 and was in Margaret's first class. He recalled that her father, Judge Nat Harris, was "one of the most revered adjuncts" in the school. Judge Harris "was an extremely demanding professor and students were terrified and were always well prepared in his class."[63] He went on to explain that Margaret took after her father in the classroom:

> I had her in several classes and she certainly emulated her father in that she was very meticulous and very demanding. . . . Fortunately, she gave me some very good habits in reading cases. It helped me a great deal as an appellate judge to look behind every post for what turned the case.

Amsler actively mentored her male students. She kept in close touch with Baylor graduates, particularly at the annual homecoming reception. The alumni returned her affection. She reported that "at homecoming, a lot of hugging and kissing goes on with the former students and none of the men faculty gets kissed."[64] Her "Baylors," as she affectionately called them, who were in the State Legislature responded to Amsler's requests for their support of the State Bar bills she presented there for enactment. Her daughter Rikki's husband, David, told Margaret that she had "more sons-in-law than any other woman."

Social Life

Like Harriet Daggett, Margaret Amsler enjoyed cooking, a pursuit she took up at the age of eight. McGregor was a small town sixteen miles away from Waco with a population estimated at around two thousand after

World War II.[65] She gave dinner parties three or four times a year for the faculty and their wives. She once gave a party for 150 guests: she "started preparing for that a month ahead, cooking things and tucking them in the deep freeze." But her chief culinary role was that of informal hostess at the annual Baylor Law School Alumni Reunions. As she reported:

> I would start baking bread a month before and freezing it; fixing sandwich fillings—ham and cheese and chicken—and then cookies. ... Charlie Barrows was on the Texas Supreme Court then. Next time at Homecoming, after I'd retired, he said, 'Where are our homemade bread sandwiches?' I said, 'Cook resigned.'

The Texas Corporate Law Revision

Margaret Harris Amsler's publications were both more modest and more narrowly focused than those of either Barbara Nachtrieb Armstrong or Harriet Spiller Daggett. Unlike Berkeley or LSU, the law school at Baylor saw its initial mission as teaching rather than research.

In Amsler's day, publications were not required for faculty advancement. She observed that "we never paid too much attention to titles." She began as an instructor, was uncertain of the date when she became an assistant professor, but recalled that she was promoted quite informally:

> When I became a member of the Corporation Committee, I told Ab [Baylor Dean Abner McCall] that the other professor members of the Committee were Professors. Could I be a Professor, too? So he said, 'Well, of course.' So I was a professor.

The AALS records put 1949 as the date of her promotion to Associate Professor, which normally carries tenure, and 1955 to full Professor, but Amsler reported that the faculty had no concept of being tenured or non-tenured: "[w]e just considered ourselves tenured because no one else wanted the job." They had no formal contracts with the University: "In the spring they would notify you what your salary would be for the next year. And you accepted that, and that was your contract." There was, however, an expectation that the faculty would do research and publish. She explained, "Of course, I did research and publish: that was my work with the Corporation Committee."

Amsler's work with the State Bar of Texas Special Committee on Revision of Corporation Laws spanned ten years and was not limited to research and publications. It also included drafting five corporation acts, presenting them to the State Bar and the lawyers of the State, and lobbying them through the Texas Legislature. Amsler was deeply immersed in all aspects of this law reform project. After the work had been completed in 1961, the State Bar of Texas presented her with its first President's Award, created to recognize the member who had performed the most outstanding service for the organized Bar during the past year.[66]

The Committee on Revision of Corporation Laws was appointed by the State Bar of Texas in July 1950 to "draft and propose a sound and modern Business Corporations Act" and began its work immediately.[67] The impetus came from the general recognition that the existing Texas law, which had not been completely revised since 1874, had been designed—as Amsler put it—to "complement an agricultural economy" and was ill-suited to serve the needs of "the modern business corporation, with its complicated structure, its nation-wide (or even world-wide) market, its large contribution of capital, and its many, widely scattered shareholders."[68]

The final draft of the act was submitted to and approved by the State Bar in July 1952. It was introduced into the legislature in 1953, and hearings were held at which the committee members appeared "and explained what the bill did, how they changed the old law, and why the changes were made, and what the new law would be."[69] One of the changes related to the position of married women in corporate governance and control. As Professor Margaret V. Sachs has pointed out,

> An 1887 Texas statute allowed married women to become shareholders, directors, and officers of corporations 'as if they were males.' At Amsler's insistence, the committee charged with modernizing Texas's corporation statutes adopted a version of the 1887 statute in its new corporations code.[70]

A revised version was re-introduced in 1955 and enacted in that year. Amsler played a key role in shepherding the bill through the Texas legislature. As she put it, "Fortunately I had Baylors in the House and the Senate. I just called on one of them. It went right through."

After the first part of its charge was completed in 1955, the same committee began work on a companion code for the non-profit corporation.

The timing of this was somewhat urgent because when the new Business Corporations Act was adopted, existing laws that conflicted with it would be repealed. Amsler, who was appointed Chair of the Sub-Committee on Non-Profit Code in 1956, explained:

> [M]any of the laws which should be repealed, as they affect the business corporation, are at the same time the laws which apply to our non-profit corporations. If these statutes are repealed and the Non-profit Corporation Code has not been enacted, we shall have left very little statutory law applicable to the non-profit corporation.

Amsler carried out the work of drafting the non-profit corporation act virtually alone. After the draft was complete, it was published in the *Texas Bar Journal* and Amsler "went around explaining to the members of the State Bar—El Paso, Amarillo, Beaumont, so forth—what it would do."[71] A bill embodying the proposed act was introduced to the legislature in 1957, but met unexpected opposition from the Baptist Church, which had become convinced that if the bill were enacted, "[t]he state would take over the running of the Baptist Church." The bill was withdrawn, while Amsler enlisted the support of two "important people in the Baptist church—Dr. W. R. White and Abner McCall."[72] Then she reported, "[W]e made some changes which satisfied the members of the Baptist denomination, and I went back in 1959 to the legislature, and it was passed."[73]

The committee's third project, which Amsler also led in her new role as chair, beginning in 1958,

> was to draw up a repealer bill to go through all the old law and take out that which no longer applied and keep what was still relevant; so that we ended up with two bills—the repealer bill which did away with the old laws and the Texas Miscellaneous Corporations Law Act which preserved the old laws which were still relevant. And I went down to the legislature then in 1961 with those two bills, which came out of my typewriter, as did the Non-Profit Corporations Act.[74]

Amsler reported to the State Bar in 1961 that all five bills had been enacted.[75] Tactfully, she left out of her report the fact that she had been forced to secure the enactment of the final two bills without the help of the State Bar. In 1961 the legislature also had before it SB-1, a bill to abolish

the State Bar, and was in no mood to approve any bills that were spon-
sored by the State Bar. Amsler, however, was more than equal to the task.
As she described the situation,

> [T]he President of the State Bar . . . said, 'Mrs. Margaret, the State Bar can't
> help you. We're fighting for our lives'. . . . So I went to the legislature as
> Chairman of the Committee on Corporation Laws. There was no mention of
> State Bar. There was considerable mention of the fact that I was professor of
> law at Baylor. I was, at that time, of course, silver-haired, mild-mannered,
> and nobody was mad at me. So I got my laws passed in that session of the
> legislature. This was the only State Bar legislation which was passed.[76]

The committee, having successfully completed its mandate, became a
subcommittee of the State Bar Section of Corporations, Banking, and
Business. In 1968, having served for ten years as chair, Amsler stepped
down from that post, but continued to serve as a member.

The Texas Married Women's Act

By 1963, Amsler was ready for a new project. The one she took on was not
entirely of her own choosing; she was pressed into service to help draft
and enact a set of statutes designed to obviate the need for an Equal Rights
Amendment to the Texas Constitution. Since her participation in this
endeavor was vigorously denounced by advocates of the ERA, it is appro-
priate to consider her reasons for undertaking it.[77] In her article on the
act, she explained that the Texas legislature had enacted a bill in 1913 to
remove the disabilities imposed upon married women by virtue of the
marriage, but the governor found it "entirely too radical" and strenuously
objected to its provisions and a greatly watered-down version was
enacted.[78] Fifty years later, the legislature enacted, and the governor
signed H.B. 403, a bill co-authored by Margaret Amsler and her colleague,
Angus McSwain, titled "An Act to remove the disabilities of coverture of a
married woman in connection with her contracts and her management
and control of her separate property."[79] Amsler wrote:

> During recent years, the abolition of the fictional incapacity which attached
> to a woman in Texas as soon as she married has been a primary legislative
> goal of the Texas Federation of Business and Professional Women. In

testimony presented before various House Committees during the last session of the Legislature, leaders of the movement pointed out that their first attempts to change the legal status of married women were made in the form of bills amending or repealing the existing laws. These bills, apparently, were met with legislative indifference. Frustrated in this procedure, the leaders then determined to force the desired changes through an amendment to the Texas Constitution, the so-called 'Equal Rights for Women' amendment. . . .

At this point, many members of the Bench, of the Bar, and of the Legislature became alarmed. Their deep concern was based on their conviction that the proposed amendment would not actually accomplish any of the desired changes, but that its consequence would be to throw the entire law of domestic relations into chaos.

Consequently, it was determined that it was no longer enough to say that the constitutional resolution should be defeated because the desired results should be accomplished by bills; there should be some bills. And so, Professor McSwain and the writer drafted the bills, secured the legislative sponsors, and appeared before the legislative committees to explain them. The cordiality with which they were received and treated by the Legislature indicates that that body is ready, willing, and able to do away with ancient injustices.[80]

Proponents of the Equal Rights Amendment, however, were not satisfied with the Texas Married Women's Act as a statutory solution to the obstacles facing women. As Hermine D. Tobolowsky put it in a published debate with Margaret Amsler in the *Texas Bar Journal*,

Opponents of the Amendment claim that present discriminations in the law can be corrected by statute and hence the Amendment is unnecessary, but the experience of those attempting to change the laws—an attempt which has been fruitlessly pursued since 1913—has been that where one Legislature broadens the rights of women, a following Legislature will undo everything that has been done to benefit women, nor do proponents of the Amendment consider that the 58th Legislature accomplished much, if anything, to correct the situation [by enacting H.B. 403—ed.].We have repeatedly stated that it is our objective that every law in the state of Texas shall apply in exactly the same manner to women as it does to men.[81]

In the end, both sides prevailed. Amsler's Texas Married Women's Act was enacted in 1963, but the Texas Equal Rights Amendment was adopted in 1972 in a special session called on the final day of the Regular Session.[82]

Amsler was unperturbed, remarking that "they ultimately got it, but at a time when it wouldn't do any harm. It didn't make the law more uncertain."

Governor John Connally appointed Amsler to the Texas Commission on the Status of Women in 1967.[83] She was named chair of the committee on Labor Laws Affecting Women. She had an explanation of why no legislation ever emerged from the Commission's work:

> Most of the women on the Commission came in convinced that women were discriminated against. . . . But it was upsetting to me, as I say, to find that a good deal of the Commission's time was devoted to finding fault with men. And I'd always liked men.
>
> I found myself, usually, on the losing side. I was considered an 'Aunt Tom.'[84]

"Aunt Tom" or not, Amsler's role in removing the legal disabilities of married women, by giving the wife the same freedom as that of her husband in the management and control of her separate property and allowing her to sell and transfer her separate property without his advice and consent, was a significant contribution.

Amsler's Role as Faculty Secretary

Unlike Daggett, who regularly attended the Annual Meetings of the AALS, and who served on the 1951 Round Table Council on Family Law, Amsler was not active in the Association. Faculty business was conducted informally at Baylor in Amsler's day. As Secretary to the Faculty she recorded the events that took place:

> I took minutes of the meetings. I think, until I became secretary, we didn't have a secretary. The faculty just met and made decisions. I kept the full minutes and supplied the official record.

Amsler's colleague, Ed Horner, who joined the Baylor faculty in 1948, recalled that she served as faculty secretary for twenty-five years. John Wilson, who also came to Baylor in 1948, thought the role was demeaning:

> Margaret was a hard worker. They treated her about like the Librarian, at times. They treated her with respect, don't misunderstand, but as far as recognizing the things she did and the grace with which she did them. . . . For instance, Margaret accepted this, and nobody ever said anything about it,

but the fact is that when we meet in the faculty, who keeps the minutes but Margaret? 'Prune Danish, please!' And Margaret never made an objection.

Her student, Angus McSwain, who joined the Baylor faculty in 1949 and became Dean in 1965, in retrospect was somewhat apologetic about this assignment:

> She was the secretary of the faculty as, perhaps unjustly, women were expected to be at that time. If there was a woman in the group on a committee, why, she would be the secretary. Anyway, Margaret did that and did it very well without complaint. Looking back on it now, I appreciate it more probably than I did at the time.[85]

Be that as it may, neither Barbara Armstrong nor Harriet Daggett ever served as secretary to their respective faculties. Amsler's duties in this regard were not unusual for a member of the faculty at the time, and her having done so does not appear to have diminished her influence as a member of the Baylor faculty in any significant degree. The only unusual aspect of her role was its uninterrupted duration throughout her career.

Retirement

Margaret Amsler retired from Baylor in 1972 after thirty-two years, "the longest full-time faculty tenure in the school's history."[86] Her students conferred the Baylor Professor of the Year Award upon her at her retirement, and in a moving tribute dedicating the Spring 1972 issue of the *Baylor Law Review* to "Lady A," made clear their gratitude and sense of indebtedness to her:

> Such are the fruits of her labors. She has earned her retirement. She will be missed at Baylor Law School and new students will miss the privilege of knowing her and studying with her. Her service to the legal profession, and to law students in particular, will be long remembered and appreciated. Her influence in the profession she loved will be felt for decades to come.[87]

Amsler retired in 1972, but she did not slow down. Instead, she resumed the practice of law with her husband. McGregor was a small town, and they were the only two lawyers in town, so they did practically everything.

Her activities with the State Bar of Texas continued, as well. She remained on the Corporations Committee as an emeritus member until around 1986. In 1977, she was appointed to the Board of Law Examiners for a two-year term. That was more than long enough; the position required her to grade 2,300 bar examinations each year. At the end of her term, she refused to be reappointed: "I told Judge Greenhill [then Chief Justice of the Texas Supreme Court], 'No more. This is no way to spend my golden years.'"

Amsler's outstanding position among Texas lawyers, as well as the many "firsts" she had achieved throughout her career, was recognized by her election in 1987 to the Texas Women's Hall of Fame.[88] In the same year, she received a Fifty Year Certificate from the State Bar of Texas Association.[89]

Sam Amsler died on November 11, 1990, thus ending the law partnership (and the marriage) of Amsler and Amsler. Rikki moved in with her mother after Sam died.[90] In 1995, however, Amsler suffered a "massive stroke" the week before Thanksgiving and spent the last seven years of her life in a nursing home, comatose and unable to speak. She died on Tuesday, May 14, 2002, a month and a day before her ninety-fourth birthday.

CONCLUSION

Margaret Amsler played a crucial role in my own decision to go to law school. Her daughter, Rikki, and I were classmates at Southern Methodist University from 1952 to 1956. At my mother's direction, I enrolled in courses in elementary education, to prepare for a future as a teacher. As it happened, I was also enrolled in a course in Western Philosophy. The contrast in content and intellectual challenge between the courses was more than I could bear. I had long telephone conversations with my mother telling her that I wanted to drop elementary education and major in English and Philosophy in preparation for studying law. She was adamant: women needed to be able to support themselves, she told me, so they would not be dependent on their husbands. Women could not make a living as lawyers. I should train myself to teach grammar school, just as she had done.

In the midst of this quandary, Rikki invited me to go home with her for the weekend. Two days with Margaret Amsler was all it took for me to reject my mother's advice. Here was a woman who was *both* a lawyer and a law professor! I could go on with my dreams of a career in law. I reminded Margaret of her advice when I interviewed her in 1990. I said, "Unlike my mother, you seemed to think there was no problem with women being lawyers or law professors." She replied, "And there wasn't, was there?" As it turned out, at least for me, there wasn't.

Barbara Nachtrieb Armstrong, Harriet Spiller Daggett, and Margaret Harris Amsler were the only women law professors teaching full time before World War II in schools that were ABA-approved and AALS members. While each was aware of her unique position within her own faculty, none put great emphasis on it, nor did any of them reach out to the others of whom they had heard. Like many of the women who entered the legal profession as practitioners in the United States in the late nineteenth and early twentieth centuries, they preferred "to forge a 'professional identity' as lawyers." Thinking of themselves "as *lawyers* rather than *women,* they claimed the right to practice law as *professionals,* without regard to either gender or the broader goals of women's equality."[91]

The male faculty at LSU and Baylor who spoke about the matter uniformly insisted that Daggett and Amsler were not unusual. Instead, they perceived that their women colleagues were treated just like "one of the boys." Jean Craighead Shaw, who was Mrs. Daggett's student in the late 1930s, did not disagree:

> Fiercely competitive, Harriet Spiller Daggett asked for no quarters because she was a woman and met the male on his own ground. She had no doubts about her ability in the field of law. Whining about being treated differently because she was a woman was completely foreign to her nature and she was accepted by her male colleagues as being a very competent member of the legal profession. Sometimes she was described as the best 'man' on the LSU law school faculty.[92]

Margaret Amsler was in no sense an outsider at the Baylor law school. Undoubtedly, her very presence there "challenged male exclusivity," but she did so with the support of two of the most powerful men at Baylor: her

father, a respected member of the law faculty, and the president of the
university, who thought of her as a "daughter" because of his close friend-
ship with her parents. She knew that faculty women at Baylor held posi-
tions of leadership in other departments and felt completely comfortable
as a member of the law faculty and as Acting Dean after World War II.

Amsler denied that she had ever experienced discrimination because of
her sex:

> I can honestly say that I have never felt any discrimination, except a dis-
> crimination in my favor. I think, for example, during my years [teaching] in
> law school that I was treated with more courtesy and affection than some of
> the men.[93]

Armstrong, Daggett, and Amsler all came from families that valued
education and expected their daughters to be educated. Each made her
way into law teaching by different paths and for different reasons. In their
various and individual ways, each of the three first women law professors
fit Mary Jane Mossman's assessment of the situation of the first women
lawyers:

> The rhetoric of equality tended to emphasize the opening up of opportuni-
> ties for women in relation to higher education, paid work and the profes-
> sions, but it did not encompass more fundamental reforms, including the
> transformation of relationships between women's work and their family
> responsibilities. In this context, advocates of women's equality argued for
> women's admission to the legal professions 'on the same terms as men;' their
> goal was to overcome women's exclusion from law and the legal professions,
> and they trusted that professional ideas about merit would ensure equality
> of opportunities for women in law. Clearly, however, such a concept of
> equality did not fundamentally challenge traditional ideas about either gen-
> der or professionalism.[94]

The situation of working women, including professional women,
changed greatly in the post-war years. Although the careers of all three of
these first women law professors spanned World War II, the social,
economic, and cultural forces that shaped their development were pat-
terned on pre-war attitudes and practices. The transition to a different

understanding of the role of the woman law professor began with Soia Mentschikoff, whose pivotal career began in 1947, encompassed positions at three law schools, and took her to the highest national ranks of professional recognition and accomplishment. She is the fourth of the early women law professors, and chapter 3 explores her story.

3 The Czarina of Legal Education

SOIA MENTSCHIKOFF

Soia Mentschikoff never wanted to be thought of as a "woman" law professor, but nonetheless—for a time at least—she changed the way everyone else in legal education thought about women law professors. She emerged from one of the nation's most elite law schools, was the first woman professor at two others, and ended her career as the first woman dean of a school whose standing she greatly improved. Operating on a national stage, she became the first woman president of the Association of American Law Schools. Yet her reputation and influence far exceeded her measurable performance in scholarship and teaching. One of her male colleagues at the University of Chicago Law School told a reporter that "[s]ometimes it was hard to link up her actual accomplishments on a day-to-day level, with the power of her persona."[1]

Everyone knew her simply as "Soia," although she was married to one of the country's leading legal realists, Karl Llewellyn, a man many thought a genius, who had been her professor at Columbia. And everyone did either know her or know of her. She is the only one of the fourteen early women law professors whose name was familiar to every one of the more than 175 legal educators interviewed for this book. In the memorable phrase of her junior colleague at Chicago, Frank Zimring, she was "the first woman

69

Figure 5. Soia Mentschikoff. Courtesy of University of Chicago Law School.

everything."[2] Yet this characterization of Soia's career is not fully accurate: Barbara Nachtrieb Armstrong, not Soia, was the first woman law professor, and Miriam Theresa Rooney, not Soia, was the first woman law school dean. Still, her pre-eminence remains unchallenged, her status perhaps most aptly captured by the name given her by her Miami law students: "The Czarina."[3]

FAMILY BACKGROUND

Soia Eugenia was born in Moscow, Russia, on April 2, 1915. Her father, Roman Sergie Mentschikoff, a US citizen, had emigrated to America with his father, identified in an obituary by the *New York Times* as Prince Sergei Mentschikoff, and was raised in Milwaukee, Wisconsin.[4] Her mother, Eugenia Ossipov, was born in Russia to an aristocratic White Russian fam-

ily and was a devout member of the Russian Orthodox Church.[5] They settled in California, but returned to Moscow, where her father worked at the time of Soia's birth and that of her younger brother, Alexander. The family was forced to flee in 1917 to escape the Russian Revolution; they were among the last group of Americans to leave Moscow.[6] They went briefly to Sweden before settling in New York City when Soia was three years old.

EDUCATION

Soia attended public schools in New York and was allowed to skip several grades. In 1930 she entered Hunter College, which at the time was a public school for women only, at the age of fifteen. At Hunter, Soia was an exceptional student who not only was elected president of the junior class, but also played on the successful Hunter varsity basketball team in 1932–33.[7] Her academic record earned her a fellowship to Columbia Law School.

Columbia, which had enjoyed a reputation as the nation's "leading law school" from the post–Civil War period through the 1870s, was "ultimately overshadowed by the rise of the Harvard Law School in the decades after 1870."[8] Columbia had first admitted women law students in 1927, but, as Dean David W. Leebron remarked at the school's seventy-fifth anniversary commemoration of that event, "it did so in about as grudging a fashion as one might imagine."[9] Barbara Aronstein Black, Columbia's first woman dean, put the matter more simply: "Columbia Law School opened its doors to women. It was to be some time before it opened its heart to us as well."[10] Soia's entering class had 254 students, of whom eighteen were women.[11] Early in her first year, Soia began attending the weekly "open house" for students held by Professor Karl Llewellyn and his wife, Emma Corstvet, and she became Llewellyn's research assistant during her second year.[12] As his assistant, Soia "had her own desk in his office at the law school . . . [and a] friendship soon developed" between them.[13] They kept in touch after her graduation, and, in 1941, he sought her help with the work he was doing on the proposed Uniform Commercial Code Project of the National Conference of Commissioners on Uniform State Laws (NCCUSL).

WALL STREET LAWYER

After earning her LLB from Columbia in 1937, Soia was admitted to practice in New York the following year. Scandrett, Tuttle & Chalaire offered her a position as an associate, which she accepted. In 1941, Soia left Scandrett and became general counsel for one of her clients, Cora Scovil, who owned a mannequin company.[14] Six months later, she returned to Wall Street because the company was about to go out of business.[15]

Soia joined Spence, Windels, Walser, Hotchkiss, Parker & Angell in 1941 as an associate. The same year saw her "first accidental involvement" in working with Karl Llewellyn on the Uniform Revised Sales Act:

> In 1941 I drifted over to Columbia just as Karl was finishing a draft to take to the 1941 meeting of the Commissioners. Because we worked on the warranty article and I had been his research assistant four or five years before, he said, 'I don't have time. Why don't you do these warranty points?'
>
> And I said, 'Well, how much time we got?'
>
> He said, 'We got about three days'. . . .
>
> When he came back [from the meeting] he said . . . 'It looks as though the American Law Institute may get interested in this and that there may be some money for the drafting and completion of the Uniform Revised Sales Act, and if there is, would you be willing to come and work on it?'[16]

In 1942, NCCUSL and the American Law Institute (ALI) obtained the necessary funding for the work.[17] Soia was named Assistant Reporter and took a four-month leave from her law firm to do the work.[18]

In 1944, Soia's work on the Sales Act was completed, and she continued to practice with the (renamed) firm of Spence, Hotchkiss, Parker & Duryee. In 1945, Spence, Hotchkiss promoted her to the partnership level, thus making her the first woman partner in a Wall Street law firm. A decade would elapse before another woman reached that rarified level of practice.[19]

PERSONAL LIFE

Soia married Karl Llewellyn, in 1946. She was his third wife.[20] Professor Robert Whitman states that "[a]t some point, while Karl was still married . . . a love relationship developed between Soia and Karl; neither

Soia nor Karl ever openly spoke about the subject of their relationship before their marriage."[21] Soia wrote to Karl in 1946 about the matter, stating her intention to break off their relationship:

> What you offer is that if you get hit, despite your best efforts, with a divorce, you are prepared, if it would give me any pleasure, to marry me. It is not a flattering offer. It has, however, the great virtue of candidness. You must see though that it is not one that I can accept without losing my own self-respect. And marriage without self-respect, like one without love, is built on sand.

Karl's divorce took place several months later, followed by the marriage of Soia and Karl on October 31.[22] She was thirty-one; he was fifty-three.

Soia and Karl were legal education's most prominent, if not its first, dual career academic couple.[23] Like many other such couples after them, one of their most pressing problems was to find suitable jobs in the same geographic area. None of the major East Coast law schools had yet hired a woman law professor, and, at any event, university nepotism rules were believed to prohibit the appointment of a husband and wife to the same faculty. Soia was still a partner at Spence, Hotchkiss and most likely could have remained there. By 1946, however, she had been named Associate Chief Reporter for the UCC and both she and Karl, who was the Chief Reporter, were deeply enmeshed in the drafting and presentation of the emerging drafts to the NCCUSL and the ALI. An academic position offered a better accommodation for such sustained law reform efforts than the practice of law. But it was not until 1951 that the "good lawyering" of Dean Edward Levi and his creative faculty at the University of Chicago succeeded in making appointments available to both. Before that development occurred, Soia had been offered a permanent position at Harvard, while Karl remained on the faculty at Columbia.

HARVARD'S FIRST WOMAN LAW PROFESSOR: "A MARRIAGE, NOT A CASUAL AFFAIR!"

The UCC project not only brought Soia and Karl together again, it also brought Soia to Harvard. Erwin N. Griswold, who had become Harvard Law School's dean in 1946, was a member of the ALI Council and had

watched Soia present drafts of the Code over a number of years. Dean Griswold took from it an astonishing conclusion, which he revealed in conversation: Soia could spend all day in a room full of men, focusing on the topic at hand, and nobody would think anything disruptive had occurred. She would just be taken for granted.[24] Putting this conclusion together with his own view that Harvard Law School would probably admit women students after the end of World War II, and that the appointment of a woman to the law faculty would be an opening wedge in making that transition happen more smoothly, Dean Griswold called on Miss Mentschikoff in her Wall Street office and offered her a position at Harvard. She was appointed as a Visiting Professor on November 4, 1946, four days after her marriage to Karl Llewellyn. When asked whether she had been a regular member of the Harvard faculty, Dean Griswold provided the following explanation in a letter: "At that time, I do not think that the concept of 'tenure track' had been developed to quite the extent it has now. There is no doubt, though, that Soia was appointed with the hope and expectation that she would become a permanent member of the faculty of the Harvard Law School.[25] The letter included a handwritten note: "I well remember my trip to New York and my call on Soia at her office. This was looking for a marriage, not a casual affair!"

Soia's appointment attracted immediate media attention.[26] In an interview she gave to the *Chicago Daily Tribune* in 1947, Soia was asked about opportunities for women lawyers. Although she was a bit more forthcoming on the subject than she was later on, her response foretold her firm conviction that women needed no special help to succeed at the bar: "Law is still a difficult field for women," says Miss Mentschikoff, "but there are more opportunities now, because the women who go into law today are normal, well-rounded women whose stability, efficiency, and talents equal those of their male colleagues."[27]

Given the attention paid to Soia's appointment by the media, the Harvard law students were eagerly anticipating her arrival. B. W. (Bill) Nimkin described his experience as a student in her first Sales class in the fall of 1947:

> She had not only an expertise in Sales, but she had some very novel ideas
> about how to teach the class. . . . She divided the class into teams of four to

six on each side, and we would prepare arguments and negotiate about the client's needs and goals.

The 'client' was Karl Llewellyn; he came to her class and acted the role with much verve. I remember vividly his performance as a liquor distributor. . . . He acted very gruffly. He'd say things like, 'That's the stupidest question any lawyer has ever asked me.' Or, 'What do you want to know that for?' The class was really quite amused, as was intended.[28]

The Harvard faculty invited Karl Llewellyn to come to the law school as a Visiting Professor. During the fall of 1948, he and Soia both taught separate sections of the Commercial Law course. Their experiences were very different: Soia won the respect, even the love, of her students; two-thirds of Karl's students dropped out of the class in protest of his teaching.

Jerry Shestack recalled that "[i]t was not long before a love affair developed between Soia and my class at Harvard" and went on to describe her mentoring of them:

From the outset, Soia was involved in our lives—guiding us in career choices, reassuring us, helping us overcome a bad love affair, helping us overcome even a good love affair. Most of us were veterans of World War II. Still, we needed her clear insight, her sure sense of the person she was advising, her calm faith. She gave us strength and repose.[29]

By the spring term of 1949, the Harvard faculty was prepared to give Soia a tenured professorship. They were not, however, prepared to do the same for Karl. Dean Griswold explained in a letter what had happened:

There is no doubt in my mind that there was strong hope and expectation on the part of responsible people at the Harvard Law School that Soia would become a permanent member of the faculty. The problem arose because Karl Llewellyn was brought as a Visiting Professor for the year 1948–49, and Soia and Karl were married during the course of that year. For reasons too complicated to describe here, Karl was a disaster as far as the Harvard Law School was concerned.[30]

After Griswold wrote this letter, Professor Robert Whitman published an article describing Soia and Karl's move to the Chicago Law faculty, in which he commented in a footnote: "It is generally acknowledged that Karl Llewellyn had a drinking problem. . . ."[31] Dean Griswold wrote a

second letter, dated November 11, 1992, enclosing a copy of Whitman's article and expanding his earlier account of his discussion with Soia:

> In my previous letter, I did not mention alcoholism, because I did not want to spread this about. However, as it has now been mentioned in this article, I will say that this was the basis for the complaints from students which I received in the spring of 1949. The situation was made more difficult, of course, because Soia Mentschikoff was a respected member of the faculty.[32]

So it was that Soia and Karl left Harvard at the end of the 1949 spring term. Apparently, they next sought an appointment for Soia to the Columbia faculty, but without success.

A HOME ON THE MIDWAY: SOIA (AND KARL) AT CHICAGO

The University of Chicago Law School was one year shy of the fiftieth anniversary of its founding when Soia and Karl joined its faculty in 1951, he as a professor, she as a professorial lecturer. At the time, Chicago was a strong regional law school, with ambitions to become a national law school.

Soia was not particularly enthusiastic about the prospect of moving to Chicago. She told an interviewer, "I was a provincial New Yorker." But, as she went on to explain, "Llewellyn knew what I didn't know—that Hutchins [the president of the University of Chicago] had put together what was at that time the best university in the country—small but elite."[33]

Initially some members of the Chicago law faculty were no more willing to take Soia in order to get Karl than the Harvard faculty had been willing to take Karl to get Soia. Professor Walter Blum recalled the situation vividly:

> A number of my colleagues were concerned that our interest was really only in Karl and that Soia was kind of auxiliary baggage. . . . But as we looked into the matter more, there was an increasing amount of evidence that Soia might be the more important person of the two for our faculty at that point.[34]

Once the decision was made to hire both Soia and Karl, the only remaining obstacle was the university's nepotism rule. Blum remembered that they had solved it by "creative legal thinking: the nepotism rule had a

technical loophole and I believe we sailed through that loophole." This was done by making Soia a research associate, with a rank of full professor. In the end, the Chicago law faculty was proud of its success in doing what (they thought) Harvard and Columbia had been unable to achieve. As Bernard Meltzer put it, "Everybody viewed the arrangement as a way of solving, or out-flanking, the problem created by nepotism."

CLASSROOM TEACHING

In 1951–52, Soia taught a six-unit sequence in Commercial Law Practice. Jean Allard, then a second-year student, took the course:

> I will say very quickly that she was a terrible teacher in the classroom and a marvelous teacher outside of the classroom. She was very disappointed at the level of involvement of the younger Chicago law students in terms of their lack of understanding of business transactions. . . . I think it forced her into a kind of artful teaching at Chicago that she didn't have to do at Harvard and hadn't experienced as a student at Columbia, that had to be transactional in its orientation.[35]

Mary Ann Glendon, who was the first woman law professor at Boston College School of Law, took Soia's Commercial Law class in 1959; like Jean Allard, she was not impressed:

> I did not perceive Soia as a great teacher. . . . She did not seem to be very well prepared. . . . [However,] I took a lot [of classes] from Llewellyn. He was, on one day out of three or four, brilliant; and on the other days, often pathetic. . . . But there were certain days when you knew that you were in the presence of one of the great legal figures of all time.[36]

OUTSIDE THE CLASSROOM

Soia and Karl continued the practice of hosting weekly "open houses" for Chicago students that Karl and his former wife, Emma, had established earlier at Columbia. The gatherings gave them an opportunity to provide informal mentoring. Edward Levi recalled that "Karl delivered some of his

best lectures at those events, in an informal way. The students would get him going, and he then would take a part of the history of something— usually in the commercial law field—and he had such a range of knowledge and the ability to put it forward. He was quite a raconteur."

The "love affair" that Jerry Shestack described between Soia and the Harvard Class of 1948 was not replicated at Chicago, although Jean Allard reported that Soia had "law students who were abjectly loyal to her." Soia did have a special insight about how women lawyers should present themselves to their professional colleagues, which she freely communicated to her women students. She saw the way they dressed as a central ingredient in how they could succeed in a man's world. Jean Allard recalled:

> In 1951 and 1952, when I was doing Moot Court and Law Review and all that kind of thing, I was wearing kind of glen plaid suits. Soia said to me, 'Why do you dress that way?' I said, "Because I thought that's how lawyers were supposed to dress." She said, 'We don't do that in New York. We wear basic little simple black silk dresses and white collars.'

Soia gave the same advice to Lillian Kraemer in 1963 when she was experiencing difficulties getting a job. "From that day to this," Lillian Kraemer noted, "I have never interviewed in anything other than a black dress and a small silver pin, and I have never not gotten an offer since that time."[37]

Apart from counseling her women students not to dress like men, Soia displayed no particular interest in otherwise acting as a role model for them. Martha Field, who was the first woman law professor at the University of Pennsylvania Law School, had been a 1L at Chicago in 1965. She took Elements of Law from Soia, who terrified" her:

> She was scary, and I did not respond well to being terrified, but other students did. She would call on you—most teachers did at that time, and we resented it less than students do today—and she expected you to say things absolutely correctly. . . .[38]

As to her acting as a role model for women, Field commented,

> I don't think Soia was any closer to the women students than she was to the men students. I don't think she thought of herself particularly as a role model for women.

FAMILY LIFE

Soia and Karl never had any children together. Karl and his first wife had adopted a son, Adam, who after the divorce saw his father infrequently. At the time they moved to Chicago, Soia's parents, known to everyone as "Mama Toy" and "Papa Toy"—the names given to them by their grand-daughters, after the gifts they brought when they came to visit—and her brother Alexander's two daughters, Sandy and Jeannie, were living with them. Edward Levi recalled,

> We had found them the perfect house, we thought, for two people. They scoffed at the idea of an eight-room house and proceeded to buy one almost three times that size and moved in Soia's parents, two nieces, two cats, and a miniature poodle named Happy. Every day we could see Soia clad in her usual slacks and sneakers followed by or chasing after a three-inch dog. One could tell from looking at them that they owned the world.[39]

Jean Allard explained Soia's approach to readying the new house for her extended family, and also her way of appropriating Jean as an "adjunct useful law student" to help out:

> The two nieces were young children, nine and seven, I think, who were mak-ing their home with Soia and Karl. It started out being summers, and then it was during the school year and they spent summers with their mother, who was divorced or separated from Soia's brother. I became very useful as an adjunct babysitter and someone to look after Mama Toy and Papa Toy, who were living on the third floor.

PUBLICATIONS

In addition to her work on the Uniform Sales Act, and drafts of Articles III, IV, V, and VII of the UCC, Soia's sole-authored publication list is comprised of one casebook, five law review articles, and several talks given as part of panels. The casebook, *Commercial Transactions: Cases and Materials,* was published in 1970, and was the book she used in her course at Chicago.[40]

Soia's co-authored work was primarily done with Professor Ernest Haggard, a member of the Chicago Department of Psychology who

worked with her on the arbitration project and who later followed her to Miami, and Professor Irwin P. Stotzky, whom she brought to Miami as one of her initial hires as dean. Her colleague, Walter Blum, described Soia's working relationships with collaborators:

> Soia was very good in having a retinue of people around her: it was like an army. They were the junior members in her enterprises. She had a wonderful ability to get them to do the work that normally you would think she was about to do. She would pass it out, and then, when the work product came in, Soia would make it into her own. Her imprimatur was on it.

LAW REFORM

Soia's life-long involvement with the Uniform Commercial Code began in 1942, with her appointment as Assistant Reporter of the Uniform Revised Sales Act. The basic draft was produced between January and May 1943. By September 1943, Soia as Associate Reporter presented the "eighth or ninth full draft of Article 2 of the Code, then called the Uniform Revised Sales Act" to the Commissioners. It was presented to the ALI Council in 1944. Soia offered a candid description of what she saw as her "great utility in the drafting of the Uniform Revised Sales Act:"

> I came to sales completely innocent. . . . That was my great utility in the drafting of the Uniform Revised Sales Act, because if I understood it, everybody could understand it. . . . We never sat around asking, 'What are we going to do to change the law?' because we couldn't have cared less. We wanted to do something that was sensible. If it was sensible, great; it made no difference. That's the history of the Code.[41]

In 1946, Soia was named Associate Chief Reporter for the UCC, to work directly under Karl, who was the Chief Reporter. She continued to hold that position until 1962, when she became a Consultant to the Permanent Editorial Board for the Code.

In his memorial tribute to Soia, Professor Irwin Stotzky summed up her work on the Code in a single eloquent sentence: "She help[ed] Karl Llewellyn draft and push through the legislatures in almost every state in the country the most significant statutory enactment in the history of American law—the

Uniform Commercial Code."[42] Soia herself insisted in an interview that "[i]t was Karl's code. There were thousands of people that worked on it in the sense that everyone got listened to. But in the actual drafting there was nobody else."[43] Even so, there is no doubt that it was Soia's statute: after the Code had been approved by the Commissioners on Uniform State Laws and the American Law Institute in May, 1950, she took the lead in coordinating the immense effort that culminated in securing the state-by-state enactment necessary to turn the Code into a true "Uniform" Commercial Code.

The Code was first enacted in Pennsylvania in 1953.[44] Four years went by before the second state to enact the Code, Massachusetts, did so on September 21, 1957. The struggle for the Code's enactment in New York began in 1953. Bill Nimkin, who had been a student of both Soia and Karl at Harvard, was a member of a committee of The Association of the Bar of the City of New York, which was following the Commission's work closely. He described what had happened behind the scenes:

> It was one thing to write the Code and sell it to the Commissioners' Advisory Committee and the Council of the ALI. It was another thing to get these conservative bank lawyers to support it and to accommodate to it.... A group representing the New York Clearinghouse Association—the bank law-yers' group—broke off; they wrote a very hostile and critical report.... There were many negotiations at all levels, including Llewellyn and Mentschikoff and others.... A very elaborate compromise was worked out.... [T]he Code was then approved in New York with amendments embodying the compromise, with the support of the Clearinghouse and other bank lawyers.
>
> After that happened everybody else fell into line. There were maybe ten or twenty states that had adopted the Code before New York. But after New York, it was adopted in every state except Louisiana, with the New York amendments. States that had adopted it earlier reenacted it, so that—with the exception of a few odds and ends—the New York version became the official version.

FAMILY LIFE

Karl Llewellyn died suddenly on February 13, 1962. He and Soia had been at the home of Edward and Kate Levi for a dinner party. Toward the

end of the evening, Karl said he was going home. Soia stayed on and "chit-chatted" with the Levis for a while. Then she went back home, where she found Karl in bed. He had died, apparently of a heart attack. Soia was "stunned, horrified." She immediately called the Levis, who "raced down there," and stayed with her until the undertaker came.

Jean Allard confirmed the effect of Soia's religious faith on her response to Karl's death:

> She was totally devastated by his death. She grieved in the real, almost pathological way, until forty days and forty nights had passed, and the Russian Church told her she didn't have to grieve anymore. . . . She was almost sick with grief.

Soia spent the summer after Karl's death in Europe. She invited Mary Ann Glendon, then in the second year of her Chicago LLM program, to accompany her to the French Riviera:

> On the Riviera she dressed; she had a white dress. She would walk into a restaurant with her little white poodle under her arm, and she had a wonderful bearing. People would think she was royalty. She certainly knew how to do it if she wanted to.

Soia continued to live in the family home on Kimbark Avenue with her mother and two nieces. In autumn of 1963, Lillian Kraemer moved in as a self-invited, impromptu guest. She explained,

> At the beginning of my third year, I had come back from my summer job in New York, and my then-husband with whom I was not getting along terrifically well had stayed in New York. . . . I felt very disoriented and confused. When school started, I went to see Soia to say 'hello'. . . . All of a sudden, without having any idea that I was going to say it, I said, 'Oh, Miss Mentschikoff, can I come live with you?' . . . She said, 'How long will it take you to pack your bags? Can you move in this afternoon?' . . . In November, Mary Ann Glendon came back from her second year in the Master's program in Europe, and she moved in as well.

Glendon had come back to Chicago in November, 1963, to look for a job. Soia said, "Why don't you stay at my house while you're looking?" She became friendly with Mama Toy:

Soia's mother liked to go to the Russian Orthodox Church, which was way over on the west side of Chicago. Soia didn't like to drive her out there on Sunday morning, and I was willing to do that. Soia was always one for deploying her human resources.

PROFESSOR MENTSCHIKOFF, 1962-74

Soia was listed in the 1962–63 *University of Chicago Announcements* as "Professor of Law." One of the stories that has persisted about this change in Soia's academic status is that it did not occur until after Karl died. In fact, as Provost Gerhard Casper wrote in a letter, her new appointment had been approved prior to Karl's death: "[Dean] Edward Levi, in November 1961, requested that her appointment be converted to a tenured professorship, effective 7/1/62. This was done *before* Karl's death. . . . Karl died on 2/13/62."[45]

Soia taught a regular load at Chicago during 1962–63. Frank Zimring, who had been appointed an Assistant Professor in 1967, gave a description of working with Soia during his early years on the faculty:

> I liked Soia enormously, and she liked me. . . . She was socially and personally enormously generous. She had essentially a bimodal distribution of people. You were either in her Pantheon or not; and I spent my time comfortably in it. She is the only colleague I ever had who pinched me on both cheeks.

In the mid-1960s, Soia began accepting external professional commitments. In 1964, she was a member of the American Delegation to the International Sales Convention at the Hague. In the same year, she joined the American Society of International Law, and remained a member until 1968. In 1965, President Johnson appointed her to the Council of the National Endowment for the Humanities; she served until 1971. Also, in 1965, she was appointed to the National Advisory Commission on the OEO Legal Services, serving until 1967. She spent four years, from 1965–69, on the Executive Committee for the Council for the Study of Mankind, an organization of educators and scholars based in Santa Monica, California, who, in association with civic, professional, and business

leaders, sought to further a new approach for helping to find solutions for the problems facing mankind. In 1966, Illinois Governor Otto Kerner appointed her to NCCUSL as a Commissioner from Illinois; she served until 1970. She also became a Council member of the ABA Section on Individual Rights and Responsibilities and a Director of the National Legal Aid and Defender Association, both in 1966. In 1972, she became the first woman Trustee of the RAND Corporation.

Soia's interest in innovative legal education attracted her to the Antioch Law School, an experimental law school established in Washington, DC by Edgar S. and Jean Camper Cahn in 1972. The Cahns pioneered a model of comprehensive clinical education in which students dedicated to public interest advocacy would both learn the law and practice with their teacher-lawyers as a public interest law firm representing the poor and disadvantaged population of the District of Columbia. The law school was affiliated with Antioch University in Ohio, which had long been a leader in educational innovation. Soia became the advisor-counselor for the Cahns in their bid for Antioch's ABA accreditation. Mike Cardozo, who at the time was Executive Director of the AALS, advised Jean Cahn on the accreditation process. He recalled their appearance before the Council of the ABA Section on Legal Education and Admissions to the Bar:

> In those days, there was no separate ABA Accreditation Committee. The visiting committee made its report directly to the Council. Jean and Edgar Cahn were there, and they had brought Soia as their counsel and spokesperson. It was a difficult meeting. Antioch had been set up as an unusual law school without course names, so they didn't have a course in contracts, for example. Soia was trying to convince the Council that it was all right. And as a matter of fact, they got through. They were provisionally approved and held their first class in 1972. And it was certainly Soia who put it over.[46]

Beginning in the late 1960s, Soia regularly spent time in Florida to seek refuge for her ailing mother from the bitter Chicago winters. She gravitated to the University of Miami Law School, where the Bulletins regularly listed her as an "Associate of the Faculty and Consultant on the Law and the Poor Program" during the years 1969 through 1973.[47] She bought a house for her mother there and relied on a combination of paid caregivers and friends from Miami to look after her when Soia had to

return to Chicago to teach. Soia's mother died in Miami on December, 30, 1969. Her funeral service was held on January 2, 1970, in Chicago at the Russian Orthodox Church she had attended.

PRESIDENT OF THE ASSOCIATION OF AMERICAN LAW SCHOOLS

In January 1973 Soia became president-elect of the AALS, the first woman to hold the office. When she became president, Soia outlined two initiatives which would change the character and function of the Annual Meeting from being a "meat market" for hiring new faculty to becoming the scholarly arm of legal education. It was an inspired solution that has lasted to this day. For many years, as she pointed out, the Annual Meeting had served as "a medium for recruitment of the young into the teaching profession," resulting in a situation where a significant number of the faculty and deans in attendance spent their time in hotel suites interviewing faculty candidates, rather than attending the programs, panels and plenary sessions presented at the meeting. She had a proposal to offer:

> I am going to propose to the Executive Committee at its meeting in January in Houston that we separate the intellectual and scholarly nature of the AALS meeting from its recruitment function. What that means is that starting with a reception Friday night, sponsored by the Association, for new recruits and for such deans and faculty members as may come up to do the initial screening, a meeting be held in Washington for two days of interviews. . . . If we succeed in this it will be a great step forward. . . . The annual meeting is the place, if there is any place in the country, for the exchange of intellectual ideas.[48]

Looking back on Soia's accomplishments as President nearly twenty years later, Maurice Rosenberg agreed that this change in function had been "a big one: the meat market used to be held in conjunction with the annual meeting, and she put it in the November cycle."

Another initiative was to expand the Teaching Clinic, previously held only for new teachers in the summer before they began teaching, to provide additional clinics for experienced teachers who could share their experiences with each other and thus refine and expand on "the other area

in which we are unique: our knowledge about legal education." She saw this not only as a worthwhile goal in itself, but also as a way of responding more effectively to the efforts by bar associations and the judiciary to reform legal education that were "frequently based on a really rather severe lack of information about what is going on in legal education."

DEAN MENTSCHIKOFF

Soia became President-Elect of the AALS in 1973, while she was a member of the University of Chicago Law Faculty. By the time she made her first speech to the Annual Meeting in December, she had accepted the deanship at the University of Miami. President Maurice Rosenberg confided to the House of Representatives that he knew how it had happened:

> I happen to know how she came to be dean at the Miami Law School. . . . She made them an offer they couldn't accept. She went down there, she looked the place over, she said it needed this and that, and there were long rows of zeros after each this and each that, and she came back and said they couldn't possibly agree to that or this, and they did.

Nearly twenty years later, Rosenberg professed himself to have been "surprised" that she had gone to Miami. So were many of her friends and colleagues in the legal profession. Vice-President Delmar Karlen of the Institute of Judicial Administration wrote her on October 18, 1973, saying that he "never expected" to hear such news, and that had he known there was a "possibility" that she might be interested in becoming a dean, he "would have mentioned [her] name often and loud when occasion arose to suggest names for such posts."[49] Soia responded, "I do not intend to dean for more than 3–5 years because all that I have undertaken to do is to establish a base for 'greatness.'"[50]

The University of Miami Law School had been in an administrative turmoil since 1957. Between 1957 and 1974, when Soia arrived, the school had gone through three deans, two acting deans, an interim dean, and had endured incessant wrangling within the faculty.[51] Soia had been teaching there part-time. She'd teach at Chicago in the fall and spring, and spend the winter term in Miami.

Professor Daniel Murray, who chaired the search committee, credited his wife with the suggestion that they try to persuade Soia to accept the deanship:

> I couldn't think who to get as a candidate. One night at dinner, my wife said, 'Well, you've got a brainy woman on the faculty: Soia. Maybe you can't stand her, but why don't you have her?' I said, 'Well, that's a good idea.'[52]

A profile of Soia's years at Miami, published toward the end of her tenure in 1981, provided a significant bit of information affecting her decision to accept the Deanship:

> Before she would accept, she negotiated a contract with the President and the Board of Trustees that may prove to be one of her greatest coups. Miami is unique in that it is the only law school in the nation which operates on a three-year budget instead of the standard one-year budget. This enables the law school to meet fiscal practicalities while building reserves.[53]

Soia's "deal" became the subject of speculation and discontent around the campus. The Memorandum also provided that an addition to the Law Library, including faculty offices, would be built as rapidly as plans could be drawn and construction contracts signed. The projected cost of the addition was $1.2 million. Soia had already obtained a pledge from the school's most prominent patron, Baron de Hirsch Meyer, of $600,000. She told a reporter why she thought the project was essential: "No law school can possibly operate unless it has a first-rate library. That is, it can operate, but it's not good. I'll put it just that bluntly."[54]

Once her appointment as dean was announced, Soia set about recruiting "big name" faculty to come to Miami and hiring a group of bright young graduates to bring a fresh approach to the first-year curriculum. One of her first acts upon arrival at Miami was to hire a Miami graduate, Jeannette O. Hausler, as Assistant Dean for Admissions and Student Affairs. Jeannette was the first such dean appointed at the University of Miami and was the wife of Richard Hausler, one of the most respected members of the faculty.

"SNOW WHITE AND THE SEVEN DWARFS" AT MIAMI

The faculty that was in place in 1973–74 had spent most of its teaching career at Miami. The 1973 AALS Directory List of Law Teachers by Schools contains forty-one names for the University of Miami. One of the most unusual features of that list was that it contained the names of two women law professors who had begun their teaching careers at Miami in the late 1940s and early 1950s, a distinction that no other law school in the country could match. Both Jeanette Ozanne Smith and Maria Minnette Massey were Miami graduates who had finished first in their respective classes—Smith's grade point record was so high that it was not equaled for many years—and both had begun their careers as law librarians before joining the Miami faculty as full-time academics. Both were still on the faculty when Soia's arrival raised the number of women faculty at Miami to three.[55]

But by the time Soia had arrived in 1974, ten of the forty-one individuals on the 1973 list were no longer at Miami.[56] In their place, she recruited two professors from the Northeast and Midwest. Dr. Henry G. Manne left the Kenan Professorship at the University of Rochester to accept an appointment as Distinguished Professor and Director of the Center for Law and Economics, and Dr. Ernest A. Haggard left the University of Illinois Medical School to become Professor and Associate Director of the Center for Law and Psychiatry.

Soia also brought with her a gaggle of seven instructors, soon dubbed the "Seven Dwarfs," who served the purpose of introducing new blood into the first-year teaching staff without committing the school to giving them tenure-track appointments. Her plan was to recruit instructors from among new graduates of elite law schools, who would come to Miami for one-year terms, work with first-year students, and teach one course and a seminar.

Neither any of the new faculty, nor any of the "seven dwarfs," who joined Soia in Miami were women. Indeed, no women were tenured at Miami during her eight years as dean. Two junior women—both legal historians—were hired during that time at the initiative of the Faculty Appointments Committee: Barbara A. Singer in 1976, and Elizabeth B. Mensch in 1979. Neither became a permanent member of the faculty.

Soia did not advocate affirmative action as a tool for recruiting faculty. She stoutly defended the law school's practices in her 1975– 76 Dean's Report:

> The second [untrue] rumor is 'that the Law School does not go in for affirmative action.' It is true that we do not hire mediocre people simply because they are members of a minority group. We are, however, in a constant search pattern for minority applicants who are good, and our de facto record is one of the best in the University.

The years of Soia's deanship—1974–82—were years of expansion for legal education in general and were characterized by an enormous growth in the number of faculty women. Ninety-one ABA-AALS law schools had appointed their first woman professor when she took office in 1974, and forty-five other such schools had done so by 1982. In part, that growth was spurred by a 1970 amendment, proposed in 1969 by the newly created AALS Special Committee on Women in Legal Education, that the Association change its membership policy to require that member schools refrain from "discrimination . . . on the ground of . . . sex."[57] It was also reflected in the altered organizational structure of the AALS.

By 1979, women comprised 1.7 percent of tenure-track law teachers, numbering 516 individuals.[58] In that year, Professor Richard Huber of Boston College organized the first AALS Workshop on the Professional Development of the Woman Law Teacher, which was held in Cincinnati, Ohio, in October 1979. Both Professors Rhonda Rivera of Ohio State and Mary Ann Glendon of Boston College were members of the Workshop Planning Committee. Rivera recalled,

> We had invited Dean Soia Mentschikoff to be a keynote speaker. . . . And the gist of what she said was that she didn't understand why we were having this conference. She didn't see any reason why women should consider their professional development differently than men, and it really ought to be at the same professional development conference. . . . She didn't believe in anything that we were suggesting, and she basically thought the whole thing was a waste of time.
>
> That was shocking to me. It was hard for me to imagine a woman law professor who might hold a position like that. . . . While I still admire her commercial law work, my other admiration has ceased.[59]

Soia was the fourth woman dean of an ABA-AALS law school.[60] Only Dean Dorothy Wright Nelson of the University of Southern California, who had taken office in 1969, was active at the time of Soia's appointment in 1974. Two other women deans were appointed in the same year: Judith Grant McKelvey of Golden Gate University, and Judith Younger, who served for only one year as dean of Syracuse University Law School. With so few women deans serving at the same time, there was none of the informal networking among them at ABA or AALS meetings that developed later.[61]

IMPROVING MIAMI'S REPUTATION AND PROMINENCE

Soia took two immediate steps to upgrade her new school's reputation and prominence; as Irwin Stotsky wrote, "She took the place by storm."[62] First, she recruited several of her former students, colleagues, and friends, all of whom were either practicing lawyers, law professors, or federal judges from the East Coast and Midwest to join her visiting committee. Second, she set about obtaining the help of the leaders of the Florida Bar to create a statewide market for the services of her graduates.

Peter Lederer was a member of the first visiting committee and the only one who remained a member for twenty-odd years, through the tenures of the two deans who succeeded Soia. He recalled how the first committee had been established and explained what she hoped it would accomplish:

> The idea she started with was that she wanted urgently to show, primarily the students and secondarily the faculty, that the law school at Miami was a sufficiently important and sufficiently highly thought of institution, that people from the outside world—the bench, law schools, practice—thought it worth their while to come and spend time with the school
>
> [Another] thing she wanted to accomplish was to place Miami graduates with northeast law firms. . . . She hoped that people on the Visiting Committee would, if well impressed with the quality of the students they encountered in a variety of settings, start to entertain the heretical thought that they might hire somebody from Miami.[63]

The other members of the Visiting Committee were prominent lawyers, jurists, and academics: at one time or another they included Bill Nimkin, Sidney Cone, and Lillian Kraemer from New York; Jean Allard from

Chicago, and Judges Alvin Rubin and Peter Fay of the US Court of Appeals for the Fifth Circuit. Lillian Kraemer recalled that Soia asked her, Jean, and Helen to put together a panel on women in the practice of law:

> We were intrigued by it, because we represented three different generations of women lawyers. I was the baby at the time. I was incredibly different from my two forebears in saying that I had gotten to the point where I welcomed more women in the practice. I no longer enjoyed being the only woman in the room.
>
> There were a lot of questions from the audience, and one woman kept persistently asking why her needs as a mother of young children were not being addressed. Soia interrupted, and told her that the question was ridiculous: she had no business asking the panel or the legal profession to solve her problems as a young mother. Soia's attitude was that the questioner had to make a choice. If she couldn't practice law and be a mother, then she had to decide which one she wanted to do and that was the end of it.
>
> I think that was very much Soia's view. Of course, she was not a feminist at all, in the sense that that term is understood today.

Soia lost no time in building on her success in placing her graduates in the northeastern firms to try to expand their opportunities within Florida. The University of Florida School of Law in Gainesville was the leading law school in the state, and it dominated hiring by the upstate and central Florida law firms. She called upon Chesterfield Smith, the managing partner of the leading Florida law firm, Holland & Knight, in Tampa. He recalled:

> She had come up to see me because I headed the largest law firm in the state, and she wanted to tell me what she hoped to do with Miami. She said they had good students; they hadn't been earlier, but they were by the 1970s. . . .
>
> I've always believed that the number one graduate of any law school could be, perhaps, as good as any one you could find anywhere. . . . At the end of our conversation, I told her that I would, for three years thereafter, interview the top five candidates with academic grades who graduated from her school, and I would guarantee to hire at least one.[64]

Securing Chesterfield Smith's help was an enormous coup for Soia. She immediately put him on her visiting committee and relied on him to introduce her (several times at lunches he hosted) to lawyers in Orlando, Jacksonville, and other parts of the state.

Soia's plan to make Miami a first-rate law school required that she distance the school from the University administration as much as possible. Irwin Stotzky commented:

> The law school was totally autonomous. We had a different schedule than the rest of the university. One reason for that was that she wanted to distinguish herself from the university. To her, the University of Miami was not a great university; but the law school was going to be great. And to be great, it had to be seen as autonomous.[65]

Soia's three-year budget and her favorable tuition-sharing formula were critical aspects of her plans for the school. An equally critical—and sensitive— issue was for her to gain final authority over tenure decisions affecting the law faculty. She had refused to follow the University's practice of obtaining letters of evaluation of their scholarship from external appraisers. Her refusal was challenged in 1976 by the new Miami Provost, Clyde Wingfield.

> Wingfield refused to withdraw the memo [requiring external letters]. She refused to back down and won her point after the issue became a *cause célèbre* within the university.
>
> He resigned as provost in 1980, shortly after the trustees ended his candidacy for president.[66]

The stories about Soia at Miami are legendary. Professor Kenneth Casebeer vouched for one of these stories:

> The library books all had to be put in storage during the construction of the new building. . . . The contractor insisted that setting up the shelves and moving the equipment and books back into the library was part of the contract, and therefore had to be contracted at union rates. Soia insisted that he was hired to build a building, and nothing was covered about interiors other than fixtures.
>
> She went to the student members of the Law Review and informed them that during the coming weekend they were going to do a great service for their law school. After shutdown on the site on Friday, she supervised the students on Friday night, Saturday, and Saturday night as they assembled the shelves and moved the books into the library. When the contractor showed up on Monday morning, the work had all been done.

During her deanship, applications for admission went up and were received from a national, not merely a local, pool. Faculty morale improved

enormously. The new library was a reality. And as she proudly told a *Miami Herald* reporter two weeks before her retirement, the law school had "a million dollars in reserves."[67]

LEAVING THE DEANSHIP

Soia understood that her hard-won achievements would be entrusted to her successor, and she was determined to have as much influence as possible over the selection process. President Henry King Stanford had retired a year before she did, and Soia took care to further the candidacy of her friend, Dean Edward "Tad" Foote II of the School of Law at Washington University in St. Louis, to replace him. She knew that Foote, who took office in 1981, would most likely encourage and support the efforts of a new dean to maintain and build on the tradition she had established at the law school.

The search for Soia's successor finally came to a close in 1982 with the appointment of Professor Claude Sowle of Ohio State, who had previously served as dean of the University of Cincinnati Law School and as president of Ohio University. Sowle served as dean for four years and was replaced by Dean Mary Doyle in 1986. She, like Soia, was a graduate of the Columbia Law School, and had practiced law prior to embarking on an academic career in 1974 at the University of Arizona Law School.

Mary Doyle had met Soia only once. She recalled, "I think today how much I wish I had known then what I know now—that I was going to end up walking in her moccasins—so that I could have talked to her."[68] When she interviewed for the Miami deanship, she was confronted with Soia's memory:

> I remember saying to my husband after the first round of interviews that I had never heard a dead person invoked so many times per hour. . . . I don't think Abraham Lincoln, or Elvis Presley, is invoked as much as Soia.

RETIREMENT

Soia had announced her plan to retire from the Deanship in October 1979.[69] The lengthy search for her successor, however, meant that her actual

retirement was postponed several times. Miami being Miami, and Soia being Soia, she had three retirement dinners, in 1980, 1981, and 1982.

Soia remained on the faculty as a Distinguished Professor Emeritus from 1982 until her death in 1984, but she did not teach any classes. Instead, as Irwin Stotzky pointed out,

> Since her retirement, she had been a consultant on several major cases, an expert witness, and a public speaker. . . . What mattered to Soia was not only what occurred yesterday, but what she was just beginning.[70]

The *University of Miami Law Review* dedicated a special issue to Soia in 1983. Chief Justice Warren E. Burger contributed a tribute to her in which he called her "a dedicated, exemplary steward of legal education."[71] Professor Richard A. Hausler wrote the dedication to the issue, and observed,

> For every significant event in life, there has to be not only the right moment and the right opportunity, but also the right person to effectuate the right changes and to make the right decisions. The catalytic Soia Mentschikoff has proved to be such a person.[72]

Soia suffered from cancer, which caused her death on June 18, 1984. She remained alert, interested in new ideas and trends affecting legal education, and caring for her friends until the end.

HONORS AND AWARDS

Beginning in 1972, Hunter College bestowed an Award for Outstanding Professional Achievement upon one of its alumni each year. Soia received the second one, in 1973. In 1982, the year she retired from the Miami deanship, she was given the May A. Brunson Award, named in honor of the University of Miami's second Dean of Women, which recognizes a Miami administrator, faculty or staff member who has made an outstanding contribution to improve the status of women at the University. She also received honorary degrees from Smith College in 1967; from Boston College, Boston University, and Lafayette College in 1974; from the University of Puget Sound in 1975; and from Bard College and Columbia University on August 6, 1978. As part of the event at Boston College, Soia had delivered the grad-

uation speech. Dean Richard Huber, who had initiated the invitation, was nervous when he saw that she was speaking without notes:

> But it went extraordinarily well. It was one of the best speeches you could get. She was the first person, and I think the last, I have seen give an extemporaneous speech to an audience of probably about 20,000 people.

The Pilot reported that she had warned the 3,185 graduates against the tendency to stereotype individuals by classifying them "based on education, income, sex, color, and occupation," a tendency she saw as destructive of justice.[73]

In the late 1960s through the mid-1970s, Soia's name was repeatedly mentioned among speculations that a woman might be appointed to the United States Supreme Court to fill vacancies that occurred during the presidencies of Lyndon Johnson, Richard Nixon, and Gerald Ford.[74] She replied, through Mrs. Shea, a spokesperson at Miami, to the rumors about an appointment by President Ford with "a very definite no." Professor Richard Hausler, explained in 1982 that "[s]he wanted to be appointed because she was a good lawyer, not because she was a woman."[75]

After Soia's death, portraits of her were unveiled at Harvard and Chicago. The University of Chicago law school class of 1964 presented portraits of both Soia and Karl to the school, and Lillian Kraemer offered dedicatory remarks at the unveiling of Soia's portrait on May 12, 1990.[76] Mary Ann Glendon spoke at the dedication of Soia's portrait at Harvard in 1991. Characterizing her "friend and teacher" as "one of the most remarkable figures in twentieth century American legal education," Glendon said,

> She was a person who was especially hard to capture in a painting, or in words, because so much of what she was emanated from an exceptionally strong personality. It would take someone like W. B. Yeats describing Maud Gonne to convey a sense of the aura that Soia possessed.[77]

CONCLUSION

In Peter Lederer's insightful phrase, Soia left an "oral legacy" rather than a written record. He explained that he was referring to the fact that

"people remember things she said, less words even than attitudes she expressed." Indeed, the story of Soia's life and career is not primarily one of publications, teaching distinctions, law reform and academic service, although it includes each of those things. Instead, her story centers on the extraordinary effect she had on people—one person at a time—that was the source of her legendary success as an advocate in all aspects of her life. Irwin Stotzky commented, "She inspired and changed both her students and her colleagues simply by being Soia."[78]

Karl Llewellyn recognized the power of Soia's personality and incandescent aura and probably best summed it up in the shorthand phrase, "My gal can sail ships."

4 # From the Library to the Faculty: Five Women Who Changed Careers

MIRIAM THERESA ROONEY, JEANETTE OZANNE SMITH, JANET MARY RILEY, HELEN ELSIE STEINBINDER, AND MARIA MINNETTE MASSEY

Because librarianship is a traditionally female occupation, it is not surprising that the first professionally trained women hired to work in legal education were hired in positions of authority as law library directors (typically referred to as "law librarians") in many schools. Although men were the first law library directors, by 1940 women outnumbered men in that position by a ratio of five to four.[1] Given the disparity of salary and status between law faculty members and law librarians and the willingness of many law school deans to put law librarians into the classroom when necessary, some law library directors and staff librarians used their positions as an alternative channel to becoming law professors. By the late 1970s, this channel became less available as librarianship itself came under attack in research universities and many graduate library programs were closed.[2] As the twenty-first century approached, the movement of law library directors and staff librarians into law faculty positions had virtually ended.

The transition from law library to classroom began to gain momentum during the 1940s, when three women law graduates—Breta Peterson Dow, Dorothy Davidson Tyner, and Frances Evelyn Hickey—who were initially hired by their alma maters as law librarians later taught substantive courses in addition to their normal offering of Legal Bibliography. While

none of these became permanent academic faculty members (two briefly held assistant professor appointments before leaving legal education, while the third was appointed as an instructor), two have been recognized by their schools as the first women members of their faculties.

It was not until the 1950s that five out of the list of fourteen early women law professors left the library for good and ultimately became tenured full professors, thus establishing a path characterized both by distinct advantages and unique challenges that women who started out as regular faculty members did not share.

COMPARATIVE OVERVIEW

Women law library directors outnumbered women law professors in the early years of legal education by a ratio of four to one. By 1960, there had been only fifteen women law professors in ABA/AALS schools, but there were sixty-two women directors of academic law libraries.[3] Moreover, women library directors preceded women professors into law schools: in 1900, two schools—the University of Pennsylvania and New York Law School—had women library directors, while Barbara Nachtrieb Armstrong, the nation's first female law professor, did not begin her career until 1919.[4] Indeed, Rosamond Parma, Berkeley's first law library director, was appointed in 1911 and was serving in that capacity when Armstrong enrolled at the law school in 1913.[5]

Unlike women law professors, the number of women law library directors compared favorably with that of their male counterparts before World War II. Although men served at ten of the twelve schools that had law library directors in 1900, by 1940 women comprised 54.9 percent of these positions, a high-water mark that was not achieved again.[6] After 1940, the percentage of women law library directors declined sharply, reaching a low of 29.9 percent in 1975 before rising again.[7] The post-1940 decline appears to have been driven by the increasing number of schools that required the law library director to have both a law degree and a degree in library science.[8] In 1936, only 5 percent of academic law librarians held both degrees, while, by 1995, 171 of the 176 academic law library directors did so.[9] While men, funded by the GI Bill, flooded the

law schools after World War II, women did not embark on the study of law in large numbers until the mid-1960s, thus putting them out of the running for positions that required law degrees.[10]

Although some of the early law library directors held professorial appointments, their career training, job description, pay scale, and institutional status were not equivalent to those of regular members of the faculty.[11] Many of them taught substantive law school courses in addition to Legal Research or Legal Bibliography, but the law library, not the classroom, was their primary responsibility.[12] They were an integral part of the educational enterprise, but they were not considered to be full members of the academic mission of the school.

EARLY HISTORY

In 1906, a handful of law librarians decided to found their own specialized professional association, called the American Association of Law Libraries (AALL).[13] Its members worked in a variety of institutional settings, encompassing law libraries sponsored by state governments, bar associations, and academic institutions. AALL established its own journal, appropriately named *The Law Library Journal*, in 1908.

Given the close proximity of the law librarian to the student body and the teaching mission of the law school, it is not surprising that some law librarians became interested in changing their careers from the library to the faculty. The disparity of salary and status between law librarians and professors created a structural incentive for male as well as female librarians to consider such a career change.

Whether or not this structural incentive influenced their decisions, five of the fourteen early women law professors began their careers as librarians: Miriam Theresa Rooney at the Boston Public Library in 1924; Jeanette Ozanne Smith at the Dade County Library in Miami in 1937; Janet Mary Riley at the New Orleans Public Library in 1940; Helen Elsie Steinbinder at the Library of Congress in 1950; and Maria Minnette Massey at the University of Miami Law Library in 1951.

Once on the faculty, all of these women except for Rooney, who as Dean was focused on law school administration, became engaged in the same

academic pursuits as their male faculty colleagues. Three of them—
Rooney, Riley, and Steinbinder—taught at Catholic schools, and were also
the only ones among the fourteen early women law professors who never
married. Here are their stories.

MIRIAM THERESA ROONEY

Miriam Rooney's family came from Ireland. Miriam was born on historic
Bunker Hill, in Charlestown, Massachusetts, on July 4, 1897.[14] Her name
at birth was Frances Miriam Murphy and her parents were Susan T.
Rooney and John C. Murphy. Her mother and father's marriage disinte-
grated in the period between 1924 and 1928. Her parents were separated,
but not divorced. When her father died in 1928, Miriam, which is the
name she used, and her mother moved to Washington, DC together. Both
women changed their last names to Rooney in order to erase any connec-
tion with the despised John Murphy.[15] Before the move to DC, Miriam
completed most of her education, attending the Prince School, a neigh-
borhood public school near Commonwealth Avenue, and in 1910 enrolled
in the Girls' Latin School in Boston, where she graduated in 1914 and
then entered the Massachusetts Normal Art School from 1914 to 1915.[16]

From 1916 through 1924, she worked for various businesses in the
Boston area and sought further educational opportunities by attending
school part-time. She attended Boston University in 1918. Next she earned
an LLB from LaSalle Extension University in 1920.[17] Apparently after she
learned that she would not be allowed to take the Massachusetts Bar
Examination on the strength of her LaSalle LLB, she enrolled at Portia Law
School, a women's law school, in 1920, where she was registered as "Murphy,
Miriam T." and designated an "unclassified student" in the school's 1920–
21 Catalogue.[18] It is not clear if she attended for the whole year, and she
likely withdrew for financial reasons. In 1924, she began her career as a
librarian by taking a job at the Boston Public Library as an assistant catalo-
ger. Between 1926 and 1928, she completed a substantial portion of her
undergraduate work through the Harvard University Extension College.

In 1928 she moved to Washington, DC, where she took a job as a refer-
ence librarian with the Department of State and began her studies at

Figure 6. Miriam Theresa Rooney. Courtesy of Seton Hall Law School.

Catholic University.[19] (Actually, she was enrolled in Catholic University's affiliated but separate women's college, Trinity College, because Catholic University did not formally admit women as undergraduates at that time). She earned three degrees there in relatively quick succession for a fully-employed student: AB, 1930, MA, 1932, and PhD, 1937.[20]

Rooney was the first laywoman permitted to major in philosophy at Catholic University, and while working under the supervision of the head of the School of Philosophy, Dr. Edward A. Pace, earned the equivalent of a canonical doctorate from a pontifical university.[21] Her thesis, "Lawlessness, Law and Sanction" (1937), remains a classic study of the role of punishment in criminal law. She enrolled in George Washington Law School in 1938 while continuing to work at the State Department, and graduated in June 1942.[22] After her graduation, she remained at the State Department, becoming an assistant to the legal adviser in 1946. She also taught as a lecturer in Jurisprudence at Columbus University.[23] In 1948, she accepted an appointment as associate professor and law librarian at Catholic University School of Law, becoming the fifth woman in the nation to join the regular faculty of an ABA accredited law school. She left that position in late 1950 when she moved to New Jersey to become the founding dean of Seton Hall University School of Law. She was the first female dean of an ABA accredited law school. In fact, she is the reason that Seton Hall managed to become accredited.

Seton Hall Law School

In the 1940s, with the exception of Rutgers, which had opened the first ABA-accredited law school in the state at Newark in 1941, legal education in New Jersey was carried on primarily by proprietary law schools, which operated as for-profit institutions.[24] This practice came to an abrupt end in 1947, when New Jersey adopted a new state constitution that completely revised the court system and conferred upon the New Jersey Supreme Court "jurisdiction over the admission to the practice of law and the discipline of persons admitted."[25] Chief Justice Arthur T. Vanderbilt of the New Jersey Supreme Court, who had been instrumental in the drafting of the new constitution and who was determined to upgrade the standards of the New Jersey judiciary and bar, exercised this authority to improve the

education of new lawyers.[26] The Court, through its rulemaking power, mandated that only graduates of law schools approved by the American Bar Association could qualify for admission to the New Jersey bar.[27] In a masterpiece of understatement, Miriam Rooney noted that "the year 1950 was significant for legal education in New Jersey" because "John Marshall College and Law School in Jersey City, which had been granting degrees for over twenty years under regulations of the New Jersey State Board of Education, but had been unable to obtain ABA accreditation, closed its doors and donated all its assets to Seton Hall College as a gift."[28]

Rooney later explained the reasons for her selection as dean of Seton Hall to the assistant commissioner of the New York State Education Department. As she described it, many candidates who were "highly skilled in local New Jersey practice" were passed over, and she was selected "in the expectation that my broader experience on national and international levels and in teaching law would be particularly advantageous to legal education in New Jersey."

Seton Hall began instruction on February 5, 1951, with four full-time and one part-time faculty members and sixty-one students: fourteen in the day division and forty-seven in the evening division; late registration increased the total to sixty-nine. By September of 1951 three more part-time faculty had been added. Dean Rooney did not teach a regular course after the law school's first year, but she acted as a substitute teacher for any faculty member unable to meet a class.

Although slight in stature, Rooney was an intellectually commanding figure. Daniel A. Degnan, an early student who later joined the priesthood and ultimately became dean of the school in 1978, said that "she quickly overcame a reluctance on the part of the male faculty to have a woman as a dean."[29] Rooney's immediate goal was to obtain ABA accreditation for the law school. After a series of reports and inspections done at rocket speed, Seton Hall was added to the approved list of the ABA on a provisional basis on September 16, 1951. This action occurred at the ABA meeting held in New York, only a little more than seven months after Seton Hall's opening, and it is from this date that accreditation is officially counted by the ABA. Full approval was granted August 24, 1955.

Dean Rooney then moved on to enlist Seton Hall in the scholarly society of American legal education. AALS membership proved more difficult

to obtain than ABA accreditation. This was not in itself unusual, since the ABA performs a licensing function for American law schools, designed to ensure a school's competence to train its students, while the AALS aspires to encourage academic excellence and promotes a scholarly mission among its members. The process dragged on from August 1955 until December 1959, when the association unanimously approved the recommendation of its executive committee that Seton Hall be admitted to membership.[30]

Life After the Deanship

During her deanship, Miriam Rooney's life was the law school. Gerald Garafola, a graduate of Seton Hall, who later became its librarian, visited Rooney at her Millburn, NJ, house, which was close to the law school and where she lived alone. He observed: "Her house was an office. Every room had papers on the floor, typewritten papers, books, newspapers. It was not a home for leisure, it was an office for her."[31]

Having achieved the goals she had set for herself and the school, Miriam Rooney stepped down from the Seton Hall deanship on July 1, 1961, and was immediately replaced by Professor John P. Loftus.[32] Rooney returned to the faculty with the title "Research Professor of Law." She apparently also finally took the opportunity to satisfy the requirements for admission to the New Jersey State Bar, because her AALS biographical entry lists her as a member of that Bar in 1962.[33]

Like other deans before and after her, however, Rooney appeared reluctant to relinquish her leadership role in the school; as Garafola put it, "Dean Loftus wanted to be Dean, and I think Dr. Rooney felt she was still Dean." Whether because of interpersonal conflict with the new dean or not, Rooney absented herself from Seton Hall for two years, accepting appointment as a Fullbright-Hays Visting Senior Fellow in American Law and Government at the University of Saigon in Vietnam in 1965–66 and again at Van Han University in Vietnam in 1967–68.[34] She retired from the Seton Hall faculty in 1967, at the age of seventy. For a time, she apparently had had a summer residence in the town of East Wolfeboro, New Hampshire; after her retirement, however, she acquired an apartment at the Watergate in Washington, DC, where she spent time while serving as

an advisor to the delegation of the Holy See at the United Nations. She never owned an automobile, relying instead on public transportation.

Research and Publications

Miriam Rooney was an accomplished intellectual and a prolific scholar. Trained in jurisprudence before she studied law, her work bore the characteristic philosophic attributes of rigor, logic, and disciplined analysis. At the time she studied at Catholic University, its School of Philosophy was under the leadership of Dr. Edward A. Pace, who had studied in Rome at the American College from 1880 to 1885 under Dr. Francesco Satolli, the leading Thomist of the day, who greatly influenced Pope Leo XIII's encyclical *Aeterni Patris* (1879), which provided the vehicle for a revival of the Neo-Scholastic philosophy drawn from Saint Thomas Aquinas. By 1930, when Rooney was a student, Pace, together with John Fox, the newly-appointed dean of the law school, and Monsignor James Hugh Ryan, the university's rector, had collaborated on a program of study designed to undertake "a reappraisal of the different law school subjects on the basis of Thomistic principles."[35] Rooney enthusiastically joined this program.

Rooney herself produced one of the few published works to come out of the program, which she described as "an analysis of the philosophy of the common law" that emphasized "recourse to the primary textual sources, and of evaluation of ideas and decisions made by the great leaders of Anglo-American legal thought, against their personal backgrounds, and in the light of Thomistic principles."

Rooney had first attempted this approach to the philosophy of the law—the "extension of the method from the biographical into the subject field"—in her doctoral dissertation on criminal law, "Lawlessness, Law, and Sanction." She identified the question, "Why is law binding? as essentially a philosophical question," and continued, "it is the function of philosophy, the science of ultimate causes, to provide the answer to it."[36] Rooney examined the work of "the great common law historians, chiefly Maitland, Holdsworth, and Woodbine," in combination with "the brilliance of New Scholastic philosophical writings," and considered both of these in the context of the parallel development of "canon law studies, not yet taken into account in more general discussions."[37]

Throughout her scholarly career, Rooney continued to theorize within the framework of Neo-Scholasticism. From 1945 through 1948, she was an associate editor of a journal called *The New Scholasticism*, which began publication at Catholic University in 1927 as the organ of the American Catholic Philosophical Association. Rooney's extensive bibliography contains seventy-three entries, divided into books (her PhD dissertation was published as a monograph in 1937), book chapters (two), articles (forty-nine), book reviews (eighteen), and miscellaneous items (three, including her 1932 MA dissertation).

Retirement and Honors

Throughout her career, Rooney was active in the affairs of those institutions central to her life's work: the Catholic Church, the American Bar Association, and the National Association of Women Lawyers. She had more time for these activities after her retirement. In 1973 she became an adviser on international law to the delegation of the Holy See to the United Nations and participated in that capacity in the UN Conference on the Law of the Sea, a post she held until shortly before her death in 1981.[38] In recognition of her impact, Pope Paul VI awarded Dean Rooney the *Pro Ecclesia et Pontifice* cross in 1976 for her work in International Law with the Delegation of the Holy See at the United Nations, said to be the highest award that the Church can confer upon a woman.

In addition to this recognition by the Holy See, Rooney was repeatedly recognized and honored during her lifetime for her pathbreaking career and her many contributions to the institutions she cherished and served so loyally. In 1967, she received the Bishop Bernard J. McQuaid Medal for distinguished service to Seton Hall University. In 1971, at the World Congress of the World Peace Through Law Centre of Belgrade, Yugoslavia, she received one of the first five gold medals presented to outstanding women jurists of the world. In addition, a special tribute to Dean Rooney occurred at Seton Hall in the 1979–80 school year, organized by the Seton Hall Women's Law Forum, at the suggestion of Professor Elizabeth Defeis, the second woman law professor at the school, who had joined the faculty in 1971, and later served as dean from 1983–88.

Miriam Theresa Rooney died in a nursing home in New Jersey on March 23, 1981. At her death, she provided by will for her estate to be divided equally between Catholic University and Seton Hall University. Catholic University used the funds, approximately $120,000, to establish a scholarship at the law school in her name. Seton Hall created the Miriam Theresa Rooney Medal, to be awarded annually for service to the law school.[39] Both are fitting tributes as living memorials to a woman whose achievements were larger than life.

JEANETTE OZANNE SMITH

Jeanette Ozanne was born on September 23, 1910, in Kenosha, Wisconsin, the daughter of Chester Ozanne and Martha Wilson Ozanne.[40] When Jeanette was a child, Chester contracted pernicious anemia, and the family moved to Miami, where Martha took a job as tax collector in Coconut Grove. After Chester died Martha married a botanist, John Clayton Gifford, who ultimately became head of the Botany Department at the University of Miami.

Ozanne graduated from high school in 1927 in Sebring, Florida.[41] She then attended the Graduate Harper School for Nurses, an affiliate of Wayne University in Detroit, where she earned an RN degree in 1931. She entered the University of Miami, taking mainly social science courses, and then moved to the law school. She was awarded an LLB, magna cum laude, in 1937, graduating with one of the highest recorded grade point averages in the history of the school—a record that endured until the early 1970s.

Ozanne's first job after graduation was that of law librarian for Dade County, Florida, where she set up the law library for the courthouse, worked with the judges, and provided instruction in legal bibliography to the lawyers who used the facility but had only rudimentary ideas of how to look up the law. She held the position for four years, from 1937–41.

Ozanne volunteered during World War II (1942–44) as a Red Cross instructor, giving an eighty-hour lecture course for nurses' aides, which was designed to teach the students both the practical aspects of nursing and the medical intricacies that providing nursing care entails.[42]

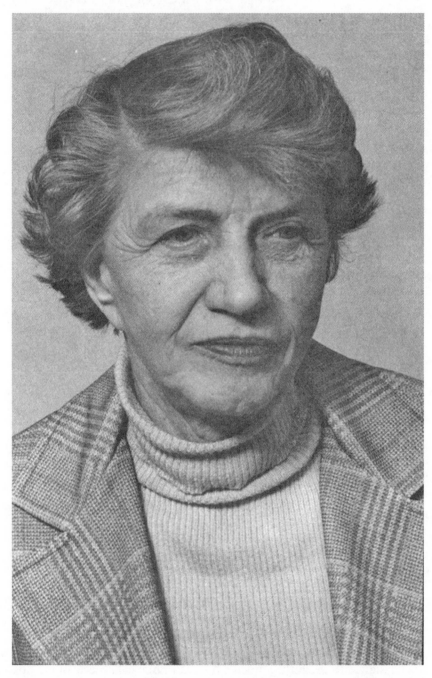

Figure 7. Jeanette Ozanne Smith. Courtesy of University of Miami Law School.

Family Life

Ozanne was married twice. At the age of fifteen, while in high school, she fell in love with Ralph Mullens, a seventeen-year-old baseball player. She became pregnant, and gave birth to her first child, Priscilla Mullens, on February 23, 1926.[43] Both families were determined to break up the relationship, and the young parents were quickly married and divorced. Priscilla was raised as part of her grandmother Martha's family.

In 1936, Ozanne met and married a fellow law student, Thomas F. Smith. He did not graduate from law school. Instead, he went into newspaper journalism and public relations, ultimately becoming the Publicity and Convention Bureau Director for the City of Miami Beach.[44] They had three children. When the eldest of the three, Jay, was born in 1941, Jeanette Ozanne Smith left her position as Dade County law librarian. Her son Jay remembered her as a devoted if unconventional mother. His earliest memories of her are rocking him to sleep singing a lullaby whose lyrics went "Hard Hearted Hannah, she's the vamp from Savannah, she's the meanest girl in town." As the years went by, Jay recalled that his mother told him that taking care of the children was not enough for her, and that she was ready to get out of the house.

Appointment at Miami

Jeanette Smith's thoughts turned to law teaching. She wrote to Dean Russell A. Rasco about a teaching position at the law school on May 11, 1948. After reminding him of her personal situation and her educational background, she noted that that she had three children, ages two, four, and six, and that all were in school. She also pointed out that she had "full time help with emergency help readily available."

Smith was appointed to the Miami law faculty on February 14, 1949, as an Assistant Professor with a salary of $3,600 per year.[45] She taught Contracts and Real and Personal Property.[46] She was promoted with tenure as an associate professor in 1952, at a salary of $4,070 per year.[47] She began teaching Constitutional Law in 1954.

Smith remained an associate professor for seventeen years, achieving promotion to Professor of Law in 1969, at a salary of $13,500.[48] After her

promotion, Smith became a member of the Appointments and Tenure Committee. She had earlier served on the Curriculum, Grading, and Library Committees.

Research and Publications

The University of Miami was popularly known as the "Fun in the Sun" school. While some members of the law faculty denied that the characterization fairly described their own aspirations for excellence, the scholarship requirement was informal at best. Beginning in 1958–59, however, an effort was made to improve the standards and to require that "in addition to teaching [the] faculty member agrees to do a substantial amount of legal research and writing with a view to publication during the 12 month period."[49]

The new "publish or perish" requirement had immediate effect. Smith had already invested in research: in 1955 she had co-edited a 750-page mimeographed volume on *Florida Constitutional Law: Cases and Materials* that she used in teaching her course. She began work on a survey of contracts cases decided by the Florida appellate courts for the *University of Miami Law Review*. Two articles in this annual survey appeared in 1960 and 1962.[50] Smith also published ten half-page book notes and new book appraisals in the *Law Library Journal* between 1958 and 1962.[51] When the requirement for "legal research and writing" was dropped in 1961–62, Smith's publications ceased. She told her son that she resented having to "churn out stuff."

Life at Miami

Socializing was part of Smith's role as a wife. She accompanied her husband to the entertainment functions that were a central part of his job. They lived in a house designed by the leading Miami architect, Alfred Browning Parker, set on a waterfront property surrounded by cypress and pine trees. Not infrequently, she would return home from her job at the law school in her 1957 Thunderbird with a stack of papers to grade piled high on the seat beside her, to find several unexpected Greyhound buses parked in front of the house, with two hundred people on the back lawn

being served cocktails and canapés. On these occasions, she pitched right in, circulated, and helped entertain the guests.

Even after she began teaching, Smith shopped daily for groceries on the way home and prepared dinner for the family. She helped the children with their homework after dinner, and also helped her husband, doing writing for him and assisting him with business decisions.

At work, Smith socialized with a small group of colleagues from the law school. They and their spouses also had dinner in each other's homes. Smith usually invited them to her home for a New Year's Eve party.

Her professional life continued to be active, too. Jeanette Smith was an active member of the Florida Bar, and participated in its efforts to revise the Florida Constitution. She also served on the Florida Supreme Court Committee on Standard Jury Instructions, was a member of Wig and Robe, and became a faculty adviser to Phi Alpha Delta. Along with two other faculty colleagues, she received a Ford Foundation Grant in 1971 to develop a program in Law and the Poor. She was on the Board of Directors of Legal Services of Greater Miami from 1971–74.[52] Described by her son as "a Roosevelt Democrat," Smith was also active in the ACLU.

The University of Miami's retirement policy required that Smith leave the faculty on May 31, 1976, at the age of 65. Smith and her husband planned to travel abroad after her retirement, to Wales, Scotland, and her beloved Paris. Unfortunately, she learned that she had cancer shortly after her retirement. She died on August 1, 1981.

JANET MARY RILEY

Janet Riley's immediate family came from New Orleans.[53] John Nichols and Mary Odile Riley had three daughters: Odile Riley, Louise Riley, and Janet, who was born on September 20, 1915, in the family home on Allard Boulevard in New Orleans. Neither of Janet's parents had a college education. Mary Riley had given piano lessons at home before her marriage. John Riley was in business for himself and invested in stocks and bonds. He died during the Depression, in March 1932, at the age of sixty.

Janet Riley attended a Catholic girls' school through the sixth grade and public school thereafter because the family was unable to afford the cost of

Figure 8. Janet Mary Riley. Image from the Janet Mary Riley Papers, located in Loyola University New Orleans Special Collections & Archives.

sending her to St. Joseph's Academy. Riley desperately wanted to go to college, but she knew there was not enough money to pay for that expense. However, a stroke of luck intervened. Several institutions of higher education offered scholarships to local public high schools, and they were distributed according to the class standing of the students. The two students ahead of Riley had declined the opportunity to attend Ursuline, and it fell to her. She was "walking on air" when she learned the news.

Ursuline Academy was the oldest educational institution for Catholic girls in the United States, having been founded in 1727 and offering preschool through twelfth grade. To celebrate the 200th anniversary of its founding, the Academy opened the College in 1927. When Riley enrolled in 1932, it was less than ten years old. During her freshman year, the Ursuline College affiliated with Loyola University of New Orleans, which at the time did not admit women as undergraduates, and became its women's college. Riley's college degree, awarded in 1936, was from Loyola. She majored in English and minored in Latin and History.

In her junior year, Riley's favorite teacher, Mother Rita, gave Riley the idea of going to law school. The idea did not bear immediate fruit. As planned, Janet became a teacher and taught in the Orleans Parish Public School system from 1937–39. Riley recalled that by the end of the second year, "I had been crying so much and telling my mother that I couldn't stand it." Riley's mother was sympathetic; she told Riley to quit "and go back to school and learn something else."

Riley decided to try library school. She entered the library school at Louisiana State University (LSU) in 1939 and earned the BS in Library Science in 1940. She was immediately hired at the New Orleans Public Library, where she worked as an assistant in the circulation department from 1940–41. Riley came to realize that librarianship had a future, and that she could enjoy the work. She accepted a job at the Loyola University Library in November 1941, in the periodicals, pamphlets, and government documents section.

Riley wanted to be active in the war effort, and her opportunity came in 1943 when she was offered a job as assistant post librarian at Camp Plauché. One month later, the librarian left, and Riley replaced her. She stayed for two years, serving as a uniformed civilian. In 1945, she transferred to LaGarde General Hospital as post librarian, and was there when the war ended.

Law Librarian and Law Student

Soon after the war ended, Mille Solange, the law librarian at Loyola, called Riley to let her know that she had just given the dean, Dr. Vernon X. Miller, notice that she was leaving to marry a soldier. Dean Miller was anxious to speak with Riley about the opportunity. Riley had a professional library degree, and Miller knew that the AALS and ABA were considering a requirement that law library directors hold both that credential and a law degree.

Riley was reluctant to sign a contract, because she wanted to try out the position. Miller agreed to hire Riley without a contract, with the understanding that she would take a few law courses to help her get accustomed to the material. He added that this strategy would permit him to tell the ABA and AALS that although their law librarian did not have a law degree, she was taking courses in the field.

On December 16, 1945, Janet Riley began work at Loyola as assistant professor and law librarian, and in January 1946 she became a law student alongside returning GIs who were resuming their interrupted civilian careers. Although at the time she thought that she was just taking a few law courses to become a better law librarian, in fact Riley had begun the next stage of her transition to the law faculty.

It was an extraordinarily busy and challenging period. As law librarian, she was learning what to do with a law library and how to adapt to the changing needs of the profession. As a law student, Riley followed the Dean's advice to take Legal Bibliography (which he taught) and Contracts, which she took from Professor Antonio E. Papale, known as "Pap." She earned an "A" in Legal Bibliography, but her real achievement—and a personal revelation—came in Contracts:

> I have never before nor since been so stimulated as I was in my first semester of Contracts. . . . At the end of the first semester . . . I got the best 'A' in the class. And that ruined me. I knew then I was probably going to keep on taking classes.

Riley stayed in the Law Library for ten years, becoming an active member of AALL and immersing herself in the work. During most of that time, she

enrolled in one or two courses depending on her library schedule. She also taught the Legal Bibliography course each semester for nine and a half years. Riley supplemented her coursework by enrolling in summer school, since that time was normally slower for the Law Library. Riley completed her law school education at the end of summer school in 1952—six and a half years after she had started. She passed the Louisiana bar examination on her first try in March 1953 and became a member of the Bar in the same year.[54]

After she had graduated from law school, Riley found that her work in the law library was losing its attractiveness. The job itself had become frustrating and she had no staff. In 1954, she pleaded unsuccessfully with the Dean (who, by that time, was her former contracts professor, Antonio "Pap" Papale) for an assistant librarian.[55] By 1955, when Loyola offered her another three-year contract as Assistant Professor and Law Librarian and Instructor in Law, with no staff assistance in sight, she turned it down in favor of a month-to month contract that would give her the freedom to look for a job in the practice of law.

Riley's search for a law firm job, however, was unsuccessful. Despite her many contacts in the local bar, she encountered an unmistakable prejudice against women practitioners. Finally, Riley was offered an in-house legal job by the California Company, an oil company. The job paid more than Riley was making at Loyola, and she accepted it, even though it was not what she really wanted.

At the same time, the law school had learned that it was about to be inspected by the ABA or the AALS in the coming months, and naturally, they did not want their Law Librarian to leave—especially now that she held both professional degrees. President Donnelly gave Riley a salary raise and changed her law faculty title from "Instructor in Law" to "Assistant Professor of Law."[56] She agreed not to leave, but she also gave Loyola a year's notice, and kept on looking for a law firm position.

Faculty Appointment at Loyola

In 1955, Riley's final year as Director of the Law Library was coming to a close, and she was about to accept a position with a small law firm, when an unexpected opportunity arose.

The Dean . . . simply walked in to my office and said, 'Janet, we really don't want you to leave.' And I started to say, 'No, Pap, I've decided I'm not going to be a librarian anymore.' And he said, 'Stop. What I'm trying to tell you is that we would like you to be a full-time faculty member. . . .' And as far as I know, there was no faculty consultation.

Riley describes her early years as a faculty member as governed by "the feeling that I had to sort of walk on eggs."

Somebody, one of my students, once asked me, 'Did you ever feel like one of the boys?' And I, very spontaneously and very quickly, without giving it any thought, said, 'Oh, never.' I never did. I was not one of the boys. I was the woman faculty member.

The year she began teaching substantive courses, Riley was given the courses Corporations and Taxation. Most of the students were men. The experience was not positive:

I found quite often that if I'd say something that a student, particularly a smart student, didn't agree with, he'd be likely to say, 'Well, I'm going to ask Mr. So-and-so on our faculty what he thinks about that.' It was as though if a man says it, it's all right. If a woman says it, let's double-check. Gradually, over the years, that wore down, but it took a long time.

Riley's classroom presence and confidence improved in subsequent years. Dean Louis Westerfield, who took Riley's Community Property class in 1972, reported that "she commanded respect":

She was well organized, and she always knew what was coming next. She used a combination of lecture and Socratic method, but she didn't badger students. It was almost as though you felt that you let her down if you weren't prepared.[57]

In the early years, Riley had few women students, no more than two or three in a class. Kathryn Venturatos Lorio, who enrolled at Loyola in 1970 and joined the faculty in 1976, took Riley's course in Persons, the Louisiana version of Family Law, as a first-year student. She recalled that her professor was able to bring the material to life; Riley "made you see the people as characters, not just litigants."[58]

Lorio went on to become Riley's research assistant, helping her during the beginning of her work in revising Louisiana's community property provisions. Their research formed the basis for Riley's article, published in the *Louisiana Bar Journal* in 1973, which alerted practitioners to the fact that other states handled the issues of community property ownership, control, and division very differently.[59]

Not long after she began teaching full-time, Riley also decided that she should earn another degree. She saw this as a necessary precaution against potential discrimination: "I had just the three degrees (the BA, the BS in LS, and the LLB), and I thought that as a woman, I had better get myself another degree. I didn't want any excuses for not getting a promotion." She received a note from Dean Papale saying that the University of Virginia planned to interview junior faculty members from Southeastern law schools for an LLM Fellowship in 1958. She was accepted and agreed to come. She wrote a thesis on the contempt power, which she later turned into her first publication as a law professor.[60] After she had obtained the LLM, Riley was promoted to associate professor (without tenure) in 1961.

Family Life

Janet Riley lived at the family home on Octavia Street with her mother until her mother died in 1958, two years after Riley joined the faculty at Loyola. She continued to live there until 1988, when she moved to her sister Louise's duplex home on Louis XIV Street. In December 1993, Louise had a stroke that left her bedridden. Riley cared for her with the assistance of twenty-four-hour "sitters," until her death seven or eight years later. Riley never married.

Riley was a devout Catholic, attending mass daily. She served as a lector one weekday per week and one Sunday per month. In 1963, she decided that she had a vocation to become a secular institute member, and she became interested in a group of consecrated laywomen known as the Society of Our Lady of the Way. Its members take vows of poverty, chastity, and obedience. Riley began her three-year period as a candidate for membership and took her first vows in 1966 for one year; she took annual vows

each year for six more years. After seven years, she took perpetual vows. After taking the permanent vow of chastity, she considered herself the bride of Jesus Christ.

Revision of the Louisiana Civil Code Provisions on Matrimonial Regimes

Like Armstrong, Daggett, and Amsler before her, Janet Riley was drawn to law reform. In her case, following in Daggett's footsteps, her chosen project was Louisiana's community property system. Indeed, it was Riley who finally achieved some of the changes that Daggett had advocated, most importantly the extension of the power to enter into marital contracts to married couples and the substitution of equal managerial control of the community property for the husband's sole authority as "head and master" of the legal community.

In the early 1970s the need for revising Louisiana's matrimonial regimes law became more urgent as a result of the United States Supreme Court's newly heightened scrutiny of sex discrimination challenges under the Equal Protection Clause.[61] Following Dean Marcel Garsaud Jr.'s recommendation, she was named Reporter for the revision of Civil Code book III, title VI in 1973. She was assisted by a nine-member Advisory Committee, including her former student, Senator Tom Casey, and Professor Robert A. Pascal of LSU, whose ideas about the scope of the Revision were substantially more conservative than her own.[62]

Anticipating Ruth Bader Ginsburg's anti-stereotyping litigation strategy in briefing and arguing the 1970s post-*Reed* sex-discrimination cases to the United States Supreme Court, Riley stressed that while "the summons that simply cannot be postponed is the constitutional issue of equal protection for the sexes," that summons was not one-sided:

> Please note, the sexes—not just women. What have we done to husbands? We've made them head and master of the community, then hedged them in with questionable deprivations.[63]

She went on to list, much as Harriet Daggett had done before her, several specific ways in which the Louisiana system penalized the husband in favor of the wife, concluding with the observation, "Pity the poor husband.

So many unequal discriminations are imposed upon him—all, clearly, the outgrowth of his status as head and master of the community."[64] But she made it clear that this "pity" was at least partially tongue-in-cheek when she asked: "But what of the wife?"

> She is the recipient of all these favors of the law. I suspect that, if most wives knew of these favors, they would gladly trade the whole bundle of them in return for getting rid of one favor the husband has—his head and mastership.[65]

Fully revealing her hand, Riley reached her conclusion about the validity of Louisiana's law. "Is the institution of automatic male 'head and mastership' a denial of equal protection to wives?" she asked her audience. "I submit that it is."[66] Riley saw the Institute's job as proposing a method of management that would be both constitutional and sound when tested against the goals she had identified.

Professor Katherine S. Spaht, who was herself involved in the later stages of the Institute's work on this project, concisely summarized what happened over the next three years, as the Advisory committee met and reviewed various alternatives:

> Throughout this period, the Reporter [Riley] also sought direction from the Council of the Law Institute as to the policy it desired implemented by the legislation. Reports of the Committee on its progress were submitted periodically to the Council. The Reporter favored equal powers of management of community property; the members of the Advisory Committee were divided as to the direction the revision should take; and the Council appeared to favor a system 'whereby each spouse would exercise control over his or her own earnings.'[67]

Spaht's rather dry language outlining the positions favored by the "Reporter" and the "Advisory Committee" describes a debate largely between Riley and Professor Robert A. Pascal. Beneath the two professors' differences over management policy lurked a deeper conflict about the nature of the Civil Law System as exemplified in Louisiana's Civil Code. As Riley saw it, Pascal adhered to the traditional interpretation that the source of binding legal obligation was the Code itself, and its predecessor Codes, traced back to the French and Spanish Codes. Louisiana case law—

even as represented by landmark decisions of the Louisiana Supreme Court—was not "law," except insofar as a particular decision was binding upon the parties to the case. Unless the rule announced in their case had been constantly repeated and had become recognized as *"jurisprudence constante,* where a case may be used to discern a pattern that may aid in interpretation," it had no precedential value.[68]

This understanding of the Civil Code prompted Pascal to dispute Riley's presentations to the Council by asserting that the law was quite different from what she had told them. Pascal was a recognized authority on the Civil Code, so at first the Council members were confused by his statements, thinking that if they agreed with Riley's version, they (and she) must have misread the cases. Once Riley realized that the problem was more fundamental, she began to neutralize Pascal's position by explaining to the Council that Pascal was ignoring the Louisiana case law in propounding his statements of the law, and telling them that, if they chose to include "jurisprudential law" in their view of "the law," then her presentation, rather than his, was correct.

Riley's strategy was sufficient to restore her credibility, but she and Pascal remained on opposite sides of the basic issues. Although the majority of the Advisory Committee sided with her on the preferred management regime, Riley and Pascal's disagreement meant that the Council was forced to choose between the competing positions of the professors. These issues had not been resolved even after three years of debate. Finally, in late 1976, Riley decided that further progress through the Institute along the lines she advocated was unlikely, and she resigned as Reporter. She did not, however, give up the reform effort. Instead, she conferred with Senator Tom Casey and they agreed that she should prepare her own bill to submit to the legislature in opposition to the "two funds" proposal expected to come from the Institute.

Riley chose a propitious moment to resign. The constitutional impetus for revision of the Civil Code that she had described to the Institute three years earlier had escalated considerably. One case, *Kirchberg v. Feenstra,* had been filed in March 1976 in the Federal District court for the Eastern District of Louisiana challenging the constitutionality of the "head and master" rule.[69] Another, *Corpus Christi Parish Credit Union v. Martin,* which raised the same issue, was pending in the Louisiana state courts at

about the same time.[70] As Riley had predicted, if the Legislature failed to act, the courts would dictate the outcome.

The Institute's proposal—essentially Pascal's plan—was introduced into the 1977 legislative session as House Bill 783. A rival measure, House Bill 1278, embodied the substance of Riley's equal management proposal. After a hearing on both bills, the House Committee on Civil Law and Procedure "took no action on House Bill 783 but reported favorably on House Bill 1278."[71] Its action turned out to be the beginning, rather than the end, of a legislative process that went on for another two years. Senator Casey, in consultation with Riley, bought some time for readying her bill for final enactment by introducing Senate Concurrent Resolution No. 54, which created a joint legislative subcommittee to draft a new bill. A six-person Advisory Committee was to be chosen to work with the Legislative Subcommittee—at Riley's suggestion, they were to be selected from a list of twelve, six men and six women—submitted to the Speaker of the House and the President of the Senate. From that point until the reform legislation became effective in 1980, Janet Riley was not a formal part of the process.

The final push for enactment of the reform package came from the Louisiana Supreme Court. One week prior to the opening of the 1978 Legislative Session, it handed down a 4–3 decision in the *Corpus Christi* case. Although the majority declared that the district court could (and should) have avoided reaching the constitutional question, the three dissenters stated in no uncertain terms that the "head and master" rule violated the Equal Protection Clause of the United States Constitution.[72]

Senator Casey reported that "When that case came down in 1978, we all realized that something had to be done quickly." The subsequent legislative history of the Act of 1980, which abolished the "head and master" rule, together with an analysis of the new legislation has been described and discussed elsewhere, both by Spaht and by Riley herself, in her preface to the 1981 edition of her casebook on Louisiana Community Property:

> It happened! In the summer of 1979 the Legislature of Louisiana, including in its membership several of my former students, enacted a complete revision to become effective January 1, 1980 of Title VI of Book III of the Civil Code of Louisiana, providing a law of Matrimonial Regimes more in keeping with present usage. Popularly called the 'equal management law,' it in

fact replaced the control of the husband as 'head and master of the community' with three kinds of control: equal management, concurrent management, and exclusive management. Not only management articles, but the entire Title was completely revised, while retaining the basic concepts of community and separate regimes.[73]

Riley's *Preface* to the second edition of her casebook was dated June 24, 1981, three months and one day after the United States Supreme Court, in *Kirchberg v. Feenstra*, had invalidated the previously repealed Louisiana "head and master" rule as unconstitutional. Janet Riley's constitutional analysis had been upheld by the highest court in the land.

Civil Rights Publications and Advocacy

Long before she signed on with the Louisiana State Law Institute—indeed, before she joined the Loyola faculty—Janet Riley had learned how to resist unjust laws through her participation in the desegregation struggle. One of her earliest publications, which first appeared in the *Bulletin of the Louisiana Library Association* in 1950, documented her advocacy against segregation by the Louisiana Library Association when Riley set out to discover "what effect segregation laws could have on our activities."[74] After a canvass of federal and state law, city and parish ordinances, and regulations of boards and commissions, she reported that the law was no excuse for segregation: "the law leaves us free to accept or refuse all our professional associates at our scheduled professional gatherings." She added, "The decision we make is our own. . . . We cannot hide behind the law as an excuse for doing it or refusing to do it. Let us make our own decision, on our own responsibility."[75] Riley's article was reprinted in *The Library Journal*, a national publication; she received letters of support from all over the country.[76]

She was also active in the Commission on Human Rights of the Catholic Community of the South, a group formed by Loyola Dean Vernon X. Miller to carry out the 1953 proclamation of Archbishop Joseph F. Rummel to end segregation in the churches of New Orleans.[77] Members of the Commission, thirty men and women, both black and white, attended early morning mass once a month on Sunday and sat together in the front pews, in defiance of the tradition that blacks could sit only in the back of

the church. After mass, they had coffee and donuts in the school cafeteria, and sometimes a picnic, violating the taboo against eating together as well. Their actions were courageous, and they were shunned by some church members who moved away from the front pews, but others recognized that what they were doing was appropriate and remained seated.[78]

Riley also worked with her colleague, Professor John P. Nelson, on one of the early US Supreme Court cases defending four students who staged sit-in protests against segregated lunch counters in the South. They had been arrested after refusing to leave the lunch counter of McCrory's Five and Ten Cent Store on Canal Street and were convicted under a Louisiana statute prohibiting criminal mischief. Their convictions were upheld by the Supreme Court of Louisiana, but reversed by the US Supreme Court in *Lombard v. Louisiana,* a pathbreaking case that was among the first five civil rights sit-in cases decided by the Supreme Court in 1963.[79] Riley's memorandum on the legal issue was the basis for Nelson's brief in support of his application for a writ of certiorari to the Court.[80] Her interest in the civil rights struggle continued with the publication of two articles on the subject in the *Loyola Law Review's* Fifth Circuit Review in the early 1970s.[81] The second included a discussion of the Supreme Court's first Title VII sex discrimination case, *Phillips* v. *Martin Marietta Corporation,* and its precedent-setting constitutional sex discrimination decision, *Reed* v. *Reed.*[82]

Promotion to Full Professor

Riley's initial promotion to associate professor in 1961 did not carry tenure, although she did receive tenure while still holding that title in 1971. That means it took her fifteen years of full-time faculty service to attain a status that normally requires no more than six years for most faculty in any field. And in law, certainly as of the 1970s, that pre-tenure period was often much shorter.

She was promoted to full professor the following year, 1972, after the publication of the first edition of her casebook on Louisiana community property. She suspected that the delay had something to do with her sex, noting that even though "the law school was very slow about giving full professorships at that time," they were "maybe even slower in my case."

Acknowledging that "it's hard to say why" the school delayed so long, Riley recalled that "of course, I thought it was because I was a woman." But, Riley admitted, her own actions—or inaction—might have played a role in the delay. As she explains: "I didn't push for it." In fact, she didn't really understand that one had to apply for the promotion. She had assumed it was something automatically awarded after a certain number of years of satisfactory work. Once she understood the rules, she did apply.

Riley did not complain about her delayed promotion at the time, but she did complain about what she saw as the University's failure to compensate her on par with her male colleagues. For the three-year period 1966–69, Riley's stipend as Associate Professor without tenure was $12,000 per year. In 1968–69, the last year of the term, she was offered a new one-year contract for 1969–70 with a $500 raise to $12,500. She heard at the time that she was among those who had been offered the lowest raise. The following year, she was offered another one-year contract without any raise at all. She surveyed her colleagues and wrote a detailed five-page letter to Rev. Thomas H. Clancy, the Academic Vice President. Riley summed up her case concisely:

> Last year my raise was only one-half as large as that of many members of the law faculty; and this year none at all. This year, if I were given a raise comparable to those of most of the law faculty members, whether in dollars or on a percentage basis, I would still be relatively behind where I was year-before-last. Frankly, I had expected to be offered, not an equal raise this year, but more than those who were given twice as much as me last year, in order to undo the unequal treatment of last year—because there is no reason for the difference.

Clancy replied tersely and declined to change his position with respect to her salary. Nonetheless, Riley's one-year re-appointment as Associate Professor for the academic year 1970–71 carried a stipend of $14,000—an increase of $1,500.00. A new Vice-President for Academic Affairs, Rev. James C. Carter, took office the following year. Thereafter, Riley received another increase of $1,500 to $15,500 for academic year 1971–72, and was promoted to full Professor effective August 23, 1972, at a stipend of $17,750. By the time she retired in 1986, her salary had more than trebled, to $64,000.

Mentors

Initially, Riley was encouraged to study law by her Ursuline teacher, Mother Rita. When she finally began her legal studies, it was Professor Antonio E. Papale's course in Contracts that made her fall in love with the law. She later called him "the best teacher I ever had." When the time came for her to get serious about completing her law degree, it was Papale who buttressed her faltering resolve, telling her "You're biting off your nose to spite your face. Go ahead and finish it. Nobody in the world respects half a law degree."

His advice prompted Riley to speed up her studies, which took her to LSU's 1950 summer school session and her transformative meeting with Professor Harriet Daggett. The two women had met earlier, while Riley was attending meetings of the Louisiana State Law Institute as a Law Librarian. After a meeting in Baton Rouge, Daggett had invited a group to her home for drinks. Telling them that "A party is not much fun unless there is singing," she led them in singing hymns together.

Riley had been used to seeing Daggett at Institute meetings in a beautifully tailored, professionally styled suit. During the hot summer in a Baton Rouge classroom unrelieved by air conditioning, however, Daggett was less formal: she wore "dainty little pink or blue cotton dresses" to class. She also indulged her inveterate smoking habit, instructing her students to sit close by the classroom door so that she could toss her ashes and cigarette butts out into the terrazzo tile corridor rather than leaving brown stains by stamping them out on the classroom's cork tile floor.

Riley was impressed—and somewhat awed—by Daggett's teaching style, remembering Daggett as a "very, very imperious sort of a person," and recalling that she was "scared to death" of her:

> She was teaching Mineral Rights. I assumed she knew everything there was to know about it, because she had written the book on the subject. When we came to the geology of it, she had somebody from the geology department come over and give us a couple of lectures, with diagrams of underground pools and everything, which I found fascinating. As I drove back home each weekend, I would be looking for oil wells. It was a good experience.

Riley was inspired by Daggett's practice of bringing in outside lecturers, and she employed outside experts in some of her own courses, particularly

her innovative seminar on Juvenile Law. Riley organized the class so that the students would see what happened to a juvenile offender at first contact and then follow his or her progress through the system. She began with a policeman who was the arresting officer, followed by the social worker who did intake at the juvenile court, then the attorneys—an Assistant DA who prosecuted the case and the indigent defense counsel for the child—and a judge, finishing up with a child psychiatrist who worked with institutionalized children.

Riley was also influenced by Daggett's substantive approach to Louisiana's community property system. In her first presentation as a Reporter to the Louisiana State Law Institute in 1973, she credited Mrs. Daggett with the idea of equal management, noting that "It was way back in 1936 that Mrs. Harriet Spiller Daggett wrote an article entitled: Is Joint Control of Community Property Possible? No one has answered her question."

Influence on the Next Generation of Women Law Professors in Louisiana

Through their combined influence as teachers and scholars, Janet Riley and Harriet Daggett nurtured an extraordinary group of young women faculty in the four Louisiana law schools, a group of women who continued to work together and to befriend each other well into the twenty-first century. Although none of them had ever met Daggett, they were inspired by her work and felt her legacy, and they all knew Janet Riley personally and worked with her at various points in their careers.

The first of this group to begin teaching was Katherine Shaw Spaht, who graduated from LSU in 1971 and joined the faculty there in 1972, becoming the school's second woman law professor, after Daggett had retired in 1961. Both of Katherine's parents had been Daggett's students at LSU, and she grew up hearing stories about their "amazing" professor. Spaht took over Daggett's courses in Community Property, Domestic Relations, Estates, and Family Law, became a prolific author, and was active in law reform related to Matrimonial Regimes, Family Law, and Successions (especially during the battle over forced heirship). Riley's stu-

dent and research assistant, Kathryn Venturatos Lorio, came next. She graduated from Loyola in 1973 and joined the faculty in 1976. She specialized in the Civil Code topic of Successions and Donations (Estates), and also taught Comparative Law, Trusts, and Domestic Relations.

The third member of this group, Cynthia A. Samuel, graduated from LSU in 1973, the year after Spaht joined the faculty, and became the first woman law professor at Tulane in 1975. She taught Community Property, initially using Riley's casebook, and co-authored a book on *Successions and Donations* with Spaht. The fourth woman, Cynthia Picou, graduated from LSU in 1970, and spent six years in practice before joining the law faculty at Southern University in 1976. She also adopted Riley's *Community Property Casebook*, and she joined the second edition of Samuel and Spaht's *Successions and Donations* book as a co-author in 2000.

Riley embraced her role as a trailblazer for other women. As she remembers, she was "so grateful" when Lorio joined the Loyola faculty, and "welcomed her with open arms," feeling true "joy to have somebody else there, with the same kinds of problems." Riley also delighted in her association with Katherine Spaht and Cynthia Samuel; as she modestly put it, "Women law professors will not really be equal until we are free to be mediocre, as I think I was. But not one of the three of them would ever fit that category."

Although two other women—Lynne Rothschild Stern and Ellen Thomas—had briefly joined the Loyola faculty after Kathryn Venturatos Lorio graduated in 1973, Riley was the only woman faculty member there when Lorio returned as an Assistant Professor in 1976. Lorio felt "very comfortable being the junior woman on a faculty that had one senior woman," recalling that Riley "was not like women I've seen so many times during the years in different places: sort of a Queen Bee." Instead of feeling threatened by another woman on the faculty, Riley "was really supportive in whatever she could do to tell me how to do things, and in sharing her experiences at the school and with the legislature."

Cynthia Samuel, the first woman law professor at Tulane, credited Riley with taking her under her wing and introducing her to the process of legislative reform. Samuel recalled meeting Riley shortly after she was hired at Tulane:

I joined the Tulane faculty in 1975, and I think it was in the spring of 1976 that I saw a notice that Professor Riley was going to speak at the Newcomb College Women's Center on a proposed scheme for revising the Community Property Laws. I knew who she was, because we had read her writings when I was a law student, but I had never met her. I wasn't teaching Community Property yet, but I planned to do so in the future, because it was my interest. So I went to hear her talk and then I introduced myself to her. She was so delighted to meet me. She knew Tulane had hired a woman. At that time, we were the only two women law teachers in New Orleans, because Kathy Lorio was hired the year after me.[83]

Riley quickly brought Samuel into the project of reforming Louisiana's community property laws, first inviting her to a Louisiana State Law Institute meeting. Samuel was impressed by Riley's influence and skill:

A lot of Janet's former students were legislators, and when she sat down to testify before them, they just listened to her. And it was obvious that she had some clout up there, just this one woman, by virtue of having taught these legislators. There were two in particular that she knew well: A. J. MacNamara, a member of the House of Representatives, and Tom Casey, a Senator. She had spent hours briefing them, and she had a bill drafted that was her equal management plan. That was important, because they had something concrete that they could look at. I've found since then that when you talk to legislators, if you don't like what's before them, you don't get far unless you have something else to offer. She did have something else to offer, and it was pretty clear that she had the ear of some important legislators.

Retirement and Honors

Cynthia Samuel and Kathryn Lorio planned a testimonial dinner for Janet Riley when she retired. It was held in a hotel in New Orleans in fall 1986 and was attended by about 150 guests. Several of her illustrious former students spoke, including Louisiana Supreme Court Chief Justice Pascal F. Calagero, Senator Tom Casey, and former New Orleans Mayor Moon Landrieu.

After her retirement, Riley offered a seminar each semester for two years "for free, as a part-time volunteer teacher," because Loyola had a policy of not paying part-time teachers. She continued this service to the school on a reduced basis of one seminar each year for another eight years until 1996. In 1997, she taught the common law family law course in her

eleventh year of retirement. Her career as a faculty member at Loyola thus spanned forty-one years.

Riley earned many honors in recognition of her exemplary life and contributions to the institutions she served. At Loyola's homecoming weekend in 2000, she received the Adjutor Hominum Award, presented annually to an outstanding alumnus of the University whose life exemplifies "moral character, service to humanity, and unquestionable integrity." She and some of her colleagues established the Janet Mary Riley Distinguished Professorship in Law at Loyola Law School in 2002, honoring excellence in teaching and public service. On January 16, 2004, she received the St. Ives Award, named after the patron saint of lawyers and presented annually by the Law School Alumni Association to a law graduate who has volunteered services to the law school or the University, maintained the highest standards of the profession, and furthered the mission of the Alumni Association. Loyola Law School also accorded her its highest respects: it conferred upon her an honorary degree in 2005.

Janet Riley died of pancreatic cancer in the Chateau de Notre Dame Nursing Home on July 8, 2008, at the age of 92.[84] A memorial mass was held for her at Our Lady of the Holy Rosary Church, followed by a memorial service at the Law School on August 22, 2008. Kathryn Lorio, her protégé, colleague, and close friend, delivered one of the eulogies.

HELEN ELSIE STEINBINDER

Helen Elsie Steinbinder was born in New York City on December 8, 1922, to parents of Austrian-Hungarian ancestry. She had one younger sister, born in 1927. Steinbinder attended a Catholic women's college, Manhattanville College of the Sacred Heart, then located in New York City, where she majored in German and History and earned a BA in 1944.[85] For the next six years, she experimented with traditional women's careers in teaching and librarianship, initially settling on librarianship. She enrolled at Columbia University, where she acquired two degrees: an MA in Teaching of History from the Columbia Teachers' College in 1949 and an MS in Library Science from the Columbia Library School in 1950. During these years she taught at Manhattanville and New York City High

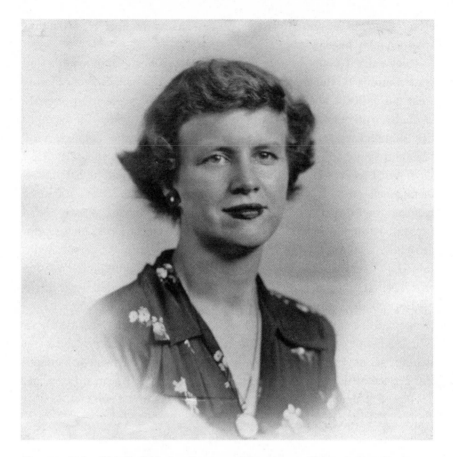

Figure 9. Helen Elsie Steinbinder. Courtesy of Georgetown University Law Center.

Schools. After receiving her MLS with distinction, she began her library career working as a special recruit at the Library of Congress.[86]

Legal Education

In 1951, Georgetown Law School, which had limited its student body to men since its inception in 1870, issued a momentous announcement headed "College Women to be Admitted."[87] Harvard Law School had come to the same decision a year earlier.[88] The action was not universally welcomed at either school.

Eight women, including Helen Elsie Steinbinder, responded to Georgetown's 1951 invitation to become law students. Because she was working at the Library of Congress during the day, Steinbinder enrolled in the late afternoon (evening) classes. During her first year, she and four of her classmates, Walter Bonner, John Bruce, Jim Knight and Howard Levine, formed a study group that lasted until they graduated.[89] All of the men had military experience, all were working, and some were beginning families. Bonner recalled that the group was inspired by Steinbinder's belief that the best way to prepare for exams was to "do it in a group." He noted that the men, accustomed to command roles in the military, had never been "under a woman's tutelage, other than perhaps schoolteachers or our own mothers." But they adjusted, and they came to appreciate the discipline that Steinbinder imposed.

The law school grind was relentless, as Bonner remembers: "leave school, go home and study until the wee hours of the morning, get a few hours' sleep, get up and go to work, then go to school." Bonner reiterated that this routine would have been impossible without Steinbinder: "She had more energy than all of the men put together, and she was really the mortar of the bricks in this effort." Despite holding a full-time job, Steinbinder was also active in student activities, becoming President of the Charles Keigwin Law Club and Dean of the Beta Mu Chapter of the Kappa Beta Pi International Law Sorority. She was also appointed as Associate Editor of the *Georgetown Law Journal*.[90]

Steinbinder was the first woman to graduate from the evening division, earning her LLB in February 1955. She was an excellent student, winning the prize for having the highest standing in her class. Steinbinder completed her legal training and earned her fifth academic degree by enrolling in the Georgetown LLM program. In 1956, she and an African American woman, Mabel Dole Haden, became the first women to receive LLM degrees from Georgetown.[91]

Family Life

Steinbinder, like Miriam Rooney and Janet Riley, never married. Like them, she was deeply religious; she attended mass daily and was a daily communicant. She lived alone in a small apartment on Capitol Hill near

the US Supreme Court building.[92] Her father had died several months before she graduated in June 1955. She was close to her mother and to her sister, nieces and nephews. Walter Bonner kept in touch with her, and he and his wife invited her often to their home for dinner.

Appointment at Georgetown Law School

In January 1956, while studying for her LLM at Georgetown University Law Center, Steinbinder was hired as Research Librarian there. Her duties included assisting professors in finding source materials, aiding students, and revising the library card catalogue.[93]

In February 1957, Steinbinder joined the Georgetown Law faculty as its first woman professor of law.[94] She has the distinction of being the only one of the first fourteen women law professors who was both a member of the first class of women students admitted to her school and the first faculty woman appointed there. Paul Dean, the dean at Georgetown, recalled that the circumstances of Steinbinder's hiring as Research Librarian, and then as Professor of Law, focused more on her abilities than on her gender. Later, when considering whether to bring Steinbinder on as a professor, Dean couldn't recall any discussion about "how unusual it would be to have a woman on the faculty." Instead, he remembers, "She had such a fine mind and she had impressed everyone, and we thought we could use her as a professor."

Steinbinder went from being a "Research Librarian" to "Professor of Law." Although the idea of tenure was clearly present, Dean said that it "was not articulated very well at that time." Steinbinder was appointed as simply "Professor," and was "grandfathered" into tenure—as was Dean himself—when Georgetown University implemented a university-wide retirement plan.

Nor did Dean believe that there was a salary differential between Steinbinder and the other newly appointed faculty. He said that Father Lucey would have set her initial salary, and his practice was to place this at about $250 or $500 per year more than the going rate for law clerks in the federal US Court of Appeals for the District of Columbia Circuit.

Teaching and Research at Georgetown

Steinbinder's first courses focused on property. David McCarthy took Real Property I from her in 1957. He remembered Steinbinder as "competent," but noted that she did not stand out among Georgetown's faculty as a classroom teacher. McCarthy speculated that Steinbinder "seemed to be striving to be masculine, as if she wanted to teach the way the boys taught, and that was how she came across."[95]

Paul Dean, who had hired Steinbinder, came to the conclusion that she was better suited to small classes than to large ones:

> She was fine in smaller classes. . . . Those kids would just love her. But the larger classes bothered her. She evidently did not come across quite as warm in a large group as she would with a small group.

Steinbinder spent a year as a Visiting Professor at the University of Oklahoma in 1968–69. She did well there as a classroom teacher, so much so that Oklahoma gave her a permanent offer. She declined, saying she did not wish to leave her mother and sister to move to Oklahoma.

After her return, McCarthy, who was then the Associate Dean, decided to capitalize on her successful experience by giving her the first-year course in Real Property. He soon realized, however, that "it was not one of my wiser choices." The (predominantly male) students were soon in McCarthy's office, complaining of Steinbinder's disorganization in the classroom.

Steinbinder's elective courses in Conveyancing, Land Use, and Community Property were successful, however. She also excelled in working with individual students. McCarthy reported that she was a "real resource" to him as Dean, because he could refer students to her who were "in trouble academically, or otherwise," and she would work with them and tutor them.

Unlike most of the other early woman law professors, Helen Steinbinder did not publish anything. In this, she was not alone among her colleagues. When she began teaching in the late 1950s, the School's primary emphasis was on classroom teaching, and full-time faculty typically taught twelve to fifteen hours per week.[96] In contrast, the normal teaching load today in

most major law schools is five or six hours per week—a schedule that leaves ample time for an entry-level professor to undertake the research and publication required for promotion to tenure and subsequent salary advances. At Georgetown, the transition from an institutional focus on teaching to one on scholarly publication began in the 1960s and gained momentum in the mid-1960s. She may not have fully adjusted to the new tenor of the school.

A World of Men

Helen Steinbinder was the sole female faculty member at Georgetown for over fifteen years, from January 1957 until the fall of 1972, when Judith Areen, who would later become Georgetown's first female dean, joined the tenure-track faculty. Areen recalled her first impressions of Steinbinder: "Her style was almost the bluntness of someone who feels excluded; she isn't going to be quiet; but she's also not optimistic that people will agree with her."[97] David McCarthy elaborated, noting that "She would get emotionally involved in institutional issues to the point where she would let herself go." Her male colleagues might have "assigned that emotional content to gender." Professor Patricia King, the first African American law professor hired at Georgetown, recalled that by the mid-70s, Steinbinder's tendency to be "snappish" at faculty meetings had alienated her from many of the younger faculty members.[98]

Helen Elsie Steinbinder retired from Georgetown on June 30, 1988, at the age of 65. Both Paul Dean and David McCarthy spoke at her retirement luncheon. Paul Dean described her appointment in 1955 as one of his "successes" as dean and lauded Steinbinder as a "trailblazer" not only at Georgetown, but across the nation. In his speech, David McCarthy emphasized the many contributions Steinbinder had made to the school, particularly her work on the Financial Aid Committee and her one-on-one tutoring of students. He also credited her with having been one of the early faculty to become involved in clinical teaching.

Helen Steinbinder lived in a world of men at Georgetown for over half of her thirty-seven years there, first as a student, then as a librarian, finally as a professor. In her early years on the faculty, her students were almost entirely men. Although none of the young women who were her colleagues thought of her as a role model for their own careers, in a very real sense,

they stood on her shoulders. Steinbinder herself was more and more isolated toward the end of her teaching years, but she did not turn her back on the institution before she retired. After she left teaching, she went to live in New Jersey, where she died on July 2, 2015, at the age of ninety-two.

MARIA MINNETTE MASSEY

Maria Minnette Massey was born in Oakland, California, on May 5, 1929, the third of six children. Minnette's mother, Una Lee Tucker, was born on July 4, 1895, in Nashville, Tennessee. She left school to go to work, eventually becoming Executive Secretary to the First Vice President of Dupont in Wilmington, Delaware. There she met Minnettte's father Augustine Herman Massey, and they were married on June 4, 1921.

The family lived together in a large old home in Stratford, Connecticut, which featured a basement fitted out as a recreation room where the children entertained their many friends. Although there was a fourteen-year spread between them, the six children were very close to each other and to their parents. Minnette did not recall any sibling rivalry or competition among them, and felt that, in times of need, everyone made themselves available.

Minnette Massey finished high school in Connecticut. She excelled in her studies, making the National Honor Society. She was homeroom president of her class all the way through high school. She then attended Dickinson Junior College (later Lycoming College) in Williamsport, Pennsylvania, for two years, earning an AA degree in 1947. As she was about to begin her third year, her father decided she should go to Florida to join her older sister, Una Lee, who was studying drama at the University of Miami. Her father also advised her to go to law school. Dean McCracken of the Business School agreed and recommended that she take the BBA to finish her undergraduate degree before entering law school. She did it in one year, graduating in 1948 with a double major in Government and Marketing.

Legal Education

Massey entered law school at the University of Miami in the summer of 1948. She took a six-hour course in Contracts from a "marvelous" teacher,

Figure 10. Maria Minnette Massey. Courtesy of University of Miami Law School.

Professor Thomas A. Wills. Like Janet Riley, she was swept away by her total immersion in Contracts, and thought it was a wonderful way to introduce students to the study of law. In 1949, Massey attended summer school in Madison, Wisconsin.

Massey spent the summer of 1950 in Switzerland conducting postgraduate work at the University of Fribourg. She and a student from the University of Michigan, Fred Sumner Howard, had some "marvelous experiences" climbing mountains on the weekends. Toward the end of the summer, they climbed the Matterhorn together. As they sat atop the mountain on August 6, 1950, eating Swiss chocolates, a British-Swiss team of mountain climbers came "huffing and puffing" up to do the first worldwide wireless broadcast from the top of the Matterhorn. When they found two "daffy American students"—Massey and Howard—already there, they quickly included a spontaneous interview with them in the broadcast. Much to Massey's surprise, the broadcast, including the interview, was actually heard around the world, and the event was written up in the *New York Times* and the *London Times*.

Massey's summer school courses at Miami and Wisconsin provided an extra semester's worth of credits, giving her enough credits to graduate by the spring of 1951. She received permission to enroll in the College of Arts and Sciences at Miami during her final semester, where she took courses toward an MA in Government with a minor in Economics. She earned her LLB from the Law School in 1951, and was elected to the Wig and Robe Legal Honor Society. She completed her MA in 1952, with a thesis on "Soviet Concepts of International Law"—a controversial topic at the time, which was not published.

Appointment as Assistant Law Librarian and Instructor in Law

During the summer of 1951, Massey was at home in Connecticut finishing her master's thesis when she received a telephone call from Dean Russell A. Rasco of the University of Miami, inviting her to join the faculty as Assistant Law Librarian.

Massey first declined the offer, but her father called the dean back to tell him that his daughter would accept the appointment. Massey's formal title was Assistant Law Librarian and Instructor in Law. Her classmate, George Onoprienko, who had worked in the law library as a student

assistant during law school, was hired at the same time with the same title.[99] Neither Massey nor Onoprienko held a library science degree.

The Law Library Director, Harriet French, to whom Massey and Onoprienko reported, was a lawyer who had graduated from West Virginia College of Law in 1930 and had come to the University of Miami in 1947. To Massey, French was the role model of what a law library professor should be. For many purposes, French was treated like the rest of the faculty, attending faculty meetings and social gatherings; French did not, however, teach substantive courses or vote on faculty appointments.

Massey and Onoprienko were each assigned to teach sections of French's course in Legal Bibliography, which was offered in both the day and evening divisions. Massey also taught Moot Court and Research and Briefing. In addition, she coached the moot court team. Her duties in the law library included devising the cataloging system, and she was basically left alone to do what needed to be done without much interference from either the Dean or the Law Library Director.

Massey was an active member of the AALL, serving as Secretary-Treasurer of its Southeastern Chapter in 1956–57. In preparation for a paper on the relationship of the law library to the law school and the university, she took the occasion of the June 1956 AALL annual meeting in Philadelphia to conduct a survey of the law librarians in attendance concerning such issues as "the law library salary level, the law librarians' status, and the[ir] internal workings and preferences in a representative group of law schools."[100] Supplemented with a mailing to librarians not in attendance at the meeting, her survey contained data from forty-two law schools, about 38 percent of the 110 ABA-accredited law schools in 1956.

Her resulting paper, "Law School Administration and the Law Librarian," is one of the earliest empirical studies of law librarians and law libraries. Among other findings, Massey's data on "remuneration" unequivocally confirmed what was uniformly believed by law librarians: they were paid less than regular faculty. She wrote that "among the twenty-nine law librarians with faculty status, the average salary is $1,100 below that of the law teachers."[101] She also documented a clear case of sex discrimination in salary levels, noting that while nine out of forty-two law librarians received more than $9,000 per year in salary at the time of Massey's survey, "not one of these is a woman."

Virtually all of the law school librarians surveyed had classroom teaching responsibilities. Of those without faculty status, half taught legal bibliography, and twenty-eight of the twenty-nine librarians with faculty status taught at least one course that encompassed legal research.[102] In addition, "a substantial number" were assigned by their deans to teach substantive courses.[103]

Massey made a call for the AALS to improve both the position of the law library and the status of the Law Library Director. While crediting the Association of American Law schools for "half a century" spent "concern[ing] itself with the law library problem of our schools," she contended that this "concern" had been at least partially misplaced, being "far more concentrated on the number of volumes to be acquired than on the development of a professional field of law librarianship that will attract competent personnel." She concluded with a plea for increased recognition that the law library—and the law librarian—were critical to the functioning of a successful law school.[104]

To ensure that her critique would reach its intended audience, Massey published it in 1957 as a *Comment* in the *Journal of Legal Education,* the official publication of the AALS. She had presented it earlier at the Summer Workshop for Law Teachers at New York University Law School (NYU) in 1956. In the same year, Massey applied for and received a Thadeus D. Kenneson Scholarship at NYU Law School. She attended three twelve-week summer sessions there in 1956, 1957, and 1958, participating in a program sponsored by the Ford Foundation for law teachers leading to the LLM. It featured distinguished professors from Columbia, Oxford, and Cambridge, as well as NYU. Massey was the first, and may have been the only, woman admitted into the program. She loved it, and particularly enjoyed her exposure to such a distinguished faculty.

Appointment to the Law Faculty

In 1958, Minnette Massey received her LLM degree from NYU. Shortly thereafter, she left the law library to join the law faculty as an Associate Professor of Law with tenure. She was asked to teach Federal Jurisdiction, an opportunity she welcomed, considering it her first real substantive course. However, a complete transfer from the library to the faculty was

not what Massey had originally envisioned. She saw herself doing both. She wanted the faculty appointment, yes, but she loved the library. Harriet French, the Law Library Director, on the other hand, declared that Massey could not do both. Massey did not want to challenge French. Therefore, the change to faculty status only was effective immediately.

Family Life

Minnette Massey and George Onoprienko married in 1959 and divorced in 1980. They did not have children. In Massey's view, neither their marriage nor their divorce affected their professional careers, which they were careful to keep separate from their personal lives. After the divorce, Onoprienko remarried, but Massey did not.

Interaction with Students

Massey was an extremely popular teacher. In 1959, after her first full year of teaching as a regular member of the faculty, and again in 1965, she received the "Best Law Prof" Award from the Student Bar Association. By the late 1960s, she had settled down to what became her signature package: Federal Jurisdiction, Civil Procedure, Pleading, and Moot Court.

Taylor Mattis took Massey's Civil Procedure I course in 1961 as a second-year student. She thought Massey was an "excellent" teacher, and she admired the way that Massey was "able to achieve the level of preparedness she wanted from her students without any kind of intimidation." Mattis noted that Massey "has the largest fan club of any professor I have ever known," as evidenced by the "mob scene" surrounding her at every homecoming breakfast.[105]

From 1952 through 1977, Massey served as the faculty advisor to Miami's extensive Moot Court program, successfully guiding its teams to victory at both the state and national championship levels.[106]

Research and Publications

As we have seen, Miami instituted a formal requirement of faculty scholarship in 1958–59, the year that Massey shifted her appointment from the

law library to the regular faculty. She had no problem with the new policy, for she was already accustomed to research and writing. In addition to the 1957 piece on *Law School Administration and the Law Librarian,* Massey had published an article on *Congressional Investigations & Individual Liberties,* which examined the tension between the Congressional power to investigate and the rights of a witness summoned to appear before a Congressional committee.[107]

Massey also authored four book reviews, including one published in the *Howard Law Review* in 1957 of Professor Ervin H. Pollock's work, *Fundamentals of Legal Research.*[108] She published a critique of the 1958 amendments to the Judicial Code.[109] This noted with approval those designed to alleviate delay and congestion in the federal courts, including increases from $3000 to $10,000 in the jurisdictional amount for diversity cases; adding "principal place of business" to "state of incorporation" as an additional measure of corporate citizenship; and prohibiting the removal to federal court of cases filed in state court under worker's compensation laws.

The editors of *The University of Miami Law Review* began publishing a biennial Survey of Florida Law in 1954, covering the work of the state courts. The various subject-matter topics were covered by Miami students in the beginning, but as time went on, members of the Miami Law faculty began to participate. Massey's first contribution, to the fifth Survey, covered Civil Procedure and appeared in 1962. Massey later became a regular contributor.[110] Each of her articles is a comprehensive, yet concise, presentation of the work products of the Florida courts, and occasionally the Legislature, in the field.[111] Minnette Massey was also a contributing editor to the journal *Lawyer of the Americas,* and was responsible for its report on legal education, which appeared between 1969 and 1972.

Massey's most significant publications were her civil procedure books. These included *Civil Procedure* (2 Volumes) (1971); *Florida Civil Procedure Handbook* (1973); *Florida Civil Discovery Manual* (1979), and *Discovery in Florida* (with Federal Cross Referencing) (1985). She also wrote two chapters—Chapter 14 on "Process and Appearance," and Chapter 18 on "Defaults and Default Judgments," in *Florida Civil Procedure Before Trial* (4th ed. 1983). Finally, she co-authored, with Valera Grapp, thirty-six chapters of *Florida Keystone Lawyer's Desk Library of Practice,* 2 Vols. (1990), with a 2003 *Supplement.*

Assistant and Acting Dean

In 1961 Wesley Sturges accepted the deanship of the Miami Law School. One of his first official acts was to appoint Massey his assistant dean, effective July 1, 1961. Dean Sturges treated Massey's appointment as a national event. The university's official press release, which was repeated in the news accounts, quoted him as saying that Massey was "one of the few women law deans in the country and the only one holding a deanship in member schools of the Association of American Law Schools."[112]

Massey enjoyed working with Sturges. He gave Massey significant freedom and responsibility, and, she noted, he was the best possible role model an aspiring administrator could have. "Just to watch him was a joy," she remembered. "His administrative ability was just superb. His writing skills were magnificent. His people skills were magnificent."

Sturges held the Miami deanship for less than two years. He died of cancer on November 9, 1962. Minnette Massey was named Acting Dean in 1962, the same year she was promoted to full professor, and held the administrative position until July 1, 1965. Massey managed the affairs of the law school for three years without the help of an Assistant Dean and while continuing to teach her courses. After a drawn-out search, Fred D. Lewis, the Dean of the Missouri, Kansas City, Law School was recruited. Lewis was appointed without a faculty vote, and Massey, who did not know him, learned of his appointment the night before he arrived.

The Women at Miami

Remarkably, three of the fourteen early women law professors discussed in this volume were on the Miami law faculty. Jeanette Ozanne Smith and Maria Minnette Massey, both Miami graduates who spent their entire careers at the school, were each hired by Dean Russell A. Rasco. Asked if she could explain why two of the first eight women law professors were at Miami, Massey attributed it to the "tremendous tolerance" of Richmond Rasco, the first Dean of Miami's law school, and his son, Russell, who became acting Dean in 1931 and full Dean in 1935. Massey never felt any discrimination from Dean Rasco, the faculty, or the student body, and she highlighted how special her experience at Miami was by describing what

happened to her when she visited the University of Florida as Miami's Acting Dean in the early 1960s:

> Frank Maloney, the Florida Dean, was proudly showing me the new addition to their law library. As I walked into the library, the students started shuffling their feet. Of course, I knew what was happening. I had had students who were undergraduates at Florida, and they told me it was common practice there for the students to shuffle their feet whenever a woman recited in class. And of course, Frank turned absolutely red, and he stammered out an apology. I said, 'Frank, don't apologize to me. But the good old boys of Florida pride themselves on being gentlemen. Don't you think it's time you taught them what the word means?' Frank and his all male faculty had always thought it was kind of cute. Nothing like that ever happened at Miami.

Soia Mentschikoff, the third woman faculty member hired at Miami, had visited sporadically since the late 1960s while still a Professor of Law at the University of Chicago. She became Dean at Miami in 1974 and ended her career there when she took emeritus status in 1983. Finally, Harriet French, the Law Library Director, was treated by her colleagues as though she were a member of the faculty. This concentration of women at one school was unparalleled when it occurred, and was not repeated until AALS member law schools were encouraged to seek out women for the faculty by the Association's 1970 policy requiring them to refrain from discrimination on the ground of sex.

There is no evidence to suggest that the presence of these women at Miami was the result of any special effort on the part of the school to reach out to women. Nor were all four women at the school at the same time. Minnette Massey is the only one whose tenure overlapped and extended beyond that of the other three. Harriet French was the first to arrive, in 1947, and her appointment as Law Library Director was not at all unusual. As noted earlier, Jeanette Smith—the first women to be appointed to the law faculty in 1949—had limited geographical mobility because of her husband's position and was looking for something interesting to do while raising their three children. It was a natural move for her to apply to her nearby alma mater, where she had compiled the highest grade-point average in the school's history. Minnette Massey was recruited by Dean Rasco to be Assistant Law Librarian and Instructor in Law in 1951, also

a familiar post for a woman law graduate at the time. What was unusual was Massey's departure from the Law Library in 1958 to join Jeanette Smith as the second female member of the regular faculty.

The Miami women did not bond together as women, nor did they see their sex either as significant or as an impediment. Like others of the pre-World War II generation, they considered themselves "lawyers," not "women lawyers." Although they came together at Miami, each of these women had achieved individual success without other women either as role models or as mentors. There were no women on the Miami faculty when Jeanette Smith was a student. Harriet French chose a conventional career as a law librarian, but she had served in the Waves in Alaska during World War II. Smith was on the faculty while Massey was in law school, but the two had no contact and Massey was "unaware" of her presence. Massey's appointment as assistant law librarian apparently was made by Dean Rasco without consultation with Harriet French. Smith and Massey were Mentschikoff's first female faculty colleagues, but their relationship to her was that of faculty members to a dean, rather than that of fellow teachers. Only two women joined the Miami faculty while Mentschikoff was dean, and both left without tenure. Mentschikoff had criticized law schools in the early 1970s for their haste to recruit faculty women, a practice she predicted would lead to unwise appointments and make it even more difficult for better qualified women to be hired later.

Activities and Honors

Throughout her career, Minnette Massey was an active participant in the affairs of the law school, the University of Miami, legal education, and the legal profession.

In 1982, Massey was appointed to serve on the National Collegiate Athletic Association (NCAA) Infractions Committee for a term of nine years. One of its better-known decisions during Massey's term was its 1987 imposition of "the death penalty" on Southern Methodist University, which resulted in the permanent suspension of its football team because of recruiting violations.[113]

Massey was an elected member of the American Law Institute, and regularly attended its annual meetings. In addition, Massey was a member of

several prestigious Honorary Organizations. She also joined the American Judicature Society. In 1998, the University of Miami Law School honored her with the establishment of the M. Minnette Massey Endowed Chair.

Retirement

Massey held her last class at Miami on April 24, 2008. The University of Miami Law School held a retirement reception during homecoming weekend, on October 23, 2008. There were no speeches, only toasts to the remarkable woman who had become the eighth of the first fourteen early women law professors when she began her career in 1951, and was the last of them to retire after fifty-seven years of devoted service to her students, her school, and her community. She died eight years later at the age of 89.

5 The Mid-Fifties

ELLEN ASH PETERS AND DOROTHY WRIGHT NELSON

Women law professors preceded women judges, but only barely, and the first women to become judges did not have their roots in academia. Barbara Nachtrieb Armstrong was appointed to the Berkeley faculty in 1919, and Florence Ellinwood Allen, the first woman judge to be elected to a state court of general jurisdiction, took her seat on the Cuyahoga, Ohio, County Court of Common Pleas in 1920.[1] Two years later, she became the first woman to serve on a state high court when she was elected to the Ohio Supreme Court.[2] Allen was later appointed to the federal court of appeals for the Sixth Circuit in 1934. Two of the first fourteen women law professors were appointed from academic positions to court positions, one (Ellen Ash Peters) to the State's highest Court, the Supreme Court, and the other (Dorothy Nelson) to the United States Court of Appeals for the Ninth Circuit. Here are their stories:

ELLEN ASH PETERS

Ellen Asch, as the family surname was spelled, was born in Berlin, Germany, on March 21, 1930. Her father, Ernst Eduard Asch, grew up in

Figure 11. Ellen Ash Peters. Courtesy of Yale University.

a town called Posen, located in the part of Germany that became Polish after World War I.[3] Like his father before him, Ernst was a practicing lawyer. Her mother, Hildegard Simon, was born in Berlin in 1905. Music was her great passion. Ellen was their only child. She had a half-sister, Renate, a daughter of her father's prior marriage.

The family remained in Germany until September 1938, long after many other Jews had left, because, she recalled, "There were many people who said they would protect my father, always with the best of intentions, and all quite mistaken." Ellen pointed to a single incident that, she believes, saved the family from the worst of the Nazi regime:

> We were finally, I think, saved because both my parents were arrested and held overnight early in September of 1938 and rescued the next morning by friends. It was clear they couldn't do that twice. Within a couple of weeks we were out of the country and in the Netherlands awaiting visas.

The family spent over a year in Amsterdam. Because Ellen, her mother, and Renate were German-born, they were on the German

visa list, but her father's status was unclear. In 1939, Ernst Asch had been unable to obtain a visa, and the family decided that Ellen, Renata, and Hildegard would travel to the United States without him. The three of them sailed on the S.S. Valendam, arriving on December 30, 1939. Soon, Ellen's mother located an apartment on Riverside Drive on the corner of 101st Street overlooking the river. The family lived there for many years.

Ernst Asch finally arrived in New York in September 1940. Ellen explained that even if her father had wanted to become a lawyer in the United States, "the money was not there" to support the family for five years while Ernst obtained the necessary legal training. Instead, Ernst Asch became a registered investment advisor, although Ellen chided him over the years for practicing law without a license. Ernst and Hildegard Asch became naturalized United States citizens, at which time her father changed the spelling of his name to Ernest Edward Ash; Ellen Ash became a "derivative citizen" in 1947 at the age of seventeen.

Ellen attended P.S. 179, a neighborhood public school three blocks from their home. Her parents then discovered the Hunter College Elementary School, and she tested into the eighth grade. Hunter had begun as a teacher training school, and the elementary school was progressive. Ellen went on to the Hunter College high school, an all-girls high school limited to gifted students that was attended by girls from all over New York City. In spite of its "elegant" Park Avenue location, the school was racially and socioeconomically integrated. In contrast to its namesake elementary school, Hunter College High School was not "experimental"—rather, it involved "lots of memory work, lots of homework, [and] very little choice in what you took."

Ellen entered Swarthmore College in 1947. In her experience, Swarthmore combined the "prodigious" support mechanisms of a smaller school with the challenges and independence of a larger environment. The faculty was accessible, and teachers were "critical and supportive at the same time which is about as ideal as it's going to be." Ash met her first husband, Robert H. Peters, Jr., at Swarthmore. They planned to marry after they had both entered professional school: he in medicine, and she in law.

Legal Education

Ellen Peters candidly described her decision to study law to a Yale audience in 1984 with the comment, "As best I can recollect, I found myself thinking about becoming a lawyer, at an early age, because my father and my grandfather had found the law a fulfilling profession—and because I was too ignorant to know that women could not become lawyers."[4]

More surprising than Ash's decision at thirteen to become a lawyer was that, as she put it, "I foresaw no obstacles whatsoever to this career choice. Indeed, it never occurred to me that a young woman in mid-century America should not aspire to become a lawyer."

Political Science professor J. Roland Pennock acted as Ash's good friend and advisor. In 1951, Ellen discussed her law school plans with Pennock, who strongly advised her to go to Yale rather than Harvard. He thought that the kind of experience Yale offered was more akin to the intellectual values that Swarthmore represented. They never discussed the fact that Harvard had not admitted women before 1950, and this unspoken topic illustrated one of the few disadvantages of Swarthmore's training:

> I came out of Swarthmore thinking I could do anything. It wasn't going to be a problem. There was just no sense at all that women were going to have different professional challenges than men.... It was a very unrealistic enclave from that point of view.

Ash's fiancé, Bob Peters, had applied for admission and scholarships to the medical schools at Harvard and Yale. He got a scholarship to Yale, but not to Harvard, so that determined the outcome for both of them. Ash reported, "I went happily to Yale." She entered in fall, 1951, one of twelve women in a class of two hundred students. The class of 1954 was unusually large, because the Korean War had begun in 1950 and the school anticipated that many of the men would be drafted and drop out.

Ash's mentor, Professor Grant Gilmore, remembered her as one of his best students, but also found that her classroom performance had an "annoying" downside: "She was quite capable, when asked a question, of answering not only the question posed but also the next four questions that I was going to put. I finally had to order her to say nothing more in class."[5]

During her first year, Ash lived in a dormitory where women from all the professional schools lived together. Ash enjoyed being around other women who were not studying law. Her best friend was a music student, and she enjoyed the respite their friendship offered of talking about something other than law. In the spring term, the first-year students with the highest grades were given staff positions on *The Yale Law Journal,* and Ash, with the highest standing in the class, was easily admitted.

Family Life

Ellen Ash and Bob Peters had decided to marry after each had successfully completed the initial hurdle of their respective professional studies: she had finished the first year of law school, and he had "finished the cadaver" in his medical school anatomy studies. The wedding date was June 5, 1952. The couple set up housekeeping in a Quonset hut that rented for $44 per month. Ellen was beginning to find her chosen field under the guidance of Professor Grant Gilmore in commercial law. That summer she worked as a research assistant on a book for Professor Ralph Brown. Brown remembered Ellen Peters as "a ball of fire: she pitched right in and was a great help."[6]

In general, Peters found that she preferred the business-oriented courses. She took many commercial courses, including Corporations, Reorganizations, Bankruptcy, and some Tax. By the time she was in her third year, she chose—admittedly somewhat stubbornly—to avoid the areas into which women were sometimes shunted in practice, particularly Family Law and Estates and Trusts. All in all, her law school experience was an excellent one, and she thought the Yale Law School was "a very intellectually lively" place.

Early Employment and Appointment at Yale

Ellen Peters graduated from Yale with her LLB cum laude in 1954, won the prize for being the top student, and was elected to the national legal honor society, the Order of the Coif.[7] Since her husband had another year of medical school to complete, she applied for a job as a law clerk. She

interviewed with both Judge Charles E. Clark—a former Dean of Yale Law School—and Judge Jerome Frank for clerkships. Both offered her positions, and she chose to clerk for Judge Clark on the United States Court of Appeals for the Second Circuit. Peters felt she had clearly made the right decision; she recalled she had a "sensational year" clerking for Judge Clark.

The couple relocated to California for a year because Bob Peters had accepted an internship in Internal Medicine at the University of California Moffitt Hospital in San Francisco. Bob was eager to consider California as a possible place for the family to settle. Ellen took a temporary position as an Associate in Law at UC–Berkeley's Boalt Hall. They lived two blocks from the hospital in San Francisco, and Ellen learned to drive by commuting across the Bay Bridge to Berkeley.

The Associate in Law program had begun in 1950–51. Three Associates were hired each year. In the fall term, their responsibilities were to teach the incoming students how to brief cases and take notes in class, and, in addition, to supervise their initial legal writing exercises and some Moot Court experiences. As time permitted, they were on call to work for faculty members who needed research assistance.

By the spring term, Bob Peters had decided to accept a residency at the Veterans Administration program as part of Yale's three-year residency in psychiatry, so Ellen Peters started her job search with law firms in New Haven. She wrote to some New Haven law firms, and to Professors Ralph Brown and Grant Gilmore at Yale. She recalled that Brown wrote back, saying, "Don't be discouraged. We may be able to find an honorable position for you at Yale."

Ellen Peters was not particularly encouraged by this suggestion. The possibility that Brown might be referring to a faculty appointment never occurred to her. But soon, Peters received a telegram from Dean Eugene Rostow, offering her a position as an Assistant Professor. She would be paid, Peters remembered, "the grand and glorious salary of $7,000, which even in 1956 wasn't exactly overly generous, but was more than I was being paid." And with her husband, Bob, "getting a little something as a Resident," the couple decided they could live "more comfortably than we had been so far."

Teaching at Yale

While Ellen Peters was Yale's first tenure-track woman law professor, she was not the first woman to teach a course at Yale Law School. That distinction belonged to the sociologist, Dorothy Swaine Thomas, who offered a seminar on Research Methods at the Law School from 1930 to 1934.[8] Twenty years later, Ellen Peters was part of a group of thirteen recruited by Dean Rostow to rebuild the faculty. Rostow was extraordinarily proud of the new faculty. Professor Boris Bittker recalled Rostow saying at the time that they were "the group to which he had nailed his banner" and that he would be willing to have his deanship judged on the basis of how that group of people panned out.[9] Interviewed twenty years later, Rostow emphasized that Peters "was elected on her merits exactly as the other candidates were chosen." Rostow allowed that "Of course we were delighted finally to be able to elect a woman member to the faculty," but he stressed that gender "was not the criterion by which she was chosen."[10]

Peters began teaching at Yale in the fall term, 1956. She drew one of the new small sections of Contracts, which she described as "a wonderful way for anybody to break into teaching." The next term was not as successful. Dean Rostow asked her to teach Commercial Law and Family Law. While she started out with a "fairly good sized" class of fifty or sixty students in Commercial Law, Peters had yet to find her own successful teaching style and instead mimicked Gilmore, her mentor—with disastrous results:

> There were things he could get away with by being quite firm—that's one way of putting it—that just didn't work for me. And it especially didn't work for me because I was twenty-six years old, and I wasn't Grant Gilmore. Enrollments dropped like flies within the first two weeks, and Associate Dean Jack Tate called me in and said, in a perfectly friendly way, 'You know, you can't go on this way.'

Peters recognized Tate's criticism for what it was: an acknowledgement that

> when things go wrong, you really have to reconsider. . . . I think that Carol Gilligan is right: we develop our own voices as men and women. Unless you develop your own teaching voice, it's not a happy profession. The other part of it is that nobody can be anybody else. I couldn't be Grant Gilmore. It was probably a useful thing to learn that lesson sooner rather than later.

Peters failed to find Family Law intellectually engaging and never taught it again after that first assignment.

Family Life and Children

Ellen and Bob Peters had three children. As she put it, "David was born when I was an Assistant Professor; Jim when I was an Associate Professor; and Julie when I was a Full Professor." Peters spoke with Rostow about her pregnancy early on. Peters sensed that Rostow was not exactly thrilled with her news, but, she noted, "on the other hand, I can't believe that other law school Deans at that time would have taken it so calmly. I could easily have seen someone saying, 'Well, you have to make some choices.'"

David B. Peters was born on August 14, 1957. Ellen began teaching after Labor Day. She and Bob hired a "wonderful woman," Dora Harris, who began working for them when David was three weeks old. Ellen and Bob's second child, James D. Peters, was born on September 4, 1960. Their third child, Julie Peters, did not arrive until June 13, 1965, a little over a year after Ellen, now a tenured professor, had become a member of the Yale Governing Board. Harris stayed with the family until Julie was fifteen years old—a period of twenty-three years. Peters explained their arrangement, describing herself as "extraordinarily lucky" to have found a competent childcare partner and illuminating the juggling act required in a two-career family—then and now.

The Struggle for Tenure

In the third year after Peters and her male cohort were hired, the Governing Board (composed entirely of tenured Full Professors) decided that all of them, except Peters, would be recommended for promotion, and that the eleven men would be promoted over time in three staged groups. Peters recalled that the arrangement was "not a secret" on campus: "Everyone was discussing who would be in the first group to be promoted, and who in the second or third. I wasn't in any of them, and it was clear that I wasn't going to be." This was, noted Peters, "the first time I felt really very painful."

Peters acknowledged that at this point, her teaching was "going fine," but her legal scholarship was "an issue yet to be resolved." However, she

pointed out that "there were others like me who had written nothing of professional stature, and they were part of the deal." This suggested that the real reason she was left out of the "deal" was not because she hadn't published, but rather because she was a woman and a mother.

Ellen Peters did not become a full professor with tenure until 1964. She had talked with Rostow about the situation. Rostow encouraged her to focus on her scholarship. Peters set out to write the "Roadmap," her classic treatment of Article Two of the Uniform Commercial Code.[11] She published the article in 1963, and she was promoted in 1964. She recalled the event as a happy ending:

> In retrospect, eight years to get tenure when you start out as an Assistant Professor is not all that long. And I wouldn't have felt badly about it, but for the interlude which I couldn't shake. But after the trauma, really, of getting through and becoming a senior member of the faculty, there were then many years of really great happiness with the teaching, and continued pressure to do writing, which I think was appropriate. I mean, Yale is a place where, no matter what, writing is what you are supposed to do, and writing is what you do do.

When Peters became a tenured professor, she joined a "very small crowd" of about fifteen tenured women at Yale University. Recalling that she had "always been very grateful" that she had come of age as a professor at Yale during a time when "the faculty did not feel under pressure to hire a woman or to promote a woman," she recognized that the women who followed her shouldered the burdens of "representational as well as educational responsibilities."

After Grant Gilmore left Yale in 1965, Peters took over the UCC courses—Commercial Law and Negotiable Instruments—in addition to teaching Contracts every year and Bankruptcy from time to time. By then, she had found her own "voice" in the classroom, and the students appreciated both the style and substance of her approach. Peters was the only woman on the Yale law faculty for sixteen years, from 1956 until Barbara Underwood's appointment in 1972. In spite of her reluctance to take on "representational responsibilities," she "had an important function as a model for those women concerned about the difficulty of combining the roles of professional woman, wife, and mother."[12]

Professional Activities and Scholarship

Ellen Peters became a member of the State Bar of Connecticut in 1957 and was admitted to practice before the US District Court for the District of Connecticut in 1965. She was also involved deeply in law reform efforts, particularly with the American Law Institute (ALI). In 1963, she was appointed an Adviser for Restatement (Second) of Contracts, a position she held until 1980 when the project had been completed.[13] She then served as an Adviser for Restatement (Second) of Restitution from 1981–84 and again for Restatement (Third) of Restitution & Unjust Enrichment, beginning in 1997. In 1972, she was elected a member of the ALI, and became the sixth female member of the Council, the ALI's governing body, in 1984.[14] She was elected to the Executive Committee in 1988.

Along with her scholarly responsibilities, Peters also undertook several Directorships, including that of her alma mater, Swarthmore College (1970–81), of Hopkins Grammar School (1972–74) where her children attended classes, and of Mory's, (1973–79), the legendary bar and grill that has served as Yale's de facto faculty club since the mid-1800s and is the haunt of the Yale Whiffenpoofs. Her position on Mory's Board was a consequence of the settlement of a lawsuit filed against the establishment after Yale College became coeducational in 1969, challenging its right to hold a liquor license because of its continued refusal to admit women as members.[15]

Contrary to unfounded beliefs held by some within the Yale community, Peters had not masterminded the litigation, but the 1972 settlement required not only that Mory's admit women undergraduates to membership but also that the Club name three women to its Board of Directors. At Yale's request, Peters agreed to be one of the three new female members, along with the Dean of the Nursing School and a senior woman in the Provost's office. Peters described their role as "mak[ing] sure that women who wanted to join Mory's after the settlement would be permitted to do so," which at the time meant "being hospitable" to women faculty as well as the new female undergraduates. Female graduate students were not admitted until 1991. She served for two three-year terms, and "was glad to be relieved" when her second term ended: "The Board of Directors were always polite," she remembered, "but their admissions practices were not always straightforward."

Meanwhile, her scholarship was progressing. When she began teaching Commercial Law, Peters set her mind to "becoming an expert" on the new Uniform Commercial Code.[16] Once she had found her voice in the classroom, her teaching became a source of inspiration for her writing:

> The *Roadmap* really grew out of my teaching, and out of the casebook that I was working on, and was in some sense a model of the kind of writing that I enjoyed doing. It was heavily related to my teaching, rather than being highly theoretical. It wasn't overly burdened with footnotes because it was drawing upon a document which had produced very little litigation at that point. It was fun to put together.

The article is well named, but modestly so. It is indeed a "roadmap" through the intricate provisions of Article 2 of the UCC, but it is also much more: it is a perceptive guide to the future problems of interpretation concealed by the deceptively open text. Peters discussed the "three major remedial choices" available in case of nonperformance by one party to a contract of sale: (1) the right to call the contract off; (2) the right to full performance; and (3) recovery of damages. In the eighty-one pages that follow, Peters leads the reader through the Code's treatment of these three choices, identifying the different possible readings of the text, highlighting inconsistencies, and testing the solutions provided against the commercial practices to which they were intended to apply.

Although she quotes relevant provisions of the statute in the text of her discussion, she also helpfully sets out the complete language of each provision in the footnotes to allow the reader to judge her sense of direction independently. Thirteen years later, Professor Edward A. Dauer called Peters's article "the starting point for serious study of the method and pathology of modern sales codification," and explained that students "have come to regard it as nearly indispensable—not only as a tour de force through the structure and meaning of U.C.C. Article 2, but even more so as an instruction in how dialogue about the U.C.C. is carried on."[17]

Peters continued to explore the intricacies of the UCC by publishing an article in 1968 on the intersections between the suretyship provisions of Article 3 and the general law of negotiable instruments. In 1971, Peters published both her casebook on *Commercial Transactions* and the first edition of her pamphlet, *A Negotiable Instruments Primer,* which was a

somewhat expanded version of chapter 8 of the casebook and which she used in a non-credit course at Yale.[18]

In recognition of her considerable scholarly accomplishments, Peters became the first woman to hold a Chair at Yale Law School when she was named as the Southmayd Professor in 1975. In 1978, Peters and her former student, Thomas H. Jackson, advanced a proposal to resolve some of the inherent internal conflicts in the UCC. This joint article turned out to be the last that Ellen Peters published as Yale's Southmayd Professor of Law.[19] Later in that same month, on April 24, 1978, Peters accepted appointment as the first woman Associate Justice of the Connecticut Supreme Court.

Mentors and Mentoring

Like most of the first fourteen women law professors profiled here, Ellen Peters was a woman who was mentored by men. From her lawyer father and grandfather through her political science professor at Swarthmore— J. Roland Pennock—to her two Yale law school professors in Contracts and Commercial Law—Fritz Kessler and Grant Gilmore—her professional aspirations and intellectual tastes were cultivated and encouraged by men. She, in turn, served as a role model for her female students and mentored both male and female students, all the while acknowledging her gratitude for the guidance she had received.[20]

Her own successful mentoring was prominently showcased by her former student and co-author, Tom Jackson, when he became President of the University of Rochester in 1994. Peters was one of three people—two mentors and one mentee—to whom Jackson especially issued invitations to be with him at the Inauguration, where he had chosen to speak about the influence people can have on other people.

Ellen Peters did not have the opportunity to mentor a junior female colleague until 1972, when Yale hired Barbara Underwood as an Assistant Professor and its second woman tenure-track faculty member. In the same year that Underwood came to Yale, the atmosphere was growing tense for young faculty at the school. Ellen Peters felt that it was "high time" to bring more women onto the faculty, and she was concerned by what she saw of the process. She had become a member of—and eventually

chaired—the Appointments Committee, which interviewed prospective faculty, and she began to observe a pattern: many of her colleagues "had a difficult time hearing women who came to be interviewed" in ways that did not seem to apply to male candidates.

> Because it was such a hypercritical faculty, both men and women had a very tough time being appointed, but women more so. The faculty really responded to people who were fairly aggressive in their presentations, who were willing to take them on. That's not a style that is congenial for all people. I expect we lost a lot of good men in that process, too.[21]

While it might have been alienating to new candidates, the "aggressive" style favored in Appointments Committee presentations went hand-in-hand with the general tenor of discussion at the law school.

Once a new faculty member—male or female—had successfully navigated the Appointments Committee, he or she next faced the challenge of obtaining tenure. Underwood recalled spending an inordinate amount of time attempting to decipher the oblique—and sometimes contradictory—advice of her colleagues. Peters's sound advice and unqualified support enabled Underwood to do some "reality checking" during that difficult period.

The faculty vote on Underwood's tenure was scheduled for May 3, 1978. It would turn out to be the last faculty vote Peters participated in as a member of the Yale Governing Board before she became a Connecticut Supreme Court Justice, and it resulted in the award of tenure to Barbara Underwood, who then became Yale's only active tenured female member of the faculty. Peters herself was named an Adjunct Professor of Law at Yale on the day she was sworn in to the Connecticut Supreme Court, a title she held until she became Chief Justice in 1984.

Appointment to the Connecticut Supreme Court

Ella Grasso was elected Governor of Connecticut in 1974, the fourth woman in the United States to become a state governor, and the first who won election to the office in her own right rather than as the successor to her husband.[22] The absence of women on the Connecticut Supreme Court did not escape her attention. Given the traditional process of appointing the members of that court, however, finding a suitable candidate was not

a simple matter. As former US Supreme Court Justice Tom C. Clark observed in 1972, Connecticut Supreme Court Justices were traditionally chosen from the ranks of sitting Superior Court judges. Clark categorized this as a "mistake," and an "undesirable form of inbreeding which is as disastrous in courts as it is in human beings."[23]

In 1976, Governor Grasso initially appointed one of the two women serving as superior court judges—Ellen Bree Burns—and the only black superior court judge—Robert L. Levister. However, President Carter had recently appointed Burns to the Federal District Court for the District of Connecticut, thus removing her from consideration and frustrating Grasso's desire to appease those who wanted change while hewing to tradition as much as possible. Two years later, Peters was approached by Jay Jackson, an emissary from the governor. Peters was surprised: she had never met Governor Grasso, and she described her appointment as "very high risk," given her background and lack of political connections:

> I mean, you name it, I didn't fit any of the current views of what a Supreme Court Justice in this state was supposed to look like. Picking an academic? One not born in this state? Not a Catholic? . . . I'd never done anything political one way or the other. Still, I didn't have any political liabilities: nobody out there had any political reason to be opposed to me. So she just decided to do it.[24]

After her conversation with Jackson, Peters consulted Harry Wellington, who was still the Dean. Wellington wrote a glowing letter in support of her nomination, describing Peters as possessing "a powerful, analytic mind capable of grappling with the most intractable legal problems," and as being regarded as "the outstanding commercial lawyer of her generation." He concluded, "[S]he is disinterested. Her views are not informed by ideology. She has the discipline and disposition of a judge."[25] Peters's nomination was approved, and she was sworn in as an Associate Justice of the Connecticut Supreme Court on May 10, 1978.[26]

Family Life

Ella Grasso was not only the instrument for moving Ellen Peters from Yale to the Connecticut Supreme Court, but also the indirect matchmaker of her second marriage. Ellen and Bob Peters had separated on July 4, 1976,

after twenty-four years of marriage. They were divorced in December 1977. In January 1979, Governor Grasso's second inaugural ball took place, an event that put her new judicial appointee in a quandary. Peters was faced with the challenge of finding an escort. "A mutual friend suggested that I call Phillip Blumberg, who, as the Dean of the University of Connecticut School of Law, had a titular relationship to the Court." Blumberg and Peters had met before but they did not know each other well. Peters called Blumberg. "It was not the easiest phone call I have ever made, nor was it the easiest phone call, I think, for Phillip to accept." Luckily, the awkward beginning had a happy ending, as Peters summed up: "we went; we came; and the rest is history."

Ellen Peters and Phillip I. Blumberg were married on September 8, 1979. At the time, she was still living in New Haven with her daughter, Julie, age fifteen (the two boys having gone to college). The ultimate decision to move the family to Hartford was difficult, and the teenager was "bitterly unhappy about it for a long time." Eventually, however, Julie adjusted: she transferred to Loomis Chaffee, a well-regarded school in Hartford, and became very happy there.

Associate Justice Peters

After she had taken her seat as the Court's first woman Justice, Ellen Peters learned that her new judicial brethren harbored a fair amount of resentment about her appointment. In nominating Peters, Governor Grasso had passed over Judge Arthur Healey, who was the senior superior court judge and had been "first in line" based on the traditional seniority appointment system. However, Peters noted, "the judges there are good enough politicians to know that once the inevitable is inevitable, they may not like it, but they aren't going to be overly difficult." In fact, Arthur Healey was named to the Court the year after Peters joined, and Peters said that they ultimately became "friends as well as colleagues."

Peters hit the ground running as an Associate Justice. Wesley W. Horton, author of *The History of the Connecticut Supreme Court*, dates the start of "The Peters Era" in the Court's history from the time of Peters's appointment in 1978, not when she became Chief Justice in 1984. Describing Peters's appointment in 1978 as the dawn of "a new era of the Supreme

Court," Horton noted that "While the press focused on her sex—she was the first female on the Supreme Court—lawyers focused on the fresh judicial air her appointment presaged." Horton noted that Peters "was the intellectual leader of the court almost from the day she took office, she continued to dominate the court as Chief Justice from 1984 to 1996, and her philosophy was largely followed by a majority of the court when she was a senior justice from 1996 to 2000." In addition, Peters also "brought a whole new way of thinking to the court, a way that continues today."[27]

Peters was an Associate Justice from 1978 to 1984. In her first year on the court, she wrote, in Horton's assessment, seven of "the ten most jurisprudentially important decisions issued" by the court, six of them decided by a unanimous vote.[28] One, "surely . . . the most important case of the year," invalidated the Connecticut "blue laws" prohibiting the sale of certain items on Sundays as irrational, and therefore unconstitutional.[29]

Yale recognized Peters's outstanding judicial contributions at its Annual Alumni weekend on November 14–15, 1983, by presenting her with the prestigious Citation of Merit Award. Chief Justice John A. Speziale of the Connecticut Supreme Court, who presented the award, delivered a gracious tribute to Peters's work as a justice, observing that he spoke for the entire Court in saying the award was not only an honor for Justice Peters, but also "is one which we feel reflects great credit on our Court."

During her term as Associate Justice, Peters served on the Connecticut Board of Pardons from 1978–81 and the Connecticut Law Revision Commission from 1978–84. She also won the 1982 Judicial Award of the Connecticut Trial Lawyers Association, and the Ella Grasso Distinguished Service Medal, awarded by the Ella Grasso Foundation on June 14, 1982.

Chief Justice Peters

Slightly over a year after Speziale presented the Citation of Merit Award to Ellen Peters, she replaced him as Chief Justice. The New York Times reported that her nomination "drew widespread praise in the legal community" and that Raymond W. Beckwith, the President of the State Bar Association, "called the appointment 'an historic moment in Connecticut.'" The Times also quoted Speziale as noting that Peters's "crisp, clear, concise, but also erudite opinions have already made an indelible mark on this court."[30]

After her service as Chief Justice had ended, Wesley Horton confirmed that Dean Wellington's prediction about her impact on the Court had been accurate. Peters served as Chief Justice from 1984–96, and, according to Horton, her tenure "began with a bang and quickly confirmed her position as the dominant justice on her court." Horton describes Peters as setting "high intellectual standards for the whole court," noting that "if one reviews at random a volume of the Connecticut Reports from the 1960s or 1970s and compares it with a volume after Peters became Chief Justice, one will in general find a much more thorough and scholarly discussion of the issues since the mid-1980s."[31]

Ellen Peters became the first female chief justice elected as president of the Conference of Chief Justices in 1994. She was the only woman to hold this office during the twentieth century.[32] The president of the Conference of Chief Justices automatically serves as chairperson of the board of directors of the National Center for State Courts. Peters, who had been a member of the National Center's Board since 1992, found the leadership position an interesting assignment. During her term as chief justice, she also held directorships in other organizations, including the Yale Corporation, from 1986 to 1992.

Once she became Chief Justice, many of the events at which Peters spoke were ceremonial occasions where her presence lent a measure of importance. She rose to these occasions with grace, dignity, and a dose of wit, whether she was delivering a law school commencement address,[33] speaking at a groundbreaking ceremony for a new law school classroom building,[34] or delivering a keynote address at a law school conference.[35] She also provided remarks at the 1986 Conference of Chief Justices and at the Annual Judicial Conference of the United States Court of Appeals for the Second Circuit.[36]

Senior Justice Peters

Ellen Peters could have remained Chief Justice until her seventieth birthday on March 21, 2000, but she voluntarily relinquished her administrative responsibilities in 1996 due to physical difficulties that required hip replacement surgery a year later. She finished out her term as a Senior Justice in March 2000. During her last years on the court, her life continued very

much as usual. Her schedule was less demanding, however, and she and Phillip took advantage of the opportunity to travel more extensively.

During this period, she also delivered two prestigious lectures, the Lockhart Lecture at the University of Minnesota Law School in 1996 and the Brennan Lecture at New York University Law School in 1998. In both she explored various aspects of the relationship between state and federal courts. Peters also used her relative freedom as a Senior Justice to experiment with a return to the classroom. She twice offered a seminar at Yale in the late 1990s on the role of state courts in the context of the federal system, drawing upon the ideas that she had explored in both the Lockhart and Brennan lectures. She was motivated by her desire to engage students in a dialogue about federalism, and she felt that the interaction between state and federal courts and judges was a relatively unexplored topic.

Honors and Awards

During the time she was Chief Justice of Connecticut, Ellen Ash Peters was elected to membership in two prestigious societies. In 1990, she was elected to the American Academy of Arts and Sciences, and in 1993 she was elected to the American Philosophical Society (APS).

Peters also received many significant awards. In the late 1980s, she received the Myrtle Wreath Award of the Connecticut Region of Hadassah and the Hartford College for Women's Pioneer Woman Award. Between 1992 and 1996, she received the Connecticut Bar Association's Henry J. Naruk Judiciary Award and three Distinguished Service Awards, from the University of Connecticut Law School Alumni Association, the Connecticut Law Tribune, and the National Center for State Courts. In 1996, she also received the Connecticut Bar Association's Special Award, and another citation from the Hartford College for Women, the Laura A. Johnson Woman of the Year. In 1994, she was inducted into the Connecticut Women's Hall of Fame.

Peters received many honorary LLD degrees, one from each of her alma maters, Swarthmore (1983) and Yale (1985); six from other Connecticut colleges and universities; and several more from around the Northeast and Midwest, including Georgetown (1984), New York Law School (1985), DePaul (1988) and the University of Rochester (1994).

Retirement

Six months after her mandatory retirement from the Connecticut Supreme Court, Peters found herself "in the process of trying to figure out, at the age of seventy, who I am now. It's clearly a different persona than I had when I was sixty." She was able to sit by assignment and, as Horton reported, Peters "distinguished herself as a very active member of the Appellate Court."[37] But she did not find its caseload as challenging as that of the Supreme Court, and noted that "the more interesting cases go directly to the Supreme Court," leaving the appellate courts for "error correction" in most cases.

DOROTHY WRIGHT NELSON

Dorothy Wright Nelson was born Dorothy Jean Wright in San Pedro, California, on September 30, 1928, the middle child between two girls. Their mother, Lorna Amy, was born in Seattle, and their father, Harry Earl Wright, was from Nebraska.

Lorna Amy was a schoolteacher and a psychologist who earned her MA at UC–Berkeley, specializing in intelligence testing. She was also an avid swimmer, who went to Hawaii between her sophomore and junior years of college to train for the Olympics. After making the semi-finals, she contracted Asian flu and was not able to compete. She remained in Maui for two years, where she taught at McKinley High School and made her reputation in the Islands as the first mainland white woman to become a surfer. Harry was a building contractor who attended the Troop Academy in Pasadena, which later became California Technical Institute (Cal Tech).

When Dorothy was in the second grade, the family moved to Los Angeles. Dorothy had "wonderful recollections" of her early childhood, remembering her mother's constant presence and "always having a house full of people of all backgrounds." Dorothy was particularly close to her older sister, Lorna Elizabeth, remembering how she "paved the way" for Dorothy in her early years and describing her as "the academic of the family, the real reader." Dorothy followed Elizabeth into the Girl Scouts and the Mariner Scouts.

Figure 12. Dorothy Wright Nelson. Courtesy of University of Southern California Gould School of Law.

When Dorothy was in the twelfth grade, her high school counselor asked her, "Dear, what are you going to do until you get married?"[38] Dorothy ignored the question. She had a strong role model in her mother, who "while placing family first at all times yet actively pursuing her own career interests, had demonstrated that with the proper balance, a woman could do both happily and productively."[39] Elizabeth had already started at UCLA, and once again Dorothy followed her lead, matriculating in 1946. She was active in student affairs and became vice-president of the student body in her senior year. She joined the UCLA Beta Delta Chapter of Alpha Phi, a women's fraternity. She earned her BA in 1950, with a major in political science, and was elected to Phi Beta Kappa.

Decision to Study Law

Dorothy loved children, and while in high school she had tentatively decided that she wanted to become a social worker. However, her eleventh-grade experience as a YMCA counselor opened her eyes to the challenges inherent in helping poor families and the power of the law to shape their communities. Dorothy concluded that "lawyers and judges had a great deal of power in the community, far more than a social worker in terms of bringing about needed changes. So, I decided to look toward law school."[40]

Her new resolve was reinforced by encounters with women lawyers and a woman judge during "Girl's Week" in her senior year. She served as a "judge for a day," and went down to the Los Angeles Juvenile Court to sit for the day with Judge Georgia Bullock. Dorothy was also invited by several women lawyers to come to visit their offices.

She finalized her decision to study law at the beginning of her senior year in 1949, the same year that UCLA opened its law school.[41] She attended a lecture there delivered by the venerable Dean Roscoe Pound of Harvard, the founder of the school of "sociological jurisprudence."[42] The ideas he discussed about making the legal system better, fairer, and more just, struck a chord with Dorothy. She was also drawn to UCLA Law for a practical reason: tuition there was $49 per semester. Dorothy had determined to put herself through law school with scholarships and working in the law library. She enrolled there in 1950, one of two women students in the second class to be admitted to the law school.

Family Life and Law School

Dorothy and her future husband, James ("Jim") Nelson, met during the summer after eleventh grade at a YMCA camp. Jim Nelson joined the Navy during World War II, and after he was discharged, as he jokingly put it, "the Navy sent me to Stanford." As Dorothy remembers it, "He was at Stanford and I was at UCLA. He quickly transferred."[43]

The couple talked about getting married, and Jim suggested that he go to law school first, then medical school. They looked for a school that would allow Jim to work during school. Loyola, in Los Angeles, held classes only in the mornings, allowing Jim to work for a law firm in the afternoons. Dorothy recalled that this work, plus Jim's GI Bill funding, plus her scholarships, "sort of moved us through the first year and a half or two." They were married after their first semester in law school, on December 27, 1950, which was just after his final exams at Loyola and before hers at UCLA. Dorothy loaded her law books into her suitcase for the couple's Mexican honeymoon.[44]

Both Jim and Dorothy were active members of different denominational churches: he was Presbyterian, while she was Episcopalian. The ceremony was conducted jointly by both their ministers. Later, they were invited to attend a Bahá'í meeting by Donald Barrett, the President of Dorothy Nelson's law school class. The invitation was the beginning of a five-year study of comparative religion for the Nelsons, which culminated in their becoming members of the Bahá'í faith. Bahá'í teachings emphasize the need for equality of men and women, universal education, a "universal auxiliary language," world government, and a world federation of nations. As Nelson characterized Bahá'í faith, "All of these principles . . . must be recognized at the same time before world peace will be possible."

Dorothy Nelson graduated from UCLA Law School in 1953. She ranked in the top third of her class, standing fifteenth in a class of forty-nine.[45] She and Jim took the bar examination together in October 1953. They both passed the bar and were sworn in together on January 14, 1954. The *Los Angeles Times* ran a picture of the two of them, looking very dignified and professional, receiving their certificates of admission to the State Bar of California from California Supreme Court Chief Justice Phil S. Gibson.[46]

Early Employment

In 1953, only two of the big Los Angeles law firms were hiring women: O'Melveny and Myers, and Gibson, Dunn and Crutcher—the same firm that had offered Sandra Day O'Connor a secretarial job when she graduated from Stanford Law School in 1952.[47] Dorothy Nelson looked at both firms and interviewed at O'Melveny. Nelson recalled the place being "huge," with almost seventy attorneys, and "going down the hall and being told I would be six months here, and then would be six months there, at $350 a month."

Dean Pound suggested a more attractive alternative: a research position at USC, working with Professor James G. Holbrook on an ABA-sponsored study of the Los Angeles court system. The work paid only $250 a month, but it came with the promise of a master's degree; the researchers would take twenty units of coursework and the work on Holbrook's study would count as the master's thesis. She interviewed for the position and was hired. Her classmates who had gone to law firms thought she was "lacking sound judgment to accept such low pay," but Nelson "liked the university atmosphere and the idea of receiving an advanced degree."[48]

The research project was "a three-year study of the superior, municipal and justice courts of Los Angeles County."[49] Nelson's appointment lasted four years. She and her co-researchers, Donald Black and Bonnie Martin, interviewed every judge in Los Angeles County as well as two hundred lawyers and two thousand jurors. The study was published in 1956, and Nelson received her LLM the same year.[50]

Appointment at USC

In 1956, Dean Robert Kingsley asked Nelson to take over the last eight weeks of a course in Judicial Administration. She immediately changed the format of the course, which previously had been very anecdotal, and put an emphasis on practical knowledge and experiences:

> My special knowledge enabled me to give a unique program, including field trips, ranging from the drunk arraignment courts to the California Supreme Court, and a class interview with Justice Tom Clark of the United States Supreme Court.[51]

The course was a great success, and the students urged the dean to bring Nelson on as a full-time instructor. She became the first full-time woman member of the USC law faculty in 1957 and remained an instructor for one year. She became an Assistant Professor in 1958, at a salary of $7,000 per year.[52]

Dorothy Nelson understood that her presence on the USC faculty would introduce a new element into the social climate of that very small group, and she took pains to allay any misgivings that might have arisen. In particular, she worked to reassure the faculty wives that she posed no threat to their marriages:

> I wanted the wives to like me because I was the first woman on the faculty. I went to the first social at the beginning of the year, and I sensed people looking me over. So . . . I had every single member of the faculty . . . to dinner at one time or another. All of a sudden, I just saw attitudes change. I showed them that I loved my husband, and I showed them that I had a happy home. . . . It sounds sort of silly, but all of a sudden, I felt accepted in that whole circle.

Family Life and Child Care

One of the reasons Dorothy Nelson wanted to take the USC research job rather than a law firm position was so that she and Jim could begin their family.[53] Their son, Franklin Wright Nelson, was born August 22, 1958, and their daughter, Lorna Jean Nelson, was born July 21, 1961. As Ellen Peters had done, Nelson found an ideal person to help her with the children:

> [A]fter interviewing over ninety applicants—who ranged from the 'I teach them to mind' to the 'You'll never see a spot on the rug' types—I found a loving new member for our family. We called her 'Nana,' and she worked for us for over thirteen years.[54]

Nelson also scheduled her work life to accommodate her family. She avoided summer classes, took five weeks off between semesters, and prepared for classes at home, "sometimes burning the midnight oil." Through careful planning and shared responsibility, Nelson became an early example of a busy working mother; as she recalled, "I was able to participate

in a part-time cooperative nursery school, and, along with my children, had all the fun of ballet lessons, music lessons, Girl Scouts, and school projects. This gave balance to my life, which I think made me a better teacher."

Dorothy Nelson's younger sister, Nancy Lou Wright Lineberger, died of cancer in 1967, leaving three young girls who became a part of the Nelson extended family. Dorothy's older sister Elizabeth had three boys who were a bit older, and they lived across the street from the Nelsons. Every summer, the Nelsons would rent a house in Newport Beach and Nancy's girls would join them there; their father would spend a week with them there and come down "off and on" throughout the rest of the summer.

Teaching and Students

Nelson's first courses as an instructor were Judicial Administration and Trusts. She taught Trusts from Professor Austin Scott's leading casebook, and she formed the habit of calling him at his Harvard office on Thursday afternoons to discuss the course with him. She taught Judicial Administration, which became her academic specialty, every year until 1980, when she left USC for the Ninth Circuit.

In 1960, Nelson was asked to teach an "innovative new course called Legal Process" with Harold Horowitz. Nelson "just fell in love with the materials," and found them incredibly creative. She felt lucky to have been asked to teach the class, and the students responded positively to the new curriculum.[55] Teaching the course was Dorothy Nelson's introduction to the "legal process school" of jurisprudence. She and Horowitz taught it together for two years. After Horowitz left USC, Nelson continued to teach the class, and added in material. She continued to teach a seminar in Judicial Administration even after she became a judge; she gave it up in 1985 because "my son had entered the Law School and I thought it best to remove myself."

Tenure and Scholarship

Dorothy Nelson was promoted to tenure as an Associate Professor in 1961. That process was a bit more formal than her initial hiring had been, but the process proceeded smoothly.

I was so naïve, and I was so busy with my life and my young children. . . . I wasn't thinking of tenure; it didn't make any difference to me. Looking back on it now, I can remember seeing the Dean sitting in the back of my classroom, and then I saw the Associate Dean. I thought, 'Isn't that nice.' And then a couple of faculty came in one day. Later, I realized that they were really watching me teach. . . . I didn't feel any pressure.

With the single exception of a book review, Dorothy Nelson devoted her scholarly writing entirely to judicial administration. She published eight articles and a casebook on the subject during her tenure at USC. Her first article, which appeared in 1957, examined how the new requirement of mandatory pre-trial conferences in California "may be used effectively as a weapon of advocacy."

Nelson's next three articles, all published in the early 1960s, drew on the empirical research she conducted while working on the Holbrook study of the Los Angeles courts. In the first of these pieces, Nelson offered three specific proposals: (1) that the single trial court be divided into departments, one being a small claims department staffed by court commissioners who would be "junior judges;" (2) that the other civil departments should follow the current pattern of the superior courts, but without any arbitrary monetary ceiling on jurisdictional amount (once the floor of the small claims department was set); and (3) that the criminal departments should also follow the current pattern of the superior courts, but include misdemeanor cases.

Three years later, she published an article in the *Los Angeles Bar Bulletin* indicating which of the recommendations of the Holbrook Report had been adopted, which had been rejected, and which still remained to be considered. In 1993, the Los Angeles County Superior Court began the process of administrative unification with three Municipal Court districts, with seventeen more joining the program in 1998–99; on January 22, 2000, the Los Angeles Superior and Municipal Court Judges voted for consolidation, and by July 2001 all fifty-eight counties had merged their trial courts as Nelson had suggested.[56]

In 1962, Nelson turned from court reform to the equally controversial topic of the selection and tenure of judges. She published a comprehensive article which summarized the history of judicial selection in the United States and around the world, calling for a method that would ensure judi-

cial independence from the politics of popular election or appointment of judges by partisan office holders.[57]

Becoming Dean Nelson

The regularity of Nelson's publications slowed when she took on additional administrative activities. Dean Robert Kingsley stepped down to accept a judgeship on the California Court of Appeals in 1963, and his associate dean, Orrin Evans, replaced him. Evans named Nelson his acting assistant dean in 1963. Nelson served as assistant dean until Evans stepped down in 1967 and changed her title to associate dean. At the time, USC was a small local law school with an evening division and a cadre of senior faculty, many of whom were due for retirement in the early 1960s. The retirements created an opportunity to rebuild the school by hiring young entry-level faculty. This group of "young bloods," as they were described by the rest of the faculty, came full of new ideas about legal education. Nelson recalled that "[s]ome of their ideas were very good and some of them proved not to be so good," but the new professors were pursuing the laudable goal of making USC Law School "the number one law school in the nation in terms of creativity and 'cutting edge' ideas."

When it became clear that Orrin Evans was unable to continue as dean, President Norman Topping of USC asked Dorothy Nelson to take on the job "just for a few months while we form the search committee." She agreed to do so, and was named Interim Dean in 1967, the same year that she was promoted to full professor. Through her diligent efforts as a new professor, she had made friends with the older faculty. At the same time, she "enjoyed the new faculty and found them to be very exciting, very stimulating, very interested in teaching and in perfecting their teaching," which, she noted, "needed some help." As such, she was not seen as a member of either of the opposing faculty groups.

After the dean search had gone on for two years, with no viable external candidate in sight, the school began to look for an insider. Attention focused on Dorothy Nelson. Matters moved swiftly once the decision was made to appoint Nelson USC's first woman dean. When Nelson got the news, she was in the middle of her negotiated six weeks of vacation in Newport Beach with her husband and children. Hastily summoned to Los

Angeles by President Topping, she was surprised to find his office full of law school faculty members. She recalled, "President Topping said he had met with the faculty and they had decided that they would like me to take on the deanship."

Nelson determined that her tenure as dean would be an extension of her approach as interim dean:

> My philosophy, even as Interim Dean, was that my job was to provide an environment where the faculty and the students could both be the best of what they could be. When the faculty wanted secretarial help, I just went and pounded on doors. When the library complained about how our library had been neglected, we raised enormous sums for the library. The alumni had been unhappy because we had decided to get rid of the night school, and I went around bringing them back into the fold.

This approach had been successful, Nelson believed, because "no one felt threatened. No one saw me using this as a power base to do anything else." She concluded that her non-threatening style had contributed significantly to her selection as dean.

Dean Nelson's First Term: A Difficult Beginning

Dorothy Nelson was interim dean and dean of USC for thirteen years, from 1967 to 1980. When she left to become a judge, the man she had replaced as dean, Orrin B. Evans, summarized her administrative career in a special Law Review dedication. Evans highlighted her leadership in developing the concept of USC as a true "law center," not just a training program for new lawyers. During her tenure as dean, Nelson oversaw the creation of programs dedicated to judicial administration, clinical externship programs, and dual degrees in conjunction with USC's schools of Public Administration, Business Administration, Economics, and Social Work. She also created a program for legal paraprofessionals and grew the Advanced Professional Program for practicing lawyers into what Evans called "among the largest in the country."

Evans was convinced, however, that Nelson's major accomplishment was intangible rather than tangible, noting, "Even more important than the tangible strengthening of the Gould School of Law—a virtual doubling

in size of the full time faculty and of the library and its staff—is the spirit engendered by Dean Nelson." He continued:

> She took office only shortly before the wave of student unrest swept the country and she has served during the controversy over minority admissions. The shock of these sometimes violent movements was absorbed in her office, and such is her transparent honesty and integrity, her patent concern for and sympathy with young people of all races and in all walks of life, and so clearly recognizable is her idealism and practical common sense that little bitterness remained to divide the Center.[58]

Virtually every point noted by Evans refers to a significant episode in the Nelson deanship that illustrates her extraordinary strengths and resourcefulness as an administrator. Only a few will be mentioned here to document what might be described—although probably not by Nelson herself—as her "management style."

Many consider Nelson's role in rebuilding the faculty her most significant accomplishment. President Topping remarked that she recruited "a bunch of young law faculty from Yale and Harvard, and she really built the law school to where it was a major law school."[59] Reflecting on his career as USC's President, Topping said, "I was able to name several deans during my years as president, and Dorothy was one of the major satisfactions."[60]

As Evans pointed out, Dean Nelson assumed her duties in turbulent times. She faced two confrontations with the USC Board of Trustees as well as student protests over minority admissions during her tenure. Her first problem with the Trustees began in 1968 while she was interim dean. The three Los Angeles law schools—USC, UCLA, and Loyola—had co-sponsored the establishment of the Western Center on Law and Poverty in response to the 1965 Watts riots. Although the Center had an independent board of directors, USC became its administrative home. The Center hired a noted civil rights activist, Derrick A. Bell, Jr., who came to Los Angeles from previous legal positions at the NAACP and HEW to serve as its first Executive Director in 1968–69. A few months after Bell arrived, the Center filed a class action suit on behalf of all black residents of Los Angeles County against the Los Angeles Police Department and Chief Edward M. Davis, charging them with violation of the plaintiffs' civil

rights by a systematic pattern of harassment and brutality in the policing of black areas of the county.[61]

Police Chief Davis was outraged. He wrote two letters to President Topping dated December 4, 1969, and December 18, 1969. In the first letter, Davis discussed USC's use of city-owned telecommunications facilities located at Mt. Lee, and stated, "as soon as we are not in a position of being adversaries in a lawsuit, we should be able to resolve the problems of your use of Mt. Lee." The second letter discussed the police protection that had been provided to the campus and commented that "[r]egardless of the manner in which you have treated us, you will still continue to receive all of the police protection that your fine institution deserves."[62] Topping sent the letters to Dean Nelson, asking for her advice.[63] Bell had left to become a member of the Harvard Law faculty in 1969, and the letters found their way to the Center's Acting Executive Director, Stanley W. Levy, who circulated them to the Center's Board and to the National Legal Services Office in Washington, DC.

Levy also spoke at an Office of Equal Opportunity (OEO) press conference in Washington, where, contrary to Dean Nelson's direction that he must not under any circumstances release the letters, he discussed their contents and said that Dean Nelson "thinks this is blackmail by the police department."[64] Despite her denial—"I have no opinion about Chief Davis' intent, and Mr. Levy had no right to draw any inferences about my views"— the publicity added fuel to the fire.[65] Nelson took heat from all sides. As she was telling her alumni that the purpose of the Center on Law and Poverty was "to take things into the court system and to keep them from being resolved on the streets," Chief Davis was on television calling her a Communist, accusing her of taking government funds to file lawsuits against government officials, and demanding that she be fired. At the urging of Superior Court Judge Arthur L. Alarcorn, who was later appointed to the Ninth Circuit, and US Attorney Matt Byrne, later a Federal District Court Judge, both of whom personally knew Davis, a secret meeting was arranged between Nelson and Davis at Paul's Duck Press restaurant.

Judge Alarcon recalled the evening at the Duck Press quite clearly. He and Matt Byrne met Dean Nelson and Chief Davis at the restaurant, and the four of them had dinner together. By the end of a very long evening, at 11:00 P.M., Chief Davis had become very sympathetic to Dean Nelson, telling her,

"I thought being a Police Chief was hard. I never want to be a Law School Dean, with all the problems you have. I would never trade jobs with you."[66]

Unfortunately, the dean's "secret" meeting did not stay secret for long: the owner of the Duck Press apparently spilled the beans to his USC-student son that same night. The reaction that greeted Nelson the next day at school was not positive:

> When I got to school the next morning, the student newspaper was out with a black band across the top, reading 'Dean Gives In To Nazi Chief Davis.' So for the students, I was a fascist. For the alumni, I was a Communist. The Board of Trustees was up in arms. And the President kept briefing me on which trustees to avoid when I went to their Board meeting. Those were very difficult times.

The Western Center for Law and Poverty hired another young black lawyer with a background in law enforcement and legal services administration, Terry J. Hatter, Jr., as its second Executive Director in 1970. Under his less confrontational leadership, the lawsuit was dismissed without prejudice, with both sides agreeing to out-of-court discussions.[67] Similarly, Nelson's relationship with Chief Davis eventually became friendly enough that, as Nelson recalled, "When the Police Chief later ran for the State Assembly, he asked if he could have his picture taken with me for his election brochure."

Nelson's second confrontation with the Trustees occurred in May 1970, shortly after she became dean. President Richard Nixon had announced the invasion of Cambodia on April 30, 1970, an event that touched off a student protest at Kent State University on May 1. On Monday, May 4, four students were shot and killed by the National Guard. The Kent State shootings caused nationwide student protests, and USC was no exception. In particular, students from the schools of Law, Architecture, and Dentistry wore black armbands and engaged in protests. Nelson recalled that her faculty had "stayed up all night with the students to keep them from engaging in violent acts," and that the protests were ultimately peaceful. "The worst thing the students did," she noted, "was to engage in a seven-mile-long march from the campus to the Post Office downtown to mail a petition to the President, picking up trash along the way to show their regard for the environment."

The march was shown on television, and in spite of its peaceful nature, the act of protest "really got to the Trustees," who seemed appalled that graduate students in such upstanding fields would participate in civil disobedience. Nelson remembered their reaction:

> The Trustees met and suggested to the new president, Jack Hubbard, that probably the deans of those three schools had served long enough. They were both good friends of mine. The Dean of Architecture was fired outright. The Dean of the School of Dentistry took a job in Washington. President Hubbard—who denies this story to this day, but it was written up—called me into his office. He said, 'Dorothy, dear, you have done such a nice job. But aren't you getting tired? Are you ready for me to appoint a search committee?'
>
> Well, I knew that everything my students and faculty had done had been appropriate and was legal under the best American standards. I came home very upset from the meeting. After talking to my husband, I stayed up all night long. I then sat down and typed out a sixteen-page missive, which I still have, to that President. I told him that if I was not doing a good job, that if the faculty and the alumni were ready for me to leave, I would be very happy to have an appropriate committee make that decision. In the meantime, I was not ready for a search committee, unless he chose to do it. No search committee was formed.

Many law schools worked to increase minority admissions in the late 1960s, a project given greater impetus by the assassination of Rev. Martin Luther King on April 4, 1968.[68] Deans Dorothy Nelson of USC, Richard Maxwell of UCLA, and Rev. Richard Vachon of Loyola joined together in the summer of 1969 to raise funds for scholarships to support the minority applicants that they had recruited for their entering classes, appealing to local business and legal communities to provide scholarships for an estimated 120 minority law students at the three Los Angeles-based schools.[69]

USC had admitted nineteen minority students in 1969. At the end of their first year, seven of the nineteen flunked out, leading to student demonstrations at the school. When classes began in 1970, the USC students—joined by law students from UCLA and Loyola, where classes had not yet begun—were massed in front of the law school demanding that the seven be readmitted. Unknown to the demonstrators, Dean Nelson had arranged with the deans of two local schools, La Verne and San Fernando

College of Law, to admit the seven students, with scholarships, and to let
them start again.

> I got a microphone and I went out there. I said to Jerry Wiley, 'Go call the
> cafeteria and have them bring as many doughnuts, cokes, and coffee as you
> can find.' Once they began to eat, the whole level went down. Then I said,
> 'You've been out on strike.' They were out on strike for a week. I told them,
> 'I've gotten those students in other law schools. We're going to try to improve
> our conditions next year. We're going to provide tutoring. Not just for the
> Black students, but for any students who are in trouble.' I said, 'You either
> come back to school next Monday, or you're all out.' They came back. And
> little, by little, I won back the alumni. But there were threats.

Once the demonstrators were back in class, Deans Nelson and Maxwell,
along with a few faculty members, engaged in talks with the students.

USC had its normal sabbatical accreditation reinspection by the ABA
and the AALS in 1972. The site inspection team provided a resounding
endorsement of Dean Nelson's concept of a "law center" as distinguished
from a "law school," adding a "special note" about "the extensive orienta-
tion of the school to the legal community." The report concluded that
USC's "institutes, continuing education programs, and programs to train
court executives and paraprofessionals, are making important contribu-
tion to the improvement of the legal profession," and held up the school as
a "a model which should and will be watched across the country."[70]

Resuming Publication and a Second Term

By the early 1970s, Dorothy Nelson felt comfortable enough in her dean-
ship to resume publication. In 1971, she co-authored a massive empirical
study with Judge William H. Levit and two others about trial court proce-
dures in qualifying jurors to serve.[71] The study had begun as a student
term paper by Richard Chernick in her Judicial Administration course.[72]
She also published two invited lectures in 1973 and 1974, the first deliv-
ered at the Oklahoma College of Law on women in the law and titled
"Adam's Lib."[73] The second was at the National College of the State
Judiciary on clinical legal education.[74]

Nelson's major publication during this period was her casebook on judi-
cial administration, which had been ten years in the making when it

appeared in 1975.[75] Noting that the "inadequacy of cases as an exclusive basis for teaching any branch of the law has been perceived in relatively recent times and modern law school books have increasingly made use of statutory and text material," she declared this need to be "particularly acute in the field of Judicial Administration." A broad range of materials, Nelson believed, was "requisite to a student's capacity for a broad understanding of the operation of the components of the justice system, the problems it faces, and for reasoned judgment in evaluating proposals for reform." In response, Nelson added numerous "legal-related" and "nonlegal" sources to her case-book, including "hearings in chambers; case studies; psychiatric reports; conciliation proceedings; probation reports; trial transcripts; appellate decisions; lawyer's files; attorney records; legislative records; and personal interviews with judges, lawyers, probation officers, and others." These materials were "interwoven" with "with materials from psychoanalysis, psychology, sociology, economics, medicine, geriatrics, jurisprudence, philosophy, business administration, law enforcement, and public administration."[76]

In 1974, after she had served as dean for five years, Dorothy Nelson decided that she "had had enough," and was ready to return to "being just a plain, free professor, with no other responsibilities." President Hubbard, however, was not ready to let Nelson go. In fact, he was prepared to go to great lengths to keep her, as Nelson learned when she told him she was ready to step down:

> He said, 'Dorothy, you're one of our best deans. You simply cannot leave. What will it take to keep you?' I was a bit flippant, but instantly I came up with a list: two hundred thousand dollars for the library; another hundred thousand to bring our salary scale up to that of Stanford; and several other things. He didn't say, 'No' to anything; in fact, he said he thought they could manage it.

With additional university support in hand, and the encouragement of her husband, she stayed on for five more years. In retrospect, Nelson viewed it as the right decision.

Mentors and Mentoring

Like Ellen Peters, Dorothy Nelson's intellectual and professional development was nurtured and furthered primarily by men. Her most trusted

confidante and friend was her husband, Jim. They enjoyed a remarkable relationship, centered on their family and their faith.

Dorothy Nelson counted many professional mentors. One of the first was Dean Roscoe Pound, whose teaching inspired her to excel in her studies, who helped her find her first job after law school, and who influenced her life-long interest in judicial administration. But there were others, most of them identified and thanked in the preface to her casebook. She singled out "one particular man to whom I owe a special debt"—Justice Tom C. Clark of the United States Supreme Court, "the Father of Modern Judicial Administration" who "more than anyone encouraged research and teaching in this area" and who "has been a constant source of encouragement and example."[77]

Dorothy Nelson's own mentoring activities were not so much directed at individuals as at the institution itself. Jerry Wiley observed, "She has presided with patience and human concern; groups and individuals have come to know that *all* persons count with her, but none more than others."

Dean Nelson also feminized the student body. When she was appointed interim dean in 1967, the entering 1L class had 137 students, of whom only 5 (3.65 percent) were women. When she left office in 1980, the entering 1L class had 184 students, of whom 67 (36.4 percent) were women.[78]

Professional and Community Activities

Dorothy Nelson's unique position as dean of USC Law School put her in the spotlight. Before her appointment as assistant dean in 1964, the only law school post she held was that of faculty advisor to the *Southern California Law Review*, beginning in 1962. That began to change in 1966, when she joined two advisory boards, one for the American Judicature Society Seventh Step Foundation, and the other for the Constitutional Rights Foundation. She also became a member of the Board of Directors of Anytown, USA in 1966, and of the Rossmore Corteze Institute in 1965.

After she became dean in 1969, she accepted more invitations to participate in external committees and appointments, including membership in the White House Conference on Children, the President's Commission on Pensions, the Board of the Air Force Academy, the Board of the

American Judicature Society, and the ABA Committee on Judicial Administration. She also joined the board of directors for the Federal Reserve Bank, Southern California Edison, and Farmers Insurance Co.

During the final years of her deanship, Nelson became even more active in professional associations. She continued her work with the American Judicature Society, serving as its vice-president from 1977 to 1979, and as chair of its board from 1979 to 1981. She accepted appointment to the Committee of the Judicial Conference of the United States to Consider Standards for Admission to Practice in the Federal Courts from 1976–79. She became national vice-president of the Order of the Coif in 1974–76. She chaired the Committee on Education in Judicial Administration of the AALS in 1976–80. As she recognized, these appointments helped "assist our school and promote its national reputation," and Nelson's national prominence reflected well on the school.

Becoming a Judge

Dean Nelson was an active participant both in implementing President Carter's judicial merit selection plan and in critiquing its provisions. Even so, she was surprised when Sam Williams, who headed the regional arm of Carter's Merit Selection Commission, asked in 1979 if he could put her on the list to be considered for a federal circuit court appointment. It was not an easy decision: becoming a judge would mean giving up her corporate board positions, which paid a substantial salary for a relatively modest amount of work. Jim Nelson persuaded her to embrace the opportunity, reminding her, "You've been writing about judicial administration. Why don't you really see how it is to be a judge?" With his encouragement, Nelson "decided to put my name in the hopper."[79]

President Carter nominated Dorothy W. Nelson to the Ninth Circuit on September 28, 1979. Her confirmation hearing before the Senate Judiciary Committee was held nearly three months later, on December 12, 1979. Two nominees for the federal district court, Judge Terry J. Hatter, Jr., the former Executive Director of the Western Center for Law and Poverty, who had become a California Superior Court Judge in 1977, and Edward Dean Price, a former President of the California State Bar Association who had been in practice since 1949, appeared with her.

During the questioning, Nelson was asked about what she had done for minorities while she was dean. She responded briefly, feeling that she "just couldn't go through the whole litany of what we had been through with minority programs, the Western Center on Law and Poverty, the Hispanic Center, the National Senior Citizens Law Center, and so forth."

After Nelson's questioning was over, it was Terry Hatter's turn. Hatter, a current Superior Court judge and the former Executive Director of the Western Center for Law and Poverty, which was founded at USC, asked to make a statement to the Committee before beginning to answer questions. "Before I answer your questions," he said, as Nelson recalled the scene, "I want to amplify Dean Nelson's answer to the question that was posed, 'And what has she done for minorities lately?'" Nelson commented on Hatter's statement:

> I treasure his words to this day. It was a sweet and wonderful thing for him to do, but he described our affirmative action programs at the USC Law School, our Western Center on Law and Poverty, our National Senior Citizens Law Center, the Black Students' Law Association, the kinds of things that we had tried to develop, and then went on and said, "Now you may ask me any questions you want of me."

Nelson, Hatter, and Price were all confirmed by the Senate on December 19, 1979, and received their commissions on December 20. She was sworn in informally on February 1, 1980, so that she could begin work. She swore Hatter in as a District Judge, and he came to her public investiture at USC on February 12, 1980, the anniversary of Abraham Lincoln's birthday.[80] The event took place in the Boyard Auditorium with 1,500 people in attendance, including such notables as Chief Judge James R. Browning of the Ninth Circuit, Los Angeles Mayor Tom Bradley, former USC President Topping, then-current President Hubbard, students, faculty, and friends.

Judge Dorothy W. Nelson

It is not difficult to understand why Judge Nelson might be thought of as "the Dean of the Ninth Circuit." Although she was never Chief Judge— Mary M. Schroeder of Arizona is the only woman to have held that post—

she instituted a number of changes, both formal and informal, in the way the court conducted its business that were not unlike some of her initiatives as dean of USC. Within months of taking office, Nelson addressed the Judicial Administration Division's 1980 annual meeting, and shared her initial reactions to the work. Her message was succinctly communicated in its title: "Why Are Things Being Done This Way? Reflections of a Former Law School Dean on Becoming a Judge."[81]

The problem was not hard to identify: the enormous backlog of cases waiting to be heard on appeal, which had grown from 4,000 at the time of her induction in February to reach 4,500 at the time of her speech. No solution was obvious, but Nelson was never one to shrink from a difficult task. She crisply listed nine "basic steps that need to be taken":

> Add more judges. Write shorter opinions. Better management of court affairs. Reduce and simplify the number of decision points in the law. Adopt experimental reforms. Federal jurisdiction should be reduced somewhat. Diversity jurisdiction should be abolished. Alternative tribunals should be utilized. Closer ties with the law school should be established.[82]

She then explained how each could help deal with the situation. These changes were required, she argued, if we are to have "courts staffed by judges who have both judicial competence and the time to be judges, not high-level bureaucrats."[83]

During the first eight years of her service on the Ninth Circuit, Nelson's tendencies toward procedural reform were encouraged by Chief Judge Browning, who retired on June 15, 1988. Nelson characterized Browning as "very open to innovation and very open to new ideas," which allowed her to experiment "like a child in a sandbox." Nelson put the weight of her expertise in Judicial Administration behind the increased use of Alternate Dispute Resolution (ADR) methods as an alternative to courtroom litigation for resolving disputes. She wrote several articles setting out its advantages, and received the ABA's D'Alemberte/Raven Award for Outstanding Contribution to Dispute Resolution in 2000 in recognition of her work in this area.[84]

Asked in 1988 to name a decision she had rendered which will have a "lasting effect on our judicial system," she chose *Doe* v. *Gallinot,* a case involving a constitutional challenge to California's statutory procedures

for commitment of the mentally ill.[85] Nelson had gained experience in the area when she conducted a study on the commitment of the mentally ill as part of her work in Judicial Administration. Her study brought her into contact with "Department 95," as the commitment court is called in California Superior Court, and she was "very distressed" at what she saw, "not because of what the judges did but because of what the law permitted." She described how the *Gallinot* case helped her change that:

> In *Doe* v. *California [Gallinot]*, a USC student was picked up on the street, could not identify himself, had no identification on him, was acting 'strangely' according to the police, and was brought down to Department 95 and given drugs to calm him down. He became quite upset about being in Department 95 and actually was held there 14 days without requesting a hearing. In *Doe* v. *California [Gallinot]*, I said no one could be held more than 72 hours without being given a hearing whether requested or not. . . . It did change the law of the commitment of the mentally ill of California, and it remains that to this day. And I am very pleased with that decision.[86]

Mentoring of Law Clerks

Although Nelson had little opportunity to mentor younger women law professors at USC, she more than made up for that lack by the prominent role she has played in mentoring her law clerks. She looked for "people who are not only very bright but who like a collegial atmosphere, who will consider the work of the chambers the work of everyone, who are not concerned with being No. 1 clerk or No. 2 clerk, [but] are concerned with working with each other." The result of her selection process is a body of clerks and former clerks whom Nelson considers to be lifelong friends.

In her tenure on the Ninth Circuit through 2010, Judge Nelson had forty-three women law clerks—four of whom went on to clerk for the United States Supreme Court—and thirty-one women law externs. When asked by a bar association representative if she had "ever had time to mentor other women," Nelson replied, "The greatest joy of judging and of teaching has been the opportunity to mentor other women."[87]

Nelson's law clerks return her high regard. One of them, Lisa A. Kloppenberg, followed Nelson's footsteps, first into law teaching at the University of Oregon and then into academic administration as dean of

the University of Dayton Law School in 2001, and then later as Dean of Santa Clara Law, beginning in 2013. Kloppenberg wrote a moving tribute to Nelson, titled "A Mentor of Her Own," crediting Nelson with having been "an inspiration, a role model, and a source of strength for me."[88] Kloppenberg has also authored a full biography titled *The Best Beloved Thing is Justice: The Life of Dorothy Wright Nelson*, to be published by Oxford University Press in 2021.

One of Nelson's male clerks in the 1994–95 Term, Theodore D. Chuang, Assistant U.S. Attorney, Criminal Division, Boston, wrote a profile of her in 1999 for the *Federal Lawyer* in which he asserted that some of her "most noteworthy opinions embody the principle that the courts must be vigilant in protecting the rights of weaker minority interests when they have been unjustifiably violated by more powerful, majority interests."

Professor Mark A. Lemley of Stanford University Law School clerked for Judge Nelson in 1991–92. He had interviewed with several judges, and always made a point of speaking with their law clerks. Judge Nelson's clerks stood out from those in other chambers because they were "just ecstatic" about their jobs. That impressed him, and proved to be a reliable indicator, for he felt the same way about his clerkship with her.

A Career of Meaning

In 1985, Nelson took the lead among a group of Ninth Circuit judges and members of the bar to establish an organization similar to those already set up in the east and mid-west to focus on conflict resolution, judicial improvement, and law-related education. The new organization was to be housed in four buildings near the Pasadena courthouse. When it was completed, the Western Justice Center Foundation described its mission as "to increase the opportunity for peaceful conflict resolution and displace the power of violence in our society. We design, implement, evaluate and promote innovative methods of conflict prevention and resolution for children, communities and courts."[89]

Judge Nelson took senior status in 1998, choosing to handle a 75 percent load. She was no longer required to take capital cases or sit on the *en banc* cases that are heard by eleven members of the Circuit, unless the subject was one of her cases. Senior status gave her some "breathing space"

and permitted her to spend more time with the Western Justice Center, which she described as "really booming."[90]

Dorothy W. Nelson has been showered with local, national, and international recognition for her many accomplishments and contributions. Beginning in the year she became interim dean in 1967, when she received UCLA's Law Alumnus of the Year Award, and continuing for forty years through 2007, when the University of Oregon Law School presented her with its Meritorious Service Award, her resume lists twenty-three awards and seven honorary degrees. In an oral history interview conducted in 1988, she identified one award that had "particular significance" for her: the World Peace Through Law Center's *Pax Orbis ex Jure Medallion* in 1975.[91] The awards were presented in Washington, DC, at the seventh biennial World Peace Through Law Conference held from October 12–17, 1975.

Finally, no account of Dorothy Nelson's career would be complete without mention of the profound influence that her Bahà'í faith had on her teaching and career. Nelson's introduction to mediation and arbitration came through Bahà'í, which believes in "resolving conflict through 'consultation' which is a high form of mediation." Under her influence, USC established what Nelson believed to be "the first 'Dispute Resolution Center' in any law school in the nation." Nelson brought her Bahà'í-influenced interest in mediation onto the Ninth Circuit, where she promoted the use of mediators and chaired the Circuit's ADR Committee for thirteen years. She also credited Bahà'í with influencing her decision to found the Western Justice Center in 1985; another good reason to take senior status when she did was to be able to attend more Bahá'í conferences and meetings on weekends.[92]

6 The End of an Era

JOAN MIDAY KRAUSKOPF AND
MARYGOLD SHIRE MELLI

Joan Krauskopf and Marygold Melli began their careers at the end of the 1950s. They shared a specialty in family law, although both also specialized in other subjects. Both were the first female tenure-track professors at their law schools; one was also the first tenured woman professor at her second law faculty. These two women represent the ending of an era when female law professors were largely isolated from each other and not fully accepted as equals by their male colleagues. Both relied on the understanding and support of their husbands and, in all respects except their choice of law as a professional career, acted as traditional wives and mothers toward their families.

JOAN MIDAY KRAUSKOPF

Barbara Joan Miday was born in Canton, Ohio on April 24, 1932, the only child of Clement I. Miday and Elizabeth (Bellinger) Miday.[1] At the time of Joan's birth, her father was out of work, and her mother was working in a boarding house. Her father ultimately became a letter carrier; her mother worked at various unskilled jobs and for years operated the postal unit in

a drugstore. Her parents put a high value on education, and Joan grew up being told that she could do anything. Her parents were loving and supportive, and her childhood was a happy one.

Joan attended grammar school in a small country school with a very homogenous—working-class, all-white, mostly Protestant—student body. Her sixth-grade teacher encouraged Joan to enter a countywide speaking contest, and, later, Joan remembered her teacher's display of confidence in her abilities as an important event in her early life. For high school, her father arranged for her to attend his alma mater in town: McKinley High School. Joan was a star member of the speech and debate team and was active in other extracurricular activities as well. She wrote for the school paper. She was elected vice-president of the student government.

Her family's limited income meant that Joan would have to go to state college, and she chose Ohio University in Athens, Ohio. OU gave her a scholarship—$90 a year, $45 a semester—which paid for the tuition. Joan continued to pursue her interests in student government and public speaking, at OU. She was first in the State in both extemporaneous speaking and debate, and majored in speech until her junior year, then switched to history. She was elected to Phi Beta Kappa in her junior year, and was an outstanding student who compiled many additional honors.

In her sophomore year, Joan met her future husband, Charles Joseph Krauskopf. They decided to get married after Joan graduated. Charley graduated in 1953 and entered the regular Navy as an officer. Joan graduated in 1954, and they were married on July 4, 1954. Since Charley's ship was scheduled to be stationed in California in 1954, and Joan wanted to begin law school right away, she would begin her studies at UCLA. After Charley got out of the Navy, the two of them would pick a location where he could get into graduate school and she could finish her legal education.

Law School

Joan Krauskopf entered UCLA Law in 1954, in the school's sixth entering class of approximately 125 students. She was one among twelve women.

Figure 13. Joan Miday Krauskopf. Portrait by Lisa Ober. Courtesy of University of Missouri School of Law.

There were no women on the faculty or in the administration. Krauskopf rented a private room in Westwood, and she saw her husband on the weekends until his ship left port in November of her first year. Krauskopf felt that her status as a married woman gave her a measure of protection from the gossip and innuendo of the co-ed law school. This both made her

more comfortable and separated her from the unmarried students, and she participated in the school's social life selectively.

Krauskopf did well at UCLA. Despite a somewhat hectic spring final exam period at the end of the year—Charley Krauskopf's ship had returned to port, and she kept running back and forth from Los Angeles to San Diego between exams to see him—her grades were good enough for her to make law review. But as things turned out, Joan never worked on the UCLA law review. Charley completed his Navy service, and UCLA did not have a graduate program in industrial psychology, his chosen field. They both applied to Ohio State University, where they could get the less expensive in-state resident tuition.

When Joan arrived at Ohio State as a second-year student, she found only one other woman in her class. She was very glad to have the companionship, and she and Joan Wharton became good friends. Wharton had "great admiration" for Krauskopf in law school, remembering her as "one of those people you meet in life who simply strike you as having been endowed with special qualities. Not only was she such a clear thinker, she just had a calm way about her."

Charley embraced Joan's dream of practicing law. However, Joan described the "unwritten—but clear—contract" that formed between them: "I could do anything I wanted to do, as long as it was my responsibility to run the household." The transfer to Ohio State proved disruptive for Joan's law school career. Ultimately, she had to take two terms of summer school to finish. During this time, Joan recalled, "Charley was always helpful, but there was no question that I occupied the traditional 'executive role' in the home."

Despite the second shift, Krauskopf's final years in law school were an "exciting, wonderful, and intellectually stimulating" time in her life. She found her professors "marvelous," and considered some to be master teachers and important role models for her in later years. Dean Frank Strong, who taught Constitutional Law, became her mentor, and remembered Krauskopf as a student who was "just outstanding."[2] Robert Lynn, who taught Evidence, remembered Krauskopf as "highly intelligent, quick, and considerate."[3] Krauskopf became the first woman to be co-editor-in-chief of the law review at Ohio State.

Faculty Appointment at Ohio State

Joan Krauskopf graduated *summa cum laude* in December 1957, tied for first in the class with Jack Evans. By that time, Charley Krauskopf had decided that he wanted to teach after finishing his PhD program, and the couple knew that they would have to leave Columbus once Charley earned his degree in three years. Joan pondered what she would do next:

> Robert Nordstrom, the Associate Dean, asked me to come to his office one day. Apparently, he and Dean Strong had talked about this. Bob said, 'Joan, how would you like to work for us next year and run a "How to Study" program for first year students?' I remember saying, 'If I do that, can I run it my way?' He replied, 'Yes, of course.'

Krauskopf started the program in the fall of 1957, before she had her degree but after she had finished her classwork. She designed a very hands-on program. All the first-year students took it, and it was not for credit. She drilled the students in how to read and brief cases, how to take class notes, how to make outlines, how to take final examinations, and how to write briefs.

> It was great fun. I had a little hole down in the basement. Somebody had started calling me 'The Chaplain,' and I put a sign out in front that said, 'The Chaplain's Office.'

Dean Strong, in one of his many letters recommending her for positions after she and Charley had left Columbus, praised Krauskopf as the most effective instructor the school had hired in the ten years of the program's existence.[4]

After she had run the program for two quarters, Joan Krauskopf summoned up the courage to ask Dean Strong if she could teach a regular class. He said, "Well, you can teach domestic relations." In 1958, she took it over, and had her first experience in teaching "a real class." She was admitted to the Ohio Bar in 1958.

In the summer of 1959, while Charley was beginning his final year of PhD work, Joan was appointed Assistant Professor of Law at Ohio State. Dean Strong reported to her later that her first appointment in 1958 had

been a tenure-track one, but now she also had the appropriate title to accompany that position. Everyone concerned—including Joan— understood that the appointment would not last beyond one year, because she and Charley would be leaving Ohio. As he recalled Joan's first appointment years later, Strong described the "predominant view" of the era as "the wife follows the husband," and remembered Joan herself feeling that "she must give Charley the first opportunity, and she would follow him."

Despite the expected time limit, Krauskopf's experience in teaching "real courses" at Ohio State was a turning point in her professional life. She liked the intellectual challenge of writing and research. She had always assumed that she would go into private practice, but the experience of teaching at Ohio State made her realize that she wanted to explore academia.

Her colleagues at Ohio State were "incredibly supportive" of her career aspirations. Looking back, Krauskopf recalled her early years at Ohio State as, in many ways, "the best years of my professional life." She reflected that these years were "the only years in which I had a really supportive group of people who were mentors to me."[5]

No Luck in Colorado

By late summer, Joan and Charley were in Boulder. His first academic position was a joint appointment between the psychology department and the university counseling service. Colorado turned out to be a disappointment for both of them. Charley's situation was not what he had expected: the school had "killed" the graduate program, leaving him unable to teach graduate students. And Joan was completely boxed out of teaching law— as Charley remembered it, one of the members of the law school faculty had gone so far as to say that "as long as he was there, nothing in skirts was going to teach in that law school." These developments left Charley "fairly open two years later to listen when Missouri came around and asked whether I would like to go there."

Joan's description of her experience trying to break into Colorado's law school mirrors Charley's recollection: she essentially ran into a brick wall. As she left Ohio State, Dean Strong did his best to help her find a place in Colorado. Strong spoke with Dean Edward C. King, but without much

hope of success, because he knew that "Ed was not sympathetic to women in law."

When Joan and Dean King met, he hired her as his assistant—partly research assistant, and partly administrative assistant, a position she held from 1960–62. She helped prepare the proposal that Colorado submitted to the Council on Legal Education for Professional Responsibility (CLEPR) for a clinical program, but funding was not made available. She passed the Colorado Bar Examination and was admitted in 1961.

In February 1962 any hope she had of being hired as a law professor at Colorado was dashed when Jack Evans, her "best friend and greatest competitor from Ohio State," came to town to interview for a faculty position teaching Torts, a subject Krauskopf had "always wanted to badly to teach." Howard Klemme, a member of Colorado's faculty, called her the next day to ask about Evans. Like a true friend, Krauskopf praised Evans's abilities. There was, however, one final twist of the knife:

> Then he said, 'Joan, I want to tell you that you have no chance of being hired here. We have a blackball system, and we have got one member of the faculty who thinks that no woman can ever engender the proper respect to be a law professor.' So after that, I gave up that dream.

Krauskopf turned back to the idea of practicing law. She had begun to do a bit of private practice from her home, doing "the kind of things that a woman who is the only woman lawyer in town would do: taking the dog cases that no one else would take." Finally, she began to get real estate cases, which she loved. She recalled working on places with "abandoned railways that had carried trains to the mines," and solving "the most intricate title problems, some the result of bad surveying."

The Move to Missouri

The University of Missouri was one of the few places where Charley's specialty of counseling psychology was offered jointly by the College of Education and the College of Arts and Sciences. As he described the Missouri program, "We had feet in two academic colleges and then again in the student services area. We needed all three of them to make it run." Charley Krauskopf eventually became director of the program and the

program's interdisciplinary nature was a source of national recognition for the University of Missouri.

Again, Joan Krauskopf accompanied her husband without having a firm job commitment for herself. Dean Strong once more recommended her in the strongest possible terms to the Missouri Dean, Joseph Covington. As Strong recalled, "Joe called me, and said, 'Hey, I've got a real problem here. I'm all in favor of naming her to the faculty, but I've got opposition, and I don't know what to do.'" He finally asked Strong to "swear an oath in support of this woman that she is outstanding and deserves a faculty position," which Strong readily did.

By the time the couple moved to Missouri in 1962, they had been married for eight years. Their dream had always been to combine their love of the outdoors with their activities as a family: to own a farm, build a house on it, and develop the property into a wilderness preserve. With the move to Missouri and Joan's uncertain employment prospects, she decided the time was right to implement that plan. She spent the fall of 1962 looking for and purchasing two farms—the couple lived in an existing farmhouse on one property while building their own house on the other. Joan described the 250-acre property as "overrun and full of junk and copperhead snakes and rattlesnakes," but proudly noted that the family "built it into a little wilderness paradise," and in the process built themselves a "very wonderful, very satisfying life."

The "very wonderful, very satisfying life" was made even better when Joan discovered she was pregnant. On December 18, 1962, Joan wrote in her journal, "So delighted and flabbergasted can barely believe it." Their first child, Timothy Krauskopf, was born on July 7, 1963, and by that time Joan had taught her first law school class at Missouri, and her world was looking much better.

Lecturer in Law (Non-Regular), 1963–74

In November 1963, Dean Covington called to ask, "Joan, someone is going to be on leave in the spring semester. Would you be interested in talking to me about teaching?" They agreed that she would teach Property in the spring. Then she learned that she was pregnant, a fact that she took care to conceal as long as she possibly could, with the "diabolical thought" that

if she could hide the pregnancy for at least six weeks, preferably into mid-semester, there was no way the school would be able to replace her.

Krauskopf jumped eagerly into teaching, and she remembered that semester of property as "absolutely marvelous." She was able to teach the subjects she was interested in, which included rights in land, rights to support—such as adjacent and sub-supportive land—and easements and profits. In addition, Krauskopf's scheme to conceal her pregnancy until it was too late in the semester to switch teachers worked perfectly.

Joan Krauskopf was given the title "Lecturer in Law." The title solved Dean Covington's problem with his faculty, because as an adjunct lecturer, Krauskopf's appointment was not put to a vote of the faculty. "Consequently," noted Krauskopf, "there would be little or no opportunity for someone who didn't want a woman on the faculty to object, if the Dean had the guts to just hire someone one semester at a time."

For the next ten years, Joan Krauskopf taught around the curriculum, filling in for one or another professor. She covered an impressive range of subjects: property, negotiable instruments, civil procedure, legal process, social legislation (encompassing Aid to Dependent Children, Social Security, and Worker's Compensation), and business organizations (agency and partnership). She drew the line at Remedies, a course that nobody at the school wanted to teach.

Krauskopf got to teach torts, her favorite subject, by accident, when the professor who had been teaching the course died in the middle of the year. While she was teaching the course, she began to write about torts issues in the hope that publication would improve her chances of obtaining a permanent position at Missouri. Her work on a two-part article on *Products Liability* began during those years. She also began to get better acquainted with the men on the faculty, a process she described as a "very incremental" one. Even as she became more comfortable, she still recalled, "It was very much 'the boys.'"

Krauskopf was excited to learn in 1966 that a faculty vacancy had opened up in torts, and she told Dean Covington that she was very interested. He did not "pull any punches:"

> He looked me straight in the eye and said, 'Joan, I'm going to hire a man to teach that course, someone who can rub elbows with the practicing Bar.'

And that was that. I didn't say anything, because there wasn't any response you could make to that in 1966 or even 1967 or 1968, and I knew that.

Covington and the school's intractability persisted even in the face of Krauskopf's success: she published her two-part article on products liability in 1968 and 1969, and her 1968 article was quoted by the Missouri Supreme Court when it adopted the strict liability approach of section 402A of the Restatement of Torts.[6] In spite of this rare accomplishment, she was not considered for a permanent position, and, in 1969, Krauskopf finally decided she had had enough of her "non regular" status. She wrote in her journal, "I cannot continue my life this way. I am going to become a member of the Bar and give up on this attempt to teach." Rather than study for yet another bar examination, she applied to be admitted on motion. Her application was accepted, and she was admitted to the Missouri Bar in 1969.

Joseph Covington was succeeded as dean by Willard L. Eckhardt. This was not good news for Krauskopf, because Eckhardt was one of the older members of the faculty and apparently had no intention of appointing a woman to a permanent faculty position. He was perfectly willing, however, to continue the temporary arrangement with her that Covington had begun. He asked her to set up the clinical program, a task no regular faculty member relished, and she did that in 1970. She also became the Supervising Attorney for the Legal Aid Clinic. Moreover, Eckhardt offered her a quasi-permanent deal to teach family law on an "indefinite," but still "year-by-year," basis. She noted wryly, "nobody else wanted to teach family law."

In 1972 there were four openings on the faculty. One of Krauskopf's friends on the faculty told her that he and some others had raised her name as a candidate for one of the four slots. The friend then relayed the dean's response—"If I put her on a regular appointment, I would have to pay her as much as a man." To add insult to injury, one of the open positions was to teach torts, Krauskopf's heart's desire. Instead of offering her the position, Eckhardt offered it to one of her former students.

The straw that broke the camel's back—and ended Joan Krauskopf's "non-regular" status at Missouri—became a part of her burden in spring 1974. The struggle for ratification of the Equal Rights Amendment in Missouri was under way, and Joan was very active in testifying in its sup-

port before the state legislature. She twice debated its most prominent female opponent, Phyllis Schlafly, the founder of the National Committee to Stop the ERA, once on TV and once before the St. Louis Press Club.

Dean Eckhardt frequently teased Krauskopf about her involvement with women's issues, in a way that was not entirely friendly. Krauskopf took the ribbing good-naturedly—until Eckhardt told her in the spring of 1974 that the University had begun to require reports from the deans about the number of women faculty in their schools and departments. Eckhardt informed Krauskopf that "he was turning in my name on the reports as 'his woman,' to show that the law school was not discriminating against women."

> When I learned that he was using me to meet his Affirmative Action require-
> ments, it was all I could take. I had asked him a number of times to be
> allowed to teach full time, and there was never enough money to put me on
> full time. I said, 'This is it.'

Krauskopf leveraged the reputation she had built in twelve years of teaching and "let the word out" that she would be willing to relocate within Missouri. "Within a week," Krauskopf noted, "I had a call from Dean Tad Foote at Washington University in St. Louis offering me a visiting professorship in the fall of 1974." Offer in hand, Krauskopf gave Eckhardt her ultimatum:

> I walked into Eckhardt's office at eleven o'clock on a Friday morning, and
> said, 'Bill, I have been offered a position at Wash U., and I am going to take
> it.' At four o'clock in the afternoon, he had the money and the offer of a per-
> manent tenure-line regular appointment.

Krauskopf remembered that Eckhardt "wanted all the terms of my employment worked out very carefully. Eventually the two of them hammered out an agreement. But there remained one last important item to discuss:

> Finally, he leaned forward and said, 'Joan, is menopause going to be a prob-
> lem?' It was the last shot of a cornered man from another era. In retrospect,
> you could think of a million sharp cracks you could have made. But I just
> said, 'Oh, no, Bill, there are medications for that now. I don't think you need
> to worry about it.'

Ironically, Joan Krauskopf came in as a tenure-track faculty member in 1974, a full sixteen years after her first tenure track appointment at Ohio State. She was appointed with the title "Professor." Dean Eckhardt had gratuitously conferred the title on her before she was given a regular appointment in order to be able to list her name on the University's affirmative action reports.

Family Life

Joan and Charley's second son, David, had been born on November 21, 1965. They also had a fifteen-year old foster son who lived with them through high school. Joan relied on neighbors for babysitting. In 1969, Joan's mother retired on minimal social security from her job running the postal unit in a drugstore, and they put up a little house for her on their farm. She was very helpful with the children and was always there when they got home from school.

Charley's career was already well established by the time Joan stepped up her efforts, so as he put it, "I could afford to do less." The family lived together in the house Joan and Charley had built on their farm. In front of the house, they put in a two-acre pond, which they stocked with fish. As the children grew, there was fishing and swimming every day as soon as the weather was warm, ice skating in the winter, and canoeing on Missouri's clear, spring-fed streams. Joan recalled with satisfaction, "It was a wonderful life."

Pro Bono Advocacy

During the years she was teaching part-time at Missouri, Joan Krauskopf was also getting pro bono practice experience. In 1969, Krauskopf began advising the local chapter of the ACLU, which was beginning to focus on prison reform. In *State* v. *Green,* she represented a nineteen-year-old youth who claimed that he had escaped from the Missouri State Training Center for Men in order to avoid a threatened rape in his cell by five prisoners.[7] The case was tried in Moberly, a small town north of Columbia where the prison was located, and Krauskopf noted, "I certainly did not endear myself to the local prosecutor." She argued a defense of necessity,

but her theory was rejected by the Supreme Court of Missouri in 1971 in a 6 to 1 decision. But Judge Seiler's dissenting opinion, which accepted the proffered defense, was cited favorably four years later by the California Court of Appeals in *People v. Lovercamp,* when it upheld the defense of necessity under similar circumstances.[8]

The ACLU used *Green* to create publicity about prison conditions in Missouri, and the case's notoriety caused something of a stir. After *Lovercamp* was decided in California and validated the idea of a necessity defense for a prison escape, Krauskopf "felt okay about the case," even though she had lost it. Krauskopf's performance in the *Green* case led to her appointment as counsel for another prisoner in the same training center on a state habeas corpus challenge to his conviction for stabbing a fellow inmate. The result, she recalled, was that "Everybody in that town hated my guts," with the predictable result that her habeas motion was denied by the trial court. Undeterred, she took the case to the Missouri Supreme Court and won, reversing her client's conviction. Krauskopf proudly noted that *Kern v. State,* in 1974, "was one of the first such challenges which the movant won in Missouri."[9]

Krauskopf's pro bono activities were not limited to criminal law cases. In the early 1980s, she took on the daunting task of persuading the Missouri Supreme Court to reverse itself in *Kuchta v. Kuchta,* a case in which it had held that a husband's TWA retirement pension benefits were not marital property subject to division in a divorce proceeding.[10] She described the case as perhaps "the most challenging task of my career to get at least one judge who had been in the majority to vote for rehearing and then to convince enough of them to reverse themselves." She continued, "It was a long and difficult task, but we succeeded: a most gratifying victory for me and an important one for the law of Missouri."

Tenure

In 1974, Ohio State University School of Law was in the midst of a dean search, and Krauskopf was invited to interview for the position. The school ultimately chose Orin Slagle. Immediately after he became dean, he reached out to recruit Krauskopf and offered her a permanent full professorship with tenure. He had taken the precaution of checking with the

psychology department and knew they would hire Charley. After much consideration, Joan and Charley "decided that we could not give up our lifestyle and move our children to a city."

Joan Krauskopf went to Missouri's Dean Eckhardt and said, "I'm not going to play games. I will tell you that we have decided to stay here." However, she added, "I have been given an offer of tenure at Ohio State, and I want tenure here." The faculty voted for Krauskopf to be given tenure, and she became the first woman to hold a tenured professorship at the University of Missouri-Columbia School of Law.

Early Research and Publications

Joan Krauskopf began publishing scholarly articles early in her career. As a student at Ohio State, she had published a law review comment, "The Law of Dead Bodies: Impeding Medical Progress," in 1958.[11] In her first year of full-time teaching she wrote an article dealing with the practical problem of how to avoid the effects of the statute of frauds. Krauskopf designed her article to "serve the practicing attorney as a check-list of available theories by which a remedy can be obtained."[12] Her next article analyzed the conflict of laws between different states interested in regulating various aspects of marriage and divorce. It was published in 1963 and was cited with approval.[13]

In 1965, Joan and Charley Krauskopf collaborated on an article published in *The Journal of Counseling Psychology* designed to inform psychologists about the possibility of tort liability for professional malpractice.[14] In 1970, Krauskopf wrote a solo article for the *Journal of the Missouri Bar* on the Proposed Uniform Adoption Act. In 1971, she published an article on criminal procedure, analyzing the historical origins and modern justification for the right of a criminal defendant to be free of physical restraints while in court.[15] The article was cited in 1973 by the 6th Circuit Court of Appeals in *Kennedy v. Cardwell* for its treatment of the historical development of the rule that a defendant should be unfettered except in extraordinary circumstances. It was also cited in 2005 as a general reference by the United States Supreme Court in *Deck v. Missouri*.[16]

In the early to mid-1970s, Krauskopf turned to writing about sex dis-crimination when she began to advocate for the ratification of the Equal Rights Amendment in Missouri. Krauskopf's own experiences with Missouri's law faculty and hiring practices helped spark her interest in the legal issues of sex discrimination. Her first article on the subject, "Sex Discrimination: Another Shibboleth Legally Shattered," presented a com-prehensive survey of an emerging field, published a year and a half before the first law school casebook on the subject appeared in January 1974.[17] All of these articles were written and published before she was ever offered a full-time position in Missouri.

Krauskopf "first began to think about the Equal Rights Amendment" in the course of doing research for her "Sex Discrimination" article. She pub-lished an article in the *Journal of the Missouri Bar* in March 1973, in which she shared her "contemplation" of how the ERA would be likely to change familiar provisions of the law, noting that her investigation had "changed an originally mildly negative bias to a positive bias."[18] She also provided a sum-mary analysis of the likely impact of the ERA on various specific areas of the law, including the military; criminal law; civil or governmental rights; fam-ily matters (including marriage, spousal support during and after marriage, child support, and custody of children); and business and employment.[19] In 1975, Krauskopf published a second article on the ERA, this time in the *California State Bar Journal,* which was more of an advocacy piece. She covered most of the same issues explored earlier in the Missouri article, but stated her own view more positively. Krauskopf gave NOW significant credit for its work in "turning things around" for women.

Life After Tenure

Joan Krauskopf's life "just utterly exploded" once she had become Missouri's first tenured woman law professor in 1974:

> I was researching and publishing. I was on the Missouri Bar Family Law Committee, and later became its Chair. I was on the United States Civil Service Commission Advisory Committee. I did everything. I thought, 'I've got to do this stuff for the Bar. I've got to do this. I've got to do that. I have to turn out all these articles.'

She continued to teach family law on a regular basis, and she began to publish in the field in 1973, writing an article on property division and separation agreements for the *Journal of the Missouri Bar.*[20] In 1974, she and her former student, Rhonda Thomas, co-authored an article on spousal support.[21] Two years later, Krauskopf returned to the subject of property division, publishing "A Theory for 'Just' Division of Marital Property in Missouri" in 1976.[22]

Krauskopf continued to develop her expertise in family law, and she published four family law articles. She contributed three to the *Journal of the Missouri Bar*—two on maintenance,[23] one on child custody[24]—and one to the *Missouri Law Review,* on property division.[25]

Judge Krauskopf?

In 1979, at the time President Carter was beginning to appoint women to the federal bench, Missouri stood out like a sore thumb. There were no women judges in any court of record in the entire state.[26] National women's groups had identified Professor Krauskopf as their ideal candidate. When Krauskopf was approached, her gut reaction was negative: "I really didn't want to do it," she recalled, "but I felt a tremendous obligation to the women's movement."

After she had agreed to throw her hat in the ring, Krauskopf prudently considered what she needed to do to make herself at least a viable candidate. Krauskopf met with Senator Tom Eagleton in January 1979:

> He was a Catholic from St. Louis, and he had to mollify those incredibly extreme anti-abortionists in St. Louis. At the same time, he had very active women's groups in the state whom he also had to mollify. To his credit, the only question he asked me about abortion was whether or not I had ever acted publicly for an abortion rights group. I said I had not.

Eagleton ultimately decided to support Krauskopf's appointment, and in March, 1979, Carter's Eighth Circuit Merit Selection Commission recommended five finalists for the Circuit Court judgeship.[27] Krauskopf was the only woman, and—as it turned out, a significant deterrent—the only academic among the five finalists. She and Charley both remembered how they learned the news:

Joan: In late March, Senator Eagleton called me at ten o'clock one night and said, 'Congratulations, Judge.' Carter had picked me.

Charley: Eagleton called one night. He talked to me for a few minutes, and then talked to her. He told her to go ahead and hire law clerks. He said, 'You're in.'

Senator Eagleton, however, had overestimated his influence. The American Bar Association found Krauskopf "unqualified" because of her lack of trial experience. Krauskopf had been interviewed by only one member of the committee, "an extremely traditional conservative Republican railroad attorney from Kansas City, who did his homework:"

> He went to the little town with the prison and talked to people there about my ACLU cases on behalf of prisoners. He came to see me, and he raised the issue of my qualifications, because I had not had any trial experience to speak of.

Krauskopf had supporters in high places who came to her defense. Eight of the nine Eighth Circuit Judges signed a letter to Attorney General Griffin Bell, objecting to the ABA's rating. It said that no candidate should be disqualified solely on the basis of limited trial experience.[28] Chief Judge Floyd R. Gibson observed that her "background in law would more than make up for her lack of trial experience. She is certainly qualified to sit on this court."[29]

Armed with the letter, Senator Eagleton and the Justice Department asked the ABA Committee to take a second look at Krauskopf's nomination, but the result remained the same.[30] On Wednesday, August 15, President Carter sent a handwritten note to Senator Eagleton, withdrawing his selection of Professor Krauskopf in reliance on the ABA's negative rating and a Justice Department recommendation against her nomination.[31]

Feminist groups called upon Carter to reconsider his decision.[32] The *St. Louis Post-Dispatch* blasted the ABA in an editorial published on August 17, 1979, charging that the Carter administration and the Justice Department "have not done themselves much credit in succumbing to the American Bar Association's veto of Joan M. Krauskopf for a federal appellate judgeship" and pointing out that "Mrs. Krauskopf seems particularly qualified for appellate work" based on her academic career.[33]

In a memorandum that she sent to President Carter's Special Assistant Sarah Weddington on August 21, 1979, Krauskopf explained why the combination of the two factors he had cited in withdrawing her nomination— lack of trial experience, and a narrow academic specialization in domestic relations—had resulted in denying her the opportunity to serve as a federal judge because of past sex discrimination. She pointed out that automatic disqualification for lack of trial experience had the effect of excluding not only herself, but also "many academics and of most women with 15 or more years of experience (particularly in the Midwest)."

Last Years at Missouri

After her nomination struggle, Joan Krauskopf "withdrew from everything public. I was depressed. It had been a very trying experience. I just went into a quiet hole, working at things and doing my research." However, by 1981 Krauskopf had shaken off her funk. "I was back and feeling great." Her star status at the law school had not been tarnished by the nomination battle. Professor Thomas E. Sullivan, who had recently joined the Missouri faculty, recalled that "Joan was one of the most influential and senior persons on the faculty, and she was held in great respect by virtually everyone."

In 1980, Krauskopf published one of her most successful and widely cited pieces. "Recompense for Financing Spouse's Education: Legal Protection for the Marital Investor in Human Capital," drew on the economic theory of investment in human capital as the basis of a legal remedy for an ex-spouse who had worked during the marriage to put the other spouse through professional school or graduate education.[34] Krauskopf's vision of "the economic model of the family as a firm choosing to invest in human capital" proved extremely influential, and had a major impact on the recommendations of the American Law Institute's Project on Family Dissolution.[35]

In 1980, Krauskopf had received a grant to prepare a Continuing Legal Education (CLE) manual, called *Law for the Elderly*.[36] Dean Allen E. Smith encouraged her to publish a book on the subject.

Al kept saying, 'Just write books!' No one had done books yet on Law and Aging. I asked him, 'Well, how do you write a book?' He said, 'You just send off a proposed table of contents.' So I sent off a proposed table of contents to

West Publishing Company. And I wrote a book almost all on my own with just a student research assistant.

West published *Advocacy for the Aging* in 1983.[37] In 1993, Krauskopf expanded the book to a two-volume set, titled *Elder Law: Advocacy for the Aging.*

In 1981, Krauskopf finally got another chance to teach torts, when the professor who had been teaching it at Missouri retired. Torts, in addition to her current course load, created a heavy burden. Resolving "to stay with family law, to keep up my research, and to teach torts just because I loved it," Krauskopf nevertheless "decided that I had to make my mark with a torts publication if I was going to teach the subject."

> I always loved to see if I could effect a change in the law, so I chose to write about the tort of wrongful discharge in employment law. I wrote it from a national perspective, but I ended up tying the Missouri law to it. I think it has been somewhat helpful in Missouri's changing its law.

Krauskop's article, "Employment Discharge: Survey and Critique of the Modern At Will Rule," was a comprehensive overview of the social and historical climate affecting legal principles from the 1880s, when the at will employment rule was developed, to the 1980s, when it was undergoing rapid modification in many states.[38] It was also—at seventy-seven pages—her longest published article. She set out emerging contractual and tort theories for employee recovery, reviewed relevant federal statutes affecting the common law rule, and focused on the tort remedy of wrongful discharge. Her article certainly served the purpose of "making her mark" in the field of torts: Professor Mack Player told her that it was the best summary that had been done and cited it in his casebook on employment discrimination law.[39]

Krauskopf kept up her steady output of family law research. She published another specialized casebook with West, a 250-page compilation called *Cases on Property Division at Marriage Dissolution,* in 1984.[40] She wrote two final articles for the *Missouri Law Review* in 1985, both designed to instruct the Missouri bench and bar in the latest developments in family law. Krauskopf also prepared articles on several family law subjects for the University of Missouri-Columbia Extension which

appeared in 1985 in the *Home Economics Guide:* property division at marriage dissolution, pension benefits at divorce, maintenance, contracts concerning marital rights, and child support. In the same year, she contributed a chapter on *Principles of Property Division* to a book for practitioners.[41]

Full Circle: Return to Ohio State

Joan Krauskopf spent 1986–87 at the University of West Virginia as the William J. Maier, Jr., Visiting Professor of Law. While there, she received a call from Professor Michael Kindred, Chair of the Ohio State Appointments Committee, who told her that they were looking for a senior woman to join their faculty. As Krauskopf remembered the conversation, Kindred told her, "Joan, your name keeps coming up around here," and while the general consensus was that she would never leave Missouri, the school saw an opening when she accepted a one-year appointment in West Virginia.

Ohio State understood that they were dealing with a dual career couple, and that they would have to put together a package that would be attractive both to Charley and Joan. They were eager to do so. Joanne Murphy, who had returned as Assistant Dean and Adjunct Professor of Banking Law, reported that "Joan had such an impressive interview here, and with the people who knew her, there just wasn't any question about her having a faculty appointment if we could get her."

Creating an attractive package for Charley Krauskopf was more difficult. Ultimately, the department used Charley's potential appointment as an opportunity to renew a request to hire someone to direct the training clinic for psychology graduate students. The result was an appointment that was "three quarters" dedicated to the psychology department and included both leading the training clinic and working with the dean of student affairs on data analysis issues.

The Krauskopfs moved back to Columbus in 1987. Joan was in her element: teaching her beloved course in Torts, as well as Family Law, Insurance, Remedies, and a seminar on Law and the Elderly. In addition, she took on major service commitments, both for the University and the Law School, which competed for her research time. The Provost immedi-

ately asked her to serve on the University Promotion and Tenure Committee—a prestigious, but extremely time-consuming assignment—and Dean Frank Beytagh urged her to accept because no law school faculty member had ever served on that committee. She served for three years. In 1988, she was appointed to the Council on Academic Excellence for Women, becoming its chair in 1991.

The Ohio State campus administration also utilized Krauskopf's expertise in sex discrimination to its fullest to examine existing practices. In January 1990, she was appointed chair of a committee to examine "family friendly" policies then being adopted by other universities. It recommended the adoption of a policy permitting the exclusion of up to two years from a faculty member's six-year tenure probationary period for purposes of child care, care of a seriously ill or injured family member, or serious illness or injury of the faculty member.[42] The recommended policy was adopted by the Faculty Senate and approved by the OSU Board of Trustees.

Krauskopf's external service commitments to the legal profession were also impressive: in 1989, she became a member of the advisory committee for the American Law Institute's Project on Family Dissolution, which lasted until the project was completed in 1999. In 1991, she was named chair of the Ohio Gender Issues in Law Schools Committee "to explore whether there was gender unfairness in Ohio's law schools that might affect general attitudes or practices in the courts or the profession."[43]

While Joan Krauskopf enjoyed her position at the center of a whirlwind of activity at Ohio State, Charley's situation was not as ideal. Joan reflected that Charley, who loved teaching and working with graduate students and conducting research, was dissatisfied with the heavy administrative content of his role at Ohio State. Making the best of his situation, Charley used the additional time to finish a book he and a co-author, David R. Saunders, had been working on for several years. *Personality and Ability: The Personality Assessment System*, was published in 1994.[44]

Honors and Activities

Joan Krauskopf was named the Manley O. Hudson Professor of Law at Missouri in 1977, and held that Chair until 1985, when she ascended to the F. R. B. Price Professorship. She was given the Missouri Alumnae

Anniversary Award for Outstanding Faculty Women in 1977 and the Alumni Association Faculty Alumni Award in 1985. At Ohio State, she was given the President's 300th Commencement Award in 1987, an honor conferred each year on a few outstanding Ohio State Alumni. She held the Presidents' Club Professorship in 1996–97. In 1984, she was elected to the American Law Institute. She served on the Executive Committee of the National Order of the Coif from 1989 to 1998, becoming its President in 1995–97.

Retirement

Joan and Charley retired from Ohio State University in 1997. In 1994, at age sixty-two, she had convinced Charley to join her trekking to 18,000 feet at the base of Mt. Everest. In the fall of 1997, they took a trip to China and India. They traveled the Silk Road together, ending up in Bukaro, Uzbekistan. They separated in Tashkent and she went on to Nepal alone. She spent ten or twelve days trekking alone with a crew of ten outfitters. Krauskopf had ample time for reflection and meditation, and on the way out, she had a transformative experience:

> We were hiking across a high slope where there was no snow. You could hear the rushing river down below, and far in the distance you could hear yak bells on the main trail. Above us were huge, snow-covered peaks against the bright blue fall sky. I looked down the slope, and it was covered with a beautiful array of fall colors, of golden colors and some dark reddish plants. There were birds flying around singing. And I stopped, and looked down, and suddenly I was in tears. I sat down, pulled out my journal, and wrote a passage beginning, 'I'm moving to the mountains.'

After Joan returned to Columbus, she and Charley began looking for a home in the mountains. They settled on Prescott, Arizona. There they bought a wonderful house that allowed them to sit on their deck at 6000 feet to see nothing but mountains, trees and blue sky. Once settled in Prescott, the Krauskopfs affiliated with the Unitarian Universalist community and also became active with the Smoki American Indian Museum as volunteers. At different times, both served on the Board of Directors. She taught numerous short courses while Charley chaired the Exhibits

Committee, acting as the museum curator. They continued to do extensive travel all over the world.

Charley died in 2015 at the age of 83. Joan died four years later, at the age of 87.

MARYGOLD SHIRE MELLI

Marygold ("Margo") Shire was born on February 8, 1926, in Rhinelander, Wisconsin, the second of three daughters of Osborne and May Bonnie Shire.[45] Margo's father was Canadian but had moved to Wisconsin to work for his uncle, Arthur Taylor, who had acquired the Coca-Cola franchise for northern Wisconsin and had a plant in Rhinelander. There he met May Bonnie, and they were married on May 20, 1916.

Early in the marriage, Osborne suffered an industrial accident, which resulted in the loss of his right hand—a traumatic event, which prompted him to return to his home country and join his older brother, Frank, on his farm near Calgary, Alberta, Canada. Osborne and May Bonnie's first daughter, Bonnie Ann, was born there on Armistice Day, November 11, 1918.

The family returned to Wisconsin a few years later. May Bonnie's marriage to a Canadian ("a foreigner") had resulted in the loss of her United States citizenship under the Expatriation Act of 1907, but she was allowed to "repatriate" and regain her status through naturalization under the Cable Act of 1922. Thereafter, she exercised her reacquired citizenship by voting regularly in elections. Margo's birth in Wisconsin in 1926 made her a "natural born citizen" of the United States. Her father became a citizen in 1939.

In 1928, the family moved to Jackson, Mississippi, and when Margo was five years old, she began attending first grade there. She wryly described the arrangement as "the result of a baby-sitting problem, not a recognition of my brilliance." The local Catholic school wanted to hire Margo's mother, but May Bonnie explained that while she would be interested in the job, she had no childcare for Margo. There was no kindergarten program available for a five-year-old at that time, but as Margo remembered it, "the nun in charge said, 'We will put her in the first grade—she is a quiet child and won't cause us any problems.'" Apparently,

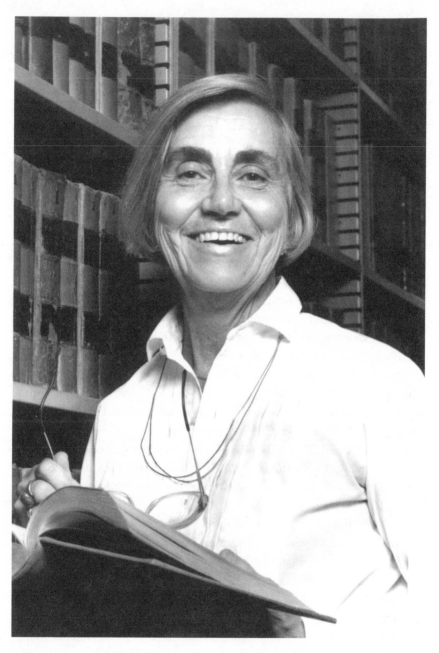

Figure 14. Marygold Shire Melli. Courtesy of the University of Wisconsin Law School.

Margo was indeed smart enough to keep up—she was passed on to the second grade at the end of the year.

By 1932, the Depression had worsened, and Margo's father lost his job at the Dr. Pepper plant. Her mother wanted to move back to Wisconsin, telling her husband that if she was going to be "desperately poor," she would rather be poor in Wisconsin—which had good social programs—than in Mississippi. They moved to Milwaukee where Margo entered second grade. As she recalled, "I had a Southern accent you could cut with a knife, and the other children were not very kind to me."

Osborne's uncle was able to find a place for his nephew, who took a job working in the uncle's Coca-Cola plant in Antigo, Wisconsin. Margo entered third grade in yet a different school, and by the time she had finished fifth grade, she had attended four different schools—one in Mississippi and three in Wisconsin. In 1936, Margo's sister Bonnie Anne graduated from high school in Antigo. Her parents thought it very important that their daughters acquire college educations—neither of them had managed it—but although they could pay her fees of $36 per semester, they could not provide the cost of room and board. So they moved to Madison so that their children could attend the University of Wisconsin.

In Madison, Margo finally found a place where she felt at home, once she started attending St. Raphael's:

> The school was run by Dominican nuns who were very supportive and praised my accomplishments. The students welcomed me, and I loved it and excelled. I then attended Edgewood High School—run by the same order of Dominican nuns—where I graduated first in my class and won a scholarship to pay my first-year fee to attend the University of Wisconsin ($48.00 in 1943).

Margo entered the University of Wisconsin in 1943, majoring in international relations. An outstanding student, she was elected to Phi Beta Kappa, Sigma Epsilon Sigma (a freshman honorary society) and Phi Kappa Phi (the nation's largest all-discipline honor society for seniors and graduate students); she was also chosen for Mortar Board.

During her undergraduate years, Margo lived at home and worked as much as twenty hours a week. That limited her participation in college activities, but she was active in a sorority and held several offices. She

served on several committees at the Student Union, the center of campus life at the time. She was also a member of the Appeals Court of the Student Government Court system.

Law School

Even as a young girl, Margo was attracted to the law. She remembered that Oliver Wendell Holmes had said, "The law is the calling of thinkers."[46] She recalled: "I remember saying to my Dad, 'Well, I know I will have to work all the rest of my life, so I might just as well do something where I can think.'" From the time she was in middle school, Margo's teachers encouraged her aspirations. The encouragement continued throughout Margo's Catholic high school career. She remembered Sister Mary Hope, who "thought law school was a very good idea," and who frequently made Margo give announcements at school, "because she said that lawyers should have the ability to speak on their feet."

Margo Shire transferred to the law school in the final semester of her senior year, beginning her legal education in January 1947. She had no difficulty being admitted. But the chaos created by the large number of returning World War II veterans may have affected the school's ability to keep track of its students. Shire contrasted the "hordes of older students who had real ideas about what they wanted" to herself, who was, in her own words "just this little kid, obviously unsophisticated—I hadn't really been anywhere—and a little young for my grade."

The faculty knew who "Miss Shire" was, but they never called on her to recite in class. Shire thought they were a little "leery" of calling on the only woman in the class: Professor Sam Mermin, who joined the Wisconsin faculty in 1951, recalled that "those who had had her as a student were all uniform in praising her" when she was being considered for the faculty in 1959.[47]

Shire's high grades assured her of a place on the *Wisconsin Law Review*. She was elected one of the *Review's* three executive editors for the fall 1949 term. Shire recalled that the Editorial Board's original idea was that she should be the articles editor, because someone was worried about the possible adverse reaction of male students to reporting to a woman. She

insisted, however, on being a note editor, and she finally prevailed. As she remembered the experience, only one male student ever became affronted by reporting to her:

> He was a bright young man, but I was really, really into him because his Note was very poorly written and very badly researched. And when I told him that, he looked at me and said, 'You know, I don't like some little girl telling me how to do these things.' I replied, 'Well, I'm sorry, but if you did them better, she wouldn't be telling you that.'

Shire kept a busy social calendar at Wisconsin. She loved being a part of the social life of the school: "I had a wonderful time, not only because I loved all the ideas, but also because everybody included me and it was a wonderful time socially." While Shire recalled that "there were several young men who thought I should marry them," she spurned them all— save one. "I wasn't particularly interested," she noted, "until I met Joe Melli."

Joseph A. Melli was born on January 1, 1924, in Kenosha, Wisconsin, the youngest of six children. His parents had immigrated from Palma di Montechiaro, Sicily, in 1912. Like Margo Shire, Joe Melli was in the first generation of his family to attend college. He graduated from the University of Wisconsin in 1946 and entered the law school that Fall, only to enlist in the US Army later that year. In January 1948, after his eighteen-month tour of duty was over, he resumed his legal studies at Wisconsin. He and Margo were in the same class, and they met each other during the first month of classes.

Joe had high hopes—so high, he said, that he proposed to Margo on their second date, election night, 1948:

> We went to the Democratic Party election doings, and we were both very happy about the way things were turning out for Harry Truman. I guess I thought she was very nice, and I thought that we'd make a very good couple. She didn't accept me then, but she didn't reject me, either. After about six months, we were sufficiently enamored with each other that we thought marriage was something we would pursue. She is the only girl I ever asked to marry me. We were married on April 8, 1950. She had graduated in January, and I graduated in June.[48]

Early Employment

Margo Shire Melli learned about the practicing bar's attitude toward women lawyers when she began to look for a job. She had superb qualifications: her grades put her at the top of the graduating class. She and the editor-in-chief of the Law Review, William Moore, were tied for first place in the class of 1950.[49] In addition, she had been note editor of the Law Review. Not unreasonably, she expected to be interviewed for a law firm position. But her ambition was thwarted not only by the firms themselves, but also by Dean Oliver Rundell, who controlled the hiring process. As Melli recalled, Rundell decided which students could interview with a particular firm and posted a list on which Melli's name—although she was a top student—never appeared. Melli approached Rundell to ask why her name had been left off. "Miss Shire," Melli remembered Rundell saying, "none of these firms would hire you. Why should I waste their time?"[50]

Melli had no better luck when she contacted some of the law firms directly. Discouraged, Melli spoke with some of her professors about what had happened. One of them, Delmar Karlen, was part of a group, the Legislative Council, which was created to form a relationship between the law school and the state legislature. The Council would conduct studies on the legislature's behalf, offering the legislature the benefits of its insights while at the same time providing fellowships to Wisconsin law school graduates, who would have the opportunity to work closely with faculty members. The first project was to recodify the Wisconsin Criminal Code. Melli recalled, "Del, having heard about my experience with the dean, came and offered me a job on the project." Melli accepted his offer.

Margo's fellow note editor on the Law Review, Orrin Helstad (who became dean of the Wisconsin Law School in 1975), was also recruited for the project. He and Melli split the code into sections, with Helstad focusing on murder and other violent crimes, Melli taking the property crimes, and the two of them working together on some other sections. After several revisions, the drafts went to a committee within the Legislative Council and then to the Council itself. Helstad said that ultimately, "We produced a Criminal Code, which was adopted in 1955. And that project set the stage for a number of law revision projects which the Legislative Council has since undertaken."

Melli had become acquainted with the members of the Legislative Council, and even before the Criminal Code project was completed in 1953, they had approached her to see if she would take charge of their next big project: the revision of the state's Children's Code. Melli had full control over the study. She ran the legislative hearings held around the state. She helped lobby the Children's Code through the Legislature, and it was enacted in 1955.

At the end of the Children's Code project, Melli declined to become a staff attorney for the state, preferring another opportunity. In 1955, John Conway, who had joined the Wisconsin Law Faculty in 1953 and was the school's representative on the state's Judicial Council, offered her the position of Executive Director of the Council.

Melli enjoyed her work with the Judicial Council, and Joe Melli recalled that it was the only time in their careers that she was making more money than he was. In 1958, Joe Melli founded the firm known as Melli Law, S.C., which ultimately specialized in Labor and Employment Law (Management), Construction and Corporate Law, General and Business Practice, Trials, School Law, and Real Estate Law. Joe himself practiced Labor and Employment Law. Both he and Margo were content with their work and were contemplating beginning their family when a new opportunity presented itself to Margo.

Assistant Professor of Law, 1959

In 1959, Wisconsin chose one of its graduates, George Young, '41, as its new Dean. One of his first official acts was to invite the Mellis to dinner, and over dinner, to ask Margo if she would be interested in joining the faculty. Melli was careful to inform Dean Young about their family plans. The Mellis had applied to adopt a child and had been told by the agency that Margo would have to be a full-time parent if the adoption came through. To her surprise, Young seemed unfazed.

She understood that Dean Young would have to put her name to a faculty vote, but the process did not involve her coming to the law school for formal interviews. "Professor Marygold Shire Melli" was informed by Clarke Smith, the Secretary of the Regents, of her appointment: "In adopting the 1959–60 University budget, the Regents of the University of

Wisconsin have appointed you assistant professor of law, at a salary of $8,250 for the academic year."[51]

Assistant Professor Melli began teaching in the fall semester, 1959. Her assigned subjects were Business Organizations, Sales, and Secured Transactions—a far cry from the course she wanted to teach. She had asked Dean Young to permit her to teach Family Law, which in the 1950's was called "Domestic Relations." Melli's work with the Children's Code had given her deep background in the area, and she thought that Family Law was "the coming area," as she put it. Ironically though, Young denied her the opportunity she wanted specifically to avoid the appearance of sexism:

> I went to George Young and said, 'I'd like to teach that course.' He said, 'There's no law there, Margo. We don't want to put you on that.' Stewart Macaulay said to me, 'Everybody will say we forced you into it because you are a woman.' So he and the Dean were not very enthusiastic about my interest in family law.

Family Life

Since Margo and Joe had been unable to have children, they applied to the local state adoption agency. Unfortunately, the female social worker assigned to their case felt that, in Margo's words, "a woman lawyer was not an appropriate model for a child, particularly for a daughter." She turned them down. Their case went up to the Director, who knew them, and whose attitude was that "the Mellis are the kind of people we'd like to have adopt our children." The matter was reassigned, and in relatively short order, the Mellis were approved as adoptive parents.

Margo and Joe were informed during the spring semester, 1960, that the agency had a child for them. Their son, Joseph Shire Melli, was born on March 18, 1960. At semester's end, Melli decided to take a year off. Since "family leave" for faculty did not exist in 1960, she went to Dean Young and resigned her tenure-track faculty appointment. But in the spring of 1961, the Dean gave her the opportunity to teach the course she had asked for: Domestic Relations. Melli taught the course. The following semester, Young again asked Melli to teach Domestic Relations, and this time, she asked for more:

I said, 'I don't want to do it that way. If I'm going to be here, I want to be part of the faculty.' But I didn't want to come in full-time, so I was appointed on a half-time basis.

Two years later, Joe and Margo adopted their first daughter, Sarah Bonnie Melli, who was born on February 7, 1962. They adopted their third child and second daughter, Sylvia Anne Melli, who was born on February 22, 1964. The Mellis' fourth and last child, James Alexander Melli, was born on October 6, 1966.

Margo Melli understood clearly that Joe expected her to take care of the children. As a result, Melli had to plan her extracurricular activities carefully: "If I had to go out to a meeting, I had to get a babysitter. If I went out, he did not stay home and take care of the children." Like many modern career women, Margo Melli found ways to outsource some of her domestic duties. As reported in the *Capital Times* in May 1969, a university student lived with the Mellis and helped with childcare, a housekeeper came during the day, there was a man who "does the floors," and "Mrs. Melli sends her ironing out."[52]

During her first two decades of teaching, Margo Melli also had another pressing family obligation: daughter of a widowed and dependent mother. Her father died of cancer in 1962, and her mother, who had never been alone and was completely dependent, required constant attention. Her mother was so feeble and frightened that Melli had to hire students to fix her mother's lunch, "otherwise she would not eat." Melli's personal and professional life was severely compromised while she cared for her mother.

The Struggle for Tenure, 1966

In 1964, Dean Young called Melli into his office to discuss his plans for handling her application for tenure at the law school. As Melli recalled, he said, "We will appoint you full-time for one year. And then we will send you up for tenure. They won't consider you for tenure unless you are full-time." Melli disagreed: "I feel very strongly that if you are going to use the talents that you have in women, you ought to really consider that their situations are different. My situation is that I want to be only part-time because I have children. And if the university can't accommodate that

now, they are going to have to face up to it someday." Melli and the Dean "had a number of somewhat contentious conversations" on the subject, but she refused to give in, and eventually "they sent me up."

Melli also understood that she did not have a publication record similar to that which had been required of others: indeed, that recognition was a large part of the reason why she had not taken the initiative of applying for promotion herself. "I realized all of my shortcomings. I had really concentrated on small children, and I hadn't done much scholarship."

The Law School recommendations were reviewed by the Social Studies Divisional Committee; and, as it happened, Melli's colleague, Professor Stewart Macaulay, was a member when her case came before the committee. Tenure review for law school faculty was always a problem, he recalled, because the other social science departments had a negative view of lawyers.

Melli's particular case made the process even more challenging. On the one hand, as Macaulay put it, she was "a woman who wanted tenure, and she was only part-time." On the other hand, she had a strong champion in Dean George Young. Support like this for women, Macaulay concluded, "was extremely rare, but it could move mountains."

Macaulay recalled objections on a number of different fronts:

> Some people put it in terms of precedent. There were remarks like, 'A woman has to be serious, and since she is adopting children, she can't be serious.' And then there was the publication question: a battle this law school had long fought with that Committee. The question was, 'What is scholarship?'

In spite of all the obstacles, Macaulay characterized Melli's case as "a fairly clear one; in the end, I think people were finally convinced that she was going to be a very productive scholar."

In 1966, Margo Melli became Wisconsin's first woman tenured part-time Associate Professor, with a half-time appointment at a full-time salary rate of $12,570.[53] Both Macaulay and Foster recalled that she was promoted to full Professor in 1967, without much additional fuss. At that time, Melli held a three-quarter time appointment at a full-time salary rate of $15,805.[54]

Wisconsin's Second Woman Law Professor

Margo Melli was luckier than other early women law professors in that she acquired a female colleague when Wisconsin hired its second female faculty member. The year was 1966, only seven years after Melli was first hired, and the year she was promoted to Associate Professor.

Shirley Abrahamson had graduated from law school at the University of Indiana in 1956, and enrolled in the SJD program at Wisconsin in 1961, where she worked with Professor Willard Hurst on American Legal History. She finished her SJD in 1962 and considered applying for an open faculty position at the law school, but Hurst advised her to get some experience in practice first, saying that it would "make her a better teacher." She began to practice law in Madison in 1962, and specialized in tax law. In 1964, the law school was "desperate for tax teachers," and Foster, who chaired the Faculty Appointments Committee, approached her about joining the faculty. She declined the opportunity.

Two years later, however, he was back again to offer Abrahamson an assistant professorship. She was skeptical: her husband was a tenured professor in the Zoology Department, and Abrahamson "knew about the tenure problem" at Wisconsin. She asked for a tenured position, but Foster protested—as Abrahamson recalled:

> Foster said, 'We can't make you an associate professor, because Margo is an assistant professor.' I said that was awful: 'What do you mean, Margo is still an assistant professor? She's doing more than her fair share and that's not appropriate. That just proves my point.' So he said, 'Well, she's teaching part time.' And I said, 'That doesn't cut any ice with me.'

This hard bargaining paid off, and Abrahamson was appointed as an Associate Professor with tenure in 1966. Margo Melli was promoted to Associate Professor, with tenure, that same year.

Abrahamson and Melli had not been close personal friends before 1966 even though they were both in the same law building, but that changed after Abrahamson joined the faculty. The two women would run into each other in the women's room and elsewhere at the school, and, as Abrahamson described it, "We were interested in the same things: in

seeing that the women law students got jobs; in having a good environ-
ment in the law school; and we were interested in the substantive subjects
that we taught."

Melli, and her husband, Joe, also spent time with Shirley and Seymour
Abrahamson: the two families lived near each other on Lake Monona and
became close personal friends. Both had young children, and Shirley
recalled that "they parked their boat at our dock, and we'd all go out on a
pontoon every few weeks together and have potluck dinners."

Associate Dean Melli, 1970–72: "Just One of the Boys"

In 1968, Spencer Kimball replaced George Young as Dean. He chose two
Associate Deans: Gordon Baldwin served from 1968 through 1970 and
William Foster from 1969 through 1971.[55] Margo Melli was appointed in
1970 to replace Baldwin, who had accepted a year's Lectureship in
Comparative Law at the University of Tehran, Iran.[56]

True to form, Melli negotiated an arrangement with Kimball to be at
the law school from 9:00 A.M. until 3:00 P.M., so that she could drop the
children off at school before she arrived and pick them up after school. As
Melli remembered it, with no Assistant Deans to share the load, she and
Foster "did everything": they met with students, they arranged the class
schedule, and they even handled the school's parking arrangements.

The years 1968–70 were "volatile years" of student unrest about the
Vietnam War, at Wisconsin as elsewhere. While Melli reflected that,
"Some days, I would love doing the job," she also recalled those times as
filled with difficult conversations: "I would get into my office, and the line
would begin to form outside the door. The kids were just troubled kids:
young men who didn't want to go over there and be killed. It was so sad."
At the end of her two-year term, Dean Kimball asked her to stay, but she
resisted. By the end of her term, "I learned more about my colleagues than
I had ever wanted to know."

Research and Publications

Between 1962 and 1984—a twenty-two year period that encompassed
the seventeen years Melli was responsible for her widowed mother, the

eighteen years until her youngest child graduated from high school, and the two-year period of her service as Associate Dean—she co-authored a casebook on *Criminal Justice Administration*, edited a practice guide on *Wisconsin Juvenile Court Practice*, wrote six monographs, and published four book reviews, an essay on child support, and a speech on the preparation of bar examination essay questions. Taken as a whole, these pieces demonstrate an original mind easily able both to recognize the flaws in conventional legal materials and to envision new ways of thinking about traditional problems, combined with a talent for clear expression.

The casebook on *Criminal Justice Administration: Materials and Cases* was the result of an ongoing collaboration among the group of Wisconsin scholars, led by Remington, engaged in "law in action" research on criminal justice.[57] The casebook was offered as a vehicle for restructuring the way criminal justice was taught in law schools and in criminology departments. It appeared in 1969 and was never revised, but nonetheless became an integral part of the intellectual history of the study of criminal justice.

Melli, who was an Associate Professor at the time, wrote Part III of the book, dealing with *The Administration of Juvenile Justice*. Part III consisted of 215 pages and contained three chapters: one on the Pre-Court Stage, the next on the Adjudication of Delinquency, and the third on the Disposition of Persons Adjudged Delinquent. Her materials, which were developed in the 1960s, represented a revolutionary approach to juvenile delinquency, treating it as a system that paralleled the adult criminal justice system.

In addition to her academic publications, Melli made history by becoming the first woman appointed as a member of the Board of Managers of the National Conference of Bar Examiners in 1980, ultimately serving as its Chair in 1989–90. She gave a speech to the Conference's seminar for new bar examiners in April 1982, which was published in its journal, *The Bar Examiner*.[58] She also published several other items on the bar examination process.[59]

In 1978, Melli prepared the first edition of a practice guide entitled *Wisconsin Juvenile Court Practice in Delinquency and Status Offense Cases* designed to help the juvenile courts cope with the new world order confronting lawyers for alleged delinquents, originally mandated by the US Supreme Court in 1967 and implemented in Wisconsin in 1978 by

statutory revision of the Children's Code.[60] Eileen A. Hirsch, a recent graduate of the University of Virginia Law School, acted as a research and writing assistant for Melli.[61] She found working with Melli to be a life-changing experience: "She insisted on academic writing, rigorous analysis, and careful choice of words. She was more than just a mentor to me; we developed a personal relationship."

University and Public Service, 1962–84

Margo Melli's record of service to the University, the State of Wisconsin, and the legal profession was nothing short of stupendous. In the 1960s, her primary obligations were to serve on the Boards of three government agencies: the Wisconsin Board of Public Welfare, a policy-making body for the state correctional, mental health, child welfare, and public assistance services (1963–67); the Advisory Committee to the Legislative Committee on Revision of the Children's Code (1966); and the Advisory Board to the Federal Reformatory for Women (1967–71).

In 1974, she commenced a lengthy association with the State Bar of Wisconsin by becoming Chairman of its Family Law Section (1974–76) and continued by serving as the Section's Reporter for a period of thirty years (1975–2005). She also became the first Editor of the Section's Newsletter, *The Wisconsin Journal of Family Law* (WJFL) in January 1976, and served through 1981. She served on the State Bar Board of Continuing Legal Education (1975–78) and was Editor of the State Bar's 1977 *Revised Divorce Procedures Handbook*. She was appointed to the Wisconsin Supreme Court Board of Attorneys Professional Competence (1978–83) and served as its Vice-Chair (1979–82).

Melli had no junior women colleagues to mentor until 1974, when as chair of the Faculty Appointments Committee in 1973–74, she recruited June Weisberger and Fredericka Paff to the faculty. Wisconsin had four faculty positions to fill that year, and Melli, who had "been somewhat annoyed with our earlier hiring committees who kept saying that they could not find women to interview," made it clear to Dean George Bunn when he asked her to chair the committee that she would not accept the job unless the committee could fill two of the positions with women. Melli recalled that as it turned out, "it took very little trouble to find women—

they were out there," and Bunn was "very supportive" of the committee's recommendation of two women to fill half of the open spots on the faculty.

Margo Melli Hits Her Stride: 1984–93

After 1984, when her mother passed away, Melli was able to make professional commitments that involved travel outside Madison. In 1984, for example, she became an elected member of the American Law Institute and served as the first Reporter for its Project on Family Dissolution from 1989 to 1994. She joined the International Society on Family Law and served on its Executive Council from 1988 to 2006, becoming its Vice-President in 1991. Her eleven-year service on the Board of Managers of the National Conference of Bar Examiners began in 1980 and involved three weekend meetings a year, always held in locations away from its headquarters in Madison.

Melli and some of her colleagues began to publish the findings that grew from several extensive empirical projects begun in the early 1980s. She became an Affiliate of the Institute for Research on Poverty (IRP) in 1981 and received a series of grants from IRP to work on its Child Support Project. Melli and Irv Garfinkel, the Director of the Institute, undertook a large empirical study to evaluate child support law and practice in Wisconsin and propose reforms to the system.

In 1984, Melli and Sherwood Zink, Child Support Legal Counsel for the Wisconsin Department of Health and Social Services, presented a paper at an international conference describing the IRP proposal for setting the amount of a child support order. Melli and Zink advocated for reforms that would "radically change the way in which the amount of support is determined and . . . strengthen considerably the manner in which it is collected." Their proposed reform would replace the traditional case-by-case judicial determination and enforcement of child support with "a legislatively determined percentage of the income of the absent parent collected through a withholding system similar to that used for the income tax."[62]

The Wisconsin legislature implemented these reforms in 1987. The state instituted a presumptive percentage standard effective July 1, 1987, the year before Congress enacted the Family Support Act of 1988.[63] The

work that Garfinkel and Melli had done through IRP was considered influential in the Family Support Act's requirements of presumptive guidelines and immediate wage withholding.

Melli was an expert in the field of Family Law, but her special interest was focused on the children within the family. That interest led her to become associated with at least two national societies dealing with the protection of children: the American Humane Association (formerly the Society for the Prevention of Cruelty to Children and Animals) and the American Association for Protecting Children. She served a ten-year term on the AHA Board between 1985 and 1995, and she became a member of its Executive Committee. She chaired the AAPC's Advisory Committee in 1986–88.

Melli also served as a member of the US Department of State's Study Group on International Adoption from 1990–93, and as a Member of the Steering Group of the National Academy of Science's Forum for Families and Children from 1992–93. Both appointments demonstrated her growing national and international reputation in this field. She also began her lengthy involvement with the International Society on Family Law during this period, an involvement she described as "intellectually very satisfying."

Retirement, Honors, and Awards

Margo Melli retired in 1993, at the age of sixty-seven. Melli's friends gave a reception in honor of her retirement on September 23. Margo and Joe Melli traveled more frequently after she stopped teaching. They went twice to Italy and spent several weeks there. They both were interested in the theater, the arts, and music, and they liked to go to New York to see plays and to New York and Chicago for the opera. Both she and Joe were active with the Madison Arts Center, she as a Board member and he as President.

Melli's status as Professor Emerita, however, did not protect her from service assignments. She served as President of the University Club from 1995 to 1997, remaining on the Board until 2001. In 1993, Melli became one of the one hundred charter members who contributed $1,000 each to create an endowment for a new organization called "A Fund for Women" to improve the lives of girls and women in the Madison community.[64]

The most lasting tribute to Professor Melli was established in 1994 by the Legal Association for Women, and was conceived by her former student and research assistant, Linda Roberson. Called the "Marygold Melli Achievement Award," it was modeled on the prestigious Margaret Brent Women Lawyers of Achievement Award, first conferred in 1991 by the American Bar Association's Commission on Women in the Profession. The Margaret Brent award was won by Professor Melli in 2013, for her outstanding professional excellence and for her work in paving the way for other women in the legal profession. The Marygold Melli award "honors an outstanding individual in Wisconsin who has achieved professional excellence and has contributed significantly to the eradication of gender bias in the legal system." Its purpose is "to recognize and celebrate on an annual basis an individual in Wisconsin who has made outstanding contributions to the interests of women in law."

Other awards came from many of the organizations Melli had devoted years to serving. For example, the State Bar of Wisconsin gave her the Award for Lifelong Contributions to the Advancement of Women in the Legal Profession in January 1994; she received the Belle Case LaFollette Award for Outstanding Service to the Profession from the Law Foundation of Wisconsin in January 1994; the Family Law Section of the State Bar of Wisconsin conferred the Award for Outstanding Service to the Family Law Section upon her in January 1997; and the Children's Justice Project Summer Fellowship Program was renamed the Marygold Melli CJP Summer Fellowship Program in 2005. She was elected as a Fellow of the Wisconsin Law Foundation in 2004.

A Family Tragedy

The Melli's second daughter, Sylvia Anne, died on May 28, 1996, at the age of thirty-two. She developed a disease of the liver, which was initially diagnosed as a stomach ulcer, while living in Zimbabwe and working on an Earthwatch project. After going into a coma, she began to improve, but then relapsed. Her parents were with her for a week, but had left for home believing that she was on the way to recovery when they received the news of her death. Margo was devastated, saying "No parent expects her child to

die—and certainly not in those circumstances. My life has been affected dramatically."

Post-Retirement Publications

However, Professor Emerita Melli continued to write, and to keep up with the work done by her colleagues at the Institute for Research on Poverty. Between 1993 and 2000, Melli published sixteen articles, five book chapters, and co-edited a book. All of this work was in family law; much of it was focused on children, in particular child custody,[65] child support,[66] and adoption.[67] In 2000, she published a brief, but classic, critique of no-fault divorce, entitled *Whatever Happened to Divorce?*, in which she described divorce today as "not an end of a relationship but a restructuring of a continuing relationship."[68]

Melli continued to publish well into the twenty-first century, providing insightful analysis of the final recommendations that emerged from the ALI project on the Principles of Family Dissolution, completed in 2002.[69]

Marygold (Margo) Shire Melli died in 2018, at age 91.

7 The Next Decades

RUTH BADER GINSBURG AND WOMEN LAW
PROFESSORS FROM THE 1960S TO THE 1980S

A new spirit of idealism and hope swept the country in the decade of the 1960s. John F. Kennedy, the first United States President born in the twentieth century, was in the White House, and he aptly proclaimed, "The torch has passed to a new generation of Americans." He and the First Lady, Jacqueline Bouvier Kennedy, presided over a rebirth of culture and sophistication in the nation's capital. His bold challenge on Inauguration Day, 1961—"Ask not what your country can do for you; ask what you can do for your country"—engaged an outpouring of activism that likely exceeded what Kennedy had in mind.[1] Civil rights, women's rights, dignity, freedom and justice: all seemed within reach.

Two major statutory victories, initially pursued by Kennedy, were signed into law by President Lyndon B. Johnson after Kennedy's assassination. They were the Civil Rights Act of 1964 and the Voting Rights Act of 1965.[2] In the wake of these enactments, volunteers spread out to register black voters and help organize the civil rights movement.

Academic lawyers were a central part of the civil rights effort. Howard Law School was front and center in the battle for desegregation which culminated in *Brown v. Board of Education*.[3] Law Professor (and later Dean) of Yale Law School Louis H. Pollak worked with Thurgood Marshall

227

and the NAACP Legal Defense Fund on the briefs and argument in *Brown*. In 1965, Pollak won a reversal of the convictions of the Freedom Riders in *Abernathy* v. *Alabama*.[4] Many of the civil rights activists, both men and women, believing that law was an essential tool for restructuring the country's priorities and inspired by the examples of Thurgood Marshall, Louis Pollak, and other advocates, decided to prepare themselves for a long struggle by becoming lawyers.

By the mid-1960s, the demographics of law school populations began to change dramatically. For one thing, virtually all law schools had removed the barriers that once prevented the admission of women students: Harvard had done so in 1950,[5] and Washington and Lee—the last hold-out—finally did so in 1972.[6] For another, the civil rights movement and the reborn women's movement, commonly dated from the 1963 publication of Betty Friedan's book *The Feminist Mystique*, had stimulated women's interest in nontraditional careers, including law. These and other factors combined to produce a surge of women determined to enter the legal profession. In the fall semester of 1960, the JD enrollment in the 132 ABA-approved U.S. law schools totaled 37,715 students, of whom 1,296, or 2.4 percent, were women.[7] By 1985, that percentage had increased to almost 40 percent.[8]

The growing pool of women law students in the ABA-approved law schools was the primary source that yielded women law professors. The number of tenure or tenure-track women law professors appointed to the faculties of the law schools that were both approved by the ABA and were members of the AALS (ABA-AALS schools) increased as well, but lagged behind the more rapid enrollment growth of women law students in these law schools.[9] That lag continues today, which should not be surprising. In order to hire additional female faculty, male faculty would have to vacate their law school positions, unless the size of law schools were to increase more rapidly than they have, thereby creating additional slots for female faculty.

Thus, as we have seen in chapters 1–6, the total number of tenure or tenure-track women law professors who began their teaching careers between 1900, when the AALS was formed with 30 charter member schools, and 1959, when there were 112 ABA-AALS schools, was only fourteen.[10] Ten of these fourteen were still actively teaching in 1959; the last to

retire did so in 2008. During the period between 1960 and 1969, the number of new tenure or tenure-track women law professors at ABA-AALS schools had jumped two and a half times, from fourteen to thirty-six.

The decade of the 1970s marked the beginning of a dramatic increase in the number of women law professors. In 1970, double-digit hiring arrived: fifteen women began teaching in ABA-AALS schools that year. In the world of practice, the demand for legal services was increasing rapidly: the legal profession grew from some 200,000 lawyers in 1950 to approximately 700,000 in 1988.[11] This increase in demand caused law schools to expand, admitting more students, and, therefore, requiring more faculty members.

Two significant developments in the early 1970s that affected law school policies helped ensure that women faculty would share in the general expansion of the legal profession. In 1970, the AALS created a powerful new incentive for law schools to hire women law professors when it became one of the first national academic organizations to prohibit sex discrimination in admissions, employment, and placement by its member schools.[12] Two years later, in 1972, Congress extended Title VII of the Civil Rights Act of 1964, which prohibited discrimination by private employers based on sex, to cover public employers, including higher education.[13] Policies of outreach and affirmative action, which accompanied the new law, opened the way for significant numbers of women to enter law teaching.[14]

Who were the women who entered law teaching in the decades following the first fourteen women? And what, if anything, did they have in common with the fourteen women who had preceded them? One of them—Ruth Bader Ginsburg—stands out both because she made one of the same career moves from the classroom to the bench that two of the earlier women did, but at the highest judicial level, and because she embodies the drive for law reform that motivated virtually all of the earlier women. She began teaching at Rutgers, Newark, in 1963; became Columbia Law School's first woman professor in 1972; reshaped the constitutional standard for sex discrimination cases as an advocate for the ACLU Women's Rights Project between 1972 and 1980; left the classroom to accept President Jimmy Carter's appointment to the US Court of Appeals for the District of Columbia Circuit in 1980; and was elevated to

the United States Supreme Court by President Bill Clinton as the country's 107th Justice and its second female justice in 1993. A brief sketch of her academic career sets the stage for a more statistical account of the women who followed her into law teaching during the twentieth century.

RUTH B. GINSBURG: TEACHER, SCHOLAR, ACTIVIST

Justice Ginsburg told the audience at Columbia Law School's Symposium, honoring her on the fortieth anniversary of her 1972 appointment to the Columbia Law faculty, that she had been inspired to become a lawyer "because of my horror at what Joe McCarthy, who saw a communist in every corner, was doing to the country."[15] Impressed by "the brave lawyers who stood up to him at hearings before the House Un-American Activities Committee and elsewhere," she wanted to be able to do as much herself. Ginsburg graduated from Columbia in 1959, and became one of the first twenty women to be appointed to a tenure or tenure-track law faculty at an ABA-AALS member school when she joined the faculty at Rutgers, Newark, as an assistant professor in 1963. Barbara Nachtrieb Armstrong, the first woman law professor at an ABA-AALS school, had been appointed at Berkeley in 1919, forty years before Ginsburg graduated from Columbia. During those forty years, thirteen other women followed Armstrong into law teaching, and their careers are presented in chapters 1–6 of this book. By the time of Ginsburg's initial appointment in 1963, Armstrong had retired. A new decade had begun.

The Context

In 1972, when Ruth Bader Ginsburg joined the Columbia faculty, women law professors were still rarities, but the long-standing practice of hiring only males to teach law was beginning to give way to the 1970 AALS requirement that member schools refrain from "discrimination . . . on the ground of . . . sex."[16] To their credit, Columbia and its peer schools were among the first to conform to the new standard.[17] As shown in Table 1, all except one of the twelve schools designated in 2000 by Professor Richard K. Neumann, Jr., as "producer" schools—those most likely to train the law

Table 1 First Woman Appointed at Twelve "Producer" Schools by Appointment
Date

School and Founding Date	Title and Date of Initial and Highest Rank	Law Degree
UC–Berkeley, 1894	Barbara Nachtrieb Armstrong Instructor, 1919 Professor, 1935	UC–Berkeley, 1915
University of Chicago, 1902	Soia Mentschikoff Professorial Lecturer, 1951 Professor, 1962	Columbia University, 1937
Yale University, 1824	Ellen Ash Peters Assistant Professor, 1956 Professor, 1964	Yale University, 1954
Georgetown University, 1870	Helen Elsie Steinbinder Professor, 1957	Georgetown University, 1955
University of Virginia, 1826	Gail Starling Marshall Instructor, 1968 Assistant Professor, 1970	University of Virginia, 1968
University of Pennsylvania, 1852	Martha A. Field Assistant Professor, 1969 Professor, 1982	University of Chicago, 1968
New York University, 1835[a]	Linda J. Silberman Assistant Professor, 1971 Professor, 1982	University of Michigan, 1968
Columbia University, 1857	Ruth Bader Ginsburg Professor, 1972	Columbia University, 1959
Duke University, 1930	Patricia H. Marschall Professor, 1972	University of Texas, 1955 Central [now Patricia H. Spearman]
Harvard University, 1817	Elisabeth A. Owens Professor, 1972	Yale University, 1951

Table 1 (continued)

School and Founding Date	Title and Date of Initial and Highest Rank	Law Degree
Stanford University, 1893	Barbara Allen Babcock Associate Professor, 1972 Professor, 1976	Yale University, 1963
University of Michigan, 1859	Christina Brooks Whitman Assistant Professor, 1973 [began teaching 1976] Professor, 1982	University of Michigan, 1974

[a] Carlyn McCaffrey was hired in 1970, a year before Silberman, but McCaffrey left NYU in 1974 to enter private practice, joining the firm of Weil, Gotshal & Manges, the same firm that Ruth Bader Gisnburg's husband, Marty, was with.

faculties of the future—had tenure or tenure-track women faculty by 1972.[18] Michigan was the lone exception, although it quickly joined the ranks of the other "producer" schools shortly thereafter with the appointment of Christina Whitman.

Ginsburg had contacts with several of these women. She shared a boat trip on the Elbe River and a long, pleasant conversation with Soia Mentschikoff in 1966, while both were attending a meeting of the International Association of Comparative Legal Studies at Hamburg.[19] She recalled speaking with Mentschikoff about the recruitment of women faculty in 1973 when the latter was being installed as President-Elect of the Association of American Law Schools. Mentschikoff was concerned that law schools, in their haste to get "their woman" for the faculty, would take women who were not the strongest candidates and then would say to later applicants, "We had a woman once, and she was unsuccessful." The solution to this problem, in Mentschikoff's view, was for the law schools to delay their recruitment of women faculty for about five years, when she believed that an abundant supply of "qualified" women would have graduated from law schools and become available for faculty positions. Ginsburg had not thought about the matter from Mentschikoff's perspective, but on reflection found much to be said for her view.

Ginsburg also met Elizabeth Owens in 1972 and conferred with her about taking over a course on Women's Rights that Ginsburg had offered in 1971–72 as a Visiting Lecturer at Harvard. She knew Ellen Peters socially, but did not work with her closely until 1984, when Peters joined Ginsburg as a member of the American Law Institute Council, at a time after both had left academia to become judges. Ginsburg met Linda Silberman, who was working as a research assistant at Michigan for Professor Arthur Miller, before she joined the NYU faculty in 1971. Both women taught civil procedure, and Ginsburg had occasion to recommend Silberman to a classmate as an expert witness. Barbara Babcock, the first female law professor appointed at Stanford, was an important supporter for both of Ginsburg's judicial appointments, both while Babcock was head of the Civil Division of the US Department of Justice, and later in her position as a Stanford law professor. By 1980, when Ginsburg left Columbia to accept President Carter's appointment to the US Court of Appeals for the District of Columbia Circuit, all of these twelve schools had added more women professors, and two of them—Georgetown and NYU—each had eight women faculty members.[20] Looking back in 1982 at her seventeen years as a law teacher, Ginsburg noted the increase in women faculty and also pointed to the corresponding growth in the number of women students during the period:

> When I started in the law-teaching business in 1963, few women appeared on my seating charts, perhaps 5 or 6 in a class of over 100. By 1980, across the country, women comprised over one-third of total law-school enrollment, up from 3.6 percent in 1963 and 9.5 percent in 1971. In more than a few law schools today, 50 percent or more of the students are women.[21]

The Beginning: Legal Education, Clerkship, First Job

Born in Brooklyn on March 15, 1933, to Jewish Americans whose families had immigrated from Central Europe and Russia, Ginsburg credits her mother, Celia Bader, for encouraging her intellectual development.[22] Ginsburg graduated from Cornell University in 1954, where she ranked first among the women in her class and was elected a member of Phi Beta Kappa. At Cornell, she earned a BA with a major in Government and made two of her life's most important choices: a career and a husband. On

June 23, 1954, she married Martin D. Ginsburg, who had graduated from Cornell the preceding year. While at Cornell, they both decided to become lawyers. Marty, as he was known, was called into military service after completing his first year at Harvard Law School. The couple spent the next two years at Fort Sill, Oklahoma. Marty served as an instructor in the artillery school while Ruth worked as a clerk in the Lawton, Oklahoma, Social Security office. Reflecting fifty-seven years later on their time in Oklahoma, Ginsburg reported,

> Coming from New York City, Lawton, Oklahoma, was not exactly a thriving place. Almost every weekend we came to Dallas. Among my fondest memories, Margot Jones had a theater in the round. The Metropolitan Opera came to the State Fair every year. We would come, stay three nights in a row, and see every opera that we could. Then we also have fond memories of having lunch in the Zodiac Room at Neiman Marcus. Models would come by and say, 'Isn't it lovely? It's only $1,000 in such-and-such room.'[23]

Their daughter, Jane Carol Ginsburg, was born on July 21, 1955. By Fall 1956, both Ginsburgs were Harvard Law School students: he resumed his studies there as a 2L while she entered as a 1L.

Harvard Law School did not admit women as students until 1950.[24] In 1956, the school had an entering class of 552 students, including nine women.[25] Ruth recalled her feelings: "We had nine women in our class and all the professors knew us. If you're a woman nowadays, you're not something special, you're not a freak. Then you were so much more conscious of your special place."[26] In 1956, there were no women on the Harvard faculty. Soia Mentschikoff, the first woman to teach law at Harvard, had come and gone before the Ginsburgs arrived.[27] Elisabeth A. Owens, Harvard's first tenured woman law professor, had been in residence at the school since 1955 as a research assistant to Professor Stanley Surrey in the international tax program following her graduation from Yale Law School in 1951 and four years of practice with a Boston law firm.[28] Neither of the Ginsburgs had any contact with Owens while they were Harvard students, perhaps because she was not at that point a regular member of the Harvard faculty and did not teach in the core program.[29]

Ruth Ginsburg spent only two years at Harvard. Her time there was not only busy—both parents shared the responsibility of raising their daugh-

ter while studying—but also academically successful. She was an excellent student who was elected to the Harvard Law Review.[30] With the other first-year women students, she attended the reception Dean Griswold gave for them, and vividly remembers his asking each guest to tell him her reasons for occupying a place in the class that would otherwise have gone to a man. Writing his own memoirs years later, Griswold confided that he was somewhat surprised to learn that the women students did not appreciate his questioning:

> To my regret, I now find that these questions—though purely factual in intent—were resented, and that they are now recalled by some women graduates as examples of sexism on my part. That was really far from my intention. I was trying, if anything, to encourage the women to make full use of their legal training, in practice or in service, of varying kinds, to the public.[31]

During the couple's second year at Harvard, Marty contracted cancer, a condition that necessitated massive surgery, followed by weeks of radiation treatments.[32] Ruth arranged for note takers among his classmates and typed his third-year paper, which he dictated in installments over several evenings.[33] He returned to class for the last two weeks of the spring semester and graduated in 1958. He then accepted a job as the seventeenth lawyer engaged by the New York City firm of Weil, Gotshal & Manges.

Not wishing to remain in Cambridge as a single mom, Ruth applied to Harvard for permission to spend her last year at Columbia in satisfaction of her Harvard degree. Her good friend, Professor Gerald Gunther, then a member of the Columbia faculty, related what came next:

> Her application was denied by the Dean: she was told that she had not made out an adequate case of exigent personal circumstances required for such permission. Her understandable desire that she and her young child reside in the same location as her husband proved to be an insufficient ground, even though to my knowledge applications by males for similar permissions were quite frequently granted.[34]

Ruth Ginsburg thereupon moved to New York and entered Columbia Law School, with full credit given for her two years at Harvard. She recalled,

gratefully, that unlike Dean Griswold, "Dean Warren didn't ask any questions. He just accepted me."[35]

At Columbia, as at Harvard, she was elected to the Law Review and excelled academically.[36] She graduated tied for first place in the Class of 1959. And at Columbia, as at Harvard, there were no women law professors who might have served as her role models and mentors. Instead, she was mentored by several male teachers at Columbia who were generous—and unusual—enough to take an interest in her career. Gunther, who recalled her as being a "petite, attractive, earnest, and obviously brilliant young woman," claimed credit for securing her first job, recounting that he had obtained a clerkship for her with District Court Judge Edmund L. Palmieri after overcoming the Judge's reluctance to hire a woman clerk, particularly one with a young child.[37]

Gunther performed this feat—so he said—by guaranteeing Palmieri a male backup as a replacement clerk should he be unable to work with her, and threatening to cut off the Judge's future supply of Columbia clerks should he be unwise enough to refuse to give her a "trial run."[38] Ginsburg, who recognized that "her status as 'a woman, a Jew, and a mother to boot" was "'a bit much' for prospective employers in those days,"[39] was grateful for the opportunity. As a Supreme Court Justice, she has frequently been asked, whether she had hoped, when she was a law student, to become a judge someday. To all such questions, her reply has been the same: "When I was finishing law school, I didn't think at all about being a judge. I just hoped to have a job."[40]

Some years after her graduation from Columbia, Ginsburg recalled that Harvard "finally thought me worthy of a degree."[41] Her response to the offer extended by Dean Albert Sacks in 1971, which conditioned the grant of a Harvard diploma upon her renunciation of her Columbia degree, was swift and unequivocal: "I hold only one earned law degree. It is from Columbia. I treasure it and will have no other."[42]

Following her two-year clerkship with Palmieri, another mentor appeared. Hans Smit, a 1958 Columbia graduate, had returned to the school in 1960 as the founding director of its Project on International Procedure. He hired Ginsburg in 1961 to work on the project for two years. She served as a research associate on the project in 1961–1962,

and as its associate director in 1962–1963. She has described Smit's profound influence on her as a scholar and teacher:

> In those days I was rather diffident, modest, and shy. Hans was the ideal person to help me overcome those traits. He encouraged me to speak in public, to write for law journals, even to take over his civil procedure class for a week. . . .
>
> Hans brought me into the comparative law circuit starting in the early 1960s, influencing my perspective on legal issues ever after, and advancing my appreciation of fine food and wine.[43]

During her work on this project, Ginsburg undertook a study of Swedish civil procedure together with Anders Bruzelius, a City Court judge in Lund, Sweden. Their joint effort was published as a book in 1965.[44] Four years later, in recognition of this work, the co-authors received honorary degrees from the University of Lund. In 1963, Smit became Professor of Law at Columbia. That same year, Associate Director Ruth Bader Ginsburg became Assistant Professor Ginsburg at Rutgers Law School—a post she credits Columbia Professor Walter Gellhorn for being instrumental in having arranged.[45]

First Academic Appointment: Rutgers, Newark, Law School, 1963–1972

At Rutgers, Ginsburg had the luxury of joining a law faculty where another woman law professor—Eva Morreale (later Hanks)—was already in residence. In 1963, only two other US law schools had two women serving together: the University of Miami, with Jeanette Ozanne Smith and Maria Minnette Massey, and Howard University, with Alessandra del Russo and Patricia Roberts Harris.[46] Ginsburg found Hanks a source of great support:

> Rutgers was surely ahead of the pack, for I was the second woman to be hired as a law teacher at this school. Eva Hanks was the first. She came on board the year before, in 1962. She was a great and good friend, tipping me off to the ways of the Brethren here, much as Sandra Day O'Connor did when I was new on the Supreme Court.[47]

During her first three years in law teaching, from 1963–1966, Assistant Professor Ginsburg was able to develop her scholarly interest in civil procedure by teaching three courses in the area: Remedies, Civil Procedure, and a Comparative Procedure Seminar, which focused on Swedish civil procedure. Her publications during this period were devoted to the same field.[48] She also contributed chapters on the Scandinavian countries (with co-authors) to a book on international judicial assistance edited by Hans Smit.[49]

Ginsburg's international and comparative law work at Rutgers brought her some key assignments in national organizations. She was named to the editorial board of the *American Journal of Comparative Law* in 1966, to the European Law Committee of the American Bar Association's Section of International Law and Practice in 1967, and to the Board of Directors of the American Foreign Law Association in 1970.

Based on this substantial record of publication, teaching, and professional service, Ginsburg was promoted to associate professor in 1966. In that year, she added the basic Comparative Law course to her teaching regime, as well as courses in Conflict of Laws and Federal Jurisdiction. The year 1968 saw publication of her translation, also co-authored with Bruzelius, of the Swedish Code of Judicial Procedure, which encompassed both criminal and civil procedure.[50] Associate Professor Ginsburg published her still-classic tenure article on the Full Faith and Credit Clause in 1969 and was promoted to full professor the next year.[51]

In a stunning reversal of field following her promotion, Professor Ruth Bader Ginsburg never published another major article on civil procedure after 1970. Instead, beginning in 1971, she focused her energies and scholarly attention on the legal status of women. Two external events appear to have sparked this change of direction. Looking back on this period in 1995, she thus described these events in a talk given at Rutgers:

> Around 1970, women students whose conscience had awakened at least as much as mine, women encouraged by a vibrant movement for racial equality, asked for a seminar on Women and the Law. I repaired to the Library. There, in the space of a month, I read every federal decision *ever* published involving women's legal status, and every law review article. That was no grand feat. There were not many decisions, and not much in the way of commentary. Probably less altogether than today accumulates in six months' time.

I was engaged in preparing materials for the seminar when Frank Askin had a visitor in his constitutional law class or constitutional litigation seminar. The visitor was Mel Wulf, then Legal Director of ACLU's National Office. The Supreme Court had just noted probable jurisdiction in a case called *Reed v. Reed*. The complainant, Sally Reed, had challenged an Idaho statute that read: As between persons "equally entitled to administer" a decedent's estate, "males must be preferred to females." The ACLU had filed the Jurisdictional Statement in *Reed* and I asked Mel if I could write the Brief for Appellant. *We* will write the brief, Mel said, and so we did, Mel and I together, with the grand aid of students from Yale, NYU, and Rutgers.[52]

Ginsburg's own personal experience of encountering sex-based obstacles to her progress in the legal profession no doubt also played an important role in her newly expressed interest in securing legal equality between men and women. She told a gathering at Rutgers that she was paid less than her male colleagues upon joining the faculty there in 1963:

Dean Willard Heckel, one of the kindest, finest men I have ever known, carefully explained about the State University's limited resources, and then added it was only fair to pay me modestly, because my husband had a very good job.[53]

The Dean's frankness was somewhat surprising, considering that the Equal Pay Act became effective in 1963, the year Ginsburg was hired. She added that "[s]ome seven years later, I was part of a class of women from all faculties at Rutgers, Newark, each of whom received an enormous raise in settlement of an Equal Pay claim."[54] In addition to unequal pay, she initially lacked job security at Rutgers and instead had a contract that was renewed annually. When she became pregnant during her second year of teaching, she feared that her contract would not be renewed for a third year if she revealed her condition. Ginsburg's fear may have stemmed from the fact that when her first child was born, "it was understood that I would leave work and not come back."[55] She developed an effective strategy to conceal her pregnancy: "I said nothing, but borrowed clothes from my ever supportive, one size larger mother-in-law. With her wardrobe at my disposal, I managed to make it through the spring semester."[56] Once the contract was signed, Ginsburg felt free to announce the good news that she was expecting a second child to a few of her colleagues. Her son, James Steven Ginsburg, was born on September 8, 1965.

Ginsburg first taught a course entitled "Women's Rights: Sex Discrimination and the Law" at Rutgers in 1970–71 and again in 1971–72, along with her regular offerings on Civil Procedure and Conflict of Laws. The AALS Directory listed her as a lecturer at Harvard Law School in 1971–72, but did not list the name of the course she was to teach. The course was Harvard's first offering on women's rights, and Ginsburg commuted from New York to teach it in the fall semester of 1971. She was invited to continue during the spring semester but, growing tired of the commute and having accepted Columbia's offer of a tenured professorship, she declined. Dean Albert Sacks then prevailed upon Elisabeth Owens to teach the course in spring 1972.[57] Ginsburg and Owens met for the first time when they conferred about the course that Owens—an expert in international tax who was unfamiliar with the subject of women's rights—would teach.

Ginsburg published her first two law review articles on women's rights in 1971 while still at Rutgers: The first criticized the meager coverage of the subject in law school and was part of an early symposium on the status of women, while the second examined constitutional aspects of the topic.[58] In 1972, she returned to her alma mater to join the Columbia faculty as Professor of Law.

Ginsburg at Columbia: Home at Last

In 1972, the year Ruth Bader Ginsburg joined the Columbia faculty, Title VII of the Civil Rights Act of 1964 was extended to cover university employment practices.[59] Thereafter, a law school's refusal to hire an otherwise qualified woman to teach law because of her sex was not only an infraction of AALS membership requirements, but also a violation of federal law. Ginsburg recalls that the circumstances of her appointment as Columbia's first tenured woman law professor were remarkably low-key: "I was not subjected to any examination or asked to show and tell. The faculty simply held a cocktail party in my honor to say welcome home."[60]

Ginsburg may have experienced her return to Columbia as uneventful, but her new dean, Michael Sovern, reportedly expressed "glee" in an interview about his school's success in recruiting her to its faculty, in part

because of her "distinguished" scholarship but also, in the reporter's view, because the school had beaten out some of its elite rivals in hiring her.[61] In any event, Ginsburg's new colleagues soon discovered that they had welcomed an activist into their midst. As she said in 1994 at a Columbia reception:

> My very first month on campus, Columbia sought to save money in the housekeeping department. The University sent layoff notices to 25 maids— and no janitors. I entered that fray, which happily ended with no layoffs. I also supported (as the Law School's representative to the University Senate) the request of the campus Commission on the Status of Women for a comprehensive equal pay salary review. . . .
>
> Hardest for my University and Law School colleagues to bear was the litigation that followed a tea Madame Wu, a world-renowned physics professor, held at her Claremont Avenue apartment on a clear winter day, for all the senior women at Columbia. (Eleven women had achieved that rank in the mid-1970s, compared to over one thousand men.) One of the eleven, Carol Meyer, Professor at the School of Social Work, wrote about the meeting years later. She was more than a little suspicious when she received the invitation, which came from me. 'Women meeting together? Was this to be a cell meeting of some kind,' she wondered. What we discussed was the sex differential then part of the University's TIAA-CREF plan, under which women received lower monthly retirement benefits because, on average, women live longer than men. Eventually, a federal case was filed, with some one hundred Columbia women—teachers and administrators—as named plaintiffs. . . . In that matter, as in many others—I recall particularly an earlier episode involving a request to extend health benefits to cover pregnant employees—I was shielded from accusations of disloyalty to the University by law school deans (first Michael Sovern, then Albert Rosenthal) and colleagues who—although they did not inevitably agree with me on the merits—recognized the value of having the questions fully aired.[62]

During each of her eight years of teaching at Columbia, Ginsburg consistently offered her course on Women's Rights: Sex Discrimination and the Law. Between 1972 and 1974, she collaborated with Kenneth M. Davidson of SUNY Buffalo and Herma Hill Kay of Berkeley in editing the first casebook on sex-based discrimination, published in 1974.[63] Thereafter, she used this casebook for her courses. Typically, she also

offered courses on Civil Procedure and Conflict of Laws, adding Constitutional Law in her final two years. She dropped Remedies and Comparative Law, although these courses continued to be listed under her name in the AALS Directories.

Following her Columbia appointment, Ginsburg was chosen for leadership positions in several national organizations. She was named to the AALS Executive Committee in 1972, filling out the term of her new Columbia colleague, Professor Maurice Rosenberg, who became AALS President-Elect in that year; to the Board of Editors of the ABA Journal in 1972; as Vice President of the American Foreign Law Association in 1973; as an original member of the Board of Governors of the Society of American Law Teachers created in 1974, and elected as its Vice President in 1978; to the Council of the American Law Institute in 1978; as Vice President of the Federal Bar Council in 1978; and to the Board of Directors of the American Bar Foundation in 1979. She also served as a member of the Executive Committee of the Association of the Bar of the City of New York from 1974 to 1978, and thereafter on its Civil Rights Committee and its Sex and Law Committee.

Ruth Bader Ginsburg did her most significant law reform work at Columbia. Like some of the early women law professors before her, she melded her teaching, scholarship, and advocacy in the service of a cause that engaged her completely for the remainder of her academic career.[64] Her cause was a grand one: to put women into the United States Constitution, and thereby, as she put it, "to help place women's rights permanently on the human rights agenda."[65] To achieve this goal, she explored two avenues simultaneously, one direct, the other indirect. The direct way was by constitutional amendment: to secure adoption of the Equal Rights Amendment (ERA), proposed by Congress and sent to the states for ratification in 1972.[66] The indirect way was to persuade the United States Supreme Court to radically alter its interpretation of the Equal Protection Clause to accord sex-based classifications strict, rather than merely rational, judicial scrutiny. The former route involved her in speeches, testimony, and publications in support of the ERA ratification effort between 1972 and 1980. The latter route lay through litigation, which she undertook through the ACLU Women's Rights Project between 1972 and 1980. Neither avenue had yielded success by 1980, when

Ginsburg left academia for the bench, but work on the first helped move the second along.

The Equal Rights Amendment

In 1972, Congresswoman Martha Griffiths, the principal House proponent of the ERA, predicted that it "will be ratified almost immediately."[67] Between 1972 and 1978, Ginsburg made a number of speeches and wrote articles in support of the ERA. Illustrative of the articles are two published in the *American Bar Association Journal* and one included in the first issue of the *Harvard Women's Law Journal*.[68] In the first ABA piece, she traced the history of the proposed amendment, noting that the objections to its adoption voiced in 1973 were "solidly answered" during the 1920s debate, but nonetheless answering them again and going on to make the affirmative case for ratification.[69] Her second ABA piece, published four years later as the time for ratification was running out, took the ABA to task for failing to carry out its 1974 undertaking "to play an active role in educating the public" about why "the E.R.A. is the way for a society that believes in the essential human dignity . . . of each man and each woman."[70] Writing in the first issue of the *Harvard Women's Law Journal* a year later, her response to the critics was more succinct:

> The ERA is not a 'unisex' amendment. It does not stamp man and woman as one (the old common law did that); it does not label them the same; it does not require similarity in result, parity or proportional representation. It simply prohibits government from allocating rights, responsibilities or opportunities among individuals solely on the basis of sex.[71]

In the end, however, Representative Griffiths's prediction of swift passage proved inaccurate, and by 1978, Ginsburg was called upon to testify before both chambers of Congress in support of an extension of the initial 1979 ratification deadline for the ERA. Reflecting her expertise as a proceduralist, she first addressed four contested issues about the extension process. She argued that Congress had authority to extend the ratification period; that it could do so by a simple majority vote; that the President's signature was unnecessary to validate a Joint Resolution extending the deadline; and that extension of the time period would not, in itself,

empower the states to rescind a prior ratification.[72] Next, addressing the merits of extension, Ginsburg supported the need for additional time by stressing the Supreme Court's failure to act decisively in setting a new course for interpretation of the Equal Protection Clause dealing with sex-based classifications.

Congress responded by extending the deadline to June 30, 1982.[73] In refashioning her arguments in 1979 for the Orgain Lecture at the University of Texas Law School, Ginsburg offered a milder, but still critical, assessment of the Court's equal protection precedents:

> Since 1971, the Supreme Court has taken significant steps in a new direction, but generally, it has done so insecurely, with divided opinions, and without crisp doctrinal development. The longing of lower courts for firmer guidance was well expressed in a 1975 opinion by Judge Newcomer of the Eastern District of Pennsylvania: In dealing with recent High Court gender discrimination precedent, Judge Newcomer said, trial judges feel like players at 'a shell game who [are] not absolutely sure there is a pea.'[74]

Supreme Court Litigation

Left modestly unsaid in this account is the fact that, since 1971, Ginsburg and her colleagues at the ACLU Women's Rights Project had been doing their best to provide the Supreme Court with just such "crisp doctrinal development." Between 1972 and 1980, she filed briefs in nine of the major sex discrimination cases decided by the Court and personally argued six of them, winning all but one.[75] She also filed amicus curiae briefs in fifteen related cases.

Full accounts of this litigation have already been provided by Ginsburg herself[76] and by others,[77] and accordingly I will not offer another one here. Rather, I will refer to my own summary of her extraordinary contributions during these years on the occasion of her selection in 1999 by the *American Lawyer* as one of its "Lawyers of the Century":

> The remarkable thing about this strategy, reexamined at the approach of the millennium, is how well it succeeded. Sex is not yet a 'suspect' classification, but it receives heightened 'intermediate' scrutiny as a direct result of Ginsburg's advocacy. Quite literally, it was her voice, raised in oral argument and reflected in the drafting of briefs, that shattered old stereotypes and

opened new opportunities for both sexes. She built, and persuaded the Court to adopt, a new constitutional framework for analyzing the achievement of equality for women and men. In doing so, Ginsburg in large part created the intellectual foundations of the present law of sex discrimination.[78]

.

Ruth Bader Ginsburg began her academic career when there were fewer than twenty women law professors in the entire country. When she left in mid-career to become a federal judge, women were well established in law teaching. Like the fourteen early women law professors, Ginsburg was obliged to confront and deal with any misgivings that others—whether colleagues, students, or administrators—may have had about women teaching law. Ginsburg swept away all such misgivings by establishing a solid reputation for the painstaking accuracy of her work, the intellectual depth of her legal concepts, and the strength and clarity of her vision that women's rights are human rights. In her modest and unassuming way, she did this for herself almost as a matter of course. Looking back at her achievements today, it is clear that she marked a path for the women who came after her to follow. Although her work as a professor of law ended with her appointment to the federal judiciary in 1980, her distinguished career as a jurist continued, and the powerful and persuasive sound of her voice has echoed through the universe of legal education well into the twenty-first century.

WOMEN LAW PROFESSORS IN THE 1960S THROUGH THE 1980S: A DIVERSITY SURPASSING SEX

The 1960s: The Circle Widens

When Ruth Bader Ginsburg joined the Rutgers–Newark, law faculty in 1963, only seventeen women had preceded her as tenure or tenure-track teachers at ABA-AALS law schools: the first fourteen early women law professors whose careers are discussed in chapters 1–6, and three others appointed respectively in 1960, 1961, and 1962.[79] In addition to Ginsburg, two other women received tenure or tenure-track appointments in 1963, making them the first twenty women law professors in the United States. After their appointments, only ten more women became

tenure or tenure-track professors at ABA-AALS schools through 1965, bringing the total count of women hired in the 1960s to sixteen by mid-decade.

The 1960s roster of women law faculty begins, as did that of the first fourteen faculty women, at Berkeley. Perhaps because the Berkeley faculty had appointed and tenured a woman so early, they felt no pressure to repeat the performance immediately. Thirty-seven years elapsed between the full-time appointment of Barbara Nachtrieb Grimes (Armstrong) as an Assistant Professor of Law in 1923, and the appointment of Herma Hill Schreter (Kay) as an Assistant Professor in 1960. Professor Richard W. Jennings, who chaired the Berkeley Faculty Appointments Committee at the time, said that while the committee "didn't have any agenda about women," he supposed that "there was an agenda when Barbara retired."[80] Indeed, Armstrong had made it clear that she expected to be replaced by a woman. Kay was found in San Francisco, clerking for Associate Justice Roger J. Traynor of the California Supreme Court, himself a former Berkeley Law Professor. In a memorandum to the tenured faculty, Dean William Prosser described it as "fortunate" that Traynor was willing to make his law clerk available so that she could be appointed to the Berkeley faculty in the spring of 1960.[81] At the time, Berkeley had a regular faculty of twenty men.

The last half of the 1960s began in 1966 with six new appointments, and ended in 1969 with seven new appointments. Total appointments over this period brought to thirty-six the number of new appointments in the 1960s.

All of the thirty-six women who began their teaching careers during the 1960s were notable. In addition to Justice Ginsburg, a few of them became famous beyond the world of law teaching. Six make cameo appearances here, in the order in which they began teaching: Patricia Roberts Harris of Howard, Brigitte Bodenheimer of Utah, Shirley Abrahamson of Wisconsin, Dawn Clark Netch of Northwestern, Shirley Crabb Zabel of Idaho, and Tamar Frankel of Boston University.

PATRICIA ROBERTS HARRIS

With her tenure-track appointment as Associate Professor at Howard in 1963, Patricia Roberts Harris became the first African American woman law professor at an ABA-AALS school in the United States.[82] Trained at

Table 2 Women Hired 1960–65 by Appointment Date

Name and Birth Year	Law School and Graduation Date	Entry School and Date Hired	Initial and Last Tenure Track Position
Kay, Herma Hill 1934	University of Chicago 1959	UC–Berkeley 1960	Assistant Professor Professor
del Russo, Alessandra Luini 1916	University of Pavia (Italy) 1943	Howard University 1961	Assistant Professor Professor
Hanks, Eva 1929	UC–Los Angeles 1969	University of Rutgers–Newark 1962	Assistant Professor Professor
Ginsburg, Ruth Bader 1933	Columbia University 1959	University of Rutgers–Newark 1963	Assistant Professor Professor
Harris, Patricia Roberts 1924	George Washington University 1960	Howard University 1963	Associate Professor Professor
Fenneberg, Doris Richings 1904	University of Michigan 1930	University of Toledo 1963	Professor Professor
Bodenheimer, Brigitte M. 1912	University of Washington 1936	University of Utah 1964	Associate Professor Professor
Kauffman, Clara E. 1919	Loyola, Los Angeles 1959	Loyola, Los Angeles 1964	Assistant Professor Professor
Mazanec, Kamilla M. 1934	University of Missouri–Kansas City 1960	Drake University 1964	Assistant Professor Professor
Rombauer, Majorie Dick 1927	University of Washington 1960	University of Washington 1964	Assistant Professor Professor

Table 2 (continued)

Name and Birth Year	Law School and Graduation Date	Entry School and Date Hired	Initial and Last Tenure Track Position
Abrahamson, Shirley S. 1933	University of Indiana-Bloomington 1956	University of Wisconsin 1965	Associate Professor Professor
King, Josephine 1921	University of Buffalo 1965	University of Buffalo 1965	Assistant Professor Professor
Kopp, Rita M. —	De Paul University 1958	De Paul University 1965	Assistant Professor Assistant Professor
Netsch, Dawn Clark 1926	Northwestern University 1952	Northwestern University 1965	Associate Professor Professor
Yerkes-Robinson, Martha S. 1914	Washburn University 1940	Loyola, Los Angeles 1965	Assistant Professor Professor
Zabel, Shirley 1928	University of Utah 1960	University of Idaho 1965	Associate Professor Associate Professor

SOURCE: AALS *Directories of Law Teachers*

Howard and George Washington University, Harris's stellar record of public service was developed under three US Presidents. She served as a trial attorney in the Kennedy Justice Department in 1960–61. President Lyndon Johnson appointed her US Ambassador to Luxembourg in 1965–67, thus making her the first African American woman to hold an ambassadorship. President Jimmy Carter named her to his cabinet as Secretary of the Department of Housing and Urban Affairs in 1977–79, and later as Secretary of the Department of Health, Education, and Welfare in 1978–81 (relinquishing the Education part of her portfolio to Shirley Hufstedler, who resigned from her post as a Judge on the Ninth Circuit Court of Appeals in 1979, to become Secretary of the newly-created Department of Education).

Table 3 Women Hired 1966–69 by Appointment Date

Name and Birth Year	Law School and Graduation Date	Entry School and Date Hired	Initial and Last Tenure Track Position
Barton, Babette B. 1930	UC–Berkeley 1954	UC–Berkeley 1966	Assistant Professor Professor
Caldwell, Mary Ellen 1922	Louisiana State 1955	Ohio State University 1966	Assistant Professor Professor
Ferster, Elyce Zenoff 1930	Northwestern University 1954	George Washington University 1966	Assistant Professor Professor
Kulzer, Barbara A. 1939	University of Rutgers– Newark 1964	University of Buffalo 1966	Assistant Professor Professor
Lombard, Frederica Koller 1939	University of Pennsylvania 1964	Wayne State University 1966	Assistant Professor Professor
Shores, Janie 1932	University of Alabama 1965	Samford University 1966	Assistant Professor Associate Professor
Velman, Sarah Ann 1934	Ohio State University 1963	University of San Diego 1967[a]	Assistant Professor Professor
Alspaugh, Doris 1931	University of Missouri– Kansas City 1956	University of San Diego 1967	Assistant Professor Professor
Cohen, Betsy Zubrow 1941	University of Pennsylvania 1966	University of Rutgers– Camden 1967	Assistant Professor Assistant Professor
Huff, Margaret M. 1941	Marquette University 1964	University of Louisville 1967	Assistant Professor Associate Professor
Brudno, Barbara E. 1941	UC–Berkeley 1967	UC Los Angeles 1968	Assistant Professor Professor

Table 3 (continued)

Name and Birth Year	Law School and Graduation Date	Entry School and Date Hired	Initial and Last Tenure Track Position
Frankel, Tamar 1925	Israel 1964	Boston University 1968	Assistant Professor Professor
Glendon, Mary Ann 1938	University of Chicago 1961	Boston College 1968	Assistant Professor Professor
Alschuler, Martha Field 1943	University of Chicago 1968	University of Pennsylvania 1969	Assistant Professor Professor
Brumbaugh, Alice A. 1933	University of Michigan 1955	University of Maryland 1969	Assistant Professor Professor
Kanovitz, Jacqueline 1942	University of Louisville 1967	University of Louisville 1969	Assistant Professor Professor
Marschall, Patricia H. 1933	University of Texas 1955	Wayne State University 1969	Assistant Professor Professor
Marshall, Gail Starling 1941	University of Virginia 1968	University of Virginia 1969	Assistant Professor Assistant Professor
Morse, Anita Louise 1941	Indiana University– Bloomington 1968	University of Florida 1969[b]	Assistant Professor Assistant Professor
Wyatt, Mary Bunting 1937	Howard University 1968	Howard University 1969	Assistant Professor Associate Professor

SOURCE: AALS *Directories of Law Teachers*

[a] Velman began at San Diego in 1965, but San Diego was not admitted to the AALS until December 1966 and Velman is therefore listed as actually teaching at an AALS member school beginning in 1967.

[b] Morse's start date at the University of Florida is given as 1969 in the 1971 AALS *Directory*, where her name first appears, and in the 1972 *Directory* when her second appointment at the University of Kentucky is shown. In her biographical AALS entries between 1973–77, her start date at Florida is given as 1970. The University of Florida Levin College of Law's faculty history page gives her dates there as 1969–71; it is treated here as authoritative.

Between her Cabinet posts, Harris returned to law teaching, and was promoted to Professor of Law at Howard in 1967, where she specialized in Torts, Constitutional Law, and International Organizations. She holds the record for the shortest term as a law school dean: appointed as Howard's first woman dean on February 1, 1969, she resigned within a month as a matter of principle because of a conflict with the University administration. Twelve days after she took office, Howard law students boycotted classes over a variety of grievances, ranging from an insistence on courses in Landlord and Tenant Law to more faculty guidance about courses and bar examination requirements, and culminating in demands for more student input into law school affairs. Although the boycott was not aimed at the new Dean, the students demanded that she remove a faculty member who had failed fourteen out of approximately fifty-six students in his course on Equity.[83] During the boycott, the students occupied the law school building, and had to be forcibly removed.

The boycott naturally drew wide coverage in the DC newspapers, which portrayed Dean Harris as being sympathetic to most of the student demands, but also as being "outraged that law students of all people should [boycott classes and seize property]."[84] *The Howard University Newsletter* reported that President James M. Nabrit, Jr., had met with a group of student leaders about their grievances on February 20, 1969.[85] Harris believed that Nabrit sought to undercut her authority by negotiating directly with the students himself, and immediately resigned her deanship. She left the Howard faculty in the same year to enter private practice, becoming a partner at the prestigious DC firm of Fried, Frank, Harris, Shriver & Kempelman in 1970.

Harris resumed her interest in politics and good government by running against Marion S. Barry, Jr., for Mayor of the District of Columbia in 1982. In the course of a hard-fought campaign, she was pictured as a candidate of middle-class whites and blacks, while Barry positioned himself as the champion of lower-income and poor blacks.[86] Not surprisingly, she lost the election.

When Harris returned to teaching towards the end of her career, it was not at Howard. Instead, she accepted the invitation of her alma mater, George Washington National Law Center, to join its faculty in 1983.

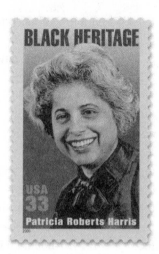

Announcing her appointment, Dean Jerome A. Barron lauded her as "one of the most distinguished graduates of the school and one of the most distinguished women in public life."[87]

Harris's student and former Howard colleague, Professor J. Clay Smith, said of her that she was "a Black woman lawyer, who would object to being called 'a Black woman Lawyer.' . . . not in negation of her Afro-American heritage, [but] based solely on the classification." Yet, as Smith himself observed, Harris did not hesitate to identify herself as a "black woman" at her confirmation hearings for Secretary of HUD.[88] Responding to a statement by [Senator William] Proxmire questioning her ability to be "sympathetic to the problems of the poor," she responded:

> You do not understand who I am. . . . I am a black woman, the daughter of a Pullman car waiter. I am a black woman who even eight years ago could not buy a house in parts of the District of Columbia. I didn't start out as a member of a prestigious law firm, but as a woman who needed a scholarship to go to school. If you think I have forgotten that, you are wrong.

Others did not forget it, either. On January 27, 2000, Harris was honored posthumously by being portrayed on a commemorative postage stamp in the Black Heritage Series, the twenty-third American and seventh woman to achieve that distinction.

BRIGETTE M. BODENHEIMER

Bodenheimer was the Reporter for NCCUSL's Uniform Child Custody Jurisdiction Act, promulgated in 1968, and the moving force behind the Congressional Parental Kidnapping Prevention Act (PKPA), enacted in 1980 to supersede the UCCJA on a provision that had been included in the Act over Bodenheimer's opposition. Yet, like Soia Mentschikoff before her, Bodenheimer's academic career encountered obstacles because her husband was also a legal academic. In Mentschikoff's case, as detailed in chapter 3, university nepotism rules prevented her appointment at Columbia, and would have prevented her appointment at Chicago except for the determination of Dean Edward Levi and his cooperative University President, Robert Hutchins, to make the rule merely a nominal barrier.

Bodenheimer encountered similar obstacles. Like Ellen Peters, she had been forced to flee Germany with her family to escape Nazi persecution.[89] She and her future husband, Edgar Bodenheimer, had met in the early 1930s while both were students in Heidelberg. She left in 1933, and they encountered each other again in the Law Library at Columbia University in New York, where she was studying law. They were married in 1935 and moved to Seattle, where Edgar enrolled at the University of Washington Law School, and she transferred there from Columbia. In 1946, he joined the law faculty at the University of Utah, but nepotism rules prevented her from being considered for an academic appointment there. Instead, she entered law practice, first as a private practitioner, and later as a special litigator for the State of Utah and a drafter of legislation and author of a manual for justices of the peace.

Sixteen years later, Utah's attitudes toward nepotism had mellowed sufficiently to permit Brigitte to teach there as a Lecturer, and in 1964 Utah formally waived its nepotism rules to permit her appointment as Associate Professor of Law. She had barely begun her new academic career at Utah, however, when Edgar was invited to become a member of the founding law faculty at the newly established University of California, Davis, School of Law. Brigitte once again was forced to give way because of nepotism policies. Instead, she received an office and an unsalaried position as Research Associate in Law. This time it took only six years before she was allowed to teach as a Lecturer in the Law School, and an additional year

before the nepotism rules were waived to permit her appointment as Professor of Law in 1972.

Brigitte Bodenheimer did not waste the opportunity which her Research Associate position at Davis gave her: she accepted appointment as NCCUSL's Reporter for the Uniform Child Custody Jurisdiction Act in 1967. The Act was promulgated in 1968, but it was not entirely to its Reporter's satisfaction. In her view, the Act's ability to achieve its purpose of ending jurisdictional disputes over child custody litigation was flawed by its having conferred jurisdiction to hear such cases on two different states: both the "home state" where the child had lived with a parent or parents prior to the time the case was filed, and the state having a "significant connection" with the child and its situation. As she had foreseen, the failure to give clear priority to the home state over the state of significant connection provided an excuse for states to continue their jurisdictional battles.

Bodenheimer understood, however, that an effort to amend the UCCJA so soon after its promulgation would be unavailing. Instead, she turned to her friends in the US Congress to seek a federal remedy. She argued that Congress, utilizing its power under the Full Faith and Credit Clause of the US Constitution to prescribe the effect of one state's judicial proceedings in the courts of a sister state, could and should provide that Full Faith and Credit would be extended only to a custody determination handed down by the child's home state. Only in the case where there was no "home state" court available, might the determination of a state of "significant connection" be entitled to Full Faith and Credit. This approach was adopted in the Parental Kidnapping Prevention Act (PKPA) of 1980, and has worked effectively to reduce, if not to eliminate, jurisdictional conflict in interstate child custody cases.[90] In 1999, as if in tribute to Professor Bodenheimer's far-sightedness, her favored "home state" priority provision was enshrined in the revised Uniform Child Custody Jurisdiction and Enforcement Act (UCCJEA). Indications are that, this time around, courts are getting the message that home state priority is essential for uniformity. Bodenheimer's central role in achieving that result was critical for the security of many of the children of divorce in the United States. She turned her hand to helping fashion a similar remedy for international child custody disputes, which resulted in the promulgation of the Hague Convention on the Civil Aspects of International Child Abduction on October 25, 1980.

SHIRLEY ABRAHAMSON

Abrahamson, a well-respected tax lawyer and professor, was Margo Melli's faculty colleague at the University of Wisconsin, starting as an associate professor in 1966. She later became a full professor. She left the classroom when Governor Patrick Lucey appointed her to be an Associate Justice of the Wisconsin Supreme Court in 1976. She was the first woman to sit on the state's highest court. She won election to the Court in 1979, and for each ten-year period thereafter until her retirement in 2019. She became the Chief Justice on August 1, 1976, a position she retained—not without several hard-fought reelection campaigns—well into the twenty-first century. In 2012, the Wisconsin Supreme Court briefly had a majority of women justices. Abrahamson served as President of the National Conference of Chief Justices. She was also a member of the Council of the American Law Institute, the American Academy of Arts and Sciences, and the American Philosophical Society. In 2004, she received the American Judicature Society's Dwight D. Opperman Award for Judicial Excellence; and in 2009, she received the National Center for State Courts Harry L. Carrico Award for Judicial Innovation, citing her service as a national leader in safeguarding judicial independence, improving inter-branch relations, and expanding outreach to the public.

DAWN CLARK NETSCH

Netsch's extraordinary career combined law teaching and politics. A 1952 graduate of Northwestern University School of Law, she spent four years as an Assistant to Governor Otto Kerner of Illinois before accepting a faculty appointment in 1965 as Associate Professor of Law at Northwestern. She was promoted to full professor in 1971, remaining there until 1992, when she became Professor Emerita.

Netsch enjoyed teaching, but as her colleague and biographer, Cynthia Grant Bowman observed, "Politics and government were in Dawn's blood."[91] Beginning in 1972, she divided her time between the classroom and pubic office in a grueling campaign for the Chicago Democratic Party's nomination for the Illinois Senate against Senator Daniel O'Brien, the candidate of Chicago Mayor Richard Daley's democratic machine. Contrary to most expectations, including her own, Netsch's door-to-door

"retail" campaigning defeated O'Brien by a five-to-four margin. She took office in January, 1973, and established "a life of constant movement between Chicago, where she continued to teach a course each semester, and Springfield, where she maintained an apartment near the capitol."[92] She was re-elected to the state senate seven times, but her first reelection campaign, in 1974, was the most difficult, with the Democratic primary turning into an "Armageddon-like battle . . . characterized by 'dirty' tactics" between Netsch and the independents against Daley's Chicago machine. She won narrowly, and although the Daley machine remained powerful, "the Chicago Democratic Organization never mounted a primary challenge to Dawn again for the sixteen more years she remained in the Illinois Senate."[93] After that victory, Dawn and a group of seven independents, known as "the Crazy Eight," opposed the Democratic Organization on a variety of issues, winning some struggles but more often losing. According to Bowman

> Evaluated in terms of results, Dawn's eighteen years in the Illinois Senate were a mixed bag. There is still no merit selection of judges in Illinois; education is still underfunded; and the tax structure is both inadequate and inequitable in many ways. Many things dear to her heart—campaign reform, the ERA, and family leave, for example—went down to defeat. In contrast, Illinois does have a modern sexual assault statute and a good deal of consumer protection legislation that Dawn sponsored.[94]

During the years between 1971 and 1991, Netsch kept up her faculty duties at Northwestern. Not surprisingly, the subject she taught most often was Local Government. She co-authored an authoritative book first published in 1977, *State and Local Government in a Federal System,* which went through several editions.[95]

Netsch made a successful run for State Comptroller in 1990, becoming the first woman elected to a statewide executive office in Illinois. She was also the first woman to run for Governor of Illinois, but her 1994 campaign was not victorious: indeed, it resulted in what Bowman called "a humiliating defeat," aptly described as a "landslide," at the hands of the incumbent Republican Governor, Jim Edgar.[96]

Her life as a public servant effectively over, Dawn Clark Netsch returned to Northwestern, where she was tapped in 1996 by Dean David Van Zandt

to perform a sensitive administrative service for him: acting as co-chair of the creation of a new strategic plan for the law school. Characteristically, as Bowman put it, "Dawn took the skills she had learned in politics and invested them in the law school that had given her her start."[97]

SHIRLEY CRABB ZABEL

Born in 1928, Shirley Crabb earned her BA in 1948 at Earlham College in Indiana, where she met and married her husband, Victor C. Zabel, who was studying geology. They had three children, born between 1950 and 1955. When he decided to continue his studies at the University of New Mexico, she enrolled there as well, earning an MA in Spanish in 1952. His career as an oil consultant took the family to Utah, where she attended law school at the University of Utah, graduating at the top of her class in 1960. After graduation, she clerked for the Utah Supreme Court in 1960, and in the same year was admitted to practice in both Utah and New Mexico. After Mr. Zabel set up his office in Santa Fe, New Mexico, his wife gained national prominence when she was appointed as New Mexico's first female Assistant Attorney General beginning on September 1, 1961.[98]

Shirley Crabb Zabel's first law faculty appointment came in 1965 at Idaho as an Associate Professor. She never advanced beyond the status of Associate Professor until the end of her career, which included stints at eight different US law schools between 1965 and 1996. She held appointments at three non-AALS member schools, all of which became AALS members after she had left: Gonzaga (1973–75), as Associate Professor; Delaware Widener (1975–79), as Associate Professor; and George Mason (1979–85), as Associate Professor and Associate Dean for Academic Affairs. She then moved to Texas, where she was affiliated with two private schools that were neither AALS members nor accredited by the ABA during most of her service: Garza Law School in McAllan, Texas (where she served as Dean for a year or two and which ultimately failed), and Texas Wesleyan (1989–96), where she was Professor of Law, and which was approved by the ABA in 1994, but did not become an AALS member school until 2012.

Zabel and her husband were divorced in the mid-1960s. In 1966 she interrupted her US law teaching career to accept appointment as one of the academics who went to Africa under the auspices of the Ford Foundation's SAILER program (Staffing of African Institutions of Legal

Education), through which "Ford engaged in a range of initiatives, including sending American lawyers to teach in several different African countries and bringing Africans to law schools in the United States to study."[99] She was one of two women who received funding from Ford to participate in the program, and one of three participants who divided their time between two different countries.[100] She went first to the Sudan, and then to Nigeria. She was the only member of the Ford team who remained in Nigeria after the three-year Biafra War began in 1967.[101] After she returned home, Zabel continued to serve as an External Examiner for the University of Lagos, Nigeria, during the summers of 1968–70. She also served as a Director of the Third World International Legal Studies Association, the successor to the African Law Association.

Zabel ended her career at Texas Wesleyan, a private denominational school, where she became a member of the founding faculty in 1989, and received honors and awards for her outstanding teaching. The Shirley Zabel Memorial Faculty Award, which recognizes the recipient's national scholarship and activities that enhance the reputation of the law school and its students, is awarded annually. She died on December 22, 1996.

TAMAR FRANKEL

Frankel was born in present-day Israel and earned her BA in 1943 at the Jerusalem Law Classes. She spent a year as an Assistant Legal Advisor to the Israeli Air Force in 1948–49, then served as Assistant Attorney General in the Israeli Ministry of Justice in 1949–50 before joining her father to engage in private practice in Israel from 1951–62. In 1964 she came to the United States, where she worked as an Associate for two distinguished law firms between 1964 and 1966: Ropes and Gray in Boston, and Arnold & Porter in Washington, DC. At that point, her eyes turned to law teaching. She began as a part-time Lecturer in 1967 at Boston University, becoming full-time in 1968 with her appointment there as Assistant Professor. She was promoted rapidly to Associate Professor in 1970 and to Professor in 1971. She taught courses in the business curriculum.

Although most of her work is aimed toward professional audiences, in 2008 Frankel published a book for the general public, *Trust and Honesty: America's Business Culture at a Crossroads,* which she described herself as having been "driven to write."[102] Her subject was fraud, and its corrosive

impact on trust. As she told an interviewer, "What did strike me was the fact that fraudulent behavior has become more acceptable." She explained:

Americans are trusting people. Americans trust their social systems more than they trust particular people. This is in contrast to China and other countries where people trust people more than they trust their social systems. Americans trust their political systems more than they do the politicians or the law more than they do the lawyers or the banks more than they do the bankers. I dread the possibility that Americans will cease to trust the law and the systems by which they live. Then, I am afraid, Americans will have lost their way of life.[103]

When she wrote the book, she thought the society was "moving toward the extreme of mistrust." She saw clearly that in her work with US corporations, she was "dealing with private power, and . . . with limitations on that power." Finally, she expressed her concern "that dishonesty will increase with the attacks on law." As she wrote in her book, "Law is not the enemy of business. It is the enemy of crooked business." Law protects business from "competing by crookedness."[104]

Frankel's critiques have been very influential. She has not limited her time exclusively to Boston University, becoming a visiting scholar at the Brookings Institution in 1987 and at the Securities and Exchange Commission from 1995–97. She has taught and lectured at Oxford University, Tokyo University, and has consulted with the People's Bank of China. In the US, she has been a visiting professor at both Harvard Law School in 1979–80 and Harvard Business School in Fall 1980, as well as at the University of California, Berkeley, in 1982–83. The list of her speaking engagements covers four pages.[105] She has indeed become the conscience of the law and business community world-wide. Tamar Frankel finally retired from Boston University in 2018 at age 93, after 50 years of service. She said, however, that she plans to continue teaching and "shaking up Wall Street."[106]

The 1970s: Prying Open the Doors for
Women of Color and Lesbians.

The number of women law students and women law professors increased approximately fourfold and sevenfold, respectively, during the decade of the 1970s. Despite this seemingly dramatic increase, by 1979 only

10 percent of tenure track law professors were women.[107] Significantly, diversity among women law professors teaching at ABA-AALS schools increased as well, with the first African American woman, Joyce Hughes, hired at a predominantly white school in 1971, and the first openly lesbian professor, Patricia A. Cain, hired in 1974 by the University of Texas. Diversity brought many positive educational benefits to legal education, but as the concept struggled for a secure foothold, it also contributed to an increase in tenure denials.

Towards the end of the decade, two intellectual movements associated with white men sprang up to challenge traditional legal thought: one radical—Critical Legal Studies—and the other doctrinal and conservative—Law and Economics. Women law professors of all races and ethnicities became affiliated with the first in the 1980s and gave it a unique turn by creating Critical Feminist Legal Studies and Critical Race Feminism, with both variants outlasting the original. Although Barbara Nachtrieb Armstrong might be characterized as the "Mother of Law and Economics," given her PhD in Economics, her initial joint appointment in the Department of Economics and the School of Law at Berkeley, and her work on the Social Security Act in 1934 with the Roosevelt administration, not many women legal academics followed her example by developing similar interests.

Several events contributed to the increase in numbers, including pressure from the AALS upon its member schools to end sex discrimination in admissions, placement, and employment in 1971; the amendment of Title VII and the enactment of Title IX of the Civil Rights Act in 1972 to ban discrimination in education, applicable both to public and private institutions; and the concomitant willingness of law schools to recruit and hire faculty from two previously unrepresented groups: women of color and lesbians.

Significantly, the AALS nondiscrimination mandate resulted from the plight of women law graduates, who were being turned aside by the law firms where they sought employment. Professor Frank "Tom" Read, then Duke Law School's Assistant Dean whose oversight responsibilities included student admissions and placement, recalled what happened:

My experiences were similar to those of others at Harvard, Yale, and Columbia. We had women students who had very good records, and should

have been interviewed as part of the top of the class, but they were just having a terrible time getting jobs, principally with the major law firms. Four of us—Ruth Bader Ginsburg, and two assistant deans from Harvard and Yale—met in her New York apartment on a Saturday afternoon in 1969 to discuss the problem. All of us had had women students vigorously complain about their treatment in interviews: overt statements that the firm had never hired women or that clients would not accept women. One firm maintained that it was an example of great liberality because it actually had hired a woman, but of course she had to work in trusts and estates and couldn't hope to work anywhere else. One of the big New York firms was particularly egregious. Some of us had communicated with or written to several law firms protesting their treatment of women, and we had decided to try to refuse to allow them to use our interview facilities. We got very arrogant answers back: it was none of our business; they would hire who they wanted to hire; and how dare they be threatened with any loss of placement facilities. And they said they would just go to other law schools: '[W]e don't have to deal with your school if you're going to treat us this way.'

We were all outraged about the overt discrimination, and we decided that the AALS nondiscrimination standards, which applied to race, were not explicit about gender. So we sat around Ruth Ginsburg's kitchen table in 1969 and cobbled together a statement, which ultimately became the AALS statement on nondiscrimination.[108]

At its December 1969 meeting the AALS adopted the following resolutions:

> 1. The Association urges that members of the legal profession provide equal employment opportunities to female applicants for legal positions.
> 2. The Association urges that member schools take steps within their power to eradicate sex-based discrimination within law schools and particularly in the placement process.

Note, however, that the resolution did not include any proposed sanctions for employers who might nonetheless engage in sex discrimination in their hiring decisions. That decision was left up to individual law schools.

In March 1970, the AALS appointed a Special Committee on Women in Legal Education, partly in response to petitions by women law students. It was chaired by Professor Daniel Collins of NYU, who specialized in Labor Law, and was the first AALS committee to have student members.[109] Commenting in 2012 on Collins's appointment as Chair,

Professor Marina Angel remarked, "If it had to be a man, and it seems it did because the AALS leadership was all male and could not think of an appropriate woman, Dan Collins was a good choice."[110] Professors Frederica Lombard, Ellen Peters, Tom Read, and James T. White were the faculty members. The Special Committee met in April 1970, and formally proposed that the AALS amend its articles to require law schools to deny use of their placement facilities to prospective employers that discriminated on the basis of sex. The Executive Committee approved the proposal, but broadened it to cover all forms of discrimination based on "race, color, religion, sex, or national origin" and set it for action at the 1970 Annual meeting.

The Special Committee's 1970 Report went beyond placement to act on several other matters, including urging member law schools to adopt recruitment programs both for women law students ("to let women know that the legal profession is open to them") and for women law professors, stating its belief that "lack of women faculty members has serious adverse effect on recruitment, education and placement of women students."

The Special Committee was reappointed in 1971, with Lombard as its chair. Ruth Bader Ginsburg was a member, and she recalled Lombard's pivotal leadership role:

> With characteristic persistence, civility, and good humor, Freddie charted the Committee's course. The aim was to show, in a year's time, why the Special Committee should become a permanent Section.[111]

Lombard's committee achieved its aim: the AALS granted its request for a change of status from a Special Committee to a Standing Committee, to be known as the Standing Committee on Equality of Opportunity for Women in Legal Education in 1971. Its report also called for the Association to sponsor a Symposium on the Law School Curriculum and the Legal Rights of Women to be held at NYU Law School in October 1972. A steering committee to plan the program content and invite the participants was named, consisting of Professors Ginsburg, Herma Hill Kay, Frederica Lombard, Ian Macneil, Carlyn McCaffrey, Tom Read, and six students.[112] What had begun as an effort to prevent law firm discrimination against women students had rapidly evolved over two years into an

effort to create teaching materials dealing with the broader issues of sex discrimination and to recruit women law faculty.

Networking: The AALS Section on Women in Legal Education and the National Conference on Women and the Law

In 1972, Professor Ginsburg followed the pattern set by Dan Collins and Frederica Lombard by serving as the chair of both the AALS Standing Committee and the newly formed Section on Women in Legal Education ("WLE Section"). In 1973, she and Shirley Raissi Bysiewicz, then Professor and Librarian at the University of Connecticut School of Law, co-chaired the Committee and the Section.[113] Ginsburg recalled that period in remarks first delivered at Seattle on November 2, 1978:

> Significant adjustment accompanied women's law school entrance in numbers. Ignoring women, or singling them out for special treatment, became inordinately difficult once they appeared all over the seating chart. Women's groups organized in the law schools, vigilant to assist teachers, administrators, and peers through the transition to new ways.
>
> In my day, there was a law wives' association, but no law women's association. By 1972, most of the accredited law schools listed law women's groups in their catalogues. These associations pressed for more vigorous recruitment of women, placement office regulations designed to reduce employer discrimination, sex-neutralization of scholarships and prizes.[114]

Marina Angel, newly appointed as an Associate Professor at Hofstra University Law School in 1971, described the 1973 AALS meeting with characteristic flair:

> I attended the AALS Annual Meeting for the first time in 1973. A meeting of the Committee on Women in Legal Education was listed on the program, so I decided to attend. The committee meeting was held in the basement of the convention hotel at the end of a long, dark corridor. Approximately ten women were at a table in a small L-shaped room, which had pipes hanging from the ceiling. The two women at the head of the table were Ruth Bader Ginsburg, newly appointed at Columbia, and Shirley Raissi Bysiewicz of the University of Connecticut School of Law. It surprised me that all the women in the room knew who I was and that I had been hired in 1971 to teach at

the new Hofstra University Law School. I later realized that there were so few tenure track women in legal education that the entry of every new woman was a cause for celebration.[115]

The Standing Committee on Equality for Women in Legal Education lasted only two years. By 1974, it had morphed into the Section on Women in Legal Education, with Bysiewicz and Mary Moers Wenig as "co-presiders." Angel explained the Section's significance:

> In those early days, many schools had only one woman teacher; some had none. The Section was the only place where women law teachers could find other women to advise them on law school processes and expectations and where they could be mentored on research, teaching, and service.[116]

The AALS annual meeting was a natural gathering place for networking, particularly after President Soia Mentschikoff had spun off the faculty recruitment aspect of the meetings to a different time and place, and had refocused the Annual Meeting to serve the function of a scholarly society for American legal education. The WLE Section served that function, but it also became a valuable resource for women law teachers as they became more integrated into the legal academy.

In addition to the AALS Section, women law students created another forum for networking and becoming socialized into the legal profession: the National Conference on Women and the Law ("the Conference"). The first Conference was held at NYU Law School in 1970 and was attended by about fifty persons, including a few Berkeley students. Nancy Davis, who in 1974, together with Wendy Williams and Mary Dunlap, co-founded the nation's first women's rights public interest law firm, Equal Rights Advocates, shared these recollections

> I met Barbara Rhine, Boalt '60, a student activist who was one of the speakers, on the airplane to New York. Eleanor Holmes Norton, then Chair of the New York City Human Rights Commission, also spoke. There were group meetings and some break-out sessions on substantive topics and some timely ones such as 'surviving law school.' I remember a wonderful woman from coal country with a lovely southern drawl who remarked, 'I've never seen so many women lawyers and law students in one place in all my life.' We all roared.

The conference provided all of us with much-needed support for the adventure we were embarking upon.[117]

The final Conference took place in Detroit in 1990, and had several thousand participants. Professor Pat Cain has provided a brief overview of the significance of the Conference:

> The National Conference on Women and the Law, during its twenty-two-year history, provided two main advantages to persons interested in feminist legal theory and practice. First, it provided the opportunity for academics and activists to meet and exchange information and ideas. Second, participants, although primarily progressive in their political outlook, were in many other ways quite diverse. Active participants included community activists as well as legal activists. From the early days, the conference was meticulous in its efforts to include panelists from different races, sexual orientations, and physical abilities. The legal issues of poor women, immigrant women, women with AIDS, sexually abused women, and women in prison were given as much attention as issues affecting professional women and middle-class married women. For those of us attending from the legal academy, teachers and students alike, this three day immersion into the real life problems of women different from ourselves was an important reality check on an otherwise sheltered perspective.[118]

The Conference gathered together women law students, practicing lawyers, judges, law professors, and community activists for three days to hear papers and hold small group discussions. In 1977, the Eighth National Conference, held at Madison, Wisconsin, organized the workshops into clusters, and for the first time included an entire cluster on lesbian issues. The Conference was never formally ended; rather, it lapsed for lack of interest. Pat Cain speculated that:

> Perhaps it ended because other conferences had begun to fill some of the needs that the National Women and the Law Conference had filled on its own for so long. And perhaps it ended because the burden of organizing the conference fell too heavily on women law students, who were becoming more and more removed from the feminist experience and concerns of those women who had organized the early conferences.[119]

Mary Dunlap attempted to revive the Conference in 1998, obtaining seed money from Golden Gate University Law School to hold the 22nd

National Conference on Women and the Law in San Francisco on March 19–22, 1998. Pat Cain expressed the "hope it will provide that energetic 'shot in the arm' I got from many past conferences" and more importantly, that "it will provide a legacy from the past to today's generation of law students and legal activists."[120] The first hope was realized: I attended the Conference and thought that its scope, depth of analysis, and facilitation of networking among the participants and overall inclusive tone matched the best of the earlier Conferences. But if the second hope was for "today's generation" to carry on the Conference, that hope was not fulfilled. The San Francisco Conference was the last three-day event to be held.

Courses in Women and the Law

Many of the women law students who helped to found the original Women and the Law Conference also had been instrumental in urging their schools to offer courses on Women and the Law. As we have seen, Ruth Bader Ginsburg was approached in 1970 by women students at Rutgers who wanted such a course. Faculty at other schools had similar experiences, and like Ginsburg, they either taught or facilitated the teaching of such courses in their own law schools or commuted to other law schools to offer them. At Texas, Pat Cain was instrumental in getting the faculty to approve a seminar on Women and the Law, which was taught in the late 1970s and early 1980s by Isabel Marcus, a Berkeley Law and PhD graduate, who had been hired by the University of Texas Government Department. Elsewhere, in the absence of a published casebook on Women and the Law, or regular members of the law faculty able or willing to teach the subject, some of these law students turned to self-help to teach it to themselves. Aleta Wallach described such a course "taught" by herself and two classmates to fifteen law students—nine women and six men—at UCLA Law School in the Spring Quarter, 1971.[121] Assistant Professor Marilyn J. Ireland, the first tenure-track woman professor at Washington University in St. Louis, agreed to teach a course on Women and the Law in 1973 "to help provide some content to the [newly-created] Women Studies Major." She recalled:

The Kanowitz book would not do since increasingly radical women students would have objected to its having been written by a man. Ruth Bader Ginsburg's text was not out yet (though she did give me an outline that helped considerably). So we just divided up the topics and students did presentations. It was a highly successful class, resulting in a paper I still wish I had, arguing that corporations had more 14th Amendment 'person' rights than women, and another that argued that the assignment of gender at birth without a hearing violated procedural due process.... This class was, to my colleagues, proof that I was only capable of teaching 'soft' material, and I was advised in the second year of my appointment that tenure was unlikely.[122]

Women of Color Law Professors

Only one woman of color was hired in a tenure or tenure-track position by an ABA-AALS law school prior to the 1970s. She was Patricia Roberts Harris, who began teaching at a historically black law school, Howard, in 1963, and whose career is summarized above. Harris was preceded by her fellow undergraduate student at Howard, Sybil Jones Dedmond, who became the first woman of color appointed as a tenured Professor of Law at an ABA-approved law school, North Carolina Central, in 1951. Like Howard, North Carolina Central was a historically black law school; unlike Howard, it did not become a member of the AALS until 2012, long after Dedmond had left legal education. The first woman of color who was hired in a tenure-track position by a predominantly white ABA-AALS law school was Joyce A. Hughes, who joined the Minnesota law faculty in 1971. All three women were black.

SYBIL JONES DEDMOND

Dedmond was born in 1921 and grew up in Pensacola, Florida, with her widowed mother and three brothers and sisters. She decided to go to law school while still a high school student. Like Dorothy Nelson, she chose law as a means to an end:

In high school, I had become somewhat of a social activist underneath. I thought that I might be able to do more about changing conditions that I had observed if I pursued the law. I strongly felt then, and I still feel now,

that lawyers do have an advantage when it comes to the background, the kinds of talents, and the outlooks that help to bring about changes in society.[123]

Dedmond pursued her goal systematically despite a certain amount of ridicule from her friends, who regarded her as "a kind of peculiarity for just selecting a career of that type. They were somewhat unbelieving that I would select something that was seemingly almost impossible to achieve at that time." Her only encouragement came from her family, especially her mother. After graduating as the valedictorian of her class at Washington High in Pensacola, she enrolled at Howard University and took a double major in political science and psychology—two subjects she thought would be helpful as preparation for law school. As an undergraduate at Howard, she met a few women students in the law school, and found "the atmosphere there more conducive to pursuing a career in law, even for a woman."

Dedmond had "always dreamed" of attending the University of Chicago, but could not afford it at the time she enrolled at Howard. After graduation, she "fortunately was able to get scholarships all along the way, which helped considerably." Chicago was the only law school to which she applied; she was impressed by its reputation and its faculty, particularly President Hutchins and Dean Edward Levi. She "had always thought of the University of Chicago as an exceptional school and more progressive— even liberal—than most." She was admitted in 1947 and had a good experience:

> There were not many women: not more than three or four in my class of approximately one hundred students. There were also a relatively small number, three or four, of black students in my class. They were all men. I did not find, at that time and at that school, much bias against women. We seemed to be accepted and no one made an issue of it. I found the type of atmosphere that I expected to find there. Chicago's only black professor, Walter Ming, was not particularly helpful to minority students. But I didn't need 'shepherding.' At that time I was especially independent and wanted to work on my own.

Dedmond did not, however, immediately realize her dream of putting her legal education to the service of social reform. One of her fellow male

black students at the University of Chicago, Harry Groves, accepted an appointment at the University of North Carolina Central (NCC) in 1949, and he promised to keep in touch with her. When he left teaching for law practice in 1951, he informed Dedmond that there was an opening on the NCC faculty and that he had recommended her as his replacement. She applied for the position and was appointed as a Professor—"we didn't have Assistant or Associate titles at that time." She did not see her new position as an abandonment of her ultimate plan to practice law; instead, she "thought it would be a good way to get some additional experience."

Once Dedmond began teaching, she "really enjoyed it." NCC's law school at the time was accredited by the ABA, but was not an AALS member school. It had five faculty members in addition to herself, and a primarily male student body of about one hundred. As the only woman law professor, the few women students sought her out for advice, and she was "most encouraging and happy to see that they were interested in law and moving in that direction." An historically black school, NCC at the time had neither white students nor faculty. Dedmond taught Criminal Law, Real Property, Future Interests, and occasionally Torts. Her impression was that she was given the same course load as her male colleagues, and she was paid the same as they were; there was "no distinction based on sex." The emphasis at NCC was primarily on teaching and, although the faculty were encouraged to write, there was no pressure on them to publish. She published one law review article on the enforcement of child support decrees in other states, because she was interested in the subject and wanted to write it, not because she was required to do it.[124]

Like Minnette Massey, Dedmond coached her school's Moot Court Team. Her team won the Southeastern Regional Area and went to the national finals in New York City in 1963. She was justifiably proud of them "because they were competing with some of the best in the country, students from larger law schools, and they made a very good showing." She called the experience of coaching them to the national finals "one of the highlights of my career."

Dedmond married one of her NCC law students in 1957, who decided to establish his law practice in her hometown of Pensacola. She thought "it would have been easier to get started in a hometown where at least one of

us had some ties." So she left teaching in 1964 to join him, and for two years they actively practiced law together.

In 1966, Dedmond finally realized her dream of using her legal training in the service of community activism. She became the Assistant Director of the Community Action Program, and undertook to persuade the Board of County Commissioners of Escambia County, which "had never been active in providing social service," to establish a Department of Human Services. Once that had happened, she became the Department's first Director—"as a black female, that was an accomplishment at that time"—and was able to put her legal training to good use in administering the relevant federal statutes and regulations.

Years later, when an opening became available at Pensacola Junior College, she was encouraged by members of various organizations to apply. "That was a time when the College was being encouraged to hire women and blacks and minorities." She joined the faculty of Pensacola Junior College as an Instructor, teaching the basic course in Business Law I and a more advanced course in Business Law II. She remained there, rising from Instructor to Professor, over a fourteen-year period. She chaired the Business Administration Department from 1982 to 1987, but had to resign when her husband had a stroke and needed her help. Two years later, in 1989, she stood for election as County Judge, an experience she found "especially challenging because right now there is only one woman judge in this county, and there are no minority women at all in judgeships." But she had three opponents, all of whom had more funding than she did—she could not afford radio or TV advertisements—and she came in third. Even though she was not elected, she relished the experience:

> That was an experience that everybody ought to have at one time. You find out what the issues are that really stir people up and find out who your friends are and that you have some very strong critics. I'm thinking seriously of running again. The next election is in 1992, and they will make an issue of my age. The Constitution of Florida has an age limit of seventy, but of course I would very definitely challenge that provision as age discrimination.

Sybil Jones Dedmond's thirteen years as the nation's first black woman law professor were an integral part of her lifelong quest for social justice,

a pursuit that began in high school and continued throughout all the different phases of her life. Whether she succeeded or failed, she always found some valuable lesson or insight to bolster her determination to continue her journey. As she looked back over her career in 1991, that determination took on crucial importance in her evaluation:

> I can't identify any points at which I felt that I looked at things differently as a woman and as a minority woman. My determination to enter into the career of law was so great that I would not have recognized any obstacle as such. I was determined to push ahead with what I wanted to do regardless of prevailing attitudes around me. I tend to be somewhat optimistic. And I think that helped me, too, to accept some of the obstacles and to find the determination to overcome them.

JOYCE A. HUGHES

Joyce Hughes's appointment in 1971 as the first black woman law professor by a predominantly white ABA-AALS law school, the University of Minnesota, was a throwback to the characteristic career of most of the first fourteen early women law professors. Like them, Hughes was hired by her alma mater, where she had graduated in 1965 as the school's first black woman student. Unlike most of them, her reception by the student body was not congenial. She recalled some of the negative details: in one instance the all-white faculty granted "administrative passes" to all of the students in one of her classes. In a second, her students filed a grievance petition claiming that she had postponed and made up an excessive number of classes, and she was not given sufficient notice to prepare for a "'hearing' on the petition." These events culminated in an "adversarial meeting" attended by the entire faculty as well as by representatives of the AALS:

> The final result of the adversarial meeting was a statement in which the faculty apologized for subjecting a colleague to such treatment. I am not aware that at any time prior to or subsequent to those events has any faculty member at that institution had to endure such treatment.[125]

One of her few minority women students, Professor Trina Grillo of UC's Hastings College of the Law, was a first-year student at Minnesota during

the year when Hughes began teaching there, and watched the entire proc-ess "snowball." She concluded that "there was no way, no matter what she did, that she could have made it at that school," adding that

> The white faculty were not particularly vicious or evil people: in fact, they probably hoped she would make it. But there was no way. . . . The students behaved like vultures: they waited for her to slip up; they circled while she was struggling; and finally they went in for the kill. . . . Inevitably, she began to withdraw and to lose the wonderful, boundless confidence she had when she started.[126]

Hughes subsequently attributed her decision to leave Minnesota for Northwestern in 1974 to the Grievance Committee hearing, commenting that "[a]s the first woman and first Black member of the University of Minnesota Law School faculty, I suffered the 'double jeopardy' of both sex and race."[127] She flourished at Northwestern, but she never forgot her "horrendous experiences" at Minnesota. One of the primary lessons she took from that experience was that one should not "take unnecessary risks before tenure" because "the first goal for Black women professors must be to achieve tenure."[128]

By the end of the 1970s, nineteen women teaching at ABA-AALS law schools had identified themselves as "Minority Law Teachers" on a list of names, called "List II," in the Appendix of the AALS Directory. Of the nineteen, only five had begun teaching prior to 1975. They were Joyce A. Hughes, Minnesota, 1971; Anita Glasco, Southwestern, 1972; Mildred Wigfall Robinson, Florida State, 1972; Patricia A. King, Georgetown, 1973; and Emma Coleman Jordan, University of California, Davis, 1974.

Lesbian Law Professors

The early to mid-1970s saw the faculty appointments of two openly les-bian professors, Patricia ("Pat") A. Cain, and Rhonda R. Rivera, and four who were in heterosexual marriages when they were first appointed, becoming self-identified as lesbians later: Marilyn J. Ireland, Jean Love, Jane L. Dolkart, and Mary Louise Fellows.[129] All were recognized as lead-ers by other women law professors, both lesbian and straight, and four served as Chair of the Section on Women in Legal Education: Rivera in

1979, Ireland in 1980, Love in 1983, and Cain in 1987. As Jean Love observed, however, the experiences of Cain and Rivera were different from that of the others:

> It seems to me there's a big difference between a Rhonda Rivera and a Pat Cain compared to a Jean Love or Mary Louise Fellows. I just was in no way a lesbian [when I was hired at Davis] and I am quite sure Mary Louise was in no way a lesbian [when she was hired at Illinois in 1975]. There is a very special struggle involved in being a lesbian on a law school faculty. That's just not a burden I carried back then in 1972. It just wouldn't be right to identify me as somebody who did.

The University of Texas led the way by hiring Pat Cain in 1974. Her partner at the time, a first-year law student at Georgia, travelled with her to Austin when she interviewed, and was introduced to Dean Ernest Smith.

> To make this move work, I had to get her admitted to the law school. I don't think he knew at first that I was a lesbian, but he supported my efforts to admit my partner as a transfer student. His wife, Paula, was a practicing lawyer downtown. One of the good things about being 'first' is that everyone wants to meet you. So, Paula and I spent a lot of time together. And then the four of us spent time together, so Ernest knew pretty soon even if he didn't know when I first arrived. In those days, if you were partnered and you didn't hide your relationship, then you were out.[130]

Pat Cain was, and is, a leading specialist in Federal Taxation, and, more recently, in feminist jurisprudence. She was promoted from Assistant Professor to Professor at Texas in 1978, and because she had tenure she was willing to assume leadership positions in newly formed national organizations. She was a founding member of the AALS Section on gay and lesbian legal issues and she served on the national board of the Lambda Legal Defense and Education Fund.

Earlier, she had served on the Executive Committee of the National Conference on Women and the Law during 1978–79, when it was hosted by the University of Texas and held in San Antonio. She was instrumental in the decision by the University of Texas to host the conference. Pat was particularly supportive of the Conference because it had added a special programming track on Lesbian Law at its Wisconsin Conference in 1977. The

keynote speaker at that 1977 conference was Elaine Nobel, the first "out" lesbian or gay elected official in the United States, who served two terms from 1975–79 as a Representative in the Massachusetts Legislature.[131] After attending those lesbian sessions, she returned to Texas committed to bringing up issues in her wills class that dealt with same-sex couples. "I used an example of a lesbian couple. When I said the word, there was a hush, and then in the silence that followed, you could have heard a pin drop."

"Still," says Cain, "I never felt discrimination because I was a lesbian, but only because I was a woman. One of my colleagues often said: 'you know, we only hired you because you're a woman.'"

Pat Cain met her future spouse, Jean Love, a law professor at the University of California, Davis, at the AALS Annual Meeting held in Houston in December 1976. At the time, Love was still married to her husband, David. Cain recalled,

> The gals from UC-Davis had a suite and hosted a cocktail party for female law professors. There were two memorable things about this event. First, UC-Davis at that time had four female faculty members—probably the highest percentage of any law school in the country for years to come. That fact alone was cause for hope that situations at male-dominated schools like my own could change. Second, the four Davis women, Carol Bruch, Jean Love, Susan French, and Emma Jordan, had rented a suite. Word quickly passed that there was a room full of female law professors and before long the Hiring Chairs of many law school faculties appeared. By the end of the party, I had something close to visiting offers at three schools. And I actually ended up visiting the following semester at Wisconsin, where I met Shirley Abrahamson, who was then on the court, for the first time. Shirley had been Jean's tax professor at Wisconsin, which I thought was a neat connection.[132]

Cain and Love met again at the AALS meeting in San Francisco in January 1984, which was the first year the newly formed Section on Gay and Lesbian Legal Issues presented a program. By that time, Love had obtained a divorce (in 1978), and had come out as a lesbian (in the fall of 1980). Both attended the program, and, as they recalled, "We got up together and we went to the Cliff House (a San Francisco landmark restaurant overlooking the Pacific Ocean) and had a cup of coffee. We've been together ever since." They consider 1984 their anniversary and celebrate it at the AALS annual meeting each year.

But all was not yet smooth sailing for the pair. In 1984, Jean Love was teaching at UC–Davis in California and Pat Cain was teaching at Texas. They sought a way to reduce that distance. During the AALS meeting, Pat had a drink with Carol Rose, then a professor at Northwestern, and Suzanne Mounts, a professor at the University of San Francisco. Carol mentioned that Pat might like to visit a Bay Area law school the following Fall. Suzanne remarked, "Well, the only thing we are looking for is a tax professor." Feeling "as if the Fates had stepped in," Pat quickly volunteered, "I am in tax, and I am available." Not long thereafter, with Suzanne's help, Pat had received a visiting offer at the University of San Francisco for the Fall semester 1984. Jean compared their experience to that of a dual career faculty couple at Davis, Brigitte and Edgar Bodenheimer:

> When I first arrived at Davis in fall 1972 . . . Edgar and Brigitte's offices, next door to each other, were just down the hall from mine. I thought it had been very easy for Brigitte to get a job because she was Edgar's wife. . . . It was not until 1991, when my life partner Patricia Cain and I were hired together at Iowa after seven long years of trying to find jobs at the same law school, that I finally understood what Brigitte and Edgar had gone through in the 1970s. Pat and I now proudly occupy offices next door to each other at Iowa, and every day when I put my key in my door, I think about Edgar and Brigitte in their offices next door at Davis. I am grateful that they were able to get their jobs together, and I am even more grateful that Pat and I were able to get our jobs together.

Iowa's hiring of two tenured lesbian women was seen as historic by some, but Dean William N. Hines downplayed it to a reporter for the National Law Journal, saying,

> I don't know whether it is historic. . . . We proceeded very conventionally to treat them both as candidates in their own right [and] they were two of the best people in their respective fields. The fact that they came together and reinforced each others' interest in moving to Iowa was just an added benefit so far as we were concerned. . . . You usually don't have access to senior women with that degree of experience and national prominence. It was an extraordinary opportunity for us.[133]

Dean Hines was always supportive of both women. He appointed Pat as his first-ever associate dean and supported her appointment as Interim

Provost some years later. Early in her tenure at Iowa, he named Jean as the first woman to hold an endowed chair in the law school.

Marilyn J. Ireland, a 1969 graduate of the University of Chicago Law School, where she had been an Editor of the Law Review, had been appointed at Washington University in St. Louis in 1972, two years before Texas hired Pat Cain, but she had not then realized that she was a lesbian. She came to that realization as a result of her stressful experience as a member of that faculty. Dean Hiram Lesar, who had hired her, left Wash. U. before she arrived to become Dean of Southern Illinois University School of Law, an ABA-accredited school then seeking to become an AALS member school. The situation at Washington University after he left was not promising:

> The faculty was split internally and at odds with the central administration. I should have guessed right away that my situation was untenable. I was the first woman to teach in the Washington University Law School, ever, in any capacity (unless you count a librarian giving a tour of the library). It was a uniqueness with which I was so familiar I failed to note its relationship to other 'firsts.' By the time I got there, affirmative action already meant 'unqualified.' That I was an affirmative action hire was what THEY thought. It did not ever enter my mind as a possibility. I was overqualified and I knew it. Unfortunately, I was the only one who thought so. I was not Soia Mentschikoff, after all. Over the years, I grew very tired of hearing that 'Yes, of course, it was possible for a woman to be a qualified woman law professor, if (and only if) she were Soia Mentschikoff.' Soia was hired by Chicago only because she was married to Karl Llewellyn, whom Chicago was so anxious to hire that they agreed to take her as part of the package. Women got ahead in those days through unusual routes, not by merit, even if merit they had in abundance.
>
> The result of all this turmoil was that the establishment totally radical-ized me. I went from being a conservative Republican wife and mother to being a radical feminist lesbian separatist. I will always be grateful to Washington University for thus changing my life.

Part of Ireland's "turmoil" had to do with the school's treatment of its female students. Ireland believed that their situation was not unique to Washington University:

> The women who went to law school before the 1970s have no idea how bad it often was for those who made up a law class of 20 to 30 percent women in the

mid-70s. Women students were being raped. Wholesale. As an experiment, I asked a random group of women law students, using anonymous slips of paper, how many had been raped. More than half answered '+.' In my graduating class in 1969, women were an oddity seldom more than ignored. Those who came behind us were true threats to male domination and faced hostility that sometimes rose to violence. I temporarily became their public voice. No way I was getting tenure anyway, so it was not truly a sacrifice to do so.

Being the public voice of the women students meant, among other things, agitating for an additional bathroom in the law school:

> There was only one commode for over 150 female law students. They clogged the halls between classes and professors could not get through to their classrooms, yet no one noticed the problem. An extension to the building was planned with additional urinals and male commodes, but only one more female commode. I exploded and threatened to bring in a potty chair and use it in the lounge unless the plans were modified. The plans were changed, but I had crossed a line. I and my female colleagues in other departments fought and failed to get tampon machines in the women's restrooms. The University administration finally agreed to it, but the janitors refused to install or service them because tampons were immoral invasions of girl students' virginity.[134]

Dean Hiram Lesar had been replaced by an administrator, Edward T. ("Tad") Foote, the University's Vice-Chancellor, General Counsel, and Secretary, who served as the School's Acting Dean from 1973–74, and then as Dean until 1980. Foote, who was not an academic, and who never held a faculty appointment, asked Ireland to be his Associate Dean. She "foolishly agreed." Her tenure in that position was rocky at best, given her agitation about the bathrooms, and she left the post after two years. Her advocacy for the students sealed her fate with her colleagues, and her first paper, prepared in 1973 and titled, "Impotence in our Criminal Justice System: Forceable Rape, A Case Study," was rejected by them as "too sociological." Ireland commented, "In retrospect, it was a work of Feminist Jurisprudence, but there was no such thing then."[135] Dean Foote fired her, but at the intervention of then-Visiting Professor F. Hodge O'Neal (a former AALS Executive Committee member), revoked his decision upon being advised that he lacked power to terminate a tenure-track professor without notice.

In addition to Ireland, Washington University had hired eight male tenure-track faculty between 1971 and 1972. Five of them received tenure; four, including Ireland, either were denied tenure or left before the tenure decision had been made.[136] Fortunately, Ireland's career was materially improved when she found a welcoming home at California Western in 1979:

> Mentally exhausted, emotionally drained, running out of time at Washington University, and trying to decide how to support my children, I attended an AALS Meeting and ran into Penn Lerblanc, a Professor at California Western School of law. It was located in San Diego, and was at that time VERY 'we all know, but don't mention it' gay. Members of the administration were gay, and actively recruited gay students from all over the country, so there were plenty of gay guys, and even a smattering of lesbian students who heard of the place from gay male friends. It didn't take much 'gaydar' to spot the favorable milieu. CWLS is still a good place for gays and lesbians to study and teach, but it is no longer quite as homey as once it was in spite of professors and students being more 'out.' As I was never 'in the closet' I never 'came out,' but anyone who wanted to know easily could classify me as of the mid 70s as a 'dyke,' a name I proudly wear, but I am not gay, thank you, please. I originally came to CWLS for a two year 'look-see' visit, mostly to serve out my term as the AALS Women Teacher's Chair before moving on to whatever. I ended up staying, and getting tenure after two years and a full professorship. At California Western, there are and always have been sufficient women's restrooms and they even have tampon machines in them. There is no epidemic of rape. If there is a better place to teach, I do not know of it.

Rhonda R. Rivera earned advanced degrees in Public Administration from Syracuse in 1960, in law from Wayne State in 1967, and in Theology from Trinity Lutheran Seminary in 1987. She was not self-identified as a lesbian when she was hired as an Assistant Professor at Ohio State Law School in 1976, but she was openly a lesbian before she was tenured there in 1979.[137] Her tenure article, "Our Straight-Laced Judges: The Legal Position of Homosexual Persons in the United States," published in 1979, was a tour de force that established her as "the Mother of Gay Rights," and strongly suggested her own identity as a lesbian.[138] The article focused on the impact of civil, rather than criminal law, on the lives of gay men and lesbians, covering in great detail the subjects of employment and related

occupational discrimination, both in private and public employment; family issues; other civil issues, including the incorporation and tax exempt status of gay rights organizations; liquor licensing laws; practices at universities and other public forums (with particular emphasis on fourteenth amendment free speech and assembly issues); and immigration and naturalization.

Reflecting in 1999 on the article and the work required to produce it, Rivera commented, "The article is 156 pages in length and has 938 footnotes and covers a span of years from 1905 to 1979. The article took me four years to research and a whole summer, seven days a week from 7 A.M. to 5 P.M., to draft."[139] She modestly denied that its submission with her tenure file had been particularly courageous: "I have been told how brave I was to submit the Hastings article for my tenure piece. I must admit of no courage; I had no other choice." She added "I was incredibly naïve about law schools and law school politics."[140] She did receive tenure, however, and commented with relief, "I was then relatively safe in my position, an openly gay tenured law professor. I tried to make the most of this bully pulpit for the next twenty years."[141]

Rivera's use of her "bully pulpit," however, was not directed at her law school colleagues:

I decided a number of years ago that my battles were outside the law school. To a certain extent, I was not going to get into fights here, because it was too painful. I would rather go and be a gay rights leader or work around the University. I was too thin-skinned to do it in the law school. That's how I have protected my life.[142]

Instead, Rivera's activism played out on the stage of national legal education. She "came out" in 1978 at the first AALS Workshop for Women Law Professors:

The workshop was in Cincinnati, and it was set up to have formal small group discussions, but there were also a lot of small group discussions in people's bedrooms. I remember being in a hotel room, and there were probably 20 to 25 women in the room. And I hadn't planned to come out. But I just said, about whatever issue we were talking about, "Well, it's a more important issue to me, because I'm a lesbian." And there were people who went, "Eeeek!" But it was very positive, and very exciting. I never had any

negative problems from women law professors, and there were only women in the room. It was a pretty cozy environment. The next year, probably, I did it in bigger groups that included men.

The 1980s: Establishing an Identity

ROLE OF THE AALS

The role of the AALS in providing a convenient organizing forum for the new law professors began in the 1970s and was solidified during the 1980s. The Section on Women in Legal Education ("WLE") was the first of the so-called "affinity" Sections to be organized under its auspices. It was followed by three others: the Minority Groups Section, which held its first meeting jointly with the WLE Section in 1974 (program topic: "Equal Employment Litigation"); the Section on Native American Rights in 1977 (program topic: "Criminal Jurisdiction over Non-Indians Within Reservation Boundaries"); and the Section on Gay and Lesbian Legal Issues in 1984.

Rhonda Rivera and then-Associate Professor Arthur "Art" Leonard of New York Law School (whom she calls "the Father of Sexual Orientation Law") attended the annual AALS meetings and were instrumental in gathering together the gay and lesbian law teachers in "unofficial, semi-secret meetings."[143] They kept an informal list of those who attended. By January 1983, at the AALS Annual Meeting in Cincinnati, the idea of establishing a formal GLBT Section was discussed. Leonard recalled:

> I was the one who suggested the name that was adopted for the proposed Section on Gay and Lesbian Legal Issues. At that time, I volunteered to set up a mailing list in my office computer and get a newsletter started for the section. Although AALS required that a list with a minimum number of names be submitted in order to approve a formal section, it was clear that most of those who wanted to get the newsletter and announcements did not want their names going to the AALS at that point, so we promised confidentiality to everybody.[144]

A petition to establish the Section was signed at the Cincinnati meeting. Rivera wrote that she and Leonard "founded the Section" and that at the first couple of meetings, they agreed that she, "then Art Leonard, then Doug Whaley [of Ohio State] would be the first 'presidents' because we were out."

The AALS began publishing an annual Handbook in 1984. Among the information it contains is an annual list of the chairs of the various AALS Sections. The first chair of the Gay and Lesbian Legal Issues Section was listed as Craig W. Christensen of Syracuse University. The Section early on decided to alternate between male and female chairs, so the 1985 chair was Patricia A. Cain of Texas, the 1986 chair was Art Leonard, the 1987 chair was Jean C. Love, and the 1988 chair was Douglas J. Whaley. That practice continued through the end of the century, but the Section's name was changed in 2002 to "Sexual Orientation and Gender Identity Issues."

Public identification with both the WLE Section and the Gay and Lesbian Legal Issues Section was problematic, particularly for nontenured faculty members in the early 1980s. Myrna Raeder remembered why signing on for the WLE Section had been so difficult for junior faculty:

> Most of us thought twice about volunteering and were not eager to become noticeable as either officers or executive committee members. Even being identified as an active Section member conveyed an implicit message to deans and more traditional male colleagues that this was a potential troublemaker who would not ignore gender stereotypes or discrimination in her own institution.[145]

The explanation was more direct for the Gay and Lesbian Legal Issues Section. Being active in that Section was seen as essentially the same thing as coming out, a risky decision for nontenured faculty and one fraught with danger even after tenure in some schools. For example, a closeted gay man who had originally agreed to serve on the first Executive Committee of the Gay and Lesbian Legal Issues Section immediately changed his mind, saying "I'm not tenured, I can't do this: this is like coming out." Raeder, who chaired the WLE Section in 1982, recalled that "many of us active in the WLE Section signed the petition that supported the [Gay and Lesbian Section's] creation . . . in 1983, in part, so that the sexual preference of the female signers would not be discernable, a real concern at the time."[146] Similar hesitations do not seem to have inhibited those active in either the Minority Groups or the Native American Rights Sections.

The central importance of the AALS in providing a home for the affinity sections cannot obscure, however, the restraints that the organization's rules placed on the more activist sections. By 1986, chair Marina Angel charged

that "the AALS rules not only obstruct the Women's Section but every other activist section."[147] A primary source of this friction was the power reserved by the AALS leadership to appoint the members of all AALS committees, including committees established to plan and put on workshops:

> The AALS officers and staff may not even consult with the section that proposed the workshop on who should be on the workshop committee. The final program and speaker list put together by an AALS workshop committee might not bear the slightest resemblance to a section's original proposal.[148]

Formation of Women's Groups Outside the AALS

Today there is better communication between the AALS leadership and activist sections. But by the 1980s there was less need to rely on the AALS as the only place where the few women law professors scattered across the country could congregate. That is because there were by the 1980s a sufficient number of women law professors to make it possible to form groups outside of the AALS. Women law professors were no longer as isolated as they had been in the 1970s. It was even possible to establish regional groups rather than primarily relying on one single national organization as the sole gathering mechanism for otherwise geographically dispersed women in the legal academy.

A group of "femcrits" (the feminist spin-off from Critical Legal Studies) came together on the east coast and held meetings where female law professors had the opportunity to share their work with like-minded feminist critics of law as a male-centered discipline. A similar group formed on the West Coast in California. While there is no direct empirical evidence to show how these groups may have affected feminist legal scholarship, there is certainly evidence to show that the field of feminist legal scholarship was growing substantially during this era. The first publication to mention the term "feminist jurisprudence" was authored by Ann Scales and published in 1981.[149] Patricia Cain has written about this rise in feminist legal scholarship, questioning whether it was adequately valued in the academy by male colleagues, and pointing out the need for feminist community to engage in such scholarship.[150]

Another prominent and important group outside the AALS in the 1980s was formed by black women law professors. These professors

began an informal discussion group in one another's homes in Washington, DC in March 1988, and ultimately became known as the Northeast Corridor Collective of Black Women Law Professors. Emma Coleman Jordan described its growth in 1990:

> The group has continued to expand in numbers as well as in geographic coverage. The first meeting was attended by 16 black women. In the three years since it was organized, the group has grown to encompass participation by many of the 91 black women on the mailing list. While the name of the group suggests a criterion of geographic eligibility, participants have ranged from as far west as California (Margalynne Armstrong) and as far south as Florida (Denise Morgan).[151]

Fighting Tenure Denials

Few of the women hired in the 1970s who faced tenure problems complained publicly about their situation. Some, like Joyce Hughes and Marilyn Ireland, quietly and efficiently took care of the problem by moving to new institutions in which they found success. Others simply exited the academy altogether. By the 1980s, however, women who had been hired at several schools in the late 1970s, and who had received negative tenure evaluations, did complain about discriminatory treatment and made their cases public.

Two well-known cases arose at my own institution in Berkeley. The first was that of Marjorie Maguire Shultz, a 1976 Boalt graduate who had been such an outstanding student that she was appointed to the faculty immediately upon her graduation. The second was that of Eleanor Swift, a 1970 Yale graduate who had been hired at Berkeley in 1979, after three years of clerkship experience (two with Judge David Bazelon of the Court of Appeals for the District of Columbia) and five years of law practice with the firm of Vinson & Elkins in Houston, Texas. Both women were ultimately successful in retaining their jobs and being granted tenure. But the battles were painful and stained Berkeley's reputation in the wider legal academic community regarding support for women in legal education.

Harvard went through a similar, very public tenure battle over a female faculty member, Clare Dalton. Dalton was active in the "femcrits"

community and revered by many of her female peers around the country. Harvard eventually settled and Dalton went on to teach elsewhere. But, as with Berkeley, the controversy stained Harvard's reputation as a possible supportive place for women. Texas was another highly-ranked school that went through tenure problems with women faculty in the late 1980s and into the 1990s. In some cases, alternative arrangements were made to keep women on in non-tenured positions and, in other cases, the women left.

These examples are provided to show that, despite the major gains that women made in joining the law school faculties during the 1980s, there was always some pushback. Yes, men have been denied tenure by law schools over the years. Boalt (now Berkeley Law) had experienced problems tenuring male faculty before the problems arose with Shultz and Swift. In fact, in 1982 the concerns over these tenure battles contributed to the departure of a particularly promising faculty hire, Carol Rose, who later became a chaired professor at Yale.

Nonetheless, by the 1990s, women had made a substantial inroad in entering the legal academy as faculty members. In 1989, a record number of female law professors was hired: eighty-four in a single year. While the female percentage on faculties remained low at some schools, particularly at top tier schools, the presence of women in many law schools was reaching a critical mass. By the end of the century there were 1,788 female law professors, constituting approximately 25 percent of all law faculty at AALS/ABA schools, and new female assistant professors were being hired at a rate approaching female law school enrollment, which had risen to 50 percent.[152]

If 25 percent is considered a critical mass then women law professors appear to have reached that status by the 1990s. But it is worth pointing out that the national average may be misleading as to individual law schools. Research has shown that the highly ranked, more prestigious law schools have lagged behind the national average in hiring women.[153] In fact, as of 2000, the three law schools identified above as having problems in granting tenure to women were all obvious laggards. Texas was the lowest at 12 percent female faculty in 2000. Harvard came next at 17 percent. And Berkeley was at 20 percent, but if the denials of Shultz and Swift had been upheld, it would have been at 16 percent.[154]

INCREASE IN FEMALE DEANS

Three of the first fourteen women law professors, Miriam Theresa Rooney, Dorothy Wright Nelson, and Soia Mentschikoff, were also three of the first four women law school deans. As we have seen, Rooney was the founding dean of Seton Hall law school in New Jersey who held office from 1951–62; Nelson served as Dean at USC from 1969–80, when she was appointed to the Ninth Circuit Court of Appeals; and Soia Mentschikoff completed her illustrious career as practitioner and law professor at Harvard and the University of Chicago by becoming Dean of the University of Miami School of Law in 1974 and serving until 1982. But most of these deanships did not overlap, so at any given time there was only one law school headed by a female dean.[155] However, there was a period in the mid 1970s when there were six female law deans, five of them at ABA accredited schools.[156]

As of 2002, there were 180 ABA accredited law schools, and 26 of them were led by female deans.[157] That means the percentage of schools led by a female dean in 2002 was just over 14 percent. The numbers continue to rise. In 2005/2006 over 18 percent of ABA/AALS law schools were headed by female deans.[158] And by 2016, the number of female law school deans doubled, from 30 in 2006 to 61 in 2016.[159]

Breaking the deanship barrier in legal education has been the last frontier for women. Years after the percentage of female students reached 50 percent and the number of new faculty appointments of women reached 50 percent, the presence of women in deanships is approaching 50 percent. As further evidence of this successful breakthrough, note that the top law schools can be added to the list of those run by female deans. Harvard has had two female deans.[160] Stanford has had three.[161] And Yale's current dean (as of 2020) is female.[162] These breakthroughs, at the student, faculty, and deanship levels, are proof that the first fourteen women law professors led the way to breaking down the barriers that have historically kept women out of the legal academy.

Conclusion

This book has presented the stories of the fourteen early women law professors who entered the all-male world of law school teaching between 1900 and 1959 and who ultimately became tenured professors of law. What they did was extraordinary, and it opened the way for those of us who followed them into a challenging, difficult, but not infrequently rewarding profession. None of them, however, thought that what she did was particularly courageous, or even unusual. In holding this attitude, they were reinforced by their male colleagues, many of whom thought of them—not disparagingly—as "just one of the boys."

As the six chapters (and the appendix) describing the individual careers of the early women law professors have shown, the first few did not experience any sex discrimination during their appointment processes. Some of them had difficulties that may have been sex-related at the time of their tenure review, and several of them experienced wage discrimination when they were paid less than comparable male colleagues. But none of them were excluded because of their sex.

Although each of these fourteen women carved out an individual niche for herself, there are many similarities among them. They came from families who prized education, and they were expected to make something of

themselves. Most were encouraged to study law, either expressly by a well-meaning, if not always particularly well-informed, mentor during her early years, or implicitly by the example of her lawyer-father (none of them had lawyer-mothers). And each was guided into law teaching, not infrequently because no suitable jobs were available in the practice of law. Once established in their law school settings, all of them became highly regarded teachers who mentored their own students, both male and female. All except one published—several were recognized as excellent scholars—and most were active in law reform. Nearly all were active in public affairs and community organizations outside the law school, and this activity increased after their retirement from teaching.

Altogether, they were a fairly homogenous group of women. All were white.[1] None were lesbians. Most of them (all but three) were married and had children. That perhaps made them seem familiar and "safe" to the men who hired and mentored them.

Female hires in the 1960s added some diversity. These hires included additional Jewish faculty as well as the first woman of color hired at an ABA/AALS law school, Patricia Harris, in 1963. Diversity increased in the 1970s and 1980s, as shown in chapter 7, with the addition of more women of color and the first "out" lesbians.

I believe this diversity has added to our ability to attain a critical mass of women at individual institutions. No longer was one woman expected to present the female view of matters on behalf of all women. Different voices began to be heard. Ellen Peters, one of the first fourteen, noted how much easier it was for her to be heard in faculty meetings once she had two female colleagues. As she said: "It has been well documented that there is something about a critical mass for hearing different voices" and that this phenomenon, she continued, "was alive and well at the Yale law school."

While there were times when this diversity may have strained our sense of togetherness as women, there were times when it improved our ability to do our work on behalf of "all women." At least half of the first fourteen consciously devoted a portion of their professional agenda to improving the legal status of women. This effort was demonstrated most clearly by the five of them who were known as family law specialists, but it was also evident in the work of others. The women who followed them have been

similarly committed to improving the legal status of women, especially Ruth Bader Ginsburg.

There was less opportunity for the first fourteen to engage in any "networking" with each other. Only a few of them knew each other personally. Three of them were on the University of Miami Law faculty at the same time, and two of them worked together on the same ALI law reform project. But as Ellen Peters observed to me, "We didn't talk about what we were doing: we just did it." And although I had the very good fortune to be mentored by Barbara Armstrong, she and I didn't talk about it either. Instead, our conversations focused on the subject matter interests we shared, Family Law and California Marital Property; the institutional affairs of the law school; and occasionally political issues of the day. What I absorbed about feminism from Barbara was a tacit understanding of how to function in a largely male environment and how to support our women students in their struggle to survive and even flourish there. And the lesson I take away from my now fifty-five years of teaching law at Berkeley is that not until a critical mass of women faculty has achieved tenure and acquired the means to shape the image of the profession to their own liking will entry-level women become welcome and prized for their intellectual diversity at any particular school.

I do think the first fourteen paved the way for us to create this critical mass at the national level by the end of the twentieth century. I learn constantly from the now critical mass of women students and junior colleagues at Berkeley and elsewhere. The core lesson centers on why it is so important to talk about who we are and what we are doing as women lawyers and law professors. Many of us identify as feminists, whereas none of the early women, despite their support for women's causes, appear to have embraced that nomenclature.

The importance of theorizing about feminism grew out of consciousness-raising and what my student (and later Dean of Duke University Law School) Kate Bartlett famously called "Asking the Woman Question."[2] As we have increased the number of women in the legal academy, the opportunities for "networking" and "consciousness raising" have increased, opportunities that were not available to the early women. "Asking the Woman Question" has led many of us to a lived-out focus in our scholarship and law reform activities that celebrates and seeks to

understand the work that women do—for themselves, for their communities, for the establishment of an ideal of justice for all people that transcends sex, race, color, creed, religion, sexual orientation, age, and disability.

Today's women law professors have sought to create an environment at their schools where they can function at a productive level, while enjoying the respect and cooperation of their students and colleagues. While this goal has been attained more fully at some schools than at others, help is readily at hand for those who teach at the schools that still need improvement from the nationwide society of their sisters-in-law. In that context, perhaps all of us are feminists. If so, let us unfurl a transcendent feminist banner broad enough to encompass us all together, nourish our energies, and sustain our work.

Appendix

A NOTE ON CLEMENCE MYERS SMITH,
THE SIXTH WOMAN LAW PROFESSOR

Clemence Myers Smith was the sixth of the first fourteen early women law profes-
sors. She began teaching in 1952 at Loyola, Los Angeles, a school that had articu-
lated a mission of training lawyers for the practice of their profession and that
prided itself on its prowess in teaching law.

"Clem" Smith, like her female predecessors, had an impressive law school
record. She had graduated from Loyola first in her class, with the highest GPA
that had ever been recorded. Some claim that this feat was even more amazing
because, at the time, she was a single parent of a young son. She was thereby
forced to take many courses in the evening division (or whenever her childcare
responsibilities would allow). This meant that she was unable to take law school
courses in the recommended order. But, of course, like her counterparts at other
institutions, she was not unique in figuring out a way to balance parenting
demands against the demands of being a law student.

Clemence Josephine Myers was born in Hastings, Nebraska, on April 18,
1920. She was the daughter of Rollie J. Myers and Ella Aquart Withington Myers.
Unlike most of her early counterparts, Clem Smith came from a family that had
no special connections nor educational achievements. Her father had finished the
eighth grade, and her mother had finished the ninth.

Also, unlike most of her early counterparts, she did not publish legal books,
treatises, or articles that might have brought her to the attention of the wider
legal world, or even to the world of legal education. Publication was not only not

Figure 16. Clemence Myers Smith. Courtesy of the Joanna Smith.

a requirement for the Loyola faculty, it was discouraged if it interfered with one's teaching responsibilities. In this regard, Smith was living exactly the same sort of academic life that her former professors, who subsequently became her colleagues, were living. Like the best of them, however, she was an excellent teacher.

Stan Goldman was a student in Smith's classes in the early 1970s, and later became a colleague. He describes her as one of the most brilliant people he had ever met at that time.[1] He also thought Smith herself embraced that aspect of herself. That is, she knew she was brilliant. Goldman described her voice as "remarkable," one that compelled your attention. If you closed your eyes, he said, you would think you were in the midst of a Katharine Hepburn movie with Spencer Tracy or Cary Grant. Apparently, she was quite a character.

Fred Lower was a student of hers even earlier. He took her course in Equity in 1961. He praises her teaching and says that he embraced her style as much as possible when he joined the Loyola faculty some years later. She was known for her "novelist's talent for creating imaginative hypotheticals."[2]

Her subjects were demanding ones, including Commercial Law, Commercial Paper, Contracts, Community Property and Equity, as well as (in her early years) Law and Psychiatry and Trusts and Estates. Once the culture of the school began to change under pressure from the younger faculty who had graduated from schools with higher academic aspirations, and from the dean who recruited these scholar-teachers, some say that Smith sided with those among her colleagues who opposed the new ways. Others say she was never political. She was too practical. Things simply were the way they were.

In struggling through this transformation, Loyola was not unlike several of the other schools where the early women law professors had taught. Its sister Catholic institution, Georgetown, endured a similar maturation process. So did the University of Miami Law School, where Soia Mentschikoff, who became the dean in 1974 and where she built on the momentum that had begun in the early 1950s. Loyola's neighbor, the University of Southern California, started from a somewhat higher level, and strove for a more ambitious achievement, led by the "Young Turks" from Yale and other first-class law schools, who transformed the school during the deanship of Dorothy Wright Nelson in the 1970s.

Like several of the other early women law professors, Clem Smith did not survive the transition from a school that trained practitioners to a school that nurtured scholars. But she did continue teaching for over thirty years. Helen Steinbinder at Georgetown and Jeanette Ozanne Smith at Miami shared her experience. Smith did write a couple of short creative essays. One of these was published in the *Loyola Digest*, a publication of the law school.[3] The story, called "Trespass by Pigeons in the State of Loyola," demonstrated a flair for clever writing. She even cited a North Carolina case that she thought might help her win a court injunction against the trespassing pigeons. One imagines that she wrote it for the best of all reasons: to please herself.

Clem Smith's son, Michael O. Smith, who predeceased her, was an Associate Professor of Psychiatry at Cornell Medical School and was certified by the American Society of Addiction Medicine. He was internationally known for developing the use of acupuncture in the field of chemical dependency and was best known as the Director of Lincoln Hospital Recovery Center. She also had two grandchildren, including Joanna Smith, a graduate of NYU Law School, now practicing law in New York City, and Jessica Hunter, a French teacher in the state of New York. Clemence Smith died on February 22, 2019, just shy of her ninety-ninth birthday.

Afterword

In January 2006, I arrived in Berkeley, California, for a job interview for an entry-level position teaching at the law school. The day was already pressure-filled, so imagine my utter terror when the appointments chair informed me that that Herma Hill Kay, Berkeley Law's former dean and resident expert in Family Law and gender equality, was "very interested in talking to [me]."

Our first audience began inauspiciously. I perched awkwardly on a chair in her office, trying hard not to stare at the photos and newspaper clippings that dotted the wall and shelves. I knew that Herma was a leader in many academic fields—Family Law, Conflict of Laws, Sex Equality—but it was nonetheless overwhelming to see her professional accomplishments splayed out across her office.

There was Herma, resplendent in navy blue and gold, the first female dean of Berkeley Law. A framed certificate honored Herma's service as one of the first women presidents of the Association of American Law Schools. On an adjacent shelf was the American Bar Association's Margaret Brent Award, honoring Herma's work advancing women's rights and professional progress. There was a framed certificate commemorating Herma's work as a member of Governor Edmund Brown's Commission on the Family, which paved the way for California's adoption of a no-fault divorce statute in 1969. Newspaper clippings chronicled Herma's advocacy on behalf of California's therapeutic abortion statute and the state's ratification of the Equal Rights Amendment. In a smaller sil-ver-edged frame was a photograph of Herma and Ruth Bader Ginsburg, heads together, editing their Sex Discrimination casebook. A framed newspaper article

featured a photo of Herma throwing out the first ball at an Oakland As game with enviable form. There was even a photo of Herma piloting a single-engine plane.

I tried hard to pay attention as she peppered me with questions, but I was dazzled. Everywhere I looked, I came face to face with Herma's status as a living legend—a pioneer for women in the law.

Six months after that first meeting, I joined the Berkeley Law faculty as an assistant professor, and Herma and I began building a professional and personal friendship that would last until her death in 2017. But curiously, in the ten years of our friendship, we rarely talked about Herma's many accomplishments. Whenever I would try to get her to open up about her many successes, she would gracefully steer the conversation in another direction. The only aspect of her work that she seemed especially eager to discuss was her book project chronicling the careers of the fourteen women who had preceded her as professors at accredited law schools. This project occupied her attention for the last fifteen years of her life. She spent countless hours interviewing her subjects and their colleagues, and poring over microfiche, newspaper clippings, and remnants of the women's personal papers. Her goal, as she noted on more than one occasion, was to paint a complete picture of their professional lives. Despite long odds, these women had persisted, claiming a place in a profession that was often dismissive of them and their professional aspirations. Herma wanted to capture both the exhilaration of having made it, and the often-palpable loneliness of being the only woman in the room. She also wanted to ensure that, even as the profession and the professorate grows ever more diverse, these pioneering women were not forgotten.

In this, she was, predictably, wildly successful. The book paints a searing portrait of what it was like to be a woman in the legal academy at a time when women were scarce and white men dominated both the ranks of the professorate and the student body. Her accounts of her pathbreaking predecessors make clear the indignities, both banal and profound, that these women routinely endured as the lone female on their faculties. One can only wince upon learning that for much of her career at Berkeley, Barbara Nachtrieb Armstrong was chronically underpaid relative to her male colleagues. By the same token, it is cringeworthy to read that the social worker charged with evaluating Marygold Melli for an adoption balked at the prospect of an adoptive mother who was also a full-time law professor. Of course, we can all chuckle at Melli's pluck in dealing with the situation: she briefly surrendered her faculty position at the University of Wisconsin, only to be immediately reappointed to the faculty once the adoption was finalized.

But even as it is a collection of biographical sketches, this book is also a biography of the legal academy. Each woman's story reflects, in ways small and large, the conflicts of the times, the law's role in shaping and resolving these conflicts, and the academy's role in shaping the lawyers who would go out into the world to solve—and in some cases, exacerbate—these conflicts. If the fourteen women are

the protagonists of this story, then the academy, where Herma spent so much of her professional life, is a crucial supporting character.

Given the background role that it plays in Herma's account, it is worth considering what the "legal academy" encompasses—both in this book and more generally. In choosing to focus her inquiry on the first fourteen women to teach at laws schools accredited by the American Bar Association, Herma suggests that, at least for the purposes of the book, her vision of the legal academy is the collection of law schools that enjoy the status of ABA accreditation. But obviously the academy is not defined exclusively by the ABA and its accreditation process. Even today, not all law schools enjoy accreditation status—and some lose it and regain it again. Regardless of accreditation status, these schools are part of the "academy." So, how does Herma's choice to limit her inquiry to those teaching at ABA-accredited institutions shape the story of the academy and the women in it? What institutions are overlooked? And by extension, what women are overlooked?

In this regard, it is worth saying a bit about the origins of the ABA and its accreditation process. In documenting the fledgling United States, Alexis de Tocqueville noted that the American aristocracy "occupies the judicial bench and bar." De Tocqueville's observation was hardly earth-shattering. Many of the nation's founders—men like Thomas Jefferson, James Madison, John Jay, John Marshall, and Alexander Hamilton—were lawyers as well as statesmen.

But even as de Tocqueville documented these facts, change was afoot. Concerned that men of modest means were being excluded from the profession, states began to eliminate bar exams, apprenticeship requirements, and the other educational trappings that previously governed entry to the bar. Whereas in 1800, fourteen of the nineteen states had often lengthy and costly apprenticeship requirements for bar passage, by 1860, these remained in just nine of thirty-nine states.

Not everyone cheered this impulse. In 1878, partly as a response to the democratization of the profession, a small group of lawyers formed the American Bar Association. Reflecting its founders' formal law school training, one of the ABA's first actions was to create a Committee on Legal Education and admission to the bar, aimed at partnering with state bar associations to improve legal education and bar admissions standards. At the ABA's second annual meeting, the committee recommended that states condition bar admission on the completion of three years of specialized legal study covering thirteen fields of law.

The ABA's interest in reforming admission to the profession, and its prioritization of formal legal education, dovetailed with a shift in legal training. Between 1890 and 1930, the number of law students in America increased nearly tenfold as legal education began to displace apprenticeships as the preferred method for entry into the profession. Critically, this shift was not driven by government requirements—until 1923, no state required a law school education as a condition for bar admission. Instead, the growth was fueled by immigrants and their children who sought formal legal education because they were routinely excluded

from the traditional apprenticeship system, which relied on access to networks within the profession. Others who were likely to be left out of apprenticeships, including newly freed African Americans and women, also turned to formal legal education as a conduit to the profession. The democratization of the legal profession in the nineteenth century led to an expansion of existing law schools and the creation of new schools, particularly part-time schools. Notably, part-time law schools primarily served lower-middle-class and working-class students, and disproportionately served ethnic minorities.

Of course, the democratization of legal education—and the proliferation of part-time programs that made the legal profession more accessible to women, minorities, and immigrants—was not what the ABA had in mind when it was created in 1878. Soon its interest in professionalizing the bar began to focus on making legal education less accessible and more elite. In the early twentieth century, the ABA began to push for accreditation standards for formal legal education. As part of this effort, in 1900, the ABA invited delegates from thirty-five law schools to form the Association of American Law Schools (AALS), an approval and accreditation vehicle. To become a member of the AALS, a law school had to restrict admission to students with a high school or equivalent education, offer ten hours of instruction per week for at least two years (raised to three in 1905), graduate students only after they passed an examination, and maintain a library containing reports of the US Supreme Court and the high court of the school's home state.

Over time, the ABA, in tandem with the AALS, would further refine its accreditation standards. By 1921, in order to become ABA-accredited, law schools were required to admit only students who had completed at least two years of college study, maintain three-year, full-time programs or four-year, part-time programs, house an adequate law library, and employ a sufficient full-time faculty. These new standards took a toll on part-time, for-profit law schools, whose students were less likely to be college educated and for whom the law library and full-time faculty requirements added significant costs. (Most part-time programs relied on less costly, part-time adjunct faculty.) In 1929, the ABA added a fifth standard that prohibited for-profit programs entirely.

As the ABA's standards took root, state-level regulators took notice. In 1923, no state required students to graduate from an ABA-approved law school as a condition of bar admission. But just fifteen years later, twenty-three of forty-eight states required graduation from an ABA-approved institution in order to be admitted to practice. By 1984, forty-eight of fifty states required bar applicants to have graduated from an ABA-accredited school.

The ABA's predominance—and its mission—came at a cost. The ABA's approval standards recast the American legal education market in the image of its elite, exclusively white, and largely male membership. They required that students first invest in a college education—a significant cost that deterred working class stu-

dents from pursuing a legal career. Additionally, the new standards required law schools to provide pricey amenities like full-time staff and extensive legal libraries. These costly requirements wreaked havoc on the business model of part-time for-profit law schools. Faced with the prospect of either absorbing these costs, or passing them along to students, many of the schools that served Black, immigrant, and female students collapsed. Within a generation, the ABA, through the accreditation process, had transformed both legal education and the profession. Three-year, full-time law school programs became the norm—and not surprisingly, their enrollment often reflected the ABA's elite aspirations for the profession. In just a generation, the ABA had managed to stem the rising tide of democratization, rendering the legal profession more exclusive and less accessible.

I document these aspects of the ABA's rise and predominance in the legal profession because they are relevant to this book and the women it chronicles. Herma chose to limit her inquiry to those women teaching at "ABA-accredited" institutions. Her choice was certainly sensible, and indeed predictable—the professional milieu of the AALS and the ABA was the world that Herma inhabited and knew best. Over the course of her career, she would serve as president of the AALS and secretary of the ABA's Section on Legal Education and Admissions to the Bar. In 1992, she received the ABA's Margaret Brent Award for women lawyers who achieved professional distinction. Undoubtedly, these organizations shaped her understanding of, and experience in, the academy and the profession. In this regard, it is wholly unsurprising that her inquiry would be confined to the professional stratum she occupied.

But neither the legal profession nor the academy was limited to those institutions that the ABA and the AALS blessed through its accreditation process. And the decision to focus on accredited institutions means that other aspects of the profession and academy are occluded. It also means that other women are obscured—including women who actually preceded Herma's subjects in the academy. To be sure, Herma acknowledges these earlier entrants to the law school habitus. But the focus on women who were law professors at accredited institutions means that the spotlight skirts their predecessors at unaccredited law schools.

The oversight is unfortunate, as these women—and their careers—were as remarkable as those of the women pathbreakers that populate this book. Consider Lutie Lytle's story. Born in 1875 to parents who had been enslaved, Lytle spent her early childhood years in Nashville, Tennessee, where her father, John Lytle, was a barber turned merchant, primarily selling basic dry goods and equipment to farmers. When Lytle was seven, her family relocated to Topeka, Kansas, alongside thousands of other Black "Exodusters" fleeing the rising tide of racial violence in the post-Reconstruction South. The Lytles also hoped to ensure an education for their children. A star pupil, Lytle was, in 1896, the first woman to enroll at Central Tennessee College, a school founded for the purpose of educating the formerly enslaved and their children, and which had built a reputation

as a leader in training Black attorneys in the South. Lytle distinguished herself academically, graduating first in a class of roughly six law students.

Upon graduating in 1897, Lytle became the first woman admitted to the Tennessee bar and just the third Black woman to be admitted to the bar in any American jurisdiction. She would later become the first Black woman to be admitted to practice in Kansas. In 1898, a full twenty-five years before Barbara Nachtrieb Armstrong joined Berkeley's faculty, Lytle joined the faculty of Central Tennessee College, her alma mater, where she taught matrimonial law, evidence, and criminal procedure. Although Lytle only taught for one academic year, she went on to have a long career in social activism and political organizing, advocating for racial and gender equality.

Although the press heralded Lytle as the first woman law professor "in the world," in fact, she entered the professorate at the same time as Ellen Spencer Mussey and Emma Gillett. Born in Geneva, Ohio in 1850, Ellen Spencer was the daughter of two abolitionists and temperance advocates. Her father, Platt Rogers Spencer, created the "Spencerian penmanship" method, which became the de facto style of business correspondence from 1850 until the adoption of the typewriter. As a child, Spencer helped her father run his penmanship school, eventually moving in 1869 to Washington, DC, to work for her brother as the head of the "women's division" of the local branch of the Spencerian Business College. She married Rueben Mussey, a Civil War general and lawyer, in 1871. The Musseys would often discuss his work and cases, but even as Mrs. Mussey became more fluent in the law, she insisted that it was improper for a woman to practice. Fate would soon intervene, forcing Mussey to take over her husband's practice when he became ill with malaria between 1876 and 1878. Upon recovery, Rueben Mussey convinced his reluctant wife to stay on and help run the practice.

When her husband died in 1892, Mussey found a male partner who was admitted to the bar, but also got to work on her own admission, with an eye toward running the practice independently. At the time, law school graduates were automatically admitted to the DC bar. However, when Mussey applied to National University and Columbian College (now George Washington University Law School), she was rejected because of her sex. Instead, relying on the network of contacts she had cultivated over her years of working as her husband's adjunct, she was able to gain admission after a special oral "examination." Mussey maintained a successful independent law practice for years and became just the third woman to argue a case before the United States Supreme Court

Like Mussey, Emma Gillett had spent a considerable amount of time on the periphery of Washington, DC legal practice. Born in 1852 in Princeton, Wisconsin to homesteader parents, Gillett's first career was as a teacher. However, her experience settling her mother's estate, coupled with the low pay afforded teachers, soon propelled her toward the law. In 1880, Gillett moved to Washington and began studying under Belva R. Lockwood, a suffragist who was the first woman

to be admitted to the Supreme Court bar. Most law schools did not admit women, but Gillett was able to enroll at Howard Law School, a historically Black institution, from which she graduated with an LLB in 1882 and an LLM in 1883. As a law school graduate, she was admitted to the DC bar in 1883, and worked for eighteen years in private practice, specializing in real estate and pension law. Gillett became the seventh female member of the Supreme Court bar and was the first woman to be admitted to that bar by the motion of another woman.

As part of the small sorority of women lawyers working in Washington, DC, it is not surprising that Mussey and Gillett were acquainted. Neither set out to be a pioneer in legal education, but in 1896, they joined forces to teach three female students in Mussey's law office. Their hope was that their students would then be admitted to a formal law school program. But when Columbian College refused to enroll the three students, on the ground that "women did not have the mentality for law," the two women decided to incorporate their "Women's Law Class" into the Washington College of Law (WCL), a coeducational law school that was specifically open to women.

While Gillett was an alumna of Howard Law School, and had benefited from Howard's broad admissions ethos, the duo's vision for WCL was decidedly narrower. The pair marketed WCL as the only law school exclusively for white people that admitted women. Indeed, WCL did not enroll Black students until it was absorbed by American University in the early 1950s. Despite its racial exclusivity, WCL shattered glass ceilings for women in legal education. Mussey served as WCL's first dean from 1898 until 1913, making her the first female dean of an American law school. She would be followed by Gillett, who served as the school's second dean from 1914 until 1923, and by four other women deans. Under the leadership of Mussey, Gillett, and their successors, WCL grew from an inaugural class of a handful of women to an institution with dozens of full-time and hundreds of part-time students.

This history is illuminating on a number of fronts, but particularly in the context of this book. Though entirely understandable, Herma's decision to focus her inquiry on the women who taught at ABA-accredited institutions yields a more limited account of the academy, the institutions that shaped it, and the women in it. For years, critics have noted that the ABA was established, in part, to limit minorities' access to the legal profession. Further, their accreditation process, for many years, disproportionately excluded historically black law schools and women's law schools, limiting the employment prospects of the lawyers trained in those institutions. A discussion of the ABA and its efforts to professionalize the bar and academy would have provided crucial context for Herma's discussion of her subjects and the academy.

As important, widening the lens beyond ABA-accredited institutions would have produced a more robust discussion of Lytle, Mussey, and Gillett—and the complementary and conflicting roles of race, class, and gender in shaping the

legal profession in its earliest days. At the very least, it would make clear that women were present, however grudgingly accepted, in the profession and the academy much earlier than the accounts of Herma's subjects suggest. It would also underscore that the boundaries of the legal academy did not stop at the doors of elite three-year law schools, but also included the less vaunted institutions that welcomed the working class, immigrants, women, and minorities.

This is all to say that, although this was not Herma's intent, the decision to focus exclusively on ABA-accredited institutions risks further entrenching a professional exclusivity that was neither desirable nor inevitable. It also consigns to the periphery the presence of the women who entered the profession and the academy before Armstrong's introduction in 1923, resulting in a narrative that is focused predominantly on the professional experiences of white women. To my mind, this is deeply unfortunate. In focusing on the women who preceded her in the elite echelons of the academy, Herma may have inadvertently sidelined one of the most important aspects of her own legacy as a professional pioneer: her deep commitment to expanding and diversifying the academy.

I experienced this commitment firsthand. When I joined the Berkeley faculty in 2006, I was only the second Black woman to be hired at Berkeley Law. In those days, each new recruit received a letter documenting the process that resulted in her hiring. Mine noted that some colleagues expressed doubt as to whether I would ever develop into a scholar of "considerable repute." But a few sentences later, the letter noted that any objections were "swiftly answered" by "a senior colleague in the field" who insisted that "Murray will make enormous contributions in and outside of Berkeley" and vowed to be my "conscientious and active mentor." I knew immediately who had vouched for me—who had expended some of the capital she had amassed as a trailblazer to ensure that I could blaze my own trail.

And she was as good as her word. On my first day at Berkeley, Herma took me to lunch at the Women's Faculty Club—a remnant of a time when *the* Faculty Club did not admit women, prompting Berkeley's women professors to create their own haven. As I chattered on about my first class and my fears about the tenure process, which loomed large in my mind, Herma interrupted me. "Melissa," she announced solemnly between sips of water, "I just want you to know that I do not plan to retire until you get tenure." She paused, weighing her words carefully: "But please, don't take too long going about it!"

Her words overwhelmed me. I had just begun my professional journey toward tenure and could not even conceive of its completion, and here was Herma committing to stay the course with me—to steer me through whatever turbulent shoals I might encounter and see me safely to the other side. For the next four years, I benefited from Herma's graciousness and generosity more times than I can count. She read every paper that I wrote, attended my classes, and provided helpful criticism, and more often, calm assurances that everything would work out in the end.

I was so often on the receiving end of Herma's kindness that it is easy to forget that I was not the only beneficiary of her friendship and care—and her commitment to diversifying the academy. From coast to coast, the legal academy and the profession are filled with young women and men, including people of color, who Herma mentored, befriended, and guided over the years. Some of these scholars were former students who, inspired by Herma's example, went on to become first-rate legal scholars in their own right. Others were simply fellow travelers with whom Herma found common cause. In either case, her influence cannot be overstated.

To the extent that I have criticized how Herma defined "first," I want to make clear that being first is not the critical issue in this manuscript, or in the academy itself. The women chronicled here were the women who shepherded Herma as she began her career in the academy. As the history I have recounted suggests, these women were not necessarily "firsts" in the academy, broadly construed. But they were the women to whom Herma looked for guidance and support as she began to climb the career ladder at one of the world's premier research universities. The women whose lives Herma so lovingly recounted were the ones who smoothed that path for her and reached back to bring her along. And she, in turn, did the same for the scores of women who followed.

In this regard, although this book is an homage to fourteen extraordinary women, in fact, it is also a testament to all of the women who followed, smoothing the trail blazed by these women, and those who ascended to the podium even earlier. And above all, it is a testament to its extraordinary author, who, though not the first woman law professor, was stoutly determined not to be the last.

Melissa Murray
Frederick I. and Grace Stokes Professor
New York University, School of Law

Notes

FOREWORD

1. Brainerd Currie and Herma Hill Schreter, "Unconstitutional Discrimination in the Conflict of Laws: Equal Protection," 28 *U. Chi. L. Rev.* 1 (1960); Brainerd Currie and Herma Hill Schreter, "Unconstitutional Discrimination in the Conflict of Laws: Privileges and Immunities," 69 *Yale L. J.* 1323 (1960).

2. Kenneth M. Davidson, Ruth Bader Ginsburg, and Herma Hill Kay, *Sex-Based Discrimination: Texts, Cases, and Materials* (Eagan, MN: West Publishing Company, 1974).

3. Roger Cramton, David Currie, and Herma Hill Kay, *Conflict of Laws*, 2nd ed. (Eagan, MN: West Publishing Company, 1975); Herma Hill Kay, Larry Kramer, and Kermit Roosevelt, *Conflict of Laws*, 9th ed. (Eagan, MN: West Publishing Company, 2013).

4. Herma Hill Kay, "A Defense of Currie's Governmental Interest Analysis," 215 *Recueil des Cours* 9 (1989).

5. *Hisquierdo v. Hisquierdo*, 439 U.S. 572 (1979). Herma argued on behalf of the NOW Legal Defense and Education Fund as amicus curiae. Despite the excellence of her argument, the Court held that the Railroad Retirement Act of 1974 prohibits states, in dividing property upon divorce, from treating as community property a spouse's expectancy interest in pension benefits under that Act.

INTRODUCTION

1. Richard K. Neumann Jr., "Women in Legal Education: What the Statistics Show," 50 *J. Legal Educ* 50(3): 313 (2000).

2. Patricia McCormick, *Lady Bullfighter: The Autobiography of the North American Matador* (1954).

3. Joseph A. Hill, *Women in Gainful Occupations 1870 to 1920*, Department of Commerce, Bureau of the Census, Census Monographs IX (1929).

4. U.S. Census Bureau, Census 2000 EEO Data Tool, http://www.census.gov /eeo2000 [Select "Employment by Census Occupation Codes" and "Residence," then "NEXT"; select "US Total," then "NEXT"; select one or more occupation categories and "Show Detailed Race/Ethnicity Categories"; then display table].

5. The discussion in this section is taken from Herma Hill Kay, "The Future of Women Law Professors," 77 *Iowa L. Rev.* 5 (1991).

6. Barbara Babcock, *Fish Raincoats: A Woman Lawyer's Life*, 112 (2016).

CHAPTER 1. LEADING THE WAY: BARBARA NACHTRIEB ARMSTRONG

1. Interview with Martha Naylor, Boalt Hall Class of 1925, Berkeley, CA, July 20, 1990 (all quotations from Martha Naylor, except where otherwise specified, are from this interview). See Janet Ruyle, "Dean Lucy Sprague, The Partheneia, and the Arts, Ladies Blue and Gold," 1 *Chronicle of the University of California* 65 (1998).

2. Interview with Frances Newman, San Francisco, CA, April 4, 1991 (all quotations from Frances Newman, unless otherwise specified, are from this interview). Her husband, Frank Newman, thought the offer came from Cecil B. DeMille. Interviews with Frank Newman, Armstrong's colleague at Boalt Hall, Berkeley, CA, Dec. 13, 1989 and March 26, 1991 (all quotations from Frank Newman, unless otherwise specified, are from these interviews). Members of Armstrong's family confirm the offer but were unable to identify its source. Interview with Patricia Symmes, Armstrong's daughter, Santa Cruz, CA, January 14, 1991 (all quotations from Patricia Symmes, unless otherwise specified, are from this interview); interview with Howard Mel, Armstrong's nephew, Berkeley, CA, June 22, 2006 (all quotations from Howard Mel, unless otherwise specified, are from this interview).

3. Two published reports that Armstrong was Jewish, both of which appeared in the context of contrasting Berkeley's cosmopolitanism favorably with the anti-Semitism of several eastern universities, cannot be substantiated, and were a source of surprise to one member of her family, Howard Mel, who reported that there was "no indication of that from knowing her parents as a youngster" (email, September

24, 2009). The two books in which these published reports appear were both written by Berkeley professors of sociology: Robert Nisbet, *Teachers and Scholars: A Memoir of Berkeley in Depression and War* 67 (1992) (listing among the "more notable and celebrated" "Jews at Berkeley" the names of "Max Radin and also Barbara Nachtrieb Armstrong, both professors of law in Boalt Hall") and Bob Blauner, *Resisting McCarthyism: To Sign or Not to Sign California's Loyalty Oath* 17 (2009) ("In addition to [Jessica] Piexotto by the 1930s the list of eminent Jewish professors included the scholar of Roman law Max Radin, his Boalt Hall colleague Barbara Nachtrieb Armstrong, the physicist J. Robert Oppenheimer, and the distinguished anthropologist Robert Lowie.") Blauner cited no source for this statement, but in response to an inquiry wrote that he had relied on Nisbet's account (Bob Blauner to Herma Hill Kay, September 30, 2009). An inquiry from William Benemann, the Berkeley Law School Archivist, to Lara Michels, Archivist and Librarian at Berkeley's Judah L. Magnes Museum, produced the following reply: "I have checked a few places, and the only mention I found of Barbara Nachtrieb Armstrong is in a 1910 issue of the *Emanu-El* (precursor to the *Jewish Journal*). Her name appears in a posting about events at the University of California and has to do with her appearance in a student production of *Cleopatra*. . . . I don't find any other mention of the name in our collection so far. And a search of Ancestry.com leads me to believe that John Jacob Nachtrieb's father, Gottlob, was a Methodist Minister in Cincinnati. It looks like John Jacob was born in Ohio and worked as a leather importer in San Francisco. Nothing in my genealogical searches leads me to believe there is a Jewish link here, but I cannot say for sure" (email from William Benemann, Monday, October 5, 2009). One bit of negative evidence is provided by a book written by Frances Dinkelspiel, *Towers of Gold: How One Jewish Immigrant Named Isaias Hellman Created California* (2008), which provides a detailed account of Hellman and other German Jewish families who lived in San Francisco. It does not mention the Nachtriebs. This omission is certainly not conclusive, for even if the Nachtriebs had been Jewish, they were not in the same class of wealth and privilege occupied by the group discussed by Dinkelspiel, but it is suggestive.

4. Kathryn Gehrels, "Barbara Nachtrieb Armstrong: In Memoriam," 65 *California Law Review* 933, 935 (1977). Armstrong's nephew, Howard Mel, recalled that his grandmother was Irish Catholic.

5. Geraldine Joncich Clifford, " 'Equally in View': The University of California, Its Women, and the Schools," 21 in Carroll Brentano and Sheldon Rothblatt, eds., *Chapters in the History of the University of California*, No. 4 (Center for Studies in Higher Education and the Institute of Governmental Studies, UC Berkeley, 1995).

6. Ibid.

7. Mary Ann Dzuback, "Berkeley Women Economists, Public Policy, and Civil Sensibility," in Donald Warren and John J. Patrick, eds., *Civic and Moral Learning in America*, 157 (2006).

8. Ibid., 159.

9. The course, Economics 118, does not appear on her undergraduate transcript, so perhaps she audited it. It was taught by Peixotto in 1910–1911; see *University of California Register 1910–1911* 39 (UC Press, 1912). Peixotto's course, in turn, was the outgrowth of classes on charities and poor relief taught by Ernest Moore. See Mary E. Cookingham, "Social Economists and Reform: Berkeley, 1906–1961," 19 *History of Political Economy* 50 (1987).

10. "The Reminiscences of Barbara Nachtrieb Armstrong" (1969), page 2, in the Oral History Collection of Columbia University (hereafter cited as "Armstrong Reminiscences.") Quotations from the Armstrong Reminiscences are by permission of Columbia University. The interviews of Professor Armstrong were conducted by Peter A. Corning on December 19, 20, and 22, 1965, in Berkeley, CA, as part of the Social Security Administration Project.

11. Ibid.

12. Dzuback, *supra* note 7, at 155.

13. *School of Jurisprudence Announcement for 1913–1914* 8 (UC Press 1913); *School of Jurisprudence Announcement for 1914–1915* 24 (UC Press, 1914). Nachtrieb took Elementary Law, International Law, Jurisprudence and Roman Law, and School Legislation in California, which she later taught as a member of the faculty.

14. "Senior Week Festivities Open with Extravaganza," *Daily Californian*, April 28, 1913, at 1.

15. *University of California Register 1913–1914*, Part XII, Commencement 1913, 41 (UC Press, 1914).

16. John Lowrey Simpson, "Activities in a Troubled World: War, Relief, Banking and Business," an oral history conducted 1978, Regional Oral History Office, The Bancroft Library, University of California, Berkeley, 1978, p. 22.

17. Agnes Roddy Robb, "Interview History, The Women's Faculty Club," an oral history conducted in 1981, in The Women's Faculty Club, Regional Oral History Office, The Bancroft Library, University of California, Berkeley, 1983, p. 68. The University Medal was first awarded in 1871 and had been given to nine women prior to 1913.

18. Roger J. Traynor, "The Light Years of Barbara Armstrong: 1890–1976," 65 *California Law Review* 920, 925 (1977); Mary Ann Dzuback, "Armstrong, Barbara Nachtrieb" in John Garraty and Mark Carnes, eds., *American National Biography*, vol. 1, 607–9 (1999).

19. Sandra P. Epstein, *Law at Berkeley: The History of Boalt Hall* 302–3 (1979).

20. AALS: "Membership was open to schools rather than individuals, and the schools were required to meet certain minimum standards: students were to have a high school diploma, courses had to be two years long (thirty weeks a year), and students were required to have access to a library with U.S. reports

and local state reports" (Robert Stevens, *Law School: Legal Education in America From the 1850s to the 1980s* 96–97 [1983].).

21. Epstein, *supra* note 19, at 306.

22. Ibid., at 307.

23. Barbara Nachtrieb Armstrong, "The Nature and Purpose of Social Insurance," 170 *Annals* 1, 6 (1933).

24. Ibid., at 1.

25. Barbara Nachtrieb Armstrong, *Insuring the Essentials* xv (1932).

26. Ibid., at 2.

27. Epstein, *supra* note 19, at 91.

28. Ibid., at 308.

29. Dzuback, *supra* note 7, at 162. Felton was a Cal graduate in the Class of 1895. She was awarded the University Medal, but was one of three recipients who declined the honor as a matter of principle because it was too narrowly focused on grades. See Verne A. Stadtman, ed., *The Centennial Record of the University of California* (UC Press, 1968).

30. Armstrong Reminiscences, *supra* note 10, at 3.

31. Roy Lubove, *The Struggle for Social Security 1900–1935* 67 (1986).

32. Barbara Nachtrieb Grimes, "Sickness as a Cause of Poverty in California and Consideration of Social Health Insurance as a Remedy," vii (PhD dissertation, UC Berkeley Department of Economics, March 26, 1921).

33. Ibid., at viii.

34. California Social Insurance Commission, *The Causes of Poverty in California with Special Emphasis upon the Relation of Sickness to Poverty: A Consideration of Social Health Insurance as a Remedy,* 1st Biennial Report 19–123 (1917).

35. Grimes, *supra* note 32, at 145.

36. Armstrong Reminiscences, *supra* note 10, at 24.

37. Armstrong, *supra* note 25, at 4.

38. Lubove, *supra* note 31, at 82–86.

39. Ibid., at 83. Nachtrieb herself suspected that she might have inadvertently lent an aura of substance to this charge. She noted that her surname, "Nachtrieb," is a German name, and that opponents capitalized upon this to call her a socialist and to imply "that it was not beyond the bounds of reason that I was a traitor, and that if they had a traitor heading up these things . . . well!" (Armstrong Reminiscences, *supra* note 10, at 25–26).

40. Lubove, *supra* note 31, at 89.

41. Ibid.

42. Lyman Grimes had been a fellow Thespian, playing in the cast of Sophocles's *Oedipus Tyrannus*. Biographical summary from "Senior Records," *The 1915 Blue and Gold* 249 (UC Berkeley, 1914).

43. Armstrong Reminiscences, *supra* note 10, at 26.

44. She was appointed at a salary of $1,200 per year, $900 being contributed by the Economics Department, and $300 by the School of Jurisprudence (File of Barbara Armstrong, Staff Record, Card # 1, The Bancroft Library, UC Berkeley). Quoted with the permission of the archivist, William Roberts, April 3, 1991.

45. Epstein, *supra* note 19, at 77–81.

46. Ibid., at 78. Epstein also notes that one goal of the program was to encourage joint faculty appointments and course offerings between these related departments and the School of Jurisprudence.

47. *School of Jurisprudence Announcement for 1919-192*, 13 (UC Press 1919). The course, which was normally offered by Professor (and Dean) William Carey Jones, was described as "an interpretative and critical study of California school law as a resultant of social and political conditions and forces." Nachtrieb took it as part of her pre-law studies in her junior year, 1910–11. She continued to teach the course until 1925 when, two years after Jones retired, it was dropped from the curriculum.

48. Cookingham, *supra* note 9, at 47.

49. Ibid.

50. Dzuback, *supra* note 7, at 160 (noting that "[i]n the 1910s, Wheeler allowed Peixotto to seek out and appoint qualified women as assistants and lecturers").

51. Ibid., at 162.

52. The name of the faculty member who made this remark cannot be substantiated. It seems unlikely to have been uttered by a member of her committee. However, PhD final oral examinations were open to all members of the Academic Senate, so it is impossible to know who might have been present (excerpt from Action of the Academic Senate at its meeting on the March 15, 1937, bearing on revised rules in respect to the final examination for the PhD degree, section 664).

53. UC School of Jurisprudence, Minutes, Faculty Meeting of January 31, 1921 (1909–24)

54. Grimes began his career as an Assistant Attorney in the State Inheritance Tax Department, served for a time in the Army, and later became a stockbroker.

55. Ibid. The divorce judgment was entered by the Paris Tribunal on January 22, 1925 (copy of judgment on file with the author.) I am indebted to Aimé Mandel, Avocat á la Cour, LL.M. 1973, Boalt Hall, for this research.

56. See File of Barbara Armstrong, *supra* note 44. Her salary was charged $2,200 to the Department of Economics and $500 to the School of Jurisprudence.

57. Association of American Law Schools, *Directory of Teachers in Member Schools* 88 (1925). The biographical entry for Barbara mistakenly lists the date of her AB degree as 1913, instead of 1912, an error that was repeated in every subsequent entry in the *Directory*. Ibid., at 30.

58. As quoted in Epstein, *supra* note 19, at 316.

59. Interview with Babette Barton, Armstrong's student and faculty colleague at Boalt Hall, Berkeley, CA, December 13, 1989 (all quotations from Babette Barton, except where otherwise specified, are from this interview).

60. *Announcement of Courses of Instruction, Primarily for Students in Departments at Berkeley for the Academic Year 1924–25* 86–87 University of California General Catalog 1924–1925 (UC Press, 1924).

61. *School of Jurisprudence Announcement for 1925–26* 14 (UC Press, 1925)

62. Gehrels, *supra* note 4, at 935.

63. Traynor, *supra* note 18, at 925.

64. Gehrels, *supra* note 4, at 933–34.

65. Ibid.

66. Louis H. Heilbron, *Most of a Century: Law and Public Service, 1930s to 1990s,* an oral history conducted 1989–1993, Regional Oral History Office, The Bancroft Library, University of California, Berkeley, 1995, pp. 24–25.

67. George Marion Johnson, *The Making of a Liberal* 14 (Bound Manuscript 1985), cited in J. Clay Smith, Jr., *Emancipation: The Making of the Black Lawyer, 1844–1944* 38 (1993).

68. Pauli Murray, *Song in a Weary Throat: An American Pilgrimage* 262–63 (1987).

69. Armstrong, *supra* note 25, at xv.

70. Ibid., at xiii.

71. Ibid., at 560.

72. Grimes, *supra* note 32, at viii.

73. Armstrong, *supra* note 25, at 562.

74. Frances Perkins, *The Roosevelt I Knew* 182 (1946).

75. Ibid.

76. Arthur J. Altmeyer, *The Formative Years of Social Security* 9 (University of Wisconsin Press 1966).

77. Franklin D. Roosevelt, Message to the Congress Reviewing the Broad Objectives and Accomplishments of the Administration (June 8, 1934), in 3 *The Public Papers and Addresses of Franklin D. Roosevelt* 287, 291 (1938).

78. Ibid., at 291–92.

79. Executive Order 6757 (June 29, 1934).

80. Armstrong Reminiscences, *supra* note 10, at 32–34.

81. Ibid., at 30.

82. Association of American Law Schools, *Directory of Teachers in Member Schools 1934* 17–18 (1935).

83. Edwin E. Witte, *The Development of the Social Security Act* 12–20 (1962).

84. Perkins, *supra* note 74, at 286–96.

85. See Barbara Nachtrieb Armstrong, "The Federal Social Security Act and Its Constitutional Aspects," 24 *Cal. L. Rev.* 247 (1936); Charles Denby, Jr., "The

Case Against the Constitutionality of the Social Security Act," 3 *Law & Contemp. Probs.* 315 (1936); Roger Sherman Hoar, "By-Products of the Social Security Decisions," 21 *Marq. L. Rev.* 215 (1937); Harry Shulman, "The Case for the Constitutionality of the Social Security Act," 3 *Law & Contemp. Probs.* 298 (1936).

86. Witte, *supra* note 83, at 12–13.

87. Wisconsin: Lubove, *supra* note 31, at 169. Armstrong's view: Armstrong Reminiscences, *supra* note 10, at 40–42. Professor Douglas also favored a national program over the Wisconsin federal-state plan; see Paul H. Douglas, *Social Security in the United States* 33–35 (2nd ed., 1939). The Armstrong memorandum itself appears to have been lost.

88. Ibid., at 51.

89. Armstrong, *supra* note 25, at 548 ("Every other country of the world of any industrial importance has abandoned as impossible the policy of leaving to the localities unaided by national assistance, the burden of unemployment.")

90. Armstrong Reminiscences, *supra* note 10, at 72–73.

91. Witte, *supra* note 83, at 37–38.

92. Ibid., at 38, note 27.

93. Armstrong Reminiscences, *supra* note 10, at 31.

94. Ibid., at 70.

95. Ibid., at 46.

96. Ibid., at 74–76.

97. Ibid., at 95–98. Once she received the letter, Armstrong "had three copies made, and then I felt secure. I put them in three different places" (96).

98. Ibid., at 102.

99. Howard Mel further reported that, years later after Barbara's death, this young aide, who in the interim had become a Cabinet Secretary, sought his permission as a member of her family to consult her oral history as part of his research.

100. Armstrong Reminiscences, *supra* note 10, at 111.

101. Ibid.

102. Title II, 49 Stat. 622 (1935), 42 U.S.C.A. §§ 401–401a (1935 Supp.); Title VIII, 49 Stat. 636 (1935), 42 U.S.C.A. §§ 10001–1011 (1935 Supp.).

103. Title IX, 49 Stat. 639 (1945), 42 U.S.C.A. §§ 1101–1110 (1935 Supp.); Title III, 49 Stat. 626 (1935), 42 U.S.C.A. §§ 501–503 (1935 Supp.).

104. Armstrong, *supra* note 85, at 247, 252.

105. Armstrong Reminiscences, *supra* note 10, at 168.

106. Ibid., at 167.

107. Perkins, *supra* note 74, at 301.

108. Ibid., at 12.

109. See Barbara Armstrong File, *supra* note 44; UC School of Jurisprudence Minutes, *supra* note 53.

110. Epstein, *supra* note 19, at 318.

111. Richard C. Dinkelspiel, "Barbara Nachtrieb Armstrong—In Memoriam," 65 *California Law Review* 932 (1977).

112. Ibid.

113. Douglas, *supra* note 87, at 68.

114. Barbara Nachtrieb Armstrong, *The Health Insurance Doctor: His Role in Great Britain, Denmark, and France* (1939).

115. Ibid., at viii.

116. Ibid., at 252–53.

117. Ibid., at 255–56.

118. Emily H. Huntington, "A Career in Consumer Economics and Social Insurance," an oral history conducted 1969–1970, Regional Oral History Office, The Bancroft Library, University of California, Berkeley, 1971, p. 51.

119. Ibid.

120. Ibid., at 55.

121. Ibid., at 57–58. Compare Professor Douglas's list of the points that need to be included in a program of health insurance, found in Douglas, *supra* note 87, at 238–39.

122. Ibid., at 58.

123. Ibid.

124. A.B. 449 and A.B. 863

125. Huntington Oral History, *supra* note 118, at 60.

126. Armstrong Reminiscences, *supra* note 10, at 293–317.

127. Gehrels, *supra* note 4, at 935.

128. Ibid.

129. Epstein, *supra* note 19, at 181.

130. Ibid., at 182.

131. Epstein, *supra* note 19, at 193–96.

132. Ibid., at 188–92.

133. Clark Kerr, *The Gold and the Blue: Volume Two, Political Turmoil* 29 (2003).

134. Ibid., at 30–31.

135. Ibid.

136. Ibid., at 31–32. The date was later advanced to June 30, 1950.

137. Ibid., at 32.

138. Ibid. The vote was 724 to 203 in the Northern Division of the Academic Senate and 301 to 65 in the Southern Division.

139. Epstein, *supra* note19, at 210–11.

140. Kerr, *supra* note 133, at 33.

141. See *Tolman v. Underhill*, 39 Cal.2d 708 (1952).

142. Interview with Richard W. Jennings, Professor of Law, University of California, Berkeley, in Berkeley, California, Nov. 8, 1990. Unless another source is cited, all quotations from Professor Jennings are from this interview.

143. Gehrels, *supra* note 4, at 934, 936.

144. See Barbara Armstrong File, *supra* note 44.

145. Letter from Dean William L. Prosser to Chancellor Clark Kerr, November 5, 1953 (File of Barbara Nachtrieb Armstrong, Bancroft Library, University of California, Berkeley). Quoted with permission of the archivist, William Roberts, April 3, 1991.

146. Ibid.

147. "U.C. Professor's Husband Ends Life with Gun," *Oakland Tribune*, November 17, 1953, at 6.

148. Letter from Dean William L. Prosser to Chancellor Clark Kerr, October 5, 1956 (File of Barbara Nachtrieb Armstrong, Bancroft Library, University of California, Berkeley.) Quoted with permission of the archivist, William Roberts, April 3, 1991.

149. Ibid.

150. Quoted in "Dedication," 65 *California Law Review* (preceding page 920) (1977).

151. See also "Herma Hill Kay, Professor, 1960–Present, and Dean, 1992–2000," Boalt Hall School of Law, University of California, Berkeley, an oral history conducted 2003, Regional Oral History Office, The Bancroft Library, University of California, Berkeley, 2005, at 44 (narrating this story in slightly different words).

CHAPTER 2. ARMSTRONG'S PRE-WORLD WAR II CONTEMPORARIES: HARRIET SPILLER DAGGETT AND MARGARET HARRIS AMSLER

1. Frances L. Landry, "Harriet S. Daggett," 1 (Address on the Occasion of the Presentation of an Oil Portrait of Harriet Spiller Daggett by the LSU Law School Alumni Association, June 30, 1956) (copy on file with the author).

2. Edward W. Stagg, "Harriet Daggett Knows Meaning of Family Law," *New Orleans Item*, February 18, 1948.

3. At the time she graduated from the Louisiana State Normal School, it was not yet a four-year college. See 14 *Encyclopædia Britannica, Louisiana*, 428A (1963).

4. Ibid. Professor Ira Samuel Flory, who joined the LSU faculty in 1912, left to practice law in New York in 1917, then returned to the faculty in 1919, was being paid $4,000 as a full professor in 1923 after complaining about his pay. See W. Lee Hargrave, *LSU Law: The Louisiana State University Law School From 1906 to 1977*, 28, 51 (2004).

5. See Stagg, *supra* note 2.

6. Harriet Spiller Daggett, Record of Employment at LSU. (School of Law Personnel File) (quoted with permission of Professor Katherine Shaw Spaht, December 4, 1989). Daggett was paid $4,500 in 1935, $5,200 in 1937, and $ 5,500 in 1938.

7. Unlike LSU, however, Berkeley equated both the Associate and Full Professor titles with indefinite academic tenure. Armstrong was therefore the first tenured woman law professor in the nation.

8. Ibid., at 47.

9. Coleman Warner, "Academic Games," *The Times-Picayune*, January 4, 2004, at 1.

10. Harriet Spiller Daggett, *Mineral Rights in Louisiana* (1939).

11. Landry was pressed into service during World War II to teach corporations, agency, and partnership. Hargrave, *supra* note 4, at 114.

12. Susan B. Carter et al., *Historical Statistics of the United States* Table Aa832–1033: Population of Cities with at least 100,000 Population in 1990: 1790–1990 (2006).

13. See Cleanth Brooks and Robert Penn Warren, "History of the Southern Review," in *An Anthology of Stories from the Southern Review* xi–xvi (1953).

14. *See* "Resolution of the Law Faculty of Louisiana State University, Honoring Professor Harriet Spiller Daggett in Connection with Her Retirement," 21 *La. L. Rev.* 687, 691–696 (1961) (Bibliography of Publications of Harriet S. Daggett—1929–1961).

15. Harriet S. Daggett, *The Community Property System of Louisiana with Comparative Studies* ix (1931). The book had a second printing in 1945.

16. Hargrave, *supra* note 4, at 56–57.

17. Daggett, *supra* note 15, at xi (Robert Lee Tullis, *Foreword*).

18. Resolution of the Board of Supervisors, "In Memoriam: Harriett Spiller Daggett, 1891–1966," 27 *La. L. Rev.* 1, 2 (1966).

19. Ibid., at 1–3.

20. Ibid., at 205–6.

21. Ibid., at 200–1.

22. Acts 1979, No. 709, § 1, eff. Jan. 1, 1980. See Katherine S. Spaht, "Community Property Symposium: Background of Matrimonial Regimes Revision," 39 *Louisiana L. Rev.* 323, 343–45 (1979). Since another of the early women law professors—Janet Mary Riley of Loyola, New Orleans—played a prominent role in this Revision, further elaboration of its provisions will be deferred to chapter 4.

23. Daggett, *supra* note 15. The book contains text and two appendices, one on legislative acts and the other on forms. A second edition appeared in 1949.

24. Ibid., at xxxiii.

25. Ibid., at vii.

26. Ibid., at xxxiii–xxxv.

27. Resolution of the Law Faculty, *supra* note 14, at 689.

28. Harriet Spiller Daggett, ed., *Official Proceedings of Fourth Annual Mineral Law Institute* (1956). Daggett edited another edition in 1957 and was co-editor in 1958.

29. Harriet Spiller Daggett, *Louisiana Privileges and Chattel Mortgages*, Preface, vii (1942).

30. Ibid. She identified the practitioner as Mr. J. O. Modisette of Jennings, Louisiana.

31. John B. Fournet, "A Tribute to Dr. Harriet Spiller Daggett," 1–2 (June 30, 1956). Copy on file with the author. I am grateful to Professor Katherine Spaht for providing me with a typed copy of this speech.

32. Kathryn Venturatos Lorio, "The Louisiana Civil Law Tradition: Archaic or Prophetic in the Twenty-First Century?" 63 *Louisiana L. Rev.* 1, 6–7 (2002).

33. Ibid., at 5–6, discussing Daggett, Dainow, Hebert, McMahon, "A Reappraisal Appraised: A Brief for the Civil Law of Louisiana" 12 *Tulane L. Rev.* 12 (1937).

34. Resolution of the Law Faculty, *supra* note 14, at 689.

35. *Sweatt v. Painter*, 339 U.S. 629 (1950), *rehearing denied* 340 U.S. 846 (1950).

36. The brief was published in Thomas I. Emerson et al., "Segregation and the Equal Protection Clause: Brief for the Committee of Law Teachers Against Segregation in Legal Education," 34 *Minn. L. Rev.* 289 (1950). See also Paul D. Carrington, "One Law: The Role of Legal Education in the Opening of the Legal Profession Since 1776," 44 *Fla. L. Rev.* 501, 557 (1992) (citing the Committee's brief and observing that *Sweatt* "was, among other more important things, a victory for the Association.")

37. Association of American Law Schools, *1951 Proceedings*, Part One, 18 (Friday Morning Session, December 28, 1951).

38. Ibid., at 22–23.

39. Ibid., at 28–30. All four Texas schools voted against the Yale Resolution.

40. Ibid., at 41–42.

41. Ibid., at 42–45. Of the Texas schools, only St Mary's voted in favor of the Committee's proposal.

42. Paul M. Hebert, "In Memoriam, Henry George McMahon 1900–1966," 27 *Louisiana L. Rev.* 162, 167 (1967).

43. Wallach, *supra* note 18, at 7.

44. Oral Memoirs of Margaret Amsler (1972), p. 1, in the Baylor University Project of the Baylor University Program for Oral History. Hereafter cited as "Amsler Memoirs." Quotations from the Amsler Memoirs are by permission of

Baylor University. The interviews of Professor Amsler were conducted by Lista Kay Beazley on October 26, 1972, November 9, 1972, and December 7, 1972, at Professor Amsler's home in McGregor, Texas.

45. Ibid., at 2–5.

46. Ibid., at 6.

47. Ibid., at 29.

48. Ibid., at 136–37.

49. Interviews with Margaret Harris Amsler, McGregor, Texas, June 7–8, 1990. Unless another source is specified, all biographical material and quotations from Margaret Harris Amsler are from these interviews.

50. *ABA-AALS Official Guide to ABA-Approved U.S. Law Schools,* Baylor University School of Law, 108 (ABA, 2000).

51. Amsler Memoirs, *supra* note 45, at 6.

52. Ibid., at 14, 57.

53. Ibid., at 66. They were married in October 1933. She added that "He had been a student at Cambridge, in England. . . . He was raised by an aunt in Italy, and he fought in World War I as an aviator."

54. Ibid., at 92.

55. Ibid., at 61.

56. See Dean Angus S. McSwain, Jr., "Dedication: From Her Colleagues", 24 *Baylor L. Rev.* 179, 181 (1972); Baylor University Law School Graduation Program, 1937. The other two honors students who graduated with honors were Craven W. Beard and Leonard L. Gorin. I am grateful to Mr. Gorin for providing me with a copy of the program.

57. Barbara Bader Aldave, *Women in the Law in Texas: The Stories of Three Pioneers,* 25 *St. Mary's L.J.* 289, 297 (1993). In Texas, a community property state, a divorce was necessary to terminate a spouse's right to one-half of the other spouse's earnings.

58. Amsler Memoirs, *supra* note 45, at 67.

59. Ibid., at 77.

60. Ibid., at 81.

61. Ibid., at 94.

62. Ibid., at 86.

63. Interview with Dean Charles Barrow, Waco, TX, June 6, 1990. Unless another source is cited, all quotations from Dean Barrow are from this interview.

64. Amsler Memoirs, *supra* note 45, at 34–35.

65. *The Handbook of Texas Online,* http://www.tshaonline.org/handbook/online/articles/MM/hgm4.html.

66. General Assembly, President's Award, 24 *Texas Bar Journal* 738, 740 (August 22, 1961).

67. Paul Carrington, "The History of the Proposed Texas Business Corporation Act," 4 *Baylor L. Rev.* 428, 437 (1952), quoting a resolution adopted by the Texas State Bar at its 1952 Convention.

68. Margaret H. Amsler, "Organic Changes in the Corporation: Amendment, Merger and Consolidation, Sale of Assets," 4 *Baylor L. Rev.* 449, 449 (1952).

69. Amsler Memoirs, *supra* note 45, at 96–97.

70. *See* Margaret V. Sachs, "Women in Corporate Law Teaching: A Tale of Two Generations," 65 *Maryland L. Rev.* 666, 674–75 (2006). See also Margaret H. Amsler, "The Status of Married Women in the Texas Business Association," 43 *Texas L. Rev.* 669, 678 (1965).

71. See 19 *Texas Bar Journal* 283 (May, 1956); Amsler Memoirs, *supra* note 45, at 97.

72. Ibid., at 98.

73. Ibid.

74. Ibid., at 99.

75. Margaret H. Amsler, "Amendments to Corporation Acts," 24 *Texas Bar Journal* 821 (1961).

76. Amsler Memoirs, *supra* note 45, at 100.

77. Denounced: see Hermine D. Tobolowsky, "Referendum: For Equal Rights Amendment," 26 *Texas Bar Journal* 1004 (Dec. 22, 1963).

78. Margaret H. Amsler, "The New Married Women's Statutes: Meaning and Effect," 15 *Baylor L. Rev.* 154, 154 (1963).

79. Ibid.

80. Ibid., at 146–48.

81. Tobolowsky, *supra* note 78, at 1004, 1075.

82. Tex. Const. art I, § 3a (1972) ("Equality under the law shall not be denied or abridged because of sex, race, color, or national origin. This amendment is self-operative.").

83. Amsler Memoirs, *supra* note 45, at 112–13 (quoting from the Proclamation which established the Commission).

84. Ibid., at 110, 112.

85. Interview with Angus McSwain, Waco, TX, June 6, 1990. Unless another source is cited, all quotations from Angus McSwain are from this interview.

86. McSwain, *supra* note 57, at 181.

87. H. Wayne Meacham and Glenn Sodd, "Dedication: From Her Students," 24 *Baylor L. Rev.* 182, 182–83 (1972).

88. See Francine Parker, "Texas Law Breaker," *Waco Tribune-Herald*, October 7, 1987, at 1B.

89. 1987 Texas Women's Hall of Fame, Awards Program, November 12, 1987.

90. Telephone conversation with Rikki Amsler, McGregor, TX, May 19, 2002.

91. Nancy Cott, *The Grounding of Modern Feminism* 232 (1987), as cited in Mary Jane Mossman, *The First Women Lawyers* 52–53 (2006).

92. Letter from Jean Craighead Shaw to Herma Hill Kay, n.d.

93. Amsler Memoirs, *supra* note 45, at 34.

94. Mossman, *supra* note 92, at 216.

CHAPTER 3. THE CZARINA OF LEGAL EDUCATION: SOIA MENTSCHIKOFF

1. Connie Bruck, "The First Woman Everything," *The American Lawyer* 32, 36 (October 1982).

2. Ibid., at 33.

3. E. Allan Farnsworth, "Soia Mentschikoff as Reformer," 16 *U. Miami Inter-Am L. Rev.* 1, 1 (1984) (quoting her *New York Times* obituary). Bruck, *supra* note 1, at 37, suggests that the term was also used by some Miami faculty who found her style of governance "autocratic."

4. George Volsky, "Soia Mentschikoff, Professor and Ex-Law Dean, Dies at 69," *The New York Times*, June 19, 1984, at 18; Betsy Covington Smith, "Soia Mentschikoff," in *Breakthrough: Women in Law*, 79, 81 (1984).

5. Zipporah Batshaw Wiseman, "Soia Mentschikoff (1915–1984)" in *Women in Law: A Bio-Bibliographical Sourcebook* 171, 171 (Rebecca Mae Salokar and Mary L. Volcansek, eds.) (1996).

6. Smith, *supra* note 4, at 82.

7. "Hunter Classes Elect," *New York Times*, October 7, 1932, at 3 (President of Junior Class); "Hunter Student Leader Presented," *New York Times*, May 18, 1933, at 22 (President of Hunter College Student Self-Government Association); "Hunter Beats N.Y.U. at Basketball, 20–14; Misses Perlmutter and Novotny Set Pace," *New York Times*, March 4, 1933, at 17 (includes picture of team, showing Soia Mentschikoff in front row).

8. Robert Stevens, *Law School: Legal Education in America from the 1850s to the 1980s*, 23, 36 (1983).

9. Barbara Aronstein Black, "Something to Remember, Something to Celebrate: Women at Columbia Law School," 102 *Columb. L. Rev.* 1451 (2002); David W. Leebron, "In Commemoration: The 75th Anniversary of Women at Columbia Law School," 102 *Colum. L. Rev.* 1439 (2002).

10. Barbara Aronstein Black, "Remarks from the 75th Anniversary Luncheon," 12 *Columb. J. Gender & L.* 313, 314 (2003).

11. Columbia University, *Announcements of the School of Law for the Winter and Spring Sessions, 1935–1936*, 53–57 (1936). Two of the four remaining women graduated from Cornell, and one each from Michigan and Pennsylvania State. By the time the Class of 1937 had reached its third year, it was comprised of 170 students, thirteen of whom were women, including twelve who had entered as 1Ls in 1934; see Columbia University, *Announcements of the School of*

Law for the Winter and Spring Sessions, 1937–1938, 46–48 (1938). I am grateful to Sabrina Sondhi, Special Collections Librarian of the Arthur W. Diamond Law Library, Columbia University, for providing the student lists. I am responsible for the count.

12. Smith, *supra* note 4, at 85.

13. Robert Whitman, "Soia Mentschikoff and Karl Llewellyn: Moving Together to the University of Chicago Law School," 24 *Conn. L. Rev.* 1119, 1126 & n. 26 (1992).

14. Ibid.

15. Soia Mentschikoff, "Reflections of a Drafter,"43 *Ohio St. L. J.* 537, 537–38 (1982).

16. Ibid.

17. N. E. H. Hull, "Back to the "Future of the Institute: William Draper Lewis's Vision of the ALI's Mission During Its First Twenty-Five Years and the Implications for the Institute's Seventy-Fifth Anniversary," 142. See "The American Law Institute Seventy-Fifth Anniversary 1923-1998" (1998), reporting that "[a] grant from the Maurice and Laura Falk Foundation of Pittsburgh and other sources funded the ALI's participation."

18. Ibid., at 538.

19. Erwin O. Smigel, in *The Wall Street Lawyer: Professional Organization Man*, 46 (1964) counts eighteen women lawyers in Wall Street firms, including only one partner, in 1956; Cynthia Fuchs Epstein, in *Women in Law* 176, 179 (2nd ed., 1993), surveys the same Wall Street firms in 1968, identifies only three women partners, and estimates that a total of forty women lawyers were working on Wall Street or had some Wall Street experience.

20. William Twining, "The Karl Llewellyn Papers 3 (Summary of Main Events in the Life of Karl N. Llewellyn)," University of Chicago Law School, 1968.

21. Connolly, Pschirrer, and Whitman, "Alcoholism and Angst in the Life and Work of Karl Llewellyn," 24 *Ohio N.U.L.* 43 (1998) (Appendix IV).

22. Wiseman, *supra* note 5, at 173 (citing the marriage announcement from Soia's parents). Professor Myres McDougal of Yale, who had known both Karl and Emma during the 1930s and considered Emma to be a "very close friend of mine," met Soia at Columbia while visiting there during the summer of 1937 and "sensed what was going on" between Soia and Karl. He added, "I resented Soia from the time I first saw her, because I didn't want to see Emma upset. But I later knew Soia when she was Karl's wife in Chicago, and I could see that she made Karl very happy. So my resentment of her became a little less as time went on." Interview with Professor Myres McDougal, New Haven, CT, April 8, 1991. All quotations from Professor McDougal, unless otherwise specified, are from this interview.

23. Herma Hill Kay, "Legal and Social Impediments to Dual Career Marriages," 12 *U.C. Davis L. Rev.* 207, 210 (1979) (noting that Brigitte and

Edgar Bodenheimer, who were married in 1935, were legal education's first dual career couple, and taught together both at Utah and the University of California, Davis).

24. Griswold also stated in conversation with Herma Hill Kay that during these meetings, "Soia was the only woman in the room." This recollection is confirmed by the records of both organizations. NCCUSL's first woman Commissioner, Margaret Young of Montana, served from 1923 through 1942, but she did not attend either of the annual meetings in 1941 or 1942. (I am grateful to John Sebert, NCCUSL's Executive Director and to Katie Robinson, the ULC Communications Officer, for providing this information to me on June 28, 2010). Soia herself was elected to membership in the ALI in 1946, but she never became a member of the Council. Shirley Hufstedler of Los Angeles was the first woman elected to the Council, in 1974.

25. Letter from Dean Erwin N. Griswold to Herma Hill Kay, June 28, 1991 (original on file). Footnote 1 reads: "She was, as you know, appointed three and a half years before the Harvard Corporation authorized us to admit women as students. She was appointed on the strong recommendation of members of the faculty, who had worked with her on the A.L.I.'s Commercial Code project."

26. Mary Elizabeth Basile, "False Starts: Harvard Law School's Efforts Toward Integrating Women into the Faculty, 1928–1981," *Harvard J. L. & Gender* 143, 149 (2005), notes that "[t]he media made much hoopla about the fact that an attractive woman in her early thirties would be occupying the chair once held by Samuel Williston" and observes that "[r]eporters were struck by Mentschikoff's height as well as her deep voice, which was likened to that of Marlene Dietrich and Lauren Bacall."

27. Norma Lee Browning, "Woman Invades Harvard: The Better Half," *Chicago Daily Tribune*, April 27, 1947, at G2. Soia did, however, suggest that "colleges and universities could do a great deal more to interest women in law, both as a profession and as a science applied to everyday living, by including in their regular curriculum a preliminary law course designed especially for women and covering such subjects as wills, estates, taxes, and some courtroom procedures."

28. Interview with B. W. Nimkin, New York, NY, December 5, 1990. All quotations from Mr. Nimkin, unless otherwise specified, are from this interview.

29. Ibid, at 4.

30. Griswold letter of June 28, 1991, *supra* note 25. Dean Griswold was mistaken about the date of Soia and Karl's marriage: it had occurred in 1946, not during the year Karl visited at Harvard.

31. Whitman, *supra* note 13, at 1125, n. 22, citing William L. Twining, *Karl Llewellyn and the Realist Movement* 109 (1973).

32. Letter from Dean Erwin N. Griswold to Herma Hill Kay, November 11, 1992 (original on file).

33. Bruck, *supra* note 1, at 36.

34. Interview with Professor Walter Blum, Chicago, IL, August 6, 1990. All quotations from Professor Blum, unless otherwise specified, are from this interview.

35. Interview with Jean Allard, of Sonneschein, Nath & Rosenthal, Chicago, IL, August 5, 1990. All quotations from Mrs. Allard, unless otherwise specified, are from this interview.

36. Interview with Professor Mary Ann Glendon, Cambridge, MA, March 2, 1992. All quotations from Professor Glendon, unless otherwise specified, are from this interview.

37. Herma Hill Kay, "Celebrating Early Women Law Students and Law Professors," 107, 113–14 in *Pioneering Women Lawyers: From Kate Stoneman to the Present* (Patricia E. Salkin, ed.) (2008); interview with Lillian Kraemer, New York City, December 4, 1989. See also Bruck, *supra* note 1, at 32, recounting a similar version of this story also told to her by Lillian Kraemer.

38. Interview with Professor Martha Field, Cambridge, MA, February 26, 1991. All quotations from Professor Field, unless otherwise specified, are from this interview.

39. Edward H. Levi, "Remarks," 1–2 (dated May 29, 1984). The remarks were actually delivered on April 12, 1980 in Miami. I am grateful to Dean Geoffrey R. Stone of the University of Chicago Law School for providing me with a copy.

40. Soia Mentschikoff, *Commercial Transactions: Cases and Materials* (Permanent Edition, 1970). A Temporary Edition had appeared in 1968.

41. Mentschikoff, *supra* note 15, at 541–42.

42. Irwin P. Stotzky, "Soia Mentschikoff 1915–1984," *1985 Proceedings: Annual Meeting, Financial Report, and Other Association Information* 169–72 (AALS, 1985).

43. Bruck, *supra* note 1, at 33.

44. Robert Braucher, The Legislative History of the Uniform Commercial Code, 58 *Colum. L. Rev.* 798 (1958).

45. Letter from Provost Gerhard Casper to Herma Hill Kay, December 13, 1989.

46. Interview with Professor Michael H. Cardozo, San Antonio, TX, January 1, 1992. All quotations from Professor Cardozo, except where otherwise specified, are based on this interview.

47. Bulletin, School of Law, University of Miami, 10 (1969–70); Ibid., 11 (1970–71); Ibid., 17 (1971–72) (also noting under "publications and distinctions" of the faculty that Mentschikoff had been a "Visiting Distinguished Professor" there since 1967); Ibid., 18 (1972–73).

48. Remarks of President-Elect Soia Mentschikoff, Second House of Representatives Meeting, December 29, 1973, 1973 AALS Proceedings 97–98 (1973).

49. Letter from Vice-President Delmar Karlen to Soia Mentschikoff, October 18, 1973 (Mentschikoff Papers, Box 57A, # 32).

50. Letter from Soia Mentschikoff to Mr. Delmar Karlen, October 30, 1973 (Mentschikoff Papers, Box 57A, # 32).

51. See chapter 4, *infra*.

52. Interview with Professor Daniel Murray, Coral Gables, FL, January 17, 1991. All quotations from Professor Murray, except where otherwise specified, are from this interview.

53. C. D. Rogers, "Soia Mentschikoff: The Legend and the Legacy," 39 *The Barrister* 3 (May 1981).

54. Soia Mentschikoff, "On Building a Tower of Excellence," 3 *Veritas* (April 14, 1980) (excerpt from a presentation to the University of Miami Board of Trustees, March 26, 1980).

55. Smith's and Massey's careers are discussed in chapter 4, *infra*.

56. 1974 AALS Directory of Law Teachers 46 (1974). Four of the lecturers, who had taught in the Legal Writing Program, were not renewed, and the two adjunct professors, both research professors, one of the emeritus professors, and one of the assistant professors had gone.

57. Special Committees, 1969 AALS Proceedings (pt. 2) 261.

58. Donna Fossum, "Women Law Professors," 1980 *A.B.F. Research J.* 903, 914.

59. Interview with Professor Rhonda Rivera, Columbus, OH, August 28, 1990. All quotations from Professor Rivera, unless otherwise specified, are from this interview.

60. Herma Hill Kay, "Women Law School Deans: A Different Breed, or Just One of the Boys?" 14 *Yale J. L. & Fem.* 219, 240–41 (2002). The first three were Miriam Theresa Rooney of Seton Hall, whose career is discussed in chapter 4, *infra*; Patricia Roberts Harris of Howard, who served only for one month in February, 1969; and Dorothy Wright Nelson of USC, whose career is discussed in chapter 5, *infra*.

61. Ibid., at 232–33.

62. Stotzky, *supra* note 42, at 171.

63. Interview with Professor Peter D. Lederer, New York, NY, n.d. [c. 1988]. All quotations from Professor Lederer, unless otherwise specified, are from this interview.

64. Interview with Mr. Chesterfield Smith, Coral Gables, FL, November 29, 2000. All quotations from Mr. Smith, unless otherwise specified, are from this interview.

65. Stotzky, *supra* note 42.

66. George Stein, "UM Law Czarina Stepping Down from Her Throne," *The Miami Herald*, Living Today, Section B, May 11, 1982, at p. 2B.

67. Ibid., at p. 1B.

68. Interview with Dean Mary Doyle, Coral Gables, FL, January 23, 1991. All quotations from Dean Doyle, unless otherwise specified, are from this interview.

69. Rose Allegato, "Law School Dean Retiring After String of Firsts," *The Miami Herald,* Oct. 19, 1979, noting that although she "plans to retire in the spring, Mentschikoff will stay until the school finds a new dean."

70. Stotzky, *supra* note 42, at 172.

71. Chief Justice Warren E. Burger, "Tribute to Soia Dean Mentschikoff," 37 *U. Miami L. Rev. ix* (May-September 1983).

72. Richard A. Hausler, "Dedication," 37 *U. Miami L. Rev., xi* (September 1983).

73. "Boston College Grads Hear Legal Educator," *The Pilot,* May 24, 1974.

74. Lucille Preuss, "BPW Urges Woman on High Court," *The Los Angeles Times,* April 27, 1967, at D7 (to fill vacancy created by retirement of Justice Tom C. Clark). Fred P. Graham, "Nixon Problem: Woman Justice?" *The New York Times,* September 24, 1971, at 20 (to fill vacancy created by retirement of Justice John M. Harlan). Nicholas M. Horrock, "Ford is 'Actively' Considering a Woman to Fill Douglas Seat," *International Herald Tribune,* November 14, 1975 (to fill vacancy created by retirement of Justice William O. Douglas).

75. Marilyn A. Moore, "Retiring Law Dean Leaves a Legend in U-M's Time," *The Miami News,* January 28, 1982, at 11A.

76. Lillian Kraemer, Remarks on the Occasion of the Unveiling of the Portrait of Soia Mentschikoff at the University of Chicago Law School, May 12, 1990. I am grateful to Assistant Dean Holly Davis for providing me with a copy of these remarks. Another account of the unveiling is found in "Dedication," 37 *The Law School Record* 38 (Spring 1991).

77. Mary Ann Glendon, Remarks on the Dedication of a Portrait of Soia Mentschikoff, March 12, 1991, Ames Courtroom. I am grateful to Professor Glendon for making these remarks available to me.

78. Stotzky, *supra* note 42, at 170.

CHAPTER 4. FROM THE LIBRARY TO THE FACULTY:
FIVE WOMEN WHO CHANGED CAREERS: MIRIAM
THERESA ROONEY, JEANETTE OZANNE SMITH,
JANET MARY RILEY, HELEN ELSIE STEINBINDER,
AND MARIA MINNETTE MASSEY

1. Laura N. Gasaway, "Women as Directors of Academic Law Libraries," in *Law Librarianship: Historical Perspectives* (Laura N. Gasaway & Michael G. Chiorazzi, eds.) 497, 500 (1996).

2. Marion Paris, "Library School Closings: The Need for Action," 61 *The Library Quarterly* 259 (1991). See also text *infra* at notes 502-10.

3. Gasaway, *supra* note 1, at 501 (list includes non-AALS member schools, but none of these schools had Law Library Directors). The number of women

staff law librarians must have been much larger, since the first edition of the *Biographical Directory of Law Librarians* (AALL, 1964) contained 553 listings. The 1964 *Directory* and its 1966 *Supplement* contained a total of 741 listings: 380 women; 352 men; and 9 Asian names that have not been classified by sex). (I am grateful to Margaret Leary, Director of the Michigan Law Library, for providing me with this breakdown by sex.)

4. Ibid., at 500. Margaret Klingelsmith was the director of the Biddle Law Library at Pennsylvania (ibid., at 513), while Lucy D. Waterman was at New York Law School (*The Library Journal*, July, 1998, at 301). I am grateful to Camille Broussard, the Law Library Director of New York Law School, for providing the information about Lucy Waterman's appointment to me.

5. Ginny Irving, "The Boalt Law Library: 100 Years," *The Boalt Hall Transcript* 4, 5 (Spring 1995).

6. Gasaway, *supra* note 1, at 500, noting that, as of 1995, the last year included in her study, women had not regained the high-water mark set in 1940. Professor Gasaway updated her study in 2008, and reported that although women directors outnumbered men directors by 93 to 86, the percentage of law library directorships held by women was only 47.4 percent of the total because there were 12 vacancies in the 196 positions in ABA-approved law schools (email from Laura N. Gasaway to Herma Hill Kay, February 3, 2008).

7. Gasaway, *supra* note 1, at 501.

8. Ibid., at 505, citing Miles O. Price, "The Law School Librarian's Educational Qualifications: A Statistical Study," 10 *J. Legal Educ.* 222 (1957).

9. Gasaway, *supra* note 1, at 505, citing a 1936 survey of academic law librarians for the proposition that only 5 percent held both degrees at that time; ibid., at 506. Of the six without both degrees, five were women.

10. *A Review of Legal Education in the United States Fall 1986: Law Schools and Bar Admission Requirements,* 1987 A.B.A. Section of Legal Educ. and Admissions to the Bar 66.

11. Ibid., at 508–12. See also M. Minnette Massey, "Law School Administration and the Law Librarian," 10 *Journal of Legal Education* 215, 219 (1957), reporting that "among the twenty-nine law librarians with faculty status, the average salary is $1,100 below that of the law teachers" and "not one" of the nine who received salaries in excess of $9000 "is a woman"; Christine A. Brock, "Law Libraries and Librarians: A Revisionist History; or More Than You Ever Wanted to Know," 67 *Law Library Journal* 325 (1974), reprinted in Laura N. Gasaway & Michael G. Chlorazzi, *Law Librarianship: Historical Perspectives* 597, 619–21 (1996).

12. Massey, *supra* note 11, at 219–20.

13. Laura N. Gasaway, "The American Association of Law Libraries: The People, the Profession and Their Association," in *Law Librarianship: Historical Perspectives* (Laura N. Gasaway & Michael G. Chiorazzi, eds.) 289, 291–92 (1996).

The twenty-three founders included one woman, Margaret C. Klingelsmith, law librarian at the University of Pennsylvania; see also AALL website at http://www.aall.org/about/chronology.asp.

14. Francis B. Risch, Registrar, Department of Health, Township of Livingston, New Jersey (June 25, 2004); Social Security Death Index, *Miriam Rooney Individual Record* (September 30, 2000). I am grateful to Boalt Law Librarian Debbie Kearney for obtaining this information.

15. This information about Rooney's family and the reason for her name change were provided by Professor Michael Risinger, Seton Hall Law School (email from Professor Risinger to Patricia Cain, September 30, 2020). Professor Risinger is working on a full-length biography of Dean Rooney. For additional information about Rooney, as well as about other early women in the legal academy, see D. Michael Risinger, "Female Law Librarians as Pioneer Women Law Professors: A (Belated) Response to Dean Kay, with Some Suggested Additions to Her Canonical List," 112 *Law Library Journal* (forthcoming) and available on SSRN.

16. Email to Herma Hill Kay from Mr. Robert Budak, Registrar of the Boston Latin Academy, November 4, 2008; email to Herma Hill Kay from Mr. Richard McElroy, Archivist for Special Collections, Massachusetts College of Art and Design, July 17, 2009. I am grateful to Mr. Budak and Mr. McElroy for providing me with this information.

17. "Miriam Theresa Rooney," *The American Catholic Who's Who 1948–49* (Vol. 8, p. 392); Boston Public Schools Website, *Notable High School Graduates of the Boston Latin Academy (Girls' Latin School)*, http://boston.k12.ma.us/bps/alumni_latinacad.asp (last visited February 23, 2008).

18. Portia Law School Evening Division, Thirteenth Year, 1920–21, at p. 32 (list of "Unclassified Students").

19. Laura Millerberry, ed., *Digest of Women Lawyers and Judges: Biographical Sketches and Data of Women Lawyers and Judges of the United States and its Possessions*, 292–93 (1949).

20. Catholic University opened on November 13, 1889; only men were admitted as undergraduates. See C. Joseph Nuesse, *The Catholic University of America: A Centennial History* 61, 173 (1990). Miriam Rooney took her undergraduate degree through Trinity College, which was established for women in 1900 (ibid., at 258). In 1928, however, the board of trustees had decided to delegate the decision of the admission of women to graduate study to the Chancellor and the new Rector, John A. Ryan, who decided in favor of their admission (ibid., at 259). Rooney's MA and her PhD were conferred by Catholic University.

21. Letter from Miriam Theresa Rooney to Mrs. Edward F. Curry, Executive Secretary, International Federation of Catholic Alumnae, September 29, 1965 (copy on file with the author). I am grateful to Mr. C. Joseph Nuesse, President Emeritus of Catholic University, for providing me with a copy of this letter. The

PhD in Philosophy had been conferred on two women religious (sisters) in 1914. See Nuesse, *supra* note 20, at 173.

22. George Washington University Law School, "Transcript of Miriam Theresa Rooney" (copy on file with the author). A notation on the transcript indicates that she passed the District of Columbia Bar Examination in December 1941; I am grateful to Professor Thomas D. Morgan for obtaining this information for me. Rooney later ensured that Seton Hall Law School's evening students would be treated the same as the day students, invoking her own experience "as a one-time evening student."

23. Robert Stevens, *Law School: Legal Education in America from the 1850s to the 1980s* 81, 196, 207 (1963).

24. *ABA-LSAC Official Guide to ABA-Approved U.S. Law Schools, Rutgers, The State University of New Jersey, Newark* 570–71 (2002). Newark received AALS membership in 1946.

25. Robert F. Williams, *The New Jersey State Constitution: A Reference Guide* 94–97 (1990).

26. Arthur T. Vanderbilt II, *Changing Law: A Biography of Arthur T. Vanderbilt* 146–68 (1976), describing Vanderbilt's role in the adoption of the Revised New Jersey Constitution of 1947.

27. Miriam T. Rooney, "Seton Hall University School of Law," 5 *Catholic Lawyer* 305, 305 (1959).

28. Ibid.

29. "SHLC Founding Dean Dies," Res Ipsa Loquitur, 1, April–May 1981 (Seton Hall Law Center).

30. AALS 1959 Proceedings, Tuesday Morning Session, December 29, 1959, at p. 23. Rooney was notified of this action on January 5, 1960; see letter from Professor Samuel D. Thurman, Secretary-Treasurer of the AALS, to Dean Miriam Rooney, January 5, 1960 (copy on file with author).

31. Interview with Professor Gerald Garafola, Seton Hall, Newark, NJ, April 12, 1991. Unless another source is cited, all quotations from Professor Garafola are from this interview.

32. *Seton Hall University School of Law Bulletin of Information*, 1960–62, p. 10 (1961).

33. *AALS Directory of Teachers* 299 (1963).

34. Miriam Theresa Rooney, 81–84 *Contemporary Authors* 481 (1979).

35. Miriam Theresa Rooney, "Natural Law Gobbledygook," 5 *Loyola, New Orleans, Law Review* 1, 11–12 (1949).

36. Miriam Theresa Rooney, *Lawlessness, Law, and Sanction* 7 (1937).

37. Ibid., at 8.

38. "Founding Dean Dies," *supra* note 29.

39. "Miriam Rooney, Ex-Seton Law Dean," *The Star Ledger*, March 24, 1981.

40. Interview with Jay Smith, Jeanette Smith's son, Coral Gables, FL, November 23, 1991. All biographical information about Jeanette Ozanne Smith, unless another source is cited, is from this interview with Jay Smith.

41. Letter from Jeanette O. Smith to Dean Russell A. Rasco, May 11, 1948 (University of Miami Law School Archives). Sebring is located in central Florida, about 172 miles north of Miami.

42. Ibid.

43. Obituary of Priscilla Mullins Lindgren, *The Miami Herald*, February 15, 2011. Lindgren died on February 12, 2011.

44. "Jeannette [sic] O. Gifford Mullens Smith," in *Celebrating Florida's First 150 Women Lawyers* 79 (Wendy S. Loquasto, ed.) (2000).

45. Interview with Professor George Onoprienko, Coral Gables, FL, January 21, 1991. Unless another source is cited, all quotations from Professor Onoprienko are from this interview.

46. Faculty Profiles, 3 *The University of Miami Lawyer* 22 (June 1950) (also noting that she "boasts one of the top five averages at the U. of M.").

47. Dean Franklin Williams, Memorandum to Mrs. Jeanette M. Smith, April 15, 1952 (University of Miami Law School Archives).

48. A. H. Goff, Memorandum to Jeanette M. Smith, March 31, 1969 (University of Miami Law School Archives).

49. Vice-President Charles Doren Tharp, Memorandum of Employment to J. M. Smith, April 10, 1958 (University of Miami Law School Archives).

50. Jeanette O. Smith, "Analytical and Critical Survey of Appellate Cases in Contracts," 14 *U. Miami L. Rev.* 534–74 (1960) (covering the period 1958–60); Jeanette O. Smith, "Analytical and Critical Survey of Appellate Cases in Contracts," 16 *U. Miami L. Rev.* 501–32 (1962) (covering the period 1960–61).

51. Jeanette O. Smith, "New Books Appraised," 51 *Law Library Journal* 64 (Walter Berns, *Freedom, Virtue and The First Amendment*); 51 *Law Library Journal* 68 (Henry Drinker, *Some Observations on the Four Freedoms of the First Amendment*); 51 *Law Library Journal* 69 (Milton Konvitz, *Fundamental Liberties of a Free People*) (1958); 52 *Law Library Journal* 79 (John R. Schmidhauser, *The Supreme Court as Final Arbiter in Federal-State Relations*) (1959); 53 *Law Library Journal* 69 (Noel C. Stevenson, *Search and Research*); 53 *Law Library Journal* 71 (*The Public Papers of Chief Justice Earl Warren*); 53 *Law Library Journal* 160 (Harold Hyman, *To Try Men's Souls: Loyalty Trials in American History*); 53 *Law Library Journal* 236 (Carl Beck, *Contempt of Congress: A Study of the Prosecutions Initiated by the Committee on Un-American Activities, 1945-1957*) (1960); 54 *Law Library Journal* 64 (Robert J. Harris, *The Quest for Equality*) (1961); 55 *Law Library Journal* 259 (Harold C. Havighurst, *The Nature of Private Contract*) (1962) (hereafter *LLJ*).

52. *Celebrating Florida's First 150 Women Lawyers, supra* note 44, at 80.

53. All biographical information and quotations about Janet Mary Riley's life and career, unless another source is cited, are from her transcribed interviews with Herma Hill Kay in New Orleans, LA, on .February 17–18, 1991, January 3–4, 2002, March 19, 2000, and transcribed telephone interviews on December 27, 1989 and January 17, 2007, recorded at San Francisco, CA.

54. Riley was one of a handful of candidates who had to sit for the Louisiana bar examination, since veterans and those who had worked in essential industries during the war were exempted from the requirement. The next year, the State Bar persuaded the Louisiana Supreme Court to exempt all graduates of ABA-approved law schools.

55. Letter from Professor Janet Mary Riley to Dean A. E. Papale, May 14, 1954 (Janet Mary Riley Papers, Loyola University Library Archives, used with permission of Professor Riley).

56. Letter from President Donnelly to Miss Janet Riley, July 7, 1955 (Janet Mary Riley Papers, Loyola University Library Archives, used with permission of Professor Riley).

57. Interview with Dean Louis Westerfield, New Orleans, LA, February 18, 1991. Unless another source is cited, all quotations from Dean Westerfield are from this interview.

58. Interview with Professor Kathryn Venturatos Lorio, New Orleans, LA, February 19, 1991. Unless another source is cited, all quotations from Professor Lorio are from this interview.

59. Janet Mary Riley, "A Revision of the Property Law of Marriage—Why Now?" 21 *Louisiana Bar Journal* 29 (1973).

60. Janet Mary Riley, "Constitutional Limitations on Federal Contempt Proceedings," 11 *Loyola Law Review* 49 (1961–62).

61. Ibid., at 324–25 (discussing *Reed v. Reed,* 404 U.S. 71 (1971), striking down an Idaho provision that preferred men to women as administrators of decedents' estates).

62. The other seven members of the Advisory Committee were Katherine Brash Jeter, Helen Kohlman, Thomas B. Lehmann, Max Nathan, Eric O. Person, Robert Roberts III, and Wayne S. Woody. See Katherine Shaw Spaht, "Background of Matrimonial Regimes Revision," 39 *La. L. Rev.* 323, 325 (1979).

63. Riley, *supra* note 59, at 33. On Ginsburg, see Amy Leigh Campbell, "Raising the Bar: Ruth Bader Ginsburg and the ACLU Women's Rights Project," 11 *Texas Women's L. J.* 157 (2002).

64. Riley, *supra* note 59. See also Harriet S. Daggett, *The Community Property System of Louisiana with Comparative Studies,* 200–201(1931).

65. Riley, *supra* note 59, at 35.

66. Ibid., at 36.

67. Spaht, *supra* note 62, at 325.

68. Kathryn Venturatos Lorio, "The Louisiana Civil Law Tradition: Archaic or Prophetic in the Twenty-First Century?" 63 *Louisiana L. Rev.* 1, 6 (2002).

69. 430 F. Supp. 642 (E.D. La. 1977); rev'd, 609 F. 2d. 727 (5th Cir. 1979); aff'd 450 U.S. 455 (1981).

70. 358 So.2d 295 (La. 1978); certiorari denied, 439 U.S. 897 (1978).

71. Spaht, *supra* note 62, at 335.

72. 358 So.2d 295 (La. 1978), at 301-2.

73. Katherine S. Spaht, "Interim Study Year," 39 *La. L. Rev.* 551 (1979); Katherine S. Spaht and Cynthia Samuel, "Equal Management Revisited: 1979 Legislative Modifications of the 1978 Matrimonial Regimes Law," 40 *La. L. Rev.* 83 (1979); Katherine S. Spaht, "Developments in the Law: Matrimonial Regimes," 42 *La. L. Rev.* 347 (1982); Janet Mary Riley, "Louisiana Opts for 'Equal Management'—Maybe!," 5 *Community Property Journal* 261 (1978); "Analysis of the 1980 Revision of The Matrimonial Regimes Law of Louisiana," 26 *Loyola L. Rev.* 453 (1980); "Equal Management in Louisiana: Some Flaws Still Exist," 8 *Community Property Journal* 151 (1981). This last summarizes the sequence of statutory enactment at 153, n. 13: S.C.R [Senate Concurrent Resolution] 54 adopted equal management in principle and created a joint legislative subcommittee and an advisory committee to draft a bill to implement the principle. Their draft became 1978 La. Acts No. 627, to be effective January 1, 1980. Before that date, pursuant to H.C.R. [House Concurrent Resolution] 232 of 1978, it was referred back to the Louisiana State Law Institute for redrafting. It was repealed and replaced by 1979 La. Acts No. 709 which became effective January 1, 1980. The quotation is from Janet Mary Riley, *Preface, Louisiana Community Property: Cases and Materials on Louisiana Property Law of Marriage, V* (Second Edition, 1981). A *Supplement* appeared in 1983.

74. Janet Riley, "The Effect of Segregation Laws on Louisiana Library Association Activities," 13 *Bulletin of the Louisiana Library Association* 71 (1950).

75. Ibid., at 1469.

76. Letter from Wright Estes, Assistant Librarian at USC, to Janet Riley, September 28, 1950 (Janet Mary Riley Papers, Loyola University Library Archives, quoted with permission of Professor Riley)

77. Joseph F. Rummel, "Blessed are the Peacemakers," Pastoral Letter, March 15, 1953, at 5 (see Archbishop Joseph F. Rummel papers, Archdiocese of New Orleans Archives). The Archbishop's subsequent decision to desegregate the parochial schools was extremely controversial and provoked an "organized fight" against his policies, which he finally won in 1962. See John Smestad Jr., "The Role of Archbishop Joseph F. Rummel in the Desegregation of Catholic Schools in New Orleans," 25 *The Student Historical Journal* (1994), available at http://people.loyno.edu/~history/journal/1993-4/Smestad.html.

78. See Myriam Miedzian and Alisa Malinovich, *Generations: A Century of Women Speak About Their Lives*, 401, 405–06 (1997).

79. 373 U.S. 267, 273–74 (1963). See Gerald Gunther and Kathleen Sullivan, *Constitutional Law* 941 (13th ed., 1997).

80. Miedzian and Malinovich, *supra* note 78, at 406.

81. Janet Mary Riley, "Civil Rights," 17 *Loyola L. Rev.* 529 (1970–71); "Civil Rights: Equal Employment Opportunity Cases," 18 *Loyola L. Rev.* 583 (1971–72).

82. 400 U.S. 542 (1971); 404 U.S. 71 (1971).

83. John Pope, "Janet Riley, Fought for Women's Rights," *The Times-Picayune*, July 6, 2008.

84. Interview with Professor Cynthia Samuel, New Orleans, LA, February 19, 1991. Unless another source is cited, all quotations from Professor Samuel are from this interview.

85. "Miss Helen Steinbinder Named Law Center Research Librarian," 8 *Res Ipsa Loquitur* 8 (Georgetown University Law Center, January 1956). Manhattanville College subsequently moved to Purchase, NY.

86. "Five New Professors Added," 9 *Res Ipsa Loquitur* 9 (Georgetown University Law Center, March 1957).

87. "Georgetown Celebrates Four Decades of Women at the Law Center," 43 *Res Ipsa Loquitur* 11 (Fall/Winter 1993).

88. "Portia Glutz, Atty-at-Law," *The Harvard Law School Yearbook* 28–29 (1953).

89. Interview with Walter Bonner, Washington, DC, September 23, 1991. Unless another source is cited, all quotations from Walter Bonner are from this interview.

90. "Steinbinder Named Research Librarian," *supra* note 85, at 8.

91. "Four Decades of Women," *supra* note 87, at 13.

92. Interview with Professor Paul Dean, Washington, DC, January 7, 1991. Unless another source is cited, all quotations from Professor Dean are from this interview.

93. "Four Decades of Women," *supra* note 87, at 13.

94. "Five New Professors," *supra* note 86, at 9.

95. Interview with Professor and Dean David McCarthy, Washington, DC, January 7, 1991. Unless another source is cited, all quotations from Professor McCarthy are from this interview.

96. Interview with Professor Sherman Cohn, Washington, DC, January 8, 1991. Unless another source is cited, all quotations from Professor Cohn are from this interview.

97. Interview with Dean Judith Areen and Professor Wendy Williams, Washington, DC, October 25, 1990. Unless another source is cited, all quotations from Dean Areen or Professor Williams are from this interview.

98. Interview with Professor Patricia King, Washington, DC, January 8, 1991. Unless another source is cited, all quotations from Professor King are from this interview.

99. *General Announcement for the Academic Year 1951–1952*, 26 *Bulletin of the University of Miami*, No. 3, 22, 24 (April 15, 1952), listing both Massey and Onoprienko.

100. Massey, *supra* note 11, at 215.

101. Ibid., at 219.

102. Ibid., at 219.

103. Ibid., at 220.

104. Ibid., at 221.

105. Interview with Professor Taylor Mattis, Berkeley, CA, November 7, 2004. Unless another source is cited, all quotations from Professor Mattis are from this interview.

106. 11 *The University of Miami Lawyer* 37 (1958).

107. M. Minnette Massey, "Congressional Investigations and Individual Liberties," 25 *U.Cincinnati L. Rev.* 323 (1956).

108. M. Minnette Massey, Book Review, 3 *Howard L. Rev.* 187 (1957). The other reviews are published in 52 *Law Library Journal* 67 (1959) (*The History of a Law Suit* by John S. Bradway); 14 *U. Miami L. Rev.* 129–30 (1959) (*The Marble Palace: The Supreme Court in American Life* by John P. Frank); 15 *U. Miami L. Rev.* 118–20 (1960) (*Federal Jurisdiction and Procedure* by Harry G. Fins).

109. M. Minnette Massey, "Restrictions on Federal Jurisdiction—The 1958 Amendment to the Judicial Code," 13 *U. Miami. L. Rev.* 63 (1958); reprinted in 30 *Okla. B.A.J.* 493 (1959).

110. M. Minnette Massey (with Marion Westen), "Sixth Survey of Florida Law: Civil Procedure, 18 *U. Miami L.Rev.* 745–798 (1964); M. Minnette Massey (with Marion Westen), "Seventh Survey of Florida Law: Civil Procedure," 20 *U. Miami L. Rev.* 594–730 (1966); M. Minnette Massey (with Roger A. Bridges), "Eighth Survey of Florida Law: Civil Procedure," 22 *U. Miami L. Rev.* 449–508 (1968).

111. An abbreviated Survey of Florida Law, without a Civil Procedure section, appeared in vol. 34, no. 3 of the *U. Miami L. Rev.* (May 1980). Vol. 36 contains no Survey.

112. Press Release from the University of Miami News Bureau, Sunday, August 6, 1961, 1 (1961), quoted in *The Miami Herald*, August 8, 1961, at 4-A.

113. The decision was handed down on February 25, 1987. Massey and another woman law professor, Marilyn Yarbrough, an early black female law professor and the incoming Dean of the University of Tennessee Law School, were on the committee at the time.

CHAPTER 5. THE MID-FIFTIES: ELLEN ASH PETERS
AND DOROTHY WRIGHT NELSON

1. Ruth Bader Ginsburg and Laura W. Brill, "Women in the Federal Judiciary: Three Way Pavers and the Exhilarating Change President Carter Wrought," 64 *Fordham L. Rev.* 281, 282 (1995).

2. Ibid., at 282–83.

3. All biographical material and quotations from Chief Justice Ellen Ash Peters about her life and career, unless another source is specified, are from her transcribed interviews with Herma Hill Kay in Hartford, Connecticut, on April 9–10, 1991 and in Philadelphia, Pennsylvania on October 19, 2000; and follow-up emails in December 2008 and January 2009. The town's name subsequently was changed to Pozan.

4. Ellen A. Peters, "Remarks at Alumni Weekend," 30 *Yale Law Report* 12 (Spring 1984).

5. Faculty Profile, Ellen Ash Peters, 23 *Yale Law Report* No. 1, 10, 12 (Summer/Fall 1976), quoting Professor Grant Gilmore.

6. Interview with Professor Ralph Brown, New Haven, CT, April 9, 1991. All quotations from Professor Brown, unless otherwise specified, are from this interview. The book, *Loyalty and Security: Employment Tests in the United States,* was published by Yale University Press in 1958.

7. Interview with Professor Eli Clark, New Haven, CT, April 11, 1991. All quotations from Professor Clark, unless otherwise specified, are from this interview.

8. Laura Kalman, *Legal Realism at Yale, 1927–1960,* 119 (1986).

9. Interview with Professor Boris Bittker, New Haven, CT., 4/8/1991 All quotations from Professor Bittker, unless otherwise specified, are from this interview.

10. Faculty Profile, *supra* note 5.

11. Ellen A. Peters, "Remedies for Breach of Contracts Relating to the Sale of Goods Under the Uniform Commercial Code: A Roadmap for Article Two," 73 *Yale L. J.* 199 (1963).

12. Ibid., at 11.

13. ALI, *Restatement (Second) of Contracts* (1981). The advisors are listed on p. v. Peters was the only female advisor to the project.

14. ALI, *Seventy-fifth Anniversary: 1923–1998,* 325–332 (1998), listing Members of the Council, 1923–1998; list shows that Peters was preceded by Shirley M. Hufstedler (1974), Ruth Bader Ginsburg (1978), Patricia M. Wald (1978), Amalya Kearse (1981), and Betsy Levin (1983).

15. Mark Alden Branch, "A Very Special Saloon," 62 *Yale Alumni Magazine* 6 (April 1999).

16. Faculty Profile, *supra* note 5, at 10.

17. Faculty Profile, *supra* note 5, at 10.

18. Ellen A. Peters, *Commercial Transactions: Cases, Text, and Problems on Contracts Dealing with Personalty, Realty, and Services* (1971); Ellen A. Peters, *A Negotiable Instruments Primer* (1971). The second edition appeared in 1974.

19. Dedication, 87 *Yale L.J., i* (1978).

20. Peters, *Commercial Transactions, supra* note 18, at vii.

21. See also John H. Langbein, "Law School in a University: Yale's Distinctive Path in the Later Nineteenth Century," 53, 63 in *History of the Yale Law School: The Tercentennial Lectures* (Anthony T. Kronman, Ed., 2004): "Apart from [Francis] Wayland, the dean, the Yale Law School would not have its first full-time faculty member until Arthur Corbin in 1903, a generation after Eliot and Langdell began moving the Harvard Law School to the model of a full-time faculty."

22. Susan Bysiewicz, *ELLA: A Biography of Governor Ella Grasso* 141 (1984).

23. Tom C. Clark, "Judicial Reform in Connecticut," 5 *Conn. L. Rev.* 1, 7–8 (1972).

24. Governor Grasso's biographer, Susan Bysiewicz, sheds no light on the question of how Ella Grasso came to nominate Ellen Peters to the Connecticut Supreme Court. Her book does not discuss Grasso's role in appointing the first woman Justice to that court, nor does it even mention the name of Ellen Peters.

25. Ellen Ash Peters, 24 *Yale Law Report* 7 (Spring 1978), quoting letter from Dean Wellington.

26. Interview with Professor Barbara Underwood, Brooklyn Heights, NY, April 14, 1991.

27. Wesley W. Horton, *The History of the Connecticut Supreme Court* 199 (Thomson/West, 2008).

28. Ibid., at 201. The only one of the seven that was not unanimous was a religious freedom case, *Beit Havurah v. Zoning Board of Appeals*, 177 Conn. 140, 418 A.2d 82 (1979), in which the lone dissenter was a Superior Court judge sitting by assignment.

29. Id., at 201–2 (discussing *Caldor's v. Bedding Barn, Inc.*, 177 Conn. 304, 417 A.2d 343 (1979)).

30. Richard L. Madden, "Nominee for Chief Judge: Ellen Ash Peters," *The New York Times*, November 14, 1984, at B4.

31. Horton, *supra* note 27, at 220.

32. I am grateful to Sandra Knife of the National Center for State Courts for providing me with this information. The six women and the dates of their service as President are: Annice M. Wagner, Washington, DC, 2001–2002; Judith S. Kaye, New York, 2002–2003; Shirley S. Abrahamson, Wisconsin, 2004–2005; Jean Hoefer Toal, South Carolina, 2007–2008; Margaret H. Marshall, Massachusetts, 2008–2009; and Christine Durham, Utah, 2009–2010.

33. Ellen Ash Peters, "Commencement Remarks," 32 *Yale Law Report* No. 1, 6–7 (Fall 1985), an address delivered to the graduating class of Yale Law School,

May 24, 1985; "Coping With Uncertainty in the Law," 19 *Conn. L. Rev.* 1 (1986), address delivered to the graduating class of the University of Connecticut School of Law, May 17, 1986.

34. Ellen Ash Peters, "The Changing Education and Role of Lawyers," 10 *U. Bridgeport L. Rev.* 1, address delivered at groundbreaking ceremony for new law school classroom building at the University of Bridgeport School of Law, September 9, 1988.

35. Ellen Ash Peters, "The Care and Treatment of the Terminally Ill: Questions Raised by McConnell v. Beverly Enterprises-Connecticut, Inc.," 21 *Conn. L. Rev.* 543 (1989). This was a keynote address delivered at Law and Medicine Symposium at the University of Connecticut School of Law, March 29, 1989.

36. Ellen Ash Peters, "Remarks on Judicial Ethics," 66 *Neb. L. Rev.* 448 (1987); Ellen Ash Peters, "Remarks on State Constitutional Law," 115 *Federal Rules Decisions* 405 (1987).

37. Horton, *supra* note 27, at 269.

38. Dorothy W. Nelson, "Adam's Lib," 26 *Okla. L. Rev.* 375, 380 (1973), adding that, "When you consider that a woman will have at least 40 years ahead of her after her last child is born and in school full time, this type of question appears inappropriate."

39. Dorothy W. Nelson, "As a Federal Judge: Seeking Personal Balance and Public Service," in *Women Lawyers: Perspectives on Success* 205, 205 (Emily Couric, Ed.) (1984).

40. Ibid., at 205–6.

41. Sandra P. Epstein, *Law at Berkeley: The History of Boalt Hall* at 198–202 (1997), discussing the development of the UCLA Law School).

42. Roscoe Pound was born on October 27, 1870, and became Dean at Harvard in 1916.—Ed.

43. Nelson, *supra* note 39, at 206.

44. See "An Oral History of Hon. Dorothy W. Nelson," 10, conducted in 1988 by Selma Moidel Smith, the Ninth Circuit Judicial Circuit Historical Society, Pasadena, California. All quotations from Judge Nelson's Oral History are reprinted with the written permission of Mr. Bradley B. Williams, Ph.D., the Director of the Ninth Judicial Circuit Historical Society, by letter to Professor Herma Hill Kay dated April 3, 2009.

45. Letter from Nancy A. Finck, Assistant Director of Law Alumni and Development, UCLA, to Herma Hill Kay, November 19, 1991.

46. "Both Lawyers Now," *The Los Angeles Times*, January 15, 1954, at 18.

47. Jeffrey Toobin, *The Nine: Inside the Secret World of the Supreme Court* 38 (2007).

48. Nelson, *supra* note 39, at 207–8.

49. Dorothy W. Nelson, "Judicial Reform: The Holbrook Report Revisited," 38 *L.A. Bar.Bull.* 383, 383 n. 1 (1963).

50. James G. Holbrook, *Survey of Metropolitan Courts—Los Angeles Area* (Dorothy W. Nelson, Senior Research Associate) (1956).

51. Nelson, *supra* note 39, at 208.

52. All biographical material and quotations from Judge Dorothy W. Nelson about her life and career, unless another source is specified, are from her transcribed interviews with Herma Hill Kay in San Francisco, CA, on July 26, 1990, April 3, 1991, and September 20, 2000, and follow-up emails in January through May, 2009.

53. Nelson, *supra* note 44, at 16.

54. Nelson, *supra* note 39, at 208.

55. Ibid. Professors C. Robert Morris and Paul Mishkin published their legal process book, *On Law in Courts*, in 1965. *The Legal Process*, by Henry M. Hart, Jr., and Albert C. Sachs, was first published in 1958, and is recognized as one of the classic legal casebooks. It is currently edited by William N. Eskridge and Philip P. Frickey (Foundation Press, 1994; updated 2001).

56. Nelson, *supra* note 49, at 420. See http://www.lasuperiorcourt.org /aboutcourt/history.htm (last visited April 9, 2009).

57. Dorothy Nelson, "Variations on a Theme: Selection and Tenure of Judges," 36 *S.Cal.L.Rev.* 1 (1962/63).

58. Orrin B. Evans, "Dorothy W. Nelson," 53 *So.Cal.L.Rev.* 392, 392–93 (1980).

59. Interview with Chancellor Emeritus Norman Topping, Los Angeles, CA., July 15, 1991.

60. Norman Topping, *Recollections* 268 (1990).

61. Dave Smith, "Hint of Police Pressure Against USC in Brutality Suit Claimed," *Los Angeles Times*, January 15, 1971, at C1; Bernard Beck, "Western Center Suit Spurs Threats, Charges," *The Daily Trojan*, February 3, 1970, at 1.

62. Ibid.

63. Topping interview, *supra* note 59.

64. Smith, *supra* note 61; Beck, *supra* note 61.

65. Smith, *supra* note 61.

66. Telephone conversation with Judge Arthur Alarcon, April 13, 2009.

67. Gene Blake, "Police Brutality Class Action Suit Dismissed," *Los Angeles Times*, February 8, 1972, at C5.

68. Herma Hill Kay, "The Challenge to Diversity in Legal Education," 34 *Ind. L. Rev.* 55, 59–60 (2000).

69. William Endicott, "3 L.A. Law Schools Face Funds Crisis for Minority Students," *Los Angeles Times*, June 11, 1969.

70. "Law Center Commended by ABA-AALS for Improvements," *The Law Center Newsletter* 1 (March 1, 1973).

71. William H. Levit, Dorothy W. Nelson, Vaughn C. Ball, and Richard Chernick, "Expediting Voir Dire: An Empirical Study," 44 *So.Cal. L. Rev.* 916 (1971).

72. Dorothy W. Nelson, *Judicial Administration and the Administration of Justice*, Preface, *XXVII*, n. 1 (1975).

73. Nelson, *supra* note 38. The lecture was part of Oklahoma's "Enrichment Program."

74. Dorothy W. Nelson, "The Role of the Trial Judge in Clinical Legal Education," 13 *Judges' Journal* 20 (1974), based on the Robert Houghwout Jackson Memorial Lecture, delivered on August 10, 1973, in Reno, Nevada.

75. Nelson, *supra* note 72.

76. Ibid., at XXVII.

77. Ibid.

78. I am grateful to Pauline M. Aranas, Associate Dean and Acting Dean of Library and Information Technology at USC for providing me with this information. The 1967 figure is from the USC Annual Report to the Board of Councilors (1972), and the 1980 figure is from *A Review of Legal Education in the United States, Fall 1980-81: Law Schools and Bar Admission Requirements* 9 (ABA Section of Legal Education and Admission to the Bar, 1981.

79. Nelson, *supra* note 39, at 209–10; Nelson, *supra* note 44, at 22–23, noting that the corporate board service paid her between $12,000 to $20,000 per year.

80. Evans, *supra* note 58, at 393, noting the "symbolism in the coincidence of the date and the occasion," and adding "surely no judge ever took the bench with less malice toward anyone, more charity for everyone, and with better vision of the right, than Dorothy Nelson."

81. Dorothy W. Nelson, "Why Are Things Being Done This Way? Reflections of a Former Law School Dean on Becoming a Judge," 19 *Judge's Journal* 12 (Fall 1980).

82. Ibid., at 15, 45–46.

83. Ibid., at 46, quoting a paper written by Judge Alvin Rubin, "Management Problems in the Federal Courts: Curbing Bureaucratization and Reducing Other Tensions Between Justice and Efficiency."

84. Dorothy W. Nelson, "ADR in the New Era, into the 21st Century," 19 *Alternatives* 65, 66 (2000); "ADR in the 21st Century: Opportunities and Challenges," *ABA Dispute Resolution Magazine* 3 (Spring 2000); "The Immediate Future of Alternative Dispute Resolution," 14 *Pepperdine L. Rev.* 777 (1987) (one of seven essays on the subject published in that issue); "Alternative Dispute Resolution: A Supermart for Law Reform," 14 *New Mexico L. Rev.* 467 (1984).

85. 657 F.2d. 1017 (9th Cir. 1981). The trial judge had found that the plaintiff was carrying a driver's license at the time he was detained. See *Doe v. Gallinot*, 486 F. Supp. 983, 990 (C.D.Ca., 1979).

86. Nelson, *supra* note 44, at 44–45.

87. Email from Judge Dorothy Wright Nelson to Herma Hill Kay, September 14, 2010.

88. Lisa A. Kloppenberg, "A Mentor of Her Own," 33 *University of Toledo L. Rev.* 99, 102 (2001).

89. Western Justice Center Foundation Home Page, http://www .westernjustice.org (visited March 24, 2009).

90. Nelson, *supra* note 44, at 52.

91. Ibid., at 45.

92. Email from Judge Dorothy Wright Nelson to Herma Hill Kay, September 9, 2010.

CHAPTER 6. THE END OF AN ERA: JOAN MIDAY
KRAUSKOPF AND MARYGOLD SHIRE MELLI

1. All biographical material and quotations about Joan Krauskopf's life and career, unless another source is specified, are from her interviews with Herma Hill Kay in Columbus, Ohio, on August 28 and 29, 1990, and in Prescott, Arizona, on December 15 and 16, 2000; and follow-up emails in April and May, 2009.

2. Interview with Professor Frank Strong, Chapel Hill, NC, March 16, 1991. All biographical material and quotations from Professor Strong, unless another source is specified, are from this interview.

3. Interview with Professor Robert J. Lynn, Columbus, Ohio, August 29, 1990. All biographical material and quotations from Professor Lynn are from this interview.

4. Letter from Professor Frank Strong to Dr. Lawson Crowe, November 28, 1973. I am grateful to Professor Krauskopf for providing me with a copy of this letter.

5. Joan M. Krauskopf, "Ohio State Law Journal Dedication to Robert J. Lynn," 50 *Ohio St. L. J.* 215 (1989).

6. Joan M. Krauskopf, "Products Liability," 32 *Mo. L. Rev.* 459 (1967) [cited in Keener v. Dayton Electric Manufacturing Comp., 445 S.W.2d 362, 364 (Mo. 1969)]; "Products Liability, Part II: Implementation," 33 *Mo. L. Rev.* 24 (1968).

7. 470 S.W. 2d 565 (1971), cert. den. 405 U.S, 1073 (1972).

8. 43 Cal.App. 3rd 823, 829–30, 118 Cal. Rptr. 110, 113–14 (1975) (hearing denied by the California Supreme Court).

9. 507 S.W.2d 8 (Mo. 1974). The case was won by a 4–3 majority; Justice Seiler, who had dissented in *Green,* concurred with the majority.

10. *Kuchta v. Kuchta,* 636 S.W.2d 663 (Mo. Banc 1982) (noting in footnote 1 that "After arguments and submission an opinion of this Court was filed on September 8, 1981. Thereafter, a motion for rehearing was sustained and the opinion as filed was withdrawn and further arguments were heard on January 13, 1982).

11. B. Joan Krauskopf, "The Law of Dead Bodies: Impeding Medical Progress," 19 *Ohio St. L.J.* 455 (1958).

12. B. J. Krauskopf, "Solving Statute of Frauds Problems," 20 *Ohio St. L.J.* 237 (1959).

13. Joan M. Krauskopf, "Divisible Divorce and Rights to Support, Property and Custody," 24 *Ohio St. L.J.* 346 (1963), cited in R. Cramton and D. Currie, "Conflict of Laws—Cases—Comments—Questions," 689 (West 1968) and "Restatement (Second) Conflict of Laws," 77 (Reporters' Notes) (1971).

14. Joan M. Krauskopf and Charles J. Krauskopf, "Torts and Psychologists," 12 *Journal of Counseling Psychology* 227, 227 (1965).

15. Joan M. Krauskopf, "Physical Restraint of the Defendant in the Courtroom," 15 *St. Louis U.L J.* 351 (1971)

16. *Kennedy v. Cardwell*, 487 F.2d 101, 105 (6th Cir. 1973). Her article was also cited as a general reference on the subject over thirty years later by the United States Supreme Court in *Deck v. Missouri*, 544 U.S. 622, 629 (2005).

17. Joan M. Krauskopf, "Sex Discrimination—Another Shibboleth Legally Shattered," 37 *Mo. L. Rev.* 377 (1972); Kenneth M. Davidson, Ruth Bader Ginsburg, and Herma Hill Kay, *Text, Cases and Materials on Sex-Based Discrimination* (1974).

18. Joan M. Krauskopf, *The Equal Rights Amendment*, 29 *J. of Mo. Bar* 85, 85 (1973).

19. Ibid., at 88–93.

20. Joan M. Krauskopf, "Property Division and Separation Agreements," 28 *J. Mo. Bar* 508 (December 1973).

21. Joan M. Krauskopf and Rhonda Thomas, "Partnership Marriage: The Solution to an Ineffective and Inequitable Law of Support," 35 *Ohio St. L.J.* 558 (1974).

22. Joan M. Krauskopf, "A Theory for 'Just' Division of Marital Property in Missouri," 41 *Mo. L. Rev.* 165 (1976).

23. Joan M. Krauskopf, "Maintenance: Theory and Negotiation," *33 J. Mo. Bar.* 24 (1977); "Maintenance: Applying the Statute," 33 *J. Mo. Bar* 93 (1977).

24. Joan M. Krauskopf, "Child Custody Jurisdiction Under the UCCJA," 34 *J. Mo. Bar* 383 (1978). This article is also about the conflict of laws.

25. Joan M. Krauskopf, "Marital Property at Marriage Dissolution," 43 *Mo. L.Rev.* 157 (1978).

26. Karen L. Tokarz, "Women Judges and Merit Selection Under the Missouri Plan," 64 *Wash. U.L.Q.* 903, 922–23, noting that only one woman sat on the trial court—Ann Quill Niederlander, who was elevated from magistrate judge to associate circuit judge—in 1979, and that as of 1986 "[n]o woman has ever been elected or appointed to a full-time position on a Missouri appellate court."

27. Martha Shirk and Edward H. Kohn, "Carter Withdraws Selection of Missouri Woman as Judge," *St. Louis Post-Dispatch*, August 16, 1979, at 1A.

28. Martha Shirk, "2 Factors in Judicial Rejection," *St. Louis Post-Dispatch*, August 24, 1979, at 10A. See also Mary L. Clark, "Carter's Groundbreaking Appointment of Women to the Federal Bench: His Other 'Human Rights' Record," 11 *Am.U.J.Gender Soc.Pol'y & L.* 1131, 1146 (2003), noting that the Eighth Circuit Judges "passed a resolution stating that an otherwise qualified attorney should not be disqualified from sitting on the court solely because of a lack of trial experience."

29. Shirk and Kohn, *supra* note 27, at 4A.

30. Ibid.

31. Ibid, at 1A.

32. Martha Shirk, "Carter Assailed for Dumping Woman as Judge," *St. Louis Post-Dispatch*, August 17, 1979, at 3A, quoting Iris Mitgang of the National Woman's Political Caucus and Karen Tokarz of the Women Lawyers Association of St. Louis.

33. Editorial, "Bowing to the ABA," *St. Louis Post-Dispatch*, August 17, 1979, at 2C.

34. Joan M. Krauskopf, "Recompense for Financing Spouse's Education: Legal Protection for the Marital Investor in Human Capital," 28 *U.Kan.L.Rev.* 379 (1980).

35. American Law Institute, *Principles of the Law of Family Dissolution: Analysis and Recommendations* (2002).

36. Joan M. Krauskopf, *Law for the Elderly* (1980).

37. Joan M. Krauskopf, *Advocacy for the Aging* (1983) (Pocket Supplement, 1984).

38. Joan M. Krauskopf, "Employment Discharge: Survey and Critique of the Modern At Will Rule, 51 *UMKC L.Rev.* 189 (1982–83).

39. Mack Player, *Cases and Materials on Employment Discrimination Law* (2nd Ed., 1984).

40. Joan M. Krauskopf, *Cases on Property Division at Marriage Dissolution*, Preface *xv* (1984).

41. Joan M. Krauskopf, "Principles of Property Division," chap. 37, *Family Law and Practice* (1985).

42. Report of the President's Committee to Consider Exclusion of Time from the Probationary Period, submitted to Provost Frederick E. Hutchinson by Professor Joan M. Krauskopf, Chair, on November 5, 1990. I am grateful to Professor Krauskopf for providing me with a copy of this report.

43. Joan M. Krauskopf, "Touching the Elephant: Perceptions of Gender Issues in Nine Law Schools," 44 *J. Leg. Ed.* 311 (1994).

44. Charles J. Krauskopf and David R. Saunders, *Personality and Ability: The Personality Assessment System* (1994).

45. All biographical material and quotations from Marygold Shire Melli about her life and career, unless another source is specified, are from her tran-

scribed interviews with Herma Hill Kay in Madison, Wisconsin, from September 11–16, 2000, and follow-up emails, June–September 2009.

46. Oliver Wendell Holmes, "The Profession of the Law," *Speeches* 22–25 (1913), lecture delivered to Harvard undergraduates on February 17, 1886. Quoted from Max Lerner, *The Mind and Faith of Justice Holmes* 31 (1989). [The sentence preceding the quoted sentence reads, "Of course, the law is not the place for the artist or the poet."—Ed.]

47. Interview with Professor Sam Mermin, Madison, WI, Sept. 15, 2000. All biographical material and quotations from Professor Mermin, unless another source is specified, are from this interview.

48. Interview with Joseph A. Melli, Madison, WI, September 14, 2000. All biographical material and quotations from Mr. Melli about his life and career, unless another source is specified, are from this interview.

49. Interview with Professor William G. Foster, Jr., Madison, WI, September 11, 2000. All biographical material and quotations from Professor Foster, unless another source is specified, are from this interview.

50. Oral History of Marygold S. Melli, https://150.law.wisc.edu/wp-content/uploads/sites/135/2018/08/melli_interview_1.authcheckdam.pdf, at 19.

51. Letter to Professor Marygold Shire Melli from Clarke Smith, September 14, 1959, copy on file with the author. I am grateful to Professor Melli for making this document available to me.

52. Lorna Whiffen, "Mrs. Melli Juggles Two Careers with Finesse," *Capital Times*, May 24, 1969.

53. Letter from Lori Hayward, University of Wisconsin Academic Personnel Office, to Linda Greene, Professor of Law and Vice-Chancellor for Academic Affairs, University of Wisconsin, enclosing University of Wisconsin Form 108, showing Employment History of Professor Marygold Shire Melli, copy on file with the author. I am grateful to Professor Melli for providing me with this letter and its enclosure.

54. Ibid. Thereafter, her full-time salary rate increased annually, reaching $19,805 in 1970.

55. Telephone interview with Professor Spencer L. Kimball, tape recorded in San Francisco, CA, March 19, 2001. All biographical material and quotations from Professor Kimball, unless another source is specified, are from this interview.

56. "Associate Dean Baldwin to Iran," 2 *The Gargoyle*, no. 1, XIII (Autumn 1970).

57. Frank J. Remington, Donald J. Newman, Edward L. Kimball, Marygold Melli and Herman Goldstein, *Criminal Justice Administration: Materials and Cases* 951 (1969).

58. Marygold Shire Melli, "Preparation of an Essay Question for a Bar Examination," 51 *The Bar Examiner* 10 (November 1982).

59. See Marygold S. Melli, "A Look Forward—and Back: Predictions for Bar Admission in the 21st Century," 69 *The Bar Examiner* 10 (2000); "Passing the Bar: A Brief History of Bar Exam Standards," 21 *The Gargoyle* 3 (Summer 1990); "The Multi-State Essay Examination," 57 *The Bar Examiner* 5 (1988).

60. Marygold Melli, *Wisconsin Juvenile Court Practice in Delinquency and Status Offense Cases* (1978; 2nd ed., 1983). [The second edition of this contains an introductory overview, "The Changing Juvenile Court," which sets out a simi- lar critique to that found in Part III of the 1969 Casebook—Ed.]

61. Interview with Eileen A. Hirsch, Madison, WI, September 16, 2000. All biographical material and quotations from Ms. Hirsch, unless another source is specified, are from this interview.

62. Marygold Melli and Sherwood K. Zink, "Alternatives to Judicial Child Support Enforcement: A Proposal for a Child Support Tax," in *The Resolution of Family Conflict: Comparative Legal Perspectives*, chap. 32, 516–33, at p. 530 (John M. Eekelarr and Sanford N. Katz, eds.) (1984).

63. Pub. L. No. 98–378 (codified at 42 U.S.C. §§ 667).

64. A Fund for Women, *Supporter Stories*, http://www.affw.org/supporters /stories-melli.php (last visited June 5, 2009).

65. Marygold S. Melli, "Toward a Restructuring of Custody Decisionmaking at Divorce: An Alternative Approach to the Best Interests of the Child," in *Par- enthood in Modern Society*, chap. 23, 325–337 (J. Eekelaar & P. Sarcevic, eds.) (1993), advocating a "primary caretaker" approach unless the parents are able to agree on a proposed custodian; Marygold S. Melli and Patricia R. Brown, "The Economics of Shared Custody: Developing an Equitable Formula for Dual Resi- dence," 31 *Houston L. Rev.* 543 (1944); Marygold S. Melli, Patricia R. Brown, and Maria Cancian, "Child Custody in a Changing World," 1997 *U. Ill. L. Rev.* 773, discussing data from a study of 9500 divorcing families in Wisconsin between 1980 to 1992.

66. Irwin Garfinkel, Marygold S. Melli, and John G. Robertson, "Child Sup- port Orders: A Perspective on Reform," 4 *The Future of Children* 84 (1994); Marygold S. Melli, "The United States and the International Enforcement of Family Support," in *Families Across Frontiers*, chap. 48, 715–31 (Nigel Lowe and Gillian Douglas, eds.) (1996); Marygold S. Melli, "Child Support Enforce- ment in Cases of Disputed Paternity," in *Disputed Paternity Proceedings* chap. 6, 6–1–6–69 (Matthew Bender, ed.) (1997) (textbook for practitioners); Marygold S. Melli, "Guideline Review: Child Support and Time Sharing by Parents," 33 *Fam L.Q.* (1999).

67. Marygold S. Melli, "The Law Governing Transracial Adoptions," in *The Case for Transracial Adoption* chap. 2, 15–37 (Rita J. Simon, Howard Altstein, and Marygold S. Melli, eds.) (1994); Marygold S. Melli, "The United States: Focus on Adoption," in *The International Survey of Family Law 1994* 483–96 (A. Bainham, ed.) (1996).

68. Marygold S. Melli, "Whatever Happened to Divorce," 2000 *Wis.L. Rev.* 637, 638 (2000).

69. Margo S. Melli, "The American Law Institute Principles of Family Dissolution, The Approximation Rule and Shared Parenting," 25 *N. Ill. U. L. Rev.* 347 (2005).

CHAPTER 7. THE NEXT DECADES: RUTH BADER GINSBURG AND WOMEN LAW PROFESSORS FROM THE 1960S TO THE 1980S

1. Arthur M. Schlesinger, Jr., *A Thousand Days: John F. Kennedy in the White House* 5 (1965).

2. Pub. L. No. 88–352, 78 Stat. 241(1964); Pub. L. No. 89–110, 79 Stat. 437 (1965).

3. Okianer Christian Dark, "The Role of Howard University School of Law in Brown v. Board of Education," 16 *Washington History* 83–85 (2004).

4. 380 U.S.447 (1965).

5. Robert Stevens, *Law School: Legal Education in America from the 1850s to the 1980s* 84 (1983).

6. See Ruth Bader Ginsburg, "In the Beginning. . . ," 80 *U.M.K.C. L. Rev.* 663 (2012); ABA Section on Legal Education and Admissions to the Bar, Fall 1973 Review of Legal Education, 6, 34.

7. The source for the statistics quoted in this paragraph is ABA Council of Legal Education and Admissions to the Bar (2011), available at http://www.americanbar .org/content/dam/aba/administrative/legal_education_and_admissions_to_the_ bar/council_reports_and_resolutions/1947_2010_enrollment_by_gender.auth-checkdam.pdf.

8. Deborah Jones Merritt and Barbara F. Reskin, "Sex, Race, and Credentials: The Truth About Affirmative Action in Law Faculty Hiring," 97 *Colum. L. Rev.* 199 (1997).

9. All AALS member law schools have been approved by the ABA, but not all ABA-approved law schools meet the eligibility standards set by the AALS for its membership.

10. According to AALS figures, 30 schools joined the Association at its inception in 1900; these are designated "charter members." See *Members of the Association, with Dates of Admission,* 2009 Handbook, 21–25 (Association of American Law Schools, 2009). "Fourteen": see Herma Hill Kay, "The Future of Women Law Professors," 77 *Iowa L. Rev.* 5, 10, 12 (1991). Since the publication of that article, the count has changed slightly by the author's discovery that Professor Margo Melli of Wisconsin, whose career is set out in chapter 6, had begun teaching in 1959 instead of 1961. Therefore, the "first thirteen" women law professors

discussed there—plus Melli—are the "first fourteen" discussed here, and the number who entered teaching in 1961 is one, rather than two.

11. Robert MacCrate, "What Women Are Teaching a Male-Dominated Profession," 57 *Fordham L. Rev.* 989, 993 (1989), citing 1987–88 Annual Report of the Consultant on Legal Education to the American Bar Association 105–06.

12. *1970 Proceedings of the Annual Meeting of the Association of American Law Schools* 126–60 & note 2 (December 30, 1970).

13. Title VII of the Civil Rights Act of 1964, 78 Stat. 253, 42 U.S.C.A/ § 2000e et seq; Pub. L. No. 92–261, § 3, amending § 702, 86 Stat. 103 (1972).

14. See Donna Fossum, "Law Professors: A Profile of the Teaching Branch of the Legal Profession," 1980 *American Bar Foundation Research Journal* 501.

15. Gillian Metzger and Abbe Gluck, "A Conversation with Justice Ruth Bader Ginsburg: Symposium Honoring the 40th Anniversary of Justice Ruth Bader Ginsburg Joining the Columbia Law Faculty," 25 *Columbia Journal of Gender and Law* 6, 7 (2013).

16. Committee Reports, 1970 Proc. Ass'n Am. L. Schs. (pt. 2) 76, 160 n.2 (recording amendment to Approved Association Policy). The amendment had been proposed by the newly created Special Committee on Women in Legal Education, of which one of the early women law professors, Ellen Peters of Yale, was a member. Special Committees, 1969 Proc. Ass'n Am. L. Schs. (pt. 2) 233, 234. Professor Ginsburg was appointed to the renamed 1971 Special Committee on Equality of Opportunity for Women in Legal Education. Special Committees, 1970 Proc. Ass'n Am. L. Schs. (pt. 2) 261, 261. The material in this chapter on Justice Ginsburg's academic career was first published in Herma Hill Kay, "Ruth Bader Ginsburg, Professor of Law," 104 *Colum. L. Rev.* 1 (2004). Reprinted with permission of *The Columbia Law Review* given by Lilly Zaragoza, Editor in Chief, 2012.

17. Measured by a different standard, however, their performance is less commendable. I have suggested elsewhere that the length of elapsed time between a law school's founding date and the date its first woman professor was hired serves as an indicator of the school's receptivity to women faculty. See Herma Hill Kay, "UC's Women Law Faculty," 36 *U.C. Davis L. Rev.* 331, 339. Subtracting the woman's hiring date from the school's founding date gives a time lag for each of the twelve schools listed there ranging from a low of 25 years at Berkeley to a high of 155 years at Harvard, with Columbia showing a time lag of 115 years.

18. See Richard K. Neumann, Jr., "Women in Legal Education: What the Statistics Show", 50 *J. Legal Educ.* 313, 318–19 & tbl.4 (2000), identifying twelve schools, based on their students' LSAT scores, "that appear likely to graduate a high proportion of the law faculties of the future."

19. Interview with Judge Ruth Bader Ginsburg in Washington, DC, September 22, 1991. Unless a different source is cited, all quotations from Judge or Justice Ginsburg are from this interview.

20. Ass'n of American Law Schools, Directory of Law Teachers, 1980–81, at 58–59 (Berkeley), 63–64 (Chicago), 65–66 (Columbia), 73 (Duke), 76–78 (Georgetown), 81–82 (Harvard), 96–97 (Michigan), 103–05 (NYU), 111 (Pennsylvania), 122–23 (Stanford), 130–32 (Virginia), 137–38 (Yale) (1981). Columbia added three women as assistant professors in 1981. Ass'n of American Law Schools, Directory of Law Teachers 36–37 (Supp. 1981–82).

21. Ruth Bader Ginsburg, "Women's Work: The Place of Women in Law Schools," 32 *J. Legal Educ.* 272, 272 (1982), citing Donna Fossum, "Women Law Professors," 1980 *Am. B. Found. Res. J.* 903.

22. A revised version of this and the following section appears in Herma Hill Kay, "Ruth Bader Ginsburg, Law Professor Extraordinaire," in *The Legacy of Ruth Bader Ginsburg* 17–33 (Scott Dawson, ed.) (2014), used here by permission of the publisher. Ginsburg's credit to her mother: Edith Lampson Roberts, "Ruth Bader Ginsburg," in *The Supreme Court Justices: Illustrated Biographies, 1789–1995*, at 531, 531–32 (Clare Cushman, ed.) (2nd ed. 1995).

23. Mark Curriden, "Justice Ruth Bader Ginsburg, August 29–30, 2011: Jurist-in-Residence at SMU Dedman School of Law," 42 *The Quad* 9 (Fall 2011).

24. Erwin N. Griswold, *Ould Fields, New Come: The Personal Memoirs of a Twentieth Century Lawyer 171* (1992), reporting that the vote in favor of admitting women was "about three to one." The yearbook of the class of 1953 featured a drawing of a baby carriage with an attached sign reading "Portia Glutz Atty-at-Law Harvard '53"; see *The Harvard Law School Yearbook* 28–29 (1953).

25. See *Alumni Directory of the Harvard Law School, The Quinquennial Catalogue, Chronological Section*, at 116–19 (1963). The class listings have two separate columns: one for Harvard Law School graduates, and another for "Non-Graduates." The latter are students who enrolled at Harvard but did not take a degree there. The name of "Ruth Joan Ginsburg" appears in the non-graduate list of the Class of 1959. Id., at 119.

26. Ruth Bader Ginsburg, "The Equal Rights Amendment Is the Way," 1 *Harv. Women's LJ.* 19, 20 (1978), editors' introduction.

27. See *Ass'n of American Law Schools, Directory of Teachers in Member Schools 1947–48*, at 12 (continued as *AALS Directory of Law Teachers*, listing Soia Mentschikoff as a Visiting Lecturer at Harvard Law School for academic year 1947–48; *Ass'n of American Law Schools, Directory of Teachers in Member Schools 1948–49*, at 4, listing Soia Mentschikoff as a Visiting Professor for 1948–49. Judith Richards Hope reports that Mentschikoff's appointment "was a great success and had an unexpected benefit: she single-handedly integrated the Harvard Faculty Club." Judith Richards Hope, "Pinstripes and Pearls: The Women of the Harvard Law School Class of '64 Who Forged an Old-Girl Network and Paved the Way for Future Generations," 15 (2003), quoting Harvard Professor Louis Toepfer.

28. See *Ass'n of American Law Schools, Directory of Law Teachers*, 1973, at 32 (1972), listing Elisabeth Owens as Professor of Law at Harvard University Law School.

29. See Herma Hill Kay, "In Memoriam: Elisabeth A. Owens," 112 *Harv. L. Rev.* 1403, 1404 (1999), discussing Owens's career at Harvard; see also Joel Seligman, "The High Citadel: The Influence of Harvard Law School" 128 (1978), noting with apparent sarcasm that "Owens, associated with the Law School for seventeen years as a researcher and lecturer, was suddenly found to be 'professorial' material and received a full professorship effective July 1, 1972."

30. See Masthead, 71 *Harv. L. Rev.* 325 (1957).

31. Griswold, *supra* note 24, at 173–74.

32. Roberts, *supra* note 22, at 532

33. Ibid.

34. Gerald Gunther, "Ruth Bader Ginsburg: A Personal, Very Fond Tribute," 20 *U. Haw. L. Rev.* 583, 583 (1998).

35. Justice Ruth Bader Ginsburg '59, *Columbia Law School Report*, Spring 1994, at 9.

36. Masthead, 59 *Colum. L. Rev.* 152 (1959).

37. Gunther, *supra* note 34, at 583.

38. Ibid., at 584.

39. Roberts, *supra* note 22, at 532.

40. Curriden, *supra* note 23, at 11.

41. Ruth Bader Ginsburg, "Remarks for Columbia University Reception" (June 21, 1994), on file with the author.

42. Ibid.

43. Ruth Bader Ginsburg, "Introduction of Hans Smit," Columbia Law School Washington, D.C. Alumni Association Dinner (May 10, 2001), on file with the author.

44. Ruth Bader Ginsburg and Anders Bruzelius, *Civil Procedure in Sweden* (1965). Articles by Ginsburg based on the study include "The Jury and the Nämnd: Some Observations on Judicial Control of Lay Triers in Civil Proceedings in the United States and Sweden," 48 *Cornell L.Q.* 253 (1963), and "Civil Procedure: Basic Features of the Swedish System," 14 *Am. J. Comp. L.* 336 (1965).

45. Ruth Bader Ginsburg, "Remarks for First Meeting of Alumnae of Columbia Law School" (March 11, 1996), on file with the author. Because she was hired to replace Clyde Ferguson, who had left Rutgers to become Dean at Howard University Law School, Ginsburg later told a Columbia Law student reporter "that the school might have said, 'If we can't get a black to replace Clyde, let's get a woman.'" See Mitchel Ostrer, "Columbia's Gem of the Motion: A Profile of Ruth Bader Ginsburg," *Juris Dr.*, Oct. 1977, at 34, 36.

46. See Kay, "Future of Women Law Professors," *supra* note 10, at 8–10 and n26 (chronicling the "slow but steady" entry of women professors after 1945).

Jeanette Smith began teaching at Miami in 1949, while Minnette Massey started there as a law librarian in 1951 and moved to full-time law teaching in 1958. Both are among the fourteen early women law professors. Alessandra del Russo began teaching at Howard in 1961, while Patricia Roberts Harris joined her as an assistant professor in 1963. See *Ass'n of American Law Schools, Directory of Law Teachers in American Bar Association Approved Law Schools,1963,* at 32 (1962). When I joined the Berkeley faculty in 1960, Barbara Armstrong was still in residence updating her family law treatise. Although she was my invaluable mentor, she had retired in 1957.

47. Ruth Bader Ginsburg, "Remarks for Rutgers" (April 11, 1995), on file with the author.

48. See, e.g., Ruth B. Ginsburg, "Special Findings and Jury Unanimity in the Federal Courts," 65 *Colum. L. Rev.* 256 (1965); Ruth B. Ginsburg, "The Competent Court in Private International Law," 20 *Rutgers L. Rev.* 89 (1965).

49. Arthur Bostrom, Anders Bruzelius, Ormonde Goldie, and Ruth B. Ginsburg, *International Co-operation in Litigation: Sweden, in International Co-operation in Litigation: Europe* 332 (Hans Smit, ed.) (1965).

50. *Swedish Code of Judicial Procedure* (Anders Bruzelius and Ruth Bader Ginsburg, trans.) (1968).

51. Ruth B. Ginsburg, "Judgments in Search of Full Faith and Credit: The Last-in-Time Rule for Conflicting Judgments," 82 *Harv. L. Rev.* 798 (1969), clarifying the priority to be accorded to inconsistent final state court judgments.

52. Ginsburg, *supra* note 47.

53. Ibid.

54. Ibid.

55. Ibid.

56. Ibid.

57. See Kay, "Owens," *supra* note 29, at 1407.

58. Ruth Bader Ginsburg, "Treatment of Women by the Law: Awakening Consciousness in the Law Schools," 5 *Val. U. L. Rev.* 480 (1971); Ruth Bader Ginsburg, "Sex and Unequal Protection: Men and Women as Victims," Speech before the Southern Regional Conference of the National Conference of Law Women (October 1, 1971), in 11 *J. Fam. L.* 347 (1971).

59. Equal Employment Opportunity Act of 1972 § 3, Pub. L. No. 92–261, 86 Stat. 103, 103–04 (codified as amended at 42 U.S.C. § 2000e-1 (a) (2000)).

60. Ginsburg, *supra* note 47.

61. See Lesley Oelsner, "Columbia Law Snares a Prize in the Quest for Women Professors," *New York Times,* January 26, 1972, at 39, reporting that "[i]n a new accelerating competition among the nation's law schools, Columbia University has just scored a major coup: its law school, to its undisguised glee, has just bid for and won a woman for the job of full professor—the first in its 114-year history," and going on to note that "[t]he glee comes in part because the woman,

Ruth Bader Ginsburg, is what the school's dean, Michael Sovern, calls 'so distin-
guished a scholar,' that her credentials and honors would stand out in any cata-
logue of professors." Oelsner noted that Ginsburg's appointment came "[a]s the
University of Michigan Law School dean, Theodore St. Antoine, says, at a time
when many of the country's best law schools have been 'scrambling' for women,
often for the same one. Most have no women at any rung of the professorial lad-
der, and, according to other sources, the woman Columbia got was among those
being scrambled for."

62. See Ginsburg, *supra* note 47. For Meyer's account see Carol H. Meyer,
"The First Activist Feminist I Ever Met," 9 *Affilia* 85, 85 (1994): "I also have a
strong memory of Ginsburg—a diminutive woman with black hair, tied with a
huge bow. Ginsburg was gracious and funny and clearly in command as she told
us her purpose for bringing us together."

63. See Linda K. Kerber, "Writing Our Own Rare Books," 14 *Yale J.L. & Fem-
inism* 429, 430–31 (2002). Professor Kerber notes that the first monograph on
the topic was published in 1969 by Professor Leo Kanowitz under the title
Women and the Law: The Unfinished Revolution (1969). Our casebook was
Kenneth M. Davidson, Ruth Bader Ginsburg, and Herma Hill Kay, *Text, Cases
and Materials on Sex-Based Discrimination* (1974).

64. See Gunther, *supra* note 34, at 584, noting that Ginsburg "put aside her
major academic interest in comparative procedure" in order to do this work.

65. Ruth Bader Ginsburg, "Remarks for the Celebration of 75 Years of Wom-
en's Enrollment at Columbia Law School," 102 *Colum. L. Rev.* 1441, 1441 (2002).

66. H.R.J. Res. 208, 92d Cong., 86 Stat. 1523 (1972).

67. 117 Cong. Rec. 35,814–15 (daily ed. October 12, 1971) (statement of Rep.
Griffiths).

68. See Ruth Bader Ginsburg, "The Need for the Equal Rights Amendment,"
59 A.B.A.J. 1013 (1973); Ruth Bader Ginsburg, "Let's Have ERA as a Signal," 63
A.B.A.J. 70, 70 (1977); Ginsburg, *supra* note 33.

69. Ginsburg, "The Need for the Equal Rights Amendment," *supra* note 68, at
1017–18.

70. Ginsburg, "Let's Have ERA," *supra* note 68, at 73.

71. Ginsburg, *supra* note 33, at 21.

72. Equal Rights Amendment Extension: Hearings on SJ. Res. 134 Before the
Subcomm. on the Constitution of the Comm. on the Judiciary, 95th Cong. 265–
71 (1978), statement of Professor Ruth Bader Ginsburg, Columbia Law School.

73. H.R.J. Res. 638, 95th Cong. (1978), approved by the House of Representa-
tives on August 15, 1978, 124 Cong. Rec. 26,193–203 (daily ed. August 15,
1978), and by the Senate on October 6, 1978, 124 Cong. Rec. 34,314–15 (daily
ed. October 6, 1978).

74. See Ruth Bader Ginsburg, "Ratification of the Equal Rights Amendment:
A Question of Time," 57 *Tex. L. Rev.* 919, 936 (1979). The first tenure-track

woman hired by the University of Texas in 1974, Patricia A. Cain, had the honor of introducing Ginsburg that day.

75. Ironically, the one she lost was a property tax case, *Kahn v. Shevin*, 416 US 351 (1974). Her first major sex discrimination win had occurred in an income tax case that she and husband, Marty, argued before the 10th Circuit; see *Moritz v. Commissioner*, 469 F.2d 466 (10th Cir. 1972).

76. See Ruth Bader Ginsburg, "The Burger Court's Grapplings with Sex Discrimination," in *The Burger Court: The Counter-Revolution That Wasn't* 132, 132-33 (Vincent Blasi, ed.) (1983); Ruth Bader Ginsburg, "Gender and the Constitution," 44 *U. Cin. L. Rev.* 1, 2 (1975); Ruth Bader Ginsburg, "Gender in the Supreme Court: The 1973 and 1974 Terms," *Sup. Ct. Rev.* 1, 1 (1975); Ruth Bader Ginsburg, "Gender in the Supreme Court: The 1976 Term, in Constitutional Government in America," 217, 224 (Ronald K.L. Collins, ed.) (1980); Ginsburg, *supra* note 65; Ruth Bader Ginsburg, "Sex Equality and the Constitution," 52 *Tul. L. Rev.* 451, 474-75 (1978); Ruth Bader Ginsburg, "Sexual Equality Under the Fourteenth and Equal Rights Amendments," 1979 *Wash. U.L.Q.* 161, 161-62.

77. See, e.g., Wendy Webster Williams, "Ruth Bader Ginsburg's Equal Protection Clause: 1970-80," 25 *Columbia Journal of Gender & Law* 41 (2013); Amy Leigh Campbell, "Raising the Bar: Ruth Bader Ginsburg and the ACLU Women's Rights Project," 11 *Tex. J. Women & L.* 157, 158 (2002), discussing Ginsburg's contributions to constitutional law as professor, lawyer, and women's rights advocate; Ruth B. Cowan, "Women's Rights Through Litigation: An Examination of the American Civil Liberties Union Women's Rights Project, 1971-1976," 8 *Colum. Hum. Rts. L. Rev.* 373, 373-74 (1976), discussing ACLU involvement in women's rights movement; Diana Gribbon Motz, "Ruth Bader Ginsburg: Supreme Court Advocate 1971-1980," unpublished manuscript, on file with the *Columbia Law Review.*

78. Herma Hill Kay, "Ruth Bader Ginsburg," *Am. Law.* 72 (December 1999).

79. The data presented here were first published in Kay, *supra* note 10, at 10. The seventeen women who preceded Ginsburg were the first fourteen early women law professors whose careers are described in chapters 1-6, and three appointed before 1963 who are shown in Table 2, Women Hired 1960-65 By Date of Appointment: Herma Hill Kay of U.C. Berkeley, 1960; Alessandra Luini del Russo of Howard, 1961; and Eva Morreale (later Hanks) of Rutgers, Newark, 1962.

80. Interview with Richard W. Jennings, Professor of Law, University of California, Berkeley, in Berkeley, CA, November 8, 1990. Unless another source is cited, all quotations from Professor Jennings are from this interview.

81. Collected Papers of William Prosser, Berkeley Law Library Archives.

82. Sybil Marie Jones Dedmond, an African American woman, graduated from the University of Chicago Law School in 1950, and taught at North Carolina Central Law School (NCCLS) from 1951 until 1964. NCCLS was ABA-approved when she taught there, but it did not become an AALS member until 2012.

83. J. Clay Smith, "Patricia Roberts Harris: A Champion in Pursuit of Excellence," 29 *How. L. J.* 437, 449–50 (1986).

84. Ibid., at 449, quoting Greenfield, "The Brief Saga of Dean Harris," *Washington Post*, March 23, 1969, at C1; Greenfield, "Pat Harris, A Friendship," *Washington Post*, March 25, 1985.

85. Ibid., at 450, quoting *Medical Protest Ends, Law Continues Boycott*, H.U. Newsletter, February 24, 1969, at 1.

86. Ibid., at 451.

87. Ibid., at 452, quoting Dean Barron's statement in the May/June 1983 issue of *GW Times*, at 2.

88. Ibid., at 439.

89. The material concerning Brigitte Bodenheimer was first published in Kay, *supra* note 17, at 357.

90. Pub. L. No. 98–611, § 8(a), 94 Stat. 3569 (1980) (codified at 28 U.S.C.A. § 1738A(c)(2)(A) & (2)(B) (2001).

91. Cynthia Grant Bowman, *Dawn Clark Netsch: A Political Life*, 145 (2010).

92. Ibid., at 145–54.

93. Ibid., at 157.

94. Ibid., at 188.

95. Dawn Clark Netsch and Daniel R. Mandelker, *State and Local Government in a Federal System* (1977). Subsequent editions appeared in 1983, 1990, and 1995.

96. Bowman, *supra* note 91, at 261. The gubernatorial campaign is detailed at 227–59.

97. Ibid., at 263.

98. Eloise Beach, "Ex-Local Resident Named New Mexico's First Woman Assistant Attorney General," *The Richmond, Indiana Pal Item*, September 3, 1961, at 4a. I am grateful to Earlham Archivist, Anne Thomason, for providing me with this newspaper item, and for supplying some of the personal information about Shirley Crabb Zabel presented in the text.

99. See Jayanth K. Krishnan, "Academic SAILERS: The Ford Foundation and the Efforts to Shape Legal Education in Africa, 1957–1977," 52. *Am. J. Leg. Hist.* 261 (July 2012).

100. Ibid., at 284–85 (Table 1). The other woman was Judith R. Thoyer. She and Michael E. Thoyer were both at the University of Ghana from 1963 to 1964; what relationship might have existed between them is not disclosed.

101. Ibid., at 309, n. 242.

102. Tina Spee, "Conversations with Tamar Frankel," an interview with Lawdragon, posted on February 22, 2007. Available at https://tamarfrankel.com/conversations.

103. Ibid.

104. Cited in ibid.

105. Tamar Frankel, Professor of Law, http://www.tamarfrankel.com.

106. https://www.bu.edu/federal/2018/07/03/after-50-years-tamar-frankel-is-retiring-from-law-faculty/.

107. Fossum, *supra* note 14, at 906.

108. Interview with Dean Frank T. Read, San Diego, CA, February 16, 2001. Unless another source is specified, all quotations from Dean Read are from this interview. See also Frank T. Read and Elisabeth S. Petersen, "Sex Discrimination in Law School Placement," 18 *Wayne L. Rev.* 639 (1972).

109. The student members were Christine M. Durham of Duke (later appointed to the Supreme Court of Utah), Nancy Gertner of Yale (later appointed by President Clinton as a federal district court judge), Mary Kelly of NYU, Diane Middleton of Wayne State, and Susan Westerman of Michigan.

110. Marina Angel, WLE Chair—1986, "Law Stories: Reflections of Women in Legal Education: Stories from Four Decades of Section Chairs," 80 *UMKC L. Rev.* 711, 711–12 (2012).

111. Ginsburg, *supra* note 6, at 663.

112. Read, now a nationally renowned estate planning attorney, was then a faculty member at NYU. It was at this conference that Ruth Bader Ginsburg, Herma Hill Kay, and Kenneth Davidson agreed to co-author a casebook on Sex-Based Discrimination.

113. See Linda Jellum and Nancy Levit, Introduction, "Law Stories," *supra* note 109, at 660–61, listing names of Section Chairs from 1970 through 2012.

114. Ruth Bader Ginsburg, "Women at the Bar—A Generation of Change," 80 *UMKC L. Rev.* 665, 670 (2011), reprinted from 2 Puget Sound L. Rev. 1 (1978).

115. See Angel, *supra* note 109, at 711–12.

116. Ibid., at 713.

117. Email from Nancy Davis to Herma Hill Kay, July 25, 2014.

118. Patricia Cain, "The Future of Feminist Legal Theory," 11 *Wis. L. J.* 367, 372 (1997).

119. Ibid., at 373.

120. Ibid., at 374.

121. Aleta Wallach, "Genesis of a 'Women and the Law' Course: The Dawn of Consciousness at UCLA Law School," 24 *J. Legal Educ.* 309 (1972).

122. Letter from Professor Marilyn J. Ireland to Herma Hill Kay, May 31, 2008. All quotations from Professor Ireland, unless another source is specified, are from this letter.

123. Interview with Dr. Sybil Jones Dedmond by Herma Hill Kay at Pensacola, FL, January 25, 1991. All quotations from Dr. Dedmond, unless another source is specified, are from this interview.

124. Sybil Jones Dedmond, "The Problem of Family Support: The Criminal Sanctions for the Enforcement of Support," 38 *N.C.L. Rev.* 1 (1959).

125. See Emma Coleman Jordan, "Images of Black Women in the Legal Academy: An Introduction to a Symposium on Black Women Law Professors," 6 *Berkeley Wom. L.J.* 1, 21 (1990–91).

126. Trina Grillo, "Tenure and Minority Women Law Professors: Separating the Strands," 31 *U.S.F. L. Rev.* 747, 752 and note 10 (1996–97). This article was revised for posthumous publication by Professors Catharine Wells and Stephanie Wildman from the text of a speech delivered by Professor Grillo to the Southwest People of Color Conference in April, 1992.

127. Joyce A. Hughes, "Black and Female in Law," 5 *Rutgers Race & The Law J.* 105, 114 n. 39 (2003).

128. Joyce A. Hughes, "Different Strokes: The Challenges Facing Black Women Law Professors in Selecting Teaching Methods," 16 *Nat'l Black L.J.* 27, 33 (1998–2000).

129. The persons identified as "Lesbian Law Professors" in this section have all self-identified by listing their names on "List III: Gay, Lesbian and Bisexual Community Law Teachers," which first appeared in the 1996–97 *AALS Directory* at pp. 1287–88.

130. Interview with Patricia A. Cain and Jean Love, San Francisco, California, June 12, 2006. All quotations from Patricia Cain or Jean Love, unless a different source is specified, are from this interview.

131. Harvey Milk was elected to the San Francisco City and County Board of Supervisors in 1977, and took office in 1978 as the city's first openly gay elected official.

132. Patricia A. Cain, "A Section Memoir," 80 *UMKC L. Rev.* 727, 728 (2012).

133. Ken Myers, "First Appointment of Its Kind: Iowa Hires Openly Gay Couple," *Nat'l L.J.*, September 9, 1991, at 4.

134. On the significance of bathrooms in feminist legal theory, see Taunya Lovell Banks, "Toilets as a Feminist Issue: A True Story," 6 *Berkeley Wom. L. J.* 263 (1990–91).

135. The piece was published in 1978. See Marilyn J. Ireland, "Rape Reform Legislation: A New Standard of Sexual Responsibility," 49 *U. Colo. L. Rev.* 185 (1978). It was indeed a work of feminist jurisprudence, one well ahead of its time.

136. I am grateful to Professor Susan Appleton of Washington University at St. Louis for obtaining this information for me.

137. Email from Rhonda R. Rivera to Herma Hill Kay, Monday, July 31, 2006.

138. See Rhonda R. Rivera, "Our Straight-Laced Judges: The Legal Position of Homosexual Persons in the United States," 30 *Hast. L.J. 799* (1979). The article was republished in the 50th Anniversary of the *Hastings Law Journal* with a preface by Rivera, explaining how the article came to be written. See Rhonda R. Rivera, "Our Straight-Laced Judges: Twenty Years Later," 50 *Hast. L.J.* 1179 (1999).

139. Rivera, "Twenty Years Later," *supra* note 137, at 1179, n. 5.

140. Ibid., at 1182, and n. 20. She explained that she had not then completed the piece that had been intended as her "tenure article," on Section 2–105 of the Uniform Commercial Code, and had no other work to offer. That article, "Identification of Goods and Casualty to Identified Goods Under Article Two of the UCC," was published in 13 *Ind. L. Rev.* 637 in 1981.

141. Ibid., at 1184 and n. 25.

142. Interview with Rhonda R. Rivera, Ohio State University Law School, August 28, 1990. All quotations from Professor Rivera, unless another source is specified, are from this interview.

143. Email from Professor Rhonda Rivera to Herma Hill Kay, Sunday, July 30, 2006.

144. Email from Professor Arthur S. Leonard to Herma Hill Kay, Monday, July 31, 2006.

145. Myrna S. Raeder, "Reflections About Who We Were When Joining Conveyed a Message," 80 *UMKC L. Rev.* 703, 703 (2012).

146. Ibid., at 704.

147. Marina Angel, "Women in Legal Education III," 80 *UMKC L. Rev.* 711, 716.

148. Ibid.

149. Ann Scales, "Towards a Feminist Jurisprudence," 56 *Ind. L.J.* 375 (1981).

150. See Patricia A. Cain, "Feminist Legal Scholarship," 77 *Iowa L. Rev.* 19, 35 (1991).

151. Jordan, *supra* note 124, at 3 and n. 11.

152. See Women in the Profession Statistics, ABA Commission on Women at https://www.americanbar.org/groups/diversity/women/resources/statistics (last visited 7/3/2020).

153. See, e.g., Frances Olsen, "Affirmative Action: Necessary but Not Sufficient," 71 *Chi-Kent L. Rev.* 937, 938 (1996), stating that "(a)ccording to the American Bar Association's Review of Legal Education in the United States, Fall, 1994 edition, 26 percent of full-time law professors nationwide were women, but only 15 percent of law professors at Harvard were women. University of Chicago also had only 15 percent, University of Michigan 16 percent, and Berkeley and Columbia each had 22 percent." See also Richard K. Neumann Jr., "Women in Legal Education: What the Statistics Show," 50 *J. Leg. Ed.* 313, 343 (2000).

154. These calculations are based on data from the AALS Faculty Directory for 1999–2000, excluding clinical, visiting, and emeritus faculty.

155. Soia Mentschikoff and Dorothy Nelson both held deanships at the same time during the late 1970s before Nelson accepted the appointment to the Ninth Circuit.

156. Herma Hill Kay, "Women Law School Deans: A Different Breed, Or Just One of the Boys?," 14 *Yale J.L. & Feminism* 219, 231 (2002).

157. Ibid., at 222.

158. Laura M. Padilla, "A Gendered Update on Women Law Deans: Who, Where, Why, and Why Not?" 15 *Am. U. J. Gender Soc. Pol'y & L.* 443 (2007).

159. Cynthia L. Cooper, "Women Ascend in Deanships as Law Schools Undergo Dramatic Change, Perspectives" (July 9, 2016). Available at https://www.americanbar.org/groups/diversity/women/publications/perspectives /2016/summer/women_ascend_deanships_law_schools_undergo_dramatic_ change.

160. Elena Kagan (now on the Supreme Court) and Martha Minow.

161. Kathleen Sullivan, M. Elizabeth Magill, and Jenny S. Martinez.

162. Heather K. Gerken.

CONCLUSION

1. If we include Sybil Jones Dedmond, then one of the first fifteen would include one black woman. Since my focus was on ABA/AALS schools, I omitted Dedmond from the early years, but did provide a more complete story of her life in chapter 7.

2. Katharine T. Bartlett, "Feminist Legal Methods," *103 Harv. L. Rev.* 829 (1990).

APPENDIX

1. Patricia Cain phone conversation with Stanley Goldman, November 22, 2019.

2. Email from Fred Lower to Patricia Cain, December 9, 2019.

3. *Loyola Digest* 7 (March 1963).

Founded in 1893,
UNIVERSITY OF CALIFORNIA PRESS
publishes bold, progressive books and journals
on topics in the arts, humanities, social sciences,
and natural sciences—with a focus on social
justice issues—that inspire thought and action
among readers worldwide.

The UC PRESS FOUNDATION
raises funds to uphold the press's vital role
as an independent, nonprofit publisher, and
receives philanthropic support from a wide
range of individuals and institutions—and from
committed readers like you. To learn more, visit
ucpress.edu/supportus.